MARKETING THE ARTS

In recent years, there have been significant shifts in arts marketing, both as a practice and an academic discipline. The relationship between art and the market is increasingly complex and dynamic, requiring a transformation in the way the arts are marketed.

Marketing the Arts argues that arts marketing is not about the simple application of mainstream managerial marketing to the arts. With contributions from international scholars of marketing and consumer studies, this book engages directly with a range of contemporary themes, including:

- the importance of arts consumption and its social dimensions
- the importance of the aesthetic experience itself, and how to research it
- arts policy development
- the art versus commerce debate
- the role of the arts marketer as market-maker
- the artist as brand or entrepreneur

This exciting new book covers topics as diverse as Damien Hirst's *For the Love of God*, Liverpool's brand makeover, Manga scanlation, Gob Squad, Surrealism, Bluegrass music, Miles Davis, and Andy Warhol, and is sure to enthuse students and enlighten practitioners.

Daragh O'Reilly is a Lecturer in Marketing at the University of Sheffield, UK. His current research interests include arts marketing and branding.

Finola Kerrigan is a Lecturer in Marketing at King's College London, UK. She researches arts marketing and has published a number of books and articles in international journals.

MARKETING THE ARTS

A fresh approach

Edited by
Daragh O'Reilly and Finola Kerrigan

Routledge
Taylor & Francis Group

LONDON AND NEW YORK

First published 2010
by Routledge
2 Park Square, Milton Park, Abingdon, Oxon, OX14 4RN

Simultaneously published in the USA and Canada
by Routledge
270 Madison Ave, New York NY 10016

Routledge is an imprint of the Taylor & Francis Group, an Informa business

Transferred to Digital Printing 2010

Typeset in Aldus and Gill Sans
by Keystroke, Tettenhall, Wolverhampton

British Library Cataloguing in Publication Data
A catalogue record for this book is available from the British Library

Library of Congress Cataloguing in Publication Data
Marketing the arts / edited by Daragh O'Reilly and
Finola Kerrigan. — 1st ed.
 p. cm.
Includes bibliographical references and index.
1. Arts—Marketing. I. O'Reilly, Daragh. II. Kerrigan, Finola.
NX634.M38 2010
700.68′8—dc22 2009039114

ISBN 13: 978–0–415–49685–8 (hbk)
ISBN 13: 978–0–415–49686–5 (pbk)
ISBN 13: 978–0–203–85507–2 (ebk)

ISBN 10: 0–415–49685–3 (hbk)
ISBN 10: 0–415–49686–1 (pbk)
ISBN 10: 0–203–85507–8 (ebk)

For our families and friends,
and to arts marketing researchers, a very supportive community –
long may they prosper!

CONTENTS

FIGURES

TABLES

NOTES ON CONTRIBUTORS

Michela Addis is Associate Professor of Marketing in the Faculty of Economics, University of Rome Three, Italy, where she teaches Advanced Marketing and Market Research courses. She is also Professor of Marketing at SDA Bocconi School of Management, where she leads the executive education programme on customer loyalty and where she has acted as faculty director and instructor for several custom courses. She has been a visiting scholar at the Helsinki School of Economics (2000) and at the Columbia Business School (2000; 2004; 2005). Her research interests include arts marketing, consumption in the motion-picture industry, emotional and experiential aspects of consumption, customer loyalty, post-modern marketing, and fantasy in consumption. She has been published in a number of leading international journals.

Lisa Baxter is an arts marketing consultant, qualitative researcher and trainer. She is a member of the Arts Marketing Association, Association of Qualitative Research and Associate Member of the Market Research Society. Other published work includes guest editing and writing for the *Journal of Arts Marketing* on qualitative research.

Alan Bradshaw is a Senior Lecturer in Marketing at Royal Holloway, University of London. His chapter in this book, 'For the Love of God' , co-authored with Finola Kerrigan and Morris Holbrook, forms the final instalment of an art versus culture trilogy he developed with Morris Holbrook, which includes a study of artistic self-destruction published in *Marketing Theory* and a study of the commercial deployment of culture, published in *Consumption, Markets and Culture*.

Stephen Brown, an egotistical pseudo-intellectual at the best of times and a pretentious prima donna for the rest, is the P.T. Barnum Professor of

Marketing Research at the University of Ulster. He has written countless unreadable books and articles under a variety of unspeakable pseudonyms. These include Al Terego, Sue Denim, Alan Smithee, Aedh Aherne, Dave Kelley and Peregrine Faulkner, plus one or two others whose names are made available on a need-to-know basis. (Suffice it to say that Stephen's bestselling pseudonymous books range from *The Tipping Point* and *In Search of Excellence* to *Good to Great* and *The Marketing Imagination*.) Understandably, he prefers not to talk about his stunning scholarly achievements. Not with peasants like you . . .

Elizabeth Carnegie has significant experience of the museum sector and has participated in a number of high-profile and award-winning projects. She currently lectures in arts and culture at the University of Sheffield and holds a PhD in representation and an MA in Museum Studies.

Noel Dennis is a Principal Lecturer in Marketing at Teesside University. He is also a professional jazz musician (trumpet and flugelhorn), having played the trumpet since he was eight years old. He has played a host of venues in the UK and Europe with internationally renowned musicians and regularly composes and records incidental music for television. Noel has successfully combined his career in marketing with jazz and has published numerous articles on the subject. He is currently researching a PhD looking at the use of jazz improvisation techniques in marketing.

Richard Elliott is Dean of the University of Bath School of Management and also Professor of Marketing and Consumer Research. He is a Fellow of St Anne's College, Oxford, and a visiting professor at SDA Bocconi, Milan; Thammasat University Bangkok and Hong Kong Polytechnic University. Previously he was the first person to be appointed to a Readership in Marketing at the University of Oxford and was a Deputy Director of the Säid Business School. He worked for 12 years in brand management with a number of US multinationals and as an Account Director at an international advertising agency.

Matt Fenton is Director of Public Arts at Lancaster Institute for the Contemporary Arts, Lancaster University. Combining three important arts organizations – the Peter Scott Gallery, Nuffield Theatre and Lancaster International Concert Series – his role exists at the meeting point of art practice, academic teaching and research. He is also currently Scheme of Studies Director for Lancaster University's MA in Professional Contemporary Arts Practice. As a theatre director, Matt's work explores the relationship between architecture, technology and memory, and has been performed in venues and festivals across the UK.

Ian Fillis is Senior Lecturer in Marketing at the University of Stirling. His research interests include small business marketing, the relationship between marketing, management, art and creativity, alternative research methodologies such as metaphor and biography, international and export marketing, e-business and supplier development. He has published widely in European, American and Asian journals. As well as contributing to a number of edited volumes, he has published two research monographs including *Creative Marketing: an Extended Metaphor for Marketing in a New Age* (with Ruth Rentschler, Palgrave Macmillan, 2005). He has delivered invited seminars to universities in the UK, Sweden, Finland, Australia and the USA.

Christina Goulding is Professor of Consumer Research at Wolverhampton Business School. Her research interests include communities of consumption, cultural consumption, non-conformist consumption and the application and development of qualitative research methodologies. She has published her work in several leading journals including *Journal of Consumer Research, Psychology and Marketing, European Journal of Marketing, Journal of Marketing Management* and *Consumption, Markets and Culture*. She is also author of the book *Grounded Theory* (Sage 2002).

Debi Hayes is Dean of the School of Creative Enterprise at the University of the Arts, London. Her research interests and publications focus on the impact of cultural and creative industries policy on enterprise and marketing practices within the sector. She is the Deputy Editor of the *Creative Industries Journal* published by Intellect.

Elizabeth C. Hirschman was born and raised in eastern Tennessee among the Appalachian Mountains. After a long period of absence, she has now started returning to Appalachia each summer both for relaxation and to conduct research on the remarkable culture of those dwelling there. Elizabeth is presently Professor II of Marketing in the School of Business, Rutgers University, New Brunswick. She has published over 200 papers, articles and books in marketing, consumer behaviour, communications, social psychology, anthropology, sociology and semiotics. She is a past president and fellow of the Association for Consumer Research and has been named one of the most highly cited researchers in Economics and Business by the Institute for Scientific Information.

Morris B. Holbrook has recently retired from his position as the W. T. Dillard Professor of Marketing in the Graduate School of Business at Columbia University. From 1975 to 2009, he taught courses at the Columbia Business

School in such areas as Marketing Strategy, Consumer Behaviour, and Commercial Communication in the Culture of Consumption. His research has covered a wide variety of topics in marketing and consumer behaviour with a special focus on issues related to communication in general and to aesthetics, semiotics, hermeneutics, art, entertainment, music, jazz, motion pictures, nostalgia, and stereography in particular.

Finola Kerrigan is a Lecturer in Marketing at King's College London. She has published her work on arts marketing in a number of journals and scholarly books. She is chair of the Academy of Marketing's Arts, Heritage, Nonprofit and Social Marketing Special Interest Group.

Gretchen Larsen is a Lecturer in Marketing at King's College London. Prior to that, she held lecturing posts at the University of Bradford and the University of Otago, New Zealand. Her research is built around understanding how consumers construct, perform and interpret their position in a socio-cultural world and, to this end, focuses primarily on the consumption of creative arts products. Her research is disseminated at conferences and in journals, and she is an active member of the arts marketing community, being part of a team that ran an ESRC-funded seminar series 'Rethinking Arts Marketing' and a Keynote Speaker at the Arts Marketing Association Annual Conference in 2008.

Rob Lawson is a Professor of Marketing at the University of Otago, New Zealand, where he has worked since 1987. He completed his first degree in Geography at the University of Manchester, an MSc in Agricultural Marketing at the University of Newcastle upon Tyne and a PhD at the University of Sheffield. Rob's area of expertise is in the study of consumer behaviour, though he also has interests in the development of marketing theory. Within consumer behaviour his research has been concentrated into two broad areas: tourist behaviour, and the values and lifestyles of New Zealand consumers. He is co-leader of the New Zealand consumer lifestyles project. Rob's work is published in a wide range of international journals.

Hye-Kyung Lee is a Lecturer at the Centre for Cultural, Media and Creative Industries Research, School of Arts and Humanities, King's College London. Her research and teaching focuses on cultural policy discourse, creative industries policies and cultural marketing. Recently, she has been interested in cultural consumers' non-market production of culture and its implications for the industry and policy-making, and has been investigating scanlation of manga and fan translation of anime and Korean TV drama.

Michael Macaulay is Reader in Governance and Public Ethics at Teesside University Business School. With an academic background in political philosophy he has directed his research towards exploring some of the more abstract and abstruse conceptual dilemmas that repeatedly vex marketers in both the academic and professional arenas. He has a particular interest in arts marketing and, together with his co-author and best friend Noel Dennis, has published a number of articles on music and marketing.

Daragh O'Reilly is a Lecturer in Marketing at the University of Sheffield. Before moving into the education sector, he worked in a wide range of sales/marketing roles and product-markets. His doctoral research was on the marketing and consumption of popular music. He was a contributor to the ESRC-funded 'Rethinking Arts Marketing' seminar series (2005–7), and a co-investigator on the recent AHRC-funded workshop series investigating the arts-consumption experience. His research interests include arts marketing and branding, with a particular emphasis on the relationship between culture and the market.

Angela Osborne has been working in the field of arts management in a research capacity for the past four years. She has been involved in the design, development, and acquittal of several research projects in the arts management sector. She is currently a PhD candidate at Deakin University examining the discourses around multicultural arts and their impact on artists' professional identity and practice.

Anthony Patterson is a Senior Lecturer in Marketing in the Management School at the University of Liverpool. Before joining Liverpool, he taught on faculties at the University of Sheffield and the University of Ulster. Trying hard to avoid the seemingly inevitable self-obsolescence that accompanies such a strategy, much of his research focuses on providing a snapshot of current cultural practices like social networking, text messaging and speed dating, and exploring how these phenomena impact on consumer behaviour. His other research interests include city branding, nation branding, and book marketing. He is the recipient of the University of Liverpool's Sir Alistair Pilkington Award for Teaching Excellence and his publications have appeared in a number of prestigious journals.

Ruth Rentschler is Foundation Chair and Professor in Arts and Entertainment Management at Deakin University, Melbourne. She is a widely published academic who has received numerous awards for her research. She was responsible for the implementation of the first business-based arts management programme in Victoria and the first distance programme in Australia. She is deputy chair of the board of Multicultural Arts Victoria.

Simon Roodhouse has direct experience of management in the educational and cultural fields as the first Chief Operating Officer for the University Vocational Awards Council, and latterly as the founding Director of the Museum Training Institute where he developed and established national occupational standards of competence for the heritage sector. His senior management experience in higher education includes Dean of the School of Art and Design, University of Derby, Head of the School of Creative Arts, Northumbria University and Head of Academic Development, Bretton Hall, University of Leeds. Currently he is Adjunct Professor at University of Technology Sydney, and Visiting Professor in the Institute of Work Based Learning, Middlesex University, as well as running his own consultancy, Safe Hands Management Ltd. Until recently he was Professor of Creative Industries at the University of the Arts London, Visiting Professor at the University of Bolton and Adjunct Professor at the Queensland University of Technology, Brisbane. He has written extensively in national and international journals as well as published two books including *Cultural Quarters: Principles and Practice* (Chicago University Press 2010). In addition he has established and is editor of the *Creative Industries Journal*.

Annmarie Ryan is a Lecturer in Marketing at the Lancaster University Management School. Her research focuses on inter-organizational relationships and business/nonprofit relationships in particular. Arts organizations have been central to Annmarie's research, where she has looked specifically at how they maintain and enhance their identity in complex sponsorship relationships. Annmarie has published her work in many international conferences including the American Marketing Association, Academy of Marketing Science, Association for Consumer Research (ACR) and the Industrial Marketing Group (IMP) Conference. Her work also appears in the following journals: *International Journal of Nonprofit and Voluntary Sector Marketing, Journal of Marketing Management, Innovations in Education and Teaching International* and *Irish Marketing Review*.

Daniela Sangiorgi is a Lecturer in Service Design at ImaginationLancaster, Lancaster University. Her research focuses on Service Design. She has investigated services as complex social systems, proposing holistic and participatory approaches to Service Design. In her most recent work she focuses on the applications and implications of 'Personalisation' and 'Participation' in the design and supply of services. She is interested in working with and within service organizations to explore resistance to and capacity for change, with a particular focus on the education and health sectors. She is interested in the emergence of new service models, and in the practice and theory of service innovation.

Jonathan E. Schroeder is Professor of Marketing at the University of Exeter Business School. He is also a Visiting Professor in Marketing Semiotics at Bocconi University in Milan. Schroeder's research focuses on four intersecting areas: aesthetic leadership, brand culture, ethics, and visual consumption. He is the author of *Visual Consumption* (Routledge 2002) and co-editor of *Brand Culture* (Routledge 2006). He is co-editor in chief of the interdisciplinary journal *Consumption Markets & Culture,* and serves on the editorial boards of many prestigious journals. He is a founding member of the International Network of Visual Studies in Organizations (in Visio).

Avi Shankar Avi Shankar is Senior Lecturer in Marketing and Consumer Research in the School of Management at the University of Bath. His research interests focus on critiques of contemporary consumer culture, the conceptualization of illicit pleasure and its management through marketplace cultures and studies of identity and consumption. Examples of his work can be found in the *Journal of Consumer Research, European Journal of Marketing, Marketing Theory, Journal of Marketing Management* and *Consumption, Markets and Culture* amongst others. He recently co-edited the groundbreaking bestseller *Consumer Tribes.*

Dirk vom Lehn is a Lecturer in Marketing at King's College London. He specializes in ethnographic, video-based studies of social interaction in museums and galleries, street-markets and health-care settings like optometric consultations. His research focuses on social interaction and technology, looking and seeing, cultural consumption and practical aesthetics, trust and exchange, and behaviour in public places. His recent publications include a Special Issue of *Consumption, Markets and Culture* and a paper on video-based research methods in the *International Journal of Culture, Tourism and Hospitality Research* (2009).

ACKNOWLEDGEMENTS

We gratefully acknowledge Stephen Brown's invaluable help at different stages of this project, as well as the sterling support of Terry Clague and Sharon Golan of Routledge/Taylor & Francis, who have steered us calmly through the process. Our thanks go also to the Economic and Social Research Council, whose seminar series grant ('Rethinking Arts Marketing', 2005–7) was such an important stimulus for the development of scholarly cooperation in this area. We are grateful also to the anonymous reviewers of our initial proposal, as well as reviewers of individual chapters whose constructive comments were so helpful. We wish to thank also William Coupon/CORBIS for permission to use 'Andy Warhol with Self-Portrait (1986)', photographed in New York City by William Coupon in 1986 (Figure 3.1), the Andy Warhol Foundation/CORBIS for permission to use 'The Last Supper (Mr. Peanut) by Andy Warhol (1986)' (Figure 3.2), and the Andy Warhol Foundation/CORBIS for permission to use '$ (4) by Andy Warhol (1982)' (Figure 3.3). Finally, we are very grateful to Taylor & Francis for permission to reprint in this book (Chapter 7) Christina Goulding, Avi Shankar, and Richard Elliott's piece 'Working Weeks, Rave Weekends: Identity Fragmentation and the Emergence of New Communities', which originally appeared in *Consumption, Markets and Culture*, 2002, Vol. 5 (4), pp. 261–84. We thank Sage Publications for its permission to print in this book (chapter 11) a longer version of Hye-Kyung Lee's paper 'Between Fan Culture and Copyright Infringement: Manga Scanlation', which was published in *Media, Culture & Society*, 2009, Vol. 31(6), pp. 1011–1022.

Daragh O'Reilly and Finola Kerrigan

ABBREVIATIONS

ACE Arts Council England
ACGB Arts Council of Great Britain
AMA Arts Marketing Association or American Marketing Association
BBC British Broadcasting Corporation
CCCS Centre for Contemporary Cultural Studies
CD Compact Disc
DCMS Department for Culture, Media and Sport
DVD Digitally Versatile Disc
ECoC European City of Culture
FO/SO first and second order activities
GLC Greater London Council
HCMF Huddersfield Contemporary Music Festival
ICT information and communications technologies
JETRO Japanese External Trade Organization
MDMA 3,4-methylenedioxymethamphetamine ('ecstasy')
NESTA National Endowment for Science, Technology and the Arts
RDA Regional Development Agency
TRIPS Trade-Related Aspects of Intellectual Property
WIPO World Intellectual Property Organization
WTO World Trade Organization
YBA(s) Young British Artist(s)

I

MARKETING THE ARTS

Daragh O'Reilly and Finola Kerrigan

IT'S SATURDAY, 12 September 2009, three days from the publisher's deadline. We are sitting in the diner in Salt's Mill, the World Heritage Site located in the converted nineteenth-century textile factory in Saltaire, West Yorkshire, the one with the close connection to local-boy-made-art-celebrity David Hockney.

We see this book as contributing to a growing scholarly conversation about the relationship between art/culture and the market in the same vein as *Imagining Marketing: Art, Aesthetics and the Avant-Garde* (ed. Brown and Patterson 2000) and *Consuming Books* (ed. Brown 2006). This conversation also includes the recent special issues of *Consumption, Markets and Culture* on 'Oppression, Art and Aesthetics' (ed. Warren and Rehn 2006), 'The Production and Consumption of Music' (ed. Bradshaw and Shankar 2008), and 'Producing and Consuming Arts: A Marketing Perspective' (ed. Kerrigan, O'Reilly and vom Lehn 2009), as well as forthcoming special issues on arts marketing themes in the following journals: *Marketing Intelligence and Planning* (2009), *International Journal of Culture, Tourism and Hospitality Research* (2010), *Journal of Marketing Management* and *European Journal of Marketing*.

The phrases 'arts marketing' or 'marketing the arts' might suggest that in this book we are simply looking for better ways of squirting marketing lubricant into the machinery of the arts. However, the relationship between art and the market is more complex than that. Perhaps there should be a subject called 'art/market studies' which examines the different facets of this relationship. Its focus could include, for example, the marketing *of* art, marketing *in* art, marketing *through* art, marketing *from* art, and marketing *as* art (c.f. Beadshaw 2010). The marketing *of* art would deal with the strategic application of marketing practices to further the sale of art and increase levels of engagement with the arts. It is this aspect with which we are primarily

concerned here, but the intention is also to point to the complexities and uncertainties surrounding this attempted application. Marketing *in* art would include representations of markets, marketers, marketing and consumers in artistic texts, such as Martin Amis's *Money*, J.K. Rowling's *Harry Potter* series, the film *Glengarry Glenross*, or the stage play *Death of a Salesman*. Marketing *through* art could deal with issues such as product placement, advertising, and muzak. Marketing *from* art would deal with the lessons which mainstream marketers can learn from artistic practice – as Jonathan E. Schroeder asserts in this book (Chapter 3): 'Within most marketing and branding literature, art remains unseen, under-appreciated, and untapped for strategic insight.' And, finally, marketing *as* art would attract those who regard, for example, advertising or other marketing practices as art. As Alan Bradshaw, Finola Kerrigan and Morris B. Holbrook show in Chapter 2, there are some who take this aspect of the art/market relationship very seriously: Germaine Greer, discussing Damien Hirst auctioning his new work in Sotheby's, asserts (2008) that, 'the art form of the 21st century is marketing . . . the Sotheby's auction was the work'.

The book itself is not the kind of anarcho-surrealistic intervention in the field of arts marketing that Stephen Brown advocates in Chapter 18 – after all, who better than he to make such a radically creative effort? It is the outcome of a collaborative project to enrich the theoretical resources of arts marketing. It is an argument for contextualized, historically informed work on the art/ market nexus, work which acknowledges its important political, social, cultural and artistic/aesthetic dimensions. In this sense, as the subtitle suggests, it is a fresh approach. As Ian Fillis argues (Chapter 4): 'With the broadening of the marketing concept have come attempts at creating art marketing theory, and yet much of this has failed to recognize the particular needs of the sector and its powerful underlying philosophical and aesthetic dimensions.' Paradoxically, in order to understand the role of markets, marketers and marketing in the arts, it is arguably necessary to relativize their importance in relation to art itself and to the arts-consumption experience. As far as this project is concerned, we see arts marketing as being about more than money. In the words of a fellow countryman, we do not wish to be characterized as 'fumbl[ing] in a greasy till, and add[ing] halfpence to the pence . . .' (Yeats, 'September 1913'). Rather, our concern is to connect artists with their audiences by helping to develop an understanding of marketing which is sympathetic to artistic imperatives.

The book was conceived as a means of signalling current thinking about arts marketing from a variety of perspectives. Although the collected chapters cover a range of art activities, the collection was not intended as a comprehensive overview of each area, but rather a series of thought-provoking pieces

which can serve to stimulate further discussion and research. The relative freedom provided by the book format allows the contributors to explore new ideas in a way which we hope the reader will find engaging.

The arts-marketing community is a broad church, only some of which is represented in this book. In fact, many arts-marketing researchers do not identify themselves as such, but their work has been very influential in shaping the thinking in this area. This is evident from examining the extensive bibliography within this book, which reflects the breadth of theoretical and disciplinary engagement necessary in order to advance thinking in this area. Arts marketing and arts-marketing researchers must retain this eclecticism in their theoretical shopping cart if they are to contribute to understanding the domain of arts marketing. While marketing the arts should be a creative practice, often arts-marketing practitioners overlook more esoteric and insightful academic arts-marketing research in favour of two-by-two matrices and step-by-step approaches to branding. Moving forward, the academic arts-marketing community must question the acceptance of those narrowly managerial approaches to marketing which dominate the discourse of arts-marketing practice.

The art versus mart debate has not gone and will not go away. There seems to be a commonality between arts-marketing researchers in that most moonlight as arts practitioners in various forms and/or as heavy consumers of the arts. This is coupled with a fear of being associated with or identified as mainstream, managerial marketers. This inevitably influences the theoretical lens which they bring to arts-marketing research.

Another aim of this project is to encourage more people to 'get into' arts marketing, because we believe they could well find it seriously engaging. Contemporary arts marketing scholars can find (or lose) themselves in some interesting places. These could be spaces in the mind, altered states of consciousness induced by the experience of art, or physical spaces like an artist's attic, backstage at the theatre, in the moshpit at a rock concert, contemplating a pile of boxes in Tate Modern's Turbine Hall, filming people at a music festival, talking to fans in a pub, watching movies at the cinema, reading novels and comics, watching what goes on in a movie-editing suite, or, even, as Elizabeth C. Hirschman (Chapter 12) writes of her frustrating search for Carter Fold, the 'Holy Grail' of bluegrass music in the Appalachian mountains, 'driving on a desolate, dark, winding highway that seemingly is heading to oblivion'!

The book chapters cover a range of arts 'sectors', including music (Chapters 12, 13, 14), dance (7), comics (11), visual art (2, 3, 4, 18), film (10), theatre (15) and museums (8, 16). Our valiant contributors deal with a very wide range of topics. To take some examples: audience development and engagement (6, 9),

music-consumption perspectives (13), the arts experience (2, 15), branding and representation (3, 16, 18), the connection between art, culture and the marketing of cities (17), the development of arts marketing as a strategic function (5), research methods and approaches (3, 8, 9), arts policy (5, 6), the art–commerce tension (2, 4, 10, 11, 14), and questions of authenticity (12), the roles of the artist (2, 3, 5, 12, 14) and of the arts marketer (15), and what marketing can learn from the arts (3, 18). Rather than listing here what each chapter has to offer, we invite the reader to simply pick and try one. We hope s/he will find them instructive, thought-provoking and entertaining.

2

CHALLENGING CONVENTIONS IN ARTS MARKETING

Experiencing the Skull

*Alan Bradshaw, Finola Kerrigan
and Morris B. Holbrook*

THIS CHAPTER RETURNS to what might be regarded as an old direction in consumer research – namely, experientialism, which we believe is uniquely positioned to provide valuable insights into the nature of aesthetic consumption. We argue that arts marketing literature tends to focus on macro issues related to the political economy of art in general and to the oft-noted clashes between art and commerce in particular. By returning to concerns with experiential and hedonic consumption, we redirect attention towards a neglected but fundamental aspect of marketing the arts – namely, the role of aesthetic experience. Indeed, we shall argue that the absence of an engagement with aesthetic experience impoverishes not only marketing theory but also wider discussions of art. In this connection, as a case study, we shall examine one of the most iconic works of our age – *For the Love of God* – a Georgian skull encrusted with a fortune's worth of diamonds and created by the art-market innovator extraordinaire Damien Hirst. We shall note how evaluations of this work have honoured the perspective of political economy and have stressed the significance of its commercialism. By contrast, we shall demonstrate how such evaluations are turned on their head by those critics who ground their reviews in actual encounters with the physical object itself. While discussions of work by artists such as Hirst within the context of political economy help to highlight the centrality of art as a commentary on and/or a reflection of society, this chapter emphasizes neglected aspects of experientialism in the consumption of visual art.

While an interest in the experience of consumption currently enjoys a resurgence attributable in part to the endeavours of Vargo and Lusch (2004), we locate the current study in the context of Holbrook and Hirschman's (1982)

research into hedonic consumption. As opposed to studies that characterize the consumer as a rational decision maker or economic problem solver who could be understood, predicted, and even controlled by means of black-and-white logical reasoning, Holbrook and Hirschman (1982) remind consumer researchers that consumption activity is alive in Technicolor glory – a fanfare of daydreams, a fairground of creative imaginations, and a festival of fantasies, feelings, and fun. In this view, much more than a prosaic satisfaction of needs or wants, consumption becomes a site for the expression of strong emotions like love and hate, hope and regret, joy and sadness. Thus, Holbrook and Hirschman (1982) shift attention away from predictive modelling toward methodologies that explore play, creativity and self-revelation – most notably as understood by means of subjective personal introspection wherein auto-ethnographic essays are written and analysed with the aim of framing consumption experiences from the viewpoint of observant participation.

In this spirit, the experiential framework embraces various aspects of aesthetic experience and contemplation. For example, Holbrook (1995) describes how – while attending a concert by the nonpareil jazz singer Marlene VerPlanck – he hears the great opera singer Eileen Farrell utter a profound gasp of appreciation at a crucial moment during Marlene's performance of 'Skylark'. Holbrook argues that conceptualizing this 'aaah', this profound moment of transcendentally lyrical aesthetic experience, is a critical challenge for the evolution of interpretive consumer research and a key to under-standing the role of emotion in consumption.

This challenge goes against the grain of traditional consumer research on the consumption of art which tends to follow more conventional decision-oriented lines of rational economic modelling. Early examples of such schol-arship include Andreasen and Belk's (1980) study of what predicts attendance at performing-arts events; Milliman's (1982) demonstration that changing the tempo of background music influences the amount of money spent by supermarket shoppers; or Holbrook and Schindler's (1989) exploration of the link between age and musical preferences. Kerrigan (2010) shows how the majority of the literature within the area of film marketing also belongs to the predictive school. This may say more about the governance of knowledge within marketing academia and less about the real concerns of arts marketing researchers. But, in any case, this tendency prevails.

Within the arts-marketing literature, we find a pervasive focus on building (Bernstein and Kotler 2006), sustaining (Hume *et al.* 2007), and understand-ing the audience (Caldwell and Woodside 2001). Frameworks of relationship marketing (Rentschler and Radbourne 2008; Rentschler *et al.* 2001) and services marketing (Gainer 1989; Rentschler and Gilmore 2002) have been applied to the arts in order to understand the interactions of arts organizations

with the public and the manner in which arts consumption develops and spreads to broader audiences. Researchers such as Kolb (2005) or Colbert (2007) have studied the marketing of cultural organizations in general and of the arts in particular. Rather than merely extending mainstream managerial methods to the marketing of the arts, these and other arts-marketing researchers have worked towards developing theoretical frameworks that apply specifically to the arts sector.

Progressing from studies of arts marketing in general to those within marketing that focus on the visual arts in particular, we find a typical preoccupation with the organizational aspects of various marketing activities. These include the operations of museums (including guided tours and gift shops); the management of galleries; the role of art dealers; and the structuring of the arts market. Within this perspective, key concerns often privilege the artist's perspective, intentions, and creative expression at the expense of neglecting consumers of the relevant art works (Fillis 2004). Others address the consumer primarily within the institutional context. For example, Slater (2007) examines the motivations of people visiting a gallery and finds that most respondents are motivated by escapism. Vom Lehn (2006) examines how members of the arts audience interact when attending an exhibition. Both studies stop short of exploring the hedonic nature of the consumption experience in general or its intrinsic satisfactions in particular. The failure to address the latter concerns creates the gap in our understanding that this chapter addresses.

An important limitation of the studies mentioned thus far is that they generally view art as just another object of consumption, on all fours conceptually with toothpaste or vacuum cleaners; or they obsess about the challenge of developing larger audiences – that is, 'how to get more customers to watch Shakespeare' (O'Reilly 2005: 585). In short, they typically ignore the extraordinary aspects of the aesthetic experience and remain mute on the critical question of what distinguishes aesthetic appreciation from other types of consumer value (Holbrook 1999). Put differently, these studies leave us no closer to understanding the broader and surely more interesting question of what made Eileen Farrell (or anybody) gasp in such profound admiration of Marlene VerPlanck singing 'Skylark'.

RATIONAL CONCEPTS OF VALUE

The concept of value has also been discussed in relation to visual art. Much of this discussion has focused either on value assessed by expert appraisal or on value gauged by economic performance within the art market. On the one

hand, for example, Menger (1999) discusses the role of expert selection in negotiating the tension between a search for novelty and the need for acceptance within the art world. Wijnberg and Gemser (2000) explore this issue in relation to the difficulty of the French Impressionists in gaining recognition. These discussions emphasize 'rational' evaluations of value tied to the quality of artistic practice and the resulting reputation of an artist within the relevant cultural field. On the other, value has also been treated in terms of the economic benefits (less costs) of an artistic object. From this viewpoint, the well-established global art market is a key site for investors (Kottasz *et al.* 2007). However, wisely enough, Velthuis (2005) has disputed the reduction of value in the visual art market to a simplistic accounting of financial worth, thereby highlighting art's broader aspects of value. While corporate art collections may appear to be driven by monetary price tags, Kottasz *et al.* (2007) found that – beyond the role of mere market speculation – corporations do acquire art collections in the spirit of rewarding artistic merit.

More questions about art and its difficult relationship with the market-oriented forces of commerce are also explored by researchers such as Kubacki and Croft (2004), who study Polish musicians and the contentious division of their work between market-governed music and artistically motivated projects, and by Bradshaw *et al.* (2006) or Cottrell (2004), who show how the conflicting demands of artistic identity result in various meditational practices such as developing portfolios of low-paid but artistically fulfilling versus high-paid but non-fulfilling activities. Meanwhile, other studies explore how certain artists have prospered in the marketplace, with telling case studies of J.K. Rowling (Brown 2005) and Andy Warhol (Schroeder 1997). Indeed, artistic practice has repeatedly served as a case example from which business practitioners can learn in either the literal sense of the artist as entrepreneur (Schroeder 2005b) and organizer (Guillet de Monthoux 2004) or the metaphorical sense of an art form such as jazz improvisation as a template for strategic innovation (Holbrook 2008).

Yet, commercial success has often been problematized from an aesthetic perspective. For example, Holbrook and Addis (2007) document an oft-reported significant-but-weak relationship between critical acclaim and commercial success in films, suggesting that – before controlling for biases introduced by the marketplace – something less than 'good taste' may prevail. From the perspective of critical theory, Bradshaw and Holbrook (2008) argue that the culture industry cultivates a spirit of commoditization that renders unlikely any possibility of true aesthetic response to commercial art works. Similarly, Schroeder (2005a) suggests that Thomas Kinkade – the so-called 'Painter of Light' – presents an unfortunate instance of aesthetics gone awry. However, when confronted by sociologists and other socially enlightened thinkers, the

issue of taste emerges as contentious indeed. For example, in his landmark treatise on *Distinction*, Bourdieu (1984) identifies an impulse towards invidious class comparisons as the dynamic that underlies the discourse of good-versus-poor taste. Despite a resurgence of interest in how rehabilitative forms of creativity might invite wider participation (DeNora 2003), we find that the so-called *conservatoire* – that is, how European classical values of high culture and elite sophistication are reproduced through culture (Cook 2000) – is relentlessly threatened by conceptual attacks from areas such as post-modernism and feminism (Leppert and McClary 1989) and by concerns that the conservatoire offers disguised protection to out-dated and undesirable sensibilities that damage marginal groups such as blacks or gays (Miklitsch 2006). Hence, we watch discussions of aesthetic appreciation drift towards charged and contentious disputes about taste and, beyond that, to repudiation of social distinctions and ethical attacks on misplaced elitism.

We suggest that the trajectory of this debate returns us to a framing of art grounded in macro issues but reaches no closer to understanding the micro instance of aesthetic experience, however close the latter might and should lie to the central concerns of consumer researchers. Lost to this debate are curiosities raised by romanticist philosophers such as Kant or Schopenhauer (Kearney and Rasmussen 2001) or by poetic figures such as Wordsworth (Holbrook 1995) – all concerned with the excess of emotions, the sense of transcendence, and intimations of the sublime made possible through aesthetic contemplation. We submit that the challenge presented by Holbrook (1999) of conceptualizing Farrell's appreciative gasp remains unfulfilled and that the framing of arts in marketing scholarship therefore remains conceptually challenged in the face of aesthetic concerns.

If we can justifiably conclude that the framing of arts marketing is alienated from aesthetics, this predicament must surely be expected in a subject area that is broadly conceived as a social science that prides itself on rigorous analysis of data in the pursuit of a modernistic vision of objectivity. As argued by Adorno (2002), any purportedly objective framework imposed upon an inherently subjective site must surely result in some form of violence and misconception against the object itself. However, animadversions concerning the neglect of aesthetic experience are not limited to arts marketing but may also apply to wider discussions of art. In this connection, we take the art work *For the Love of God* by Damien Hirst as a case study of such alienation and, here, reflect the gist of a presentation by the artist Gustav Metzger in describing his shift from aggressive opposition to appreciative admiration. In this, we place consumers at the centre of our discussion and focus not on their reasons for visiting or their rational appraisal of the 'value' of the art but, rather, on the hedonic consumption of this work. In doing so, we acknowledge

that the consumption of art takes place in what du Gay *et al.* (1997) have referred to as circuits of cultural consumption, where identity, representation, regulation, consumption, and production are interconnected nodal points around which cultural meanings are formed. Following this, the aesthetic or hedonistic consumption of an artistic object is set within a wider relationship to this work of art.

DAMIEN HIRST AND THE SKULL

The Skull is the common name for the Damien Hirst creation *For the Love of God*, so titled because these were the words spoken by the artist's mother on hearing of the project. This art work is an eighteenth-century human skull encrusted with 8,601 diamonds weighing a total of 1,100 carats and adorned on the forehead with a 52.4 carat pink diamond (Thompson 2008). The estimated material cost of the work is believed to be in the region of £12 to £15 million and is reportedly the most expensive diamond-related project since the creation of the British crown jewels (Shaw 2008). The work was sold to a consortium for £38 million with the artist retaining a 24 per cent share, thereby producing a net evaluation of £50 million, the biggest price tag ever recorded for an art work by a living artist (Thompson 2008). *For the Love of God* was introduced to the public amidst a flurry of media attention – immediately becoming front-page news at the *Financial Times* and evoking widespread commentary concerning the audacity of the piece's potential economic value.

The association of monetary extravagance with Damien Hirst was already well established before the Skull's creation. In producing the most expensive art work sold by a living artist, he broke his own record set by *Death of a Lullaby Winter* – a collection of pills on shelves that sold for $7.4 million in 2007 (Thompson 2008). On 15 September 2008 – the very day that Lehman Brothers closed, marking the start of the most recent economic depression – Damien Hirst by-passed his dealers and brought his new work directly to auction in a strategic act of disintermediation. The Sotheby's auction achieved revenues of £95 million (Hoyle 2008), sealing not just Hirst's reputation as a man of considerable fortune but also as a powerful innovator within a rapidly burgeoning art market. Indeed stories abound suggesting that Hirst was not just mastering, but also toying with, baiting, and parodying the art world. For example, the writer A.A. Gill was unable to tempt Sotheby's to auction his portrait of Stalin by an unknown hand until Hirst painted a red clown nose on Stalin's nose and signed the portrait (Thompson 2008). The work then sold for £140,000. In another famed story, theatre director Sir

Trevor Nunn learned that a Hirst painting for which he had paid £27,000 was actually painted by the artist's two-year-old son (Cleland 2007).

Hirst's success results in part from the advertising magnate Charles Saatchi's purchases of a large amount of work by Hirst in his early days. Because Saatchi was regarded as a knowledgeable collector, his accumulation of Hirst's work had the effect of creating prestige and scarcity, thereby inflating the market valuation and making any Hirst work a valuable commodity. Since then, other buyers such as Steve Cohen – a billionaire hedge-fund manager – and various Russian tycoons have actively bought work by Hirst. Indeed, public institutions such as the Tate Modern can rarely afford to purchase Hirst's work. Where his work is exhibited in public galleries, such as *Physical Impossibility of Death in the Mind of Someone Living* (a shark suspended in a formaldehyde solution) at the Museum of Modern Art in New York – it is controversially on loan from the owner, in this case the financial guru Steve Cohen. This practice – whereby super-wealthy art collectors first bid up the prices of controversial pieces and then effectively act as museum curators – is interpreted as undermining the classic intermediary system of the art world (Thompson 2008). This raises concerns that the astronomical prices achieved by artists such as Hirst have shifted the power base of the art world away from critics, curators, and other experts towards those buyers with the deepest pockets. The case for this claim appeared in the *Guardian* in a piece by art critic Adrian Searle (2005):

> Never has the art market been stronger. Never has money been so powerful. Never have so many artists got so rich, and never has there been such alarming stuff on sale. Never have critics felt so out of the loop.

As might be expected in such a context, Hirst has vociferous critics. For example, Robert Hughes (2008) describes Hirst as follows:

> Hirst is basically a pirate, and his skill is shown by the way in which he has managed to bluff so many art-related people, from museum personnel such as [the] Tate's Nicholas Serota to billionaires in the New York real-estate trade, into giving credence to his originality and the importance of his 'ideas'. This skill at manipulation is his real success as an artist. He has manoeuvred himself into the sweet spot where wannabe collectors, no matter how dumb (indeed the dumber the better), feel somehow ignorable without a Hirst or two. Actually the presence of a Hirst in a collection is a sure sign of dullness of taste. What serious person could want those collages of dead butterflies, which are nothing more than replays of Victorian décor? What is there to those empty spin paintings,

enlarged versions of the pseudo-art made in funfairs? Who can look for long at his silly Bridget Riley spot paintings, or at the pointless imitations of drug bottles on pharmacy shelves? No wonder so many business big-shots go for Hirst: his work is both simple-minded and sensationalist, just the ticket for newbie collectors who are, to put it mildly, connoisseurship-challenged and resonance free.

But, in response to Hughes, Germaine Greer (2008) writes:

> Damien Hirst is a brand, because the art form of the twenty-first century is marketing. To develop so strong a brand on so conspicuously threadbare a rationale is hugely creative – revolutionary even. The whole stupendous gallimaufrey is a Vanitas, a reminder of futility and entropy. Hughes still believes that great art can be guaranteed to survive the ravages of time, because of its intrinsic merit. Hirst knows better. The prices the work fetches are verifications of his main point; they are not the point. No one knows better than Hirst that consumers of his work are incapable of getting that point. His dead cow is a lineal descendant of the Golden Calf. Hughes is sensitive enough to pick up the resonance. 'One might as well be in Forest Lawn (the famous LA cemetery) contemplating a loved one', he shouts at Hirst's calf with the golden hooves – auctioned for £9.2m – but does not realise it is Hirst who has put that idea into his head. Instead he asserts that there is no resonance in Hirst's work. Bob dear, the Sotheby's auction was the work.

These two authors agree that high prices form the conceptual object of Hirst's work, an assessment shared by an editorial in the *New York Times* (Editorial 2007), which proclaims that:

> Mr Hirst . . . has gone from being an artist to being what you might call the manager of the hedge fund of Damien Hirst's art. No artist has managed the escalation of prices for his own work quite as brilliantly as Mr. Hirst. That is the real concept in his conceptualism.

Lash and Lury (2007) develop the argument that Hirst and fellow members of the so-called Young British Artists movement mark a second wave of conceptual art in that the concept moves away from a reflection of the art institutions – as represented by artists such as Duchamp – towards the commerciality of the objects. Hence the sensational stories of Hirst – for example, the one about his two-year-old – are already immanent in the reactionary and seemingly outraged tabloid commentary that the British media reserve for

contemporary art, as especially evident in the annual parodic lampooning of the Turner Prize nominees. Hence Hirst's work falls squarely within an art–commerce dialogue.

Not surprisingly, when *For the Love of God* was exhibited in a darkened room surrounded by heavy security at the White Cube Gallery in London, the discourse was dominated by the financial value of the work. As the artist Gustav Metzger (2007) commented, 'We cannot afford to just look at [the Skull] as art, it needs to be seen in context with, for example, the Saturday supplement of the *Financial Times* titled 'How to Spend It' with its hyper-sumptuous ads for watches, cars, endless potentials for the very rich to amuse themselves.' This indeed forms the circuit of cultural consumption referred to by du Gay *et al.* (1997). For many critics, the work embodied the epitome of crassness and a festishization of money. According to Hughes, it was no more than a 'spectacle for money groupies' to be 'mesmerized by mere bling of rather secondary quality', while *The Times* art critic Campbell-Johnston (2007) suggests that, between the queues and the suited security guards at the White Cube, there was an overall resemblance to an Essex nightclub and that the Skull 'looks more like something you might dance around at a disco'. (For those who have yet to experience the joys of nightclubbing in Essex, it might be helpful to clarify that this analogy is not meant as a compliment!) Campbell-Johnston continues: 'When you get down to the bare bones, is it all about cash? Hirst, the master of the mark-up takes a hard look at our values. They glint from every facet of his death's-head glitterball' (Campbell-Johnston 2007). The writer Will Self describes the piece as a 'tangible exclamation mark at the end of this era of excess' and also as an 'enactment of the extreme and specialized ritual of money'.

Hence, typical readings of the Skull are driven by the conceptual implications within an art-versus-commerce context. A strong example is provided by the *Independent* critic's review, entitled 'for the love of art and money':

> It looks like the kind of thing Asprey or Harrods might sell to credulous visitors from the oil states with unlimited amounts of money to spend, little taste and no knowledge of art. I can imagine it gracing the drawing room of some African dictator or Colombian drug baron. But not just anyone made it – Hirst did. Knowing this, we look at it in a different way and realise that in the most brutal, direct way possible, *For the Love of God* questions something about the morality of art and money. This is something I've often wondered about when I read of the fantastic prices private individuals pay for works by Picasso, Klimt and Warhol. How do these people sleep at night, knowing that the hundred million they just spent could have endowed schools, built hospitals, eradicated diseases and

alleviated hunger? Don't they think about the morality of pouring so much wealth into something as dead as a diamond necklace, a painting, a private jet? Once you begin to think in this way, Hirst's title becomes ambiguous, for it is a phrase that can be said in exasperation – as in 'For the love of God, what are we all thinking?' *For the Love of God* is a hand grenade thrown into the decadent, greedy and profoundly amoral world where art meets money. But it is more. By ensuring that the price he is asking for the skull receives the maximum amount of publicity, Hirst has also made sure that whoever buys it will never be able to enjoy it. Like the Ring of the Niebelung, this glittering, deadly prize will prove at some level a curse to who possesses it. I can't remember another art work that so perfectly embodies the cynicism and ambivalence successful artists must feel towards those who promote and collect their work.

(Dorment 2007)

Clearly, the art-versus-commerce perspective seems to have pervaded the discourse generated by the Skull. However, from an experientialist perspective, it is interesting to read those reviewers who describe their physical encounter with this art work. As already noted, *For the Love of God* was exhibited under extraordinary circumstances at the White Cube Gallery in London. Reminiscent of the Crown Jewels, the piece inhabits a darkened room. Jonathan Jones (2007) describes the experience as follows:

The darkness is a work of art itself. Perhaps it is the real work of art. The public visits that are carefully orchestrated at the gallery, with timed tickets and small groups and – obviously – draconian security, are restricted to two minutes. In two minutes your eyes can't adjust to the darkness. In two minutes the iridescent object can only register as a dream of eye sockets that are blue-green pools sunk into a shimmering spectral mask. As you move closer the ghostly head bursts into all the colours of the spectrum. . . . and then the two minutes are up and you are escorted out of the building.

The artist Gustav Metzger's (2007) impressions are particularly significant:

You are taken along a darkened corridor which gets darker and darker. To the left are offices, normal offices with doors shut and then you are faced with a totally black, darkened chamber. You have no idea how big it is or if anybody is in there; it is just utterly dark. And then you have the Skull. It is that size (picks up a glass of water), glistening gloriously, glisteningly lit and that's what I want to say. I was very critical of the Skull and I now

realise that it has magnificence and it is important. It is important in so many different ways and it will go on being looked at and considered.

Gustav Metzger's evaluation is particularly interesting. Before encountering the object, he tended towards a more critical assessment. Later, he experienced the piece as a turning point. Hence, it seems that we can split the evaluation of *For the Love of God* between those who discuss the conceptual underpinnings and bemoan their consequences for the commerciality of art and those who encounter the piece as a matter of aesthetic experience. Similarly, the *Physical Impossibility of Death in the Mind of Someone Living* – or, as it was famously entitled by Thompson (2008), 'the $12 million stuffed shark' – has to be encountered in the flesh:

> The frustrating thing about *The Physical Impossibility of Death in the Mind of Someone Living* – the tiger shark Hirst placed in a tank of formaldehyde at the beginning of the 1990s – is trying to explain its power to anyone who didn't happen to walk into the Saatchi Gallery and see it when it was first exhibited. It was a stupendous, marvellous sight. It fulfilled the title because the shark, when you walked towards its mouth, really seemed to be alive and swimming towards you. You want to talk about the tradition of the memento mori, the reminder of impending death, in art? This was a memento mori, because it let you feel for a moment you were about to encounter man's most awe-inspiring predator, too close for survival.
>
> (Jones 2007)

This review by Jones (2007) is almost entirely grounded in experientialism. He describes 'a cabinet lined with fish in translucent boxes: it is mirrored and you see yourself among them. Walk around it and the same fish are laid out as skeletons – and your face is reflected among them again' and also 'a bullock whose poor brown eye looks down at you, appealing for empathy, as it hangs there pierced by arrows'. Alongside the Skull, the 'Beyond Belief' exhibition included a shark cut in two. Jones (2007) describes the encounter:

> Perfectly bisected, it is displayed in two tanks you can walk between; that is, you can stand inside a shark's mouth and in its stomach. Hirst's animal sculptures, collectively called Natural History, are the most misunderstood artworks of our time. Routinely described as if they were no more than their content – in this exhibition, as well as the divided shark, you can see cows, sheep, fish and a white dove – they are in fact optically complex works that play with apparently infinite richness in the way large

bodies of fluid refract light, and that have fun with mirrors, holes and anatomies. The shark's two halves don't just stay still in their tanks: walk alongside them and the vast volume of liquid does things to your perception. The tail seems to move in a leisurely way. The grey skin of the fish is magnified when you look from the outside: walk between the two segments and, because the exposed organs are pinned right up against the glass, there is no magnification. 'It's quite a diddy little shark,' as one visitor comments. But this is the point.

In all these instances, when the reviews of the Skull and associated works are adjusted to include the experiential aspects of encountering the physical objects, we find a shift away from what might be regarded as the dead-end implicit in the art-versus-commerce framing. Those reviewers who obsess about the art work's cost and value seem to overlook or to miss what surely amount to profound aesthetic experiences for Jones (2007) and Metzger (2007). Both men describe a sense of awe, a feeling of wonderment, and an intensity of experience as they manoeuvre around darkened spaces and encounter large numbers of sparkling diamonds. This 'iridescent object can only register as a dream of eye sockets that are blue-green pools sunk into a shimmering spectral mask' and 'glistening gloriously, glisteningly lit'.

Consequently, we might ask if the conceptual reviewers are, like the arts marketing literature reviewed earlier, alienated from a central purpose of art – namely, the creation of profound aesthetic experiences. In this connection, experientialism – as outlined by Holbrook and Hirschman (1982) and methodologically developed by Holbrook (1995) – is uniquely suited to provide an appropriate conceptual lens to facilitate discussion of art works such as the Skull. In a subject field so used to borrowing theories and methods from other areas, experientialism might well provide the pathway through which we can 'think not what art criticism can do for marketing but what marketing can do for art criticism'. As an alternative to deconstructing and interpreting the identity projects of consumers as they presumably signal class distinctions by shamelessly consuming the art of 'dead white guys', experientialism provides a framework for the radical assessment – that is, an assessment true to its roots – of art, not as a practice of invidious social comparison and not as a site of identity construction but, rather, as the source of an intrinsically valued and ultimately priceless aesthetic experience.

Our insistence on the role of the consumption experience as fundamental to the nature of consumer value in general and of aesthetic appreciation in particular is 'radical' in the sense that it harks back to the 'roots' of thought in marketing (Holbrook 1987) and mirrors the age-old thinking in the philosophy of art (Holbrook and Zirlin 1985). As long noted by philosophers

of art, the essence of aesthetic experience hinges on *intrinsic* value – that is, an experience prized for its own sake as an end in itself (Holbrook 1994, 1999). Such philosophers often mention that *only* an experience and *never* a physical object can deliver intrinsic value as a self-justifying aspect of consumption. As indicated by the illustrative case of Damien Hirst, arts marketing must look beyond aspects of *extrinsic* value such as economic worth (the price tag) or social prestige (buzz in the art world) to embrace the key role of aesthetic appreciation as an intrinsically valued self-justifying end in itself. Apparently, this is the profound lesson that awaited those brave critics in that darkened room with the gleaming skull.

3

THE ARTIST IN BRAND CULTURE

Jonathan E. Schroeder

THE BRANDED WORLD intersects with the art world in numerous ways. However, the separation of art and business – into high and low forms of communication and culture – has had a profound influence on how art is viewed by researchers, cultural critics, and consumers alike. Management courses infrequently include topics of art, art history, or visual culture. Art historians seldom discuss the cultural power of brand imagery; marketing researchers rarely apply art criticism and history – although this is changing (e.g. Gombrich 1999, Schroeder 2005a, Venkatesh and Meamber 2008). An art-centred approach to marketing, branding, and consumer research suggests re-framing this tradition to acknowledge the commercial mechanisms inherent in the art market, branding's prominent place in visual culture, as well as the interactions of aesthetics and economics.

Art provides a foundation for understanding the complex interconnections between society, economics, and culture. Artists produce the world's most expensive objects – paintings. Rather than apply marketing concepts to promoting art, let us instead turn to artists for insights into brands, marketing, and strategy. For it is art that is based on images, value, and identity above all other sectors of the market. *Who* produces an art work is the key determinant of its value. A painting by Rembrandt is worth much, much less if it is determined to be by one of his followers – yet the art work remains the same, only the producer has changed. Artists are subject to market forces, career management issues, substitution effects, and product life cycles, just like brands. In other words, artists can be discussed within a branding perspective. Yet few studies within marketing apply an art-historical imagination (see Schroeder 1992, 2008).

BRANDS IN VISUAL CULTURE

Brands are inherently visual; corporate websites, logos, marketing campaigns, packaging, and product design all draw upon visual materials to create distinctive brand identities designed to attract attention and stimulate the senses. Successful brand strategy mandates managing the brand's meaning in the marketplace – the brand image. Images, then, provide a critical marker of economic value. Yet, the market does not fully determine value. Culture, aesthetics, and history interact to inject brands into the global flow of images, or what has been called 'brand culture' (Schroeder and Salzer-Mörling 2006; Schroeder 2009).

The brand-culture perspective reveals how branding has opened up to include cultural, sociological, and theoretical inquiry that both complements and complicates economic and managerial analysis of branding. Recently, anthropologists, historians, and sociologists have looked at brands from various disciplinary perspectives, acknowledging the importance of brands in culture, and providing new directions for brand research (e.g. Bently *et al.* 2008; Manning and Uplisashvili 2007). An emphasis on brand culture forms part of a broader call for inclusion of cultural issues within management thinking (e.g. Fillis and Rentschler 2005; Lawrence and Phillips 2002; O'Reilly 2005; Schroeder and Borgerson 2002), joining in the contention that culture and history can provide a necessary contextualizing counterpoint to managerial views of branding's interaction with consumers and society.

From this perspective, branding constitutes a powerful representational system that produces knowledge, meaning, and value through discursive practices, in addition to its traditional role as marketing strategy. Art, as another important representational system, may provide important insights into understanding branding processes, particularly for building brand identities and connecting value to images. However, this trajectory need not 'merely' serve strategy – as brands open up to interdisciplinary analysis, brand research transcends the managerial and practical.

Thus, our turn to art forms part of a larger effort to understand brands as basic cultural objects, from a critical perspective. In this way, art history and criticism, traditionally outside the realm of marketing and management research, add a necessary component to understanding contemporary marketing practice, as well as useful methods for interpreting and analysing historical trends in representing, consuming, celebrating and critiquing cultural goods. Art-historical tools can provide a rich picture of the underlying mechanisms driving the evolution of consumer culture. In addition, art is a commodity, subject to market forces and consumer behaviour processes. By analysing content, form, and the uses of art, we gain insight into numerous components

of consumer culture – consumer behaviour, demand, price, and patronage, to name a few. Art, then, offers an excellent, underutilized vehicle for studying and understanding cultural forces in branding.

Many contemporary artists utilize brands in their work, commenting on, critiquing, and creatively interrogating the branding concept and its role in consumer culture (Schroeder 2005a). Successful artists may be seen as twin engines of marketing knowledge – both as consummate image managers, and as managers of their own brand, the artist. However, often management turns to art, artists, and aesthetics solely for 'inspiration' or 'creativity'. But art is serious business. Art creates enormous value, the art market is all about money, prices, and investment potential, and artists – at least most of the well-known examples – are fanatically focused on profitably promoting their careers (see Schroeder 2006). By looking at successful artists in brand culture, we gain theoretical links between disparate cultural fields such as brand management, design, and visual culture (Schroeder and Borgerson 2002). This chapter turns, perhaps predictably, to Andy Warhol as an illustrative example of fresh approaches in arts marketing.

ANDY WARHOL: ART BRAND

Andy Warhol provides a vivid example of artist as brand – his work articulately comments on brands and consumer culture, he was a brilliant strategist in his quest for fame, and he remains a valued brand years after his untimely death. Artists like Warhol offer exemplary instances of image creation in the service of building a readily recognizable look, name, and style – a *brand*, in other words. Warhol mastered images – his iconic paintings transmuted consumer goods into iconic artistic statements. From an art-historical perspective, Warhol's work poses important questions about surface and depth, appearance and 'reality' – even life and death. From a marketing perspective, he brings up no less mundane questions about attracting attention, branding, commodification, product life cycles and success.

Successful artists might be thought of as brand managers, actively engaged in developing, nurturing, and promoting themselves as recognizable 'prod-ucts' in the competitive cultural sphere (Schroeder 2005a). Twentieth- and twenty-first-century art represents an important example of the cultural codes that influence current branding activities. However, the disciplinary, intellectual, and semiotic division of art and economics often obscures the intricate interconnections between art, brands and marketing.

Warhol's career was largely about producing the ultimate brand – oneself. Celebrity, brand, superstar, artist, genius – Warhol revelled in the mechanisms

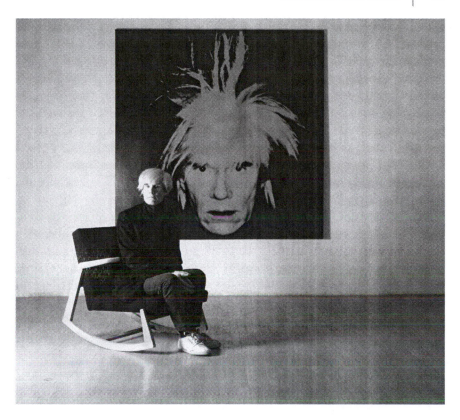

Figure 3.1
Andy Warhol with Self-Portrait (1986), photographed in New York City by William
Coupon in 1986
Credit: William Coupon/CORBIS

of fame. Warhol's prominent reputation derives equally from his artistic
talent, his phenomenally prolific output, and his omnipresence as a famous
figure and celebrity endorser. His idea that 'everyone will be famous for fifteen
minutes' comments on a world where image reigns supreme. He seemed to
anticipate today's reality television, personal websites and blogs, and a cultural
obsession with fame, imagery and celebrity.

Much like reality television, Warhol thought the mundane everyday was
entertaining and aesthetically interesting. His 'Death and Disaster' prints
from the 1960s – not so successful then – eerily reverberate with the media
frenzy over Princess Diana's death in 1997, as well as reality cop shows,
televised car chases, catastrophes, crime shows, and the internet's circulation
of gruesome images. Warhol's *Green Car Crash* (1963) from this series sold
for $71.7 million at a 2007 Christie's sale – Warhol's auction record so far, and

one of the highest prices ever paid for a painting. So, ironically, this particular product line has enjoyed a tremendous 'rebranding' and enjoys a brand new product life cycle.

Along with his stunning success as a painter, Warhol became well known as an influential and productive filmmaker. Many Warhol films are strangely comforting – *nothing happens*. Viewing his film *Empire* – which shows the iconic Empire State Building in New York City over the course of a day – recently, I couldn't help think of the iconic, endlessly repeated vision of New York's Twin Towers September 11th collapse. In Warhol's film from 1964, the skyscraper slowly comes to life as the sun moves across its massive surface and lights go on and off inside. *That's it*. There is no 'action' and no 'plot'.

Warhol matters. Warhol's work demonstrated the power of mass production, the infinite possibility of reproduction, and the disconnection between the image and lived experience. His celebrated Marilyn Monroe paintings 'comment not only on the star's iconic status as a glamour figure, but also on the role of the star as a media commodity – as a product of the entertainment industry that could be infinitely reproduced for mass consumption' (Sturken and Cartwright 2001: 39). Warhol deliberately chose tragic figures for many of his portraits. Monroe's image was glamorous, sexy and famous – yet she lived a miserable, lonely, notorious life, ending in a sordid suicide in 1962. In his portraiture, we see some of the contradictions of celebrity, the complex interconnections between outward appearance versus inward experience, and the artifice of fame. We remember Marilyn partly via Warhol's enigmatic portraits, just as his soup can pictures helped to immortalize Campbell's soup.

Warhol's artistic output, including prints, paintings, sculpture, photographs, books, films, and clothing, radiates insight into brand culture, image manufacture and pop success. As he famously pronounced:

> What is great about this country is that America started the tradition where the richest consumers buy essentially the same things as the poorest. You can be watching TV and see Coca-Cola, and you know that the President drinks Coke, Liz Taylor drinks Coke and, just think, you can drink Coke too. A Coke is a Coke and no amount of money can get you a better Coke than the one the bum on the corner is drinking. All Cokes are the same and all the Cokes are good.
>
> (Warhol 1975: 101)

This banal quip may seem like just another of his notoriously flip and trivial pronouncements, yet it captures the core strategy of one of the world's most successful brands.

Coca-Cola developed their distinctive brand on distribution power, marketing might, active awareness and emotional connection. Coke chose not to segment their market based on quality, price or additional features. Unlike many consumer brands, Coke has no premium Coke. Certainly, Coke could introduce an 'upscale' Coke – one made with real sugar, natural caramel colouring, produced in hand-blown collector bottles, perhaps, with names like 'Country Club Coke', 'Continental Coke', 'Upper Crust Coke', or 'Four Carat Coke' to combine elegantly with caviar and canapés. Some consumers might be willing to pay more for Coke with organic ingredients – to alleviate guilty feelings, perhaps – or we might imagine Coke sweetened with single-estate sugar, or even FairTrade Coke. Others might be interested in limited edition flavours, antique-style bottles, or seasonal variations.

However, this is contrary to Coke's branding campaign, and counter to its brand promise – *Coke is for everybody*. As Warhol notes, Coke is always the same, always Coke®, never different. Coke represents America – a land of opportunity, a melting pot of classes and races; a place where class distinctions fade. Coke's sameness points to the triumph of mass production, where quality control ensures consistent product outcomes. A Coke is a Coke. Coke is mass-produced, yet drinking Coke allows consumers to express themselves. Mass-produced Coke is available to all. No one can buy a better Coke. *Equal opportunity*.

Warhol's koan captures the essence of Coke's brand strategy. New Coke, introduced in the 1980s, was generally considered a flop – Coke learned how important their basic formula (or the image of an 'authentic' Coke) was to many consumers. Yet Coke *does* taste different in different markets, as least to this consumer. And, of course, Coke is better after a fast game of tennis on a hot summer day, cold out of a frosty bottle. Furthermore, Coke's formula has changed over the years, most recently with the introduction of 'high fructose corn syrup' sweetening agent – a low-cost alternative to sugar. So taste isn't everything. Coke is an idea, a concept, and a window into consumer relationships with brands. Warhol made visible how Coke taps into powerful American myths: access, choice and opportunity. Coca-Cola remains a psychological entity as much as a physical product; its brand equity goes beyond mere material ingredients.

Warhol sensed the aesthetic properties of brands long before brand theory did. Warhol's soup-can series showed that brands are psychological, un-attached to the goods they inhabit. We consume the brand as much as the soup, in other words. By taking the famous soup can out of its consumer context and into the art gallery, Warhol, along with other artists, illuminates brand culture. In many ways, Warhol's soup cans are an extension of the long tradition of still-life painting – Warhol merely painted twentieth-century

versions: Coke bottles, Campbell's soup cans, canned vegetables, and so forth. His repeated images comment on the ubiquity of brands, and their ability to appeal to different consumer groups – and form an important component in his own artistic product portfolio.

For example, in his *Two Hundred Campbell's Soup Cans* (1962) – although the visual effect is one of similarity – each can appears slightly different from the others and several soup varieties are depicted. Likewise, his *Two Hundred and Ten Coke Bottles* (1962), in which each bottle of the famous brand is painstakingly hand-painted, with varying amounts of liquid coke left in them, points to the dialectics of conformity and uniqueness, of mass production and individual choice. Warhol gave visual expression to one of the great triumphs of consumer culture – the paradox of mass-produced goods which somehow allow consumers to express their individuality, and produce their own identity via consumption.

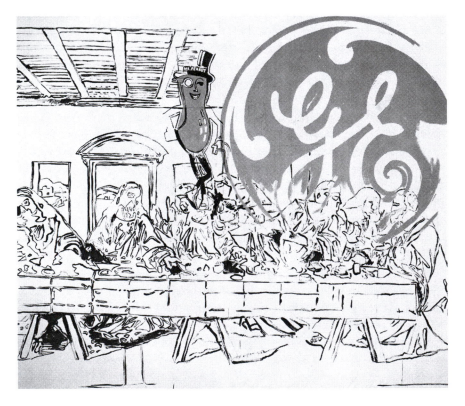

Figure 3.2
The Last Supper (Mr. Peanut) by Andy Warhol, 1986
Credit: Andy Warhol Foundation/CORBIS

Warhol's own 'product line' was highly developed – he painted many variations of the Campbell's soup can, including ones with torn labels, opened cans, discoloured labels, and cans of different flavours. His sustained 'brand' analysis questions the boundaries between brand culture and high culture as it celebrates aesthetic dimensions of product design, packaging, retail display and mass production.

His last great painting series, *The Last Supper* (1986), spectacularly linked the image of Jesus Christ from Leonardo da Vinci's masterful *The Last Supper* (1498) to popular and profane images. In over 100 variations, Warhol fused the sacred and profane, connecting commercial logos like Dove, General Electric, Planters Mr. Peanut, Wise potato chips, price tags, and tabloid ads – the ever-present ephemera of brand culture – to the holy vision of Christ's Last Supper and Da Vinci's faded masterpiece. His work thus invokes key themes of culture and commerce, Christianity and consumption, by commenting on creation (*GE brings good things to life*), cleansing (Dove soap and its peace-loving logo), and power (General Electric's famous light bulbs) in a provocative and unsettling final aesthetic statement.

When Warhol died in 1987, his estate was valued at over $400 million, and helped create a foundation for his life work. Today, amid squabbles about the authenticity of many Warhol art objects, the Warhol brand remains stronger than ever (e.g. Bockris 2003). Cultural references to Warhol abound – reality TV and YouTube can make just about anyone famous for 15 minutes, many artists court the media with marketing and public relations, and the internet features thousands of Warhol-related sites. His films pre-dated this obsession with mundane imagery by decades. Moreover, the phenomenal success of social-networking websites such as Facebook, MySpace and Twitter resonates with Warhol's celebrated dictum – you *can* be famous for at least 15 minutes, at least on the internet.

Photographic imagery comprises a major theme in Warhol's work. His portraits, soup-can series, and iconic Marilyn, Elvis, and Mao paintings capitalize on the ready reproducibility of images, mimicking and matching the ubiquity of snapshots and the mass production of digitized photographic images. He took stock photography and celebrity photographs – tools of the marketing trade – and elevated them to an art form. Warhol snapped thousands of photographs with his ever-present Polaroid: anticipating the 'snapshot aesthetics' of contemporary advertising and fashion photography (Schroeder 2008). Today, his photographs routinely command thousands of dollars as entry-level Warhol investments and collectibles.

Warhol was successful in many endeavours – commercial art, fine art, film, magazine publishing, book writing and becoming an international celebrity; his brand portfolio was diversified. He was constantly at work on new projects,

developing new ideas, and making new friends and acquaintances. In this way, he built and extended a successful and wide-ranging product portfolio under the Warhol brand. Warhol's images appeared in multiple guises – paintings, prints, illustrations, record covers, clothing, photographs and books. By actively managing his portfolio, he leveraged his brand (and fame) in ways few artists have. His goal to create Superstars was one fascinating element of his brand prowess, and reveals the power behind the brand (see Hickey 2006).

Not content with success in the art world, Warhol ventured into film making, modelling, producing the rock band The Velvet Underground (and designing their famed 'Banana' LP cover), and launching *Interview* magazine (see Marechal 2008, Schroeder 1997). His savvy strategy of leveraging his brand is a classic example of brand extension, and offers lessons in a programme of brand management. Of course, Warhol's brand remains active today, and his designs appear in myriad products, including Versace designer goods, mass-produced prints, and many lines of Warhol inspired products, including neckties, bathrobes, shower curtains, dinnerware and rugs.

REALIZING BRAND INSIGHTS

The image constitutes a key characteristic of the twenty-first-century economy. Brands are developed with images; products are advertised via images, corporate image remains critical for managerial success. Marketing is fundamentally about image management: 'in marketing practice that is most likely to succeed in contemporary society, image is primary and the product is treated as merely a variable that attempts to represent the image' (Firat *et al.* 1995: 46). If we understand that the market is based on images – brand images, corporate images, national images, and images of identity, then we realize that vision is central to understanding management in the information society. From this perspective, visual art assumes central importance to understanding the image economy.

Contemporary artists interact with brands in a numbers of ways. First, they appropriate brands and commercial symbols in their art – brands provide visual raw material. Second, the art market itself is greatly concerned with brands – well-known global brands like Picasso, Van Gogh, Rembrandt, and Caravaggio (see also Bamossy 2005; Drummond 2006; Schroeder 2000, 2006). Perhaps in no other market is the relationship between name recognition, value, and branding so clear. Third, artists create visual brands via their work – their style or look. At times, this style derives directly from the branded world – in Warhol's case, for example.

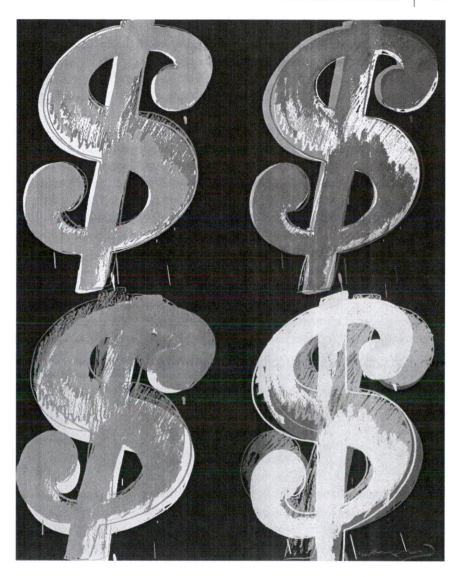

Figure 3.3
$ (4) by Andy Warhol, 1982
Credit: Andy Warhol Foundation/CORBIS

Moreover, the logic of marketing – including strategic tools such as creating distinctive products, segmenting the market, brand extension into other markets, genres and media, controlling distribution and fostering exclusivity – often informs artistic production, auction-house strategy, and gallery

oversight. The artist's use of branding helps articulate cultural meanings and associations that constitute brands. In this case, Warhol affected the iconic value of Campbell's soup, contributing to its success as a global brand. Other artists bring unwanted negative attention to brands, although this work rarely finds its way into important collections or museums. Many artists contribute to branding campaigns, via licensing of their work, active commissions, or general stylistic influence. Warhol's images have appeared in many ads, and he created the famous Absolut Warhol ad, kicking off the incredibly successful Absolut vodka campaign. Currently, Chanel promotes its iconic No. 5 cologne with a Warhol-designed print campaign, completed for the company shortly before his death.

From an aesthetic perspective, artists create images that abstract and reify things, people, and holy figures. They have honed these skills for centuries, building up a visual vocabulary that expresses our highest hopes and our deepest failures. Advertising, in turn, developed in close contact with fine art, and continues to interact with the art world on a daily basis. It should be no surprise, then, that artists know a little about branding, which is all about making emotional connections and image management. As one of his many biographers put it, 'Warhol's *Dollar Signs* are brazen, perhaps even insolent reminders that pictures by brand-name artists are metaphors for money, a situation that never troubled him' (Bourdon 1989: 384). Yet, within most marketing and branding literature, art remains unseen, under-appreciated, and untapped for strategic insight.

WARHOL'S LESSONS

Warhol's use of Campbell's soup vividly illustrates how brands produce meaning and value beyond the branded product. By isolating the Campbell's brand image, simplifying its bright white and red label, and transposing it to canvas, gallery, and art collection, Warhol uncovered links between Campbell's soups, visual design, and other mass-produced products. Today, Campbell's remains inextricably linked with Warhol. Marilyn Monroe, as well, occupies a Warholian space. Furthermore, for many, Warhol's Absolut ad stands out as *the* exemplar of Absolut vodka's spectacularly successful campaign.

Brands interact with, 'talk to', and exist among, other brands. Artists often actively animate this brand 'intertextuality' by taking brands out of the marketing context and into the gallery, often identifying and highlighting the essence of the brand. In Warhol's case, Campbell's Soup was not happy at first, but eventually hired Warhol to produce an ad campaign in the 1980s. Just as often artists appropriate existing links between brand images, brand names,

and marketing campaigns. However, artistic use of brands almost always runs counter to that expected or intended by brand managers, and therein lies its capacity for innovative insight. Certainly, the Mr. Peanut brand manager never imagined their friendly, trademarked character cavorting with Christ in a Warhol *Last Supper* painting.

Warhol's use of photography helps shed light on its symbolic power. Despite photography's – including still photography, video, film, and digital photography – contributions to brand building, most consumers receive little photographic training, and few marketing studies place photography at the centre (see Schroeder 2002). Photography just is, apparently; its transparency falsely lulls us into believing no special tools are needed to comprehend its communicative power. We have become so used to photographic representation that it seems inevitable, a natural record of what exists or what has happened. Yet photography is not the truth, it is not a simple record of some reality. I find it useful to think of photography as a consumer behaviour as well as a central brand communication technology and powerful artistic medium.

The visual arts are an impressive cultural referent system that brand managers, art directors, and advertising agencies draw upon for their strategic representational power. In the hands of art critics, artists like Warhol might seem to critique the ubiquity and banality of consumer culture. However, his work fits comfortably within conventional marketing success stories, too, and the overwhelming success of art brands like Warhol provides profound insight into marketing and branding processes.

CONCLUSION

Turning to artists and art helps develop a cultural perspective on brands and provides disparate, wide-ranging examples of how interdisciplinary research often leads to recognition of novel patterns and unique solutions. Their virtuoso command of imagery and public appreciation of their artistry make them compelling figures for insights into branding processes. I think Warhol would have appreciated being included in a book about art marketing. With his immense skills of image creation, brand building, and attention grabbing, Warhol commanded a vast audience, creatively conjuring visions of growing influence and relevance. His work commands attention today as it did when he was alive, and his value – both economic and cultural – as an artist continues to grow.

ACKNOWLEDGEMENTS

Thanks to Natasha Hayiannis at Corbis and Emma Gregg for help with picture research and permissions, and to the Harris family, who introduced me to Pop Art at an impressionable age.

4

THE TENSION BETWEEN ARTISTIC
AND MARKET ORIENTATION
IN VISUAL ART

Ian Fillis

INTRODUCTION

For centuries, artists have existed in a world which has been shaped in part by their own attitudes towards art but which also co-exists within the confines of a market structure. Many artists have thrived under the conventional notion of a market with its origins in economics and supply and demand, while others have created a market for their work through their own entrepreneurial endeavours. This chapter will explore the options open to the visual artist and examine how existing marketing theory often fails to explain how and why the artist develops an individualistic form of marketing where the self and the art work are just as important as the audience and the customer. It builds on previous work which examines the theory and practice of visual arts marketing, noting that little account has been taken of the philosophical clashes of art for art's sake versus business' sake (Fillis 2004b). Market orientation has received a large amount of attention in the marketing literature but product-centred marketing has largely been ignored. Visual art has long been a domain where product- and artist-centred marketing have been practised successfully, and yet relatively little has been written about its critical importance to arts marketing theory. The merits and implications of being prepared to ignore market demand and customer wishes are considered here.

Slater (2007) carries out an investigation into understanding the motivations of visitors to galleries and concludes that, rather than focusing on personal and social factors alone, recognition of the role of psychological factors such as beliefs, values, and motivations is also important. This being the case, we should also consider the motivations and orientations of the artist

in making art. It may be useful to think of this in terms of creating the market versus following the market. The former orientation can be viewed as innovative and even entrepreneurial while the latter is more to do with fitting in with the mainstream and taking fewer risks.

Falk and Dierking (1992) identified the three main motivations for visiting museums and galleries as social recreation, educational reasons, and reverential behaviour towards the artist. Work is now also emerging on the impact of art on the audience, moving beyond the institutional interpretation of art to embrace a more holistic understanding of the meaning of art and the artist by considering social and intrinsic motivational factors (White and Hede 2008; White *et al.* 2008). Kubacki and Croft (2004; 2006) investigate musical artists' attitudes to marketing, noting that artists both create the product and communicate it to consumers. There is a close correlation between these artists as both product and producer and that found in the visual arts. Art itself is found to have a much stronger impact on shaping artists' attitudes than external factors such as society, culture, and the economic environment. Kubacki and Croft find that musical artists tend to exhibit ambivalence towards marketing which may even extend further into antipathy towards the concept of art as business. Although there has been some progress in attempting to understand the relationship between marketing and art, this movement has been slow at best since the analysis by Thomas and Cutler (1993).

THE CLASH BETWEEN MARKET AND PRODUCT ORIENTATION

Marketing has been described as troubled, irrelevant, over-reliant on rules and formula-based thinking, and focused on selling products rather than creating markets (Day and Montgomery 1999; Morris *et al.* 2003). The marketing concept has long been criticized for being too customer focused and stifling innovation (Tauber 1974). Sometimes it is better to shape marketing from within the organization using innovative techniques (Dew *et al.* 2008), or to at least acknowledge that market orientation alone is not sufficient in itself to ensure long-term profitability (Grinstein 2008). There is also a need for outward, technological, product-oriented push (Samli *et al.* 1987). In relation to the debate on the continued usefulness of the marketing concept, Badot and Cova (2008) evaluate what they term a range of novel marketing panaceas and conclude that, rather than establishing a new way of viewing marketing, much of what is offered is actually an alternative form of marketing myopia. Recent alternatives such as customer relationship marketing have, instead of

resulting in heightened satisfaction, resulted in increased customer dis-satisfaction (Fournier *et al.* 1998) and a rise in hostility towards marketing generally (Kozinets and Handelman 2004).

Interest in measuring market orientation has grown since the 1980s (Saxe and Weitz 1982; Narver and Slater 1990; Gebhardt *et al.* 2006). There is also research into market orientation in small businesses (Blankson *et al.* 2006; Low *et al.* 2007) and this has particular resonance for the relationship between the artist and the organization (Fillis 2004c). Van Raaij and Stoelhorst (2008) review the literature on the implementation of market orientation and note that it is fragmented, with a conceptual gap between the construct and customer value generation. Exhibiting long-term customer orientation may also result in inertia, and ignoring the customer occasionally may prove fruitful. Although market orientation can impact on the success of new product development, firm innovation, competitive strength and environmental forces also have roles to play (Augusto and Coelho 2007). Brown (2007) discusses the alternative stance of creating customer lust over a product, rather than the continued faithfulness to customer orientation. There are certain similarities between the anticipation of the latest version of the iPod or the next J.K. Rowling book and the creative frenzy surrounding the next Tracey Emin or Damien Hirst exhibition. Though Rowling's book or the electronic product may have shortcomings, these are very often set aside as Brown's 'lustomers' satisfy their desires. So, too, is the case in the art world where Emin and Hirst certainly have their critics and yet they continue to out-manoeuvre their peers in the art world.

Rather than continual adoption of customer orientation, Gummesson (2008) recommends the implementation of balanced centricity involving a trade-off between a number of stakeholders. In addition, marketing as a discipline can be improved by addressing complexity issues through innovative methodologies and the incorporation of novel marketing theory. Gummesson senses that customer orientation is becoming a commodity which everybody seeks, with the result that no real competitive advantage is achieved. There may be no hard evidence that customer-centricity works in the long term, but instead incurs costs and generates limited additional revenue.

MARKET AND PRODUCT ORIENTATION IN THE ARTS

Although the impact of market orientation and performance in the non-profit organization has been investigated (Balabanis *et al.* 1997; Gainer and Padanyi 2002; Duque-Zuluaga and Schneider 2008), there is less work examining the

impact of product orientation (Voss and Voss 2000; Camarero and Garrido 2008). There is even less discussion of artist-led creativity. Product orientation incorporates an element of creativity in order to help develop new products which subsequently invigorate customer markets (Izquierdo and Samaniego 2007). The arts certainly have high levels of creative innovation, as well as an ability to engage with their various publics. With the broadening of the marketing concept have come attempts at creating art marketing theory and yet much of this has failed to recognize the particular needs of the sector and its powerful underlying philosophical, aesthetic dimensions. Rather than just concerning the philosophical dimension of beauty, art and aesthetics can also refer to the sensing nature of decision making where intuition is just as much a part of the process as rational thinking (Strati 1999). Brown and Patterson (2000) consider the growing impact of art and aesthetics on marketing practice, including analytical inputs of the lives of Edouard Manet, Salvador Dali and James Joyce. These writings promote the re-imagining of the future of marketing management and consumption issues through the interrogation of art, aesthetics and the alternative, avant garde part of society.

Hirschman (1983) suggests that the marketing concept does not match the behaviour and philosophy of the artist because of the personal values and the social norms which impact on the artistic production process. Artists create mainly to express their subjective conceptions of beauty, emotion or other aesthetic ideal (Becker 1978; Holbrook 1981). Aesthetic creativity is the central influence in the process, and is expressed or experienced purely for its own sake rather than responding to customer demand (Holbrook and Zirlin 1983). Hirschman distinguishes between artistic and commercial creativity, since the values of the individual will ultimately determine creative orientation. These differences can be compared similarly to the philosophies of 'art for art's sake' versus 'art for business' sake' (Wilde 1882; Whistler 1888). Insight into the clash between market-driven art versus self-oriented art is illustrated by Wilde (1881):

> A work of art is the unique result of a unique temperament. Its beauty comes from the fact that the author is what he is. It has nothing to do with the fact that other people want what they want.

In addition, the notion of the producer and consumer as distinctly separate entities does not necessarily hold within the art world. The subjective interpretation of issues relating to value is perhaps much more subtle than in other sectors. The dominant philosophical position of the creator as producer often clashes with classical notions of marketing orientation.

Art for art's sake philosophy is often positioned alongside the notion of the avant garde (Harrison *et al.* 1998). Although Théophile Gautier was supposedly the first to adopt the term 'L'art pour l'art' as a slogan, and Benjamin Constant utilized the phrase in his own work, Victor Cousin is credited with developing the foundations of the doctrine of art for art's sake which promotes the belief that art must remain independent from utilitarian, religious or political purpose. Derived from the school of progressive modernism, the notion of the avant garde focuses on the ability of those artistic individuals and groups who attempt to change societal thinking through the rejection of tradition by looking towards the future. The avant garde typically utilizes creativity to shape future thinking and practice, while also having a central role in defining culture (Chartrand 1984). Criticisms of the value of avant garde art are somewhat at odds with the belief that avant garde art challenges convention by creating rather than responding to demand (Fillis 2000b, 2002a, 2002b, 2004c; Fillis and Rentschler 2005). Avant garde status does not necessarily mean that popularity and financial rewards are minimized. In fact, art history is full of examples of one-time avant garde artists who, through their creative marketing activities, attract a following and create success, shaping market demand in the longer term.

Meyer and Even (1998: 273–74) suggest that product-centred entrepreneurial creativity is really what occurs in the process of art for art's sake marketing:

> . . . the artist does not find products for the customer, but seeks customers for his products . . . art becomes a traded good once it is brought to the marketplace which, however, may not be the objective during the process of creation . . .

Botti (2000) believes that marketing only becomes involved in the process once the art work has been produced. However, marketing really begins with the initial construction of the creative idea. The artist can be viewed as the owner/manager of the art product, where marketing processes concerned with idea generation and product development have been involved long before the art work has been produced. Creative marketing behaviour is ultimately driven by a set of competencies linked to the personality of the individual artist. Previous research has identified artists who have successfully followed the art for art's sake approach, and found that, by exploiting their inner creative entrepreneurial marketing competencies, development of consumer interest and market development will follow naturally (Fillis 2000c, 2003). Product-centred marketing, then, can create demand and profitability over

time. Within this framework, it is also important to understand how the inner personality of the artist affects the process of artistic creation (Evrard 1991).

ARTISTS WHO CREATE DEMAND RATHER THAN RESPOND TO IT

Tracing the development of modern art, Collings (1999) constructs a critique of how commercially aware artists such as Tracey Emin and Damien Hirst eagerly embrace individualized marketing practices once they create demand for their work. Hirst's early success followed a strategy of creative annoyance with his fish-tank animals in formaldehyde solution. This art form satisfied the demand for artistic counter culture which was also so successfully followed by Andy Warhol (Warhol 1975; Hirst 1997). This philosophy also helped him win the 1995 Turner Prize. A decade later and these artists have turned marketing on its head through their construction of an alternative artist-centred form of marketing. As curator of two groundbreaking exhibitions ('Freeze' in 1988 and 'Modern Medicine' in 1990), Hirst eagerly exploited publicity in his early shows of art meeting popular culture. Widening his product portfolio since then, Hirst has also made films, commercial music videos and opened a restaurant, among other entrepreneurial ventures. In order to partially control the market for his work, Hirst uses his company, Other Criteria, to license his imagery, develop new products and sell them on the internet. Almost in a similar vein to Andy Warhol Enterprises, Science Ltd serves as an umbrella organization which looks after his studios, employees, and other business interests.

He is one of the most prominent members of the original Young British Artists, or YBAs as they have become known. Initially courted by the art collector Charles Saatchi, Hirst recently attempted to take control of the market for his art by setting up his own auction at Sotheby's in September 2008 called 'Beautiful inside my head forever'. He raised £111m by bypassing the gallery as he targeted the collector directly, thus avoiding large commission rates. Sales of his art work now make him one of the most expensive living artists. Hirst held an exhibition in 2007 at the White Cube gallery in London which included *For the Love of God*, a human skull made of platinum and encrusted with diamonds worth £15m. Another piece that year, *Lullaby Spring*, sold for $19.2m to the Emir of Qatar. Sales of Hirst's work now outpace that of Picasso tenfold.

Hirst has faced criticisms regarding the use of studio assistants in the production of his work, but, much like the studios of the classical artists of the past, this is nothing new. The initial creative idea is spawned by Hirst and,

once executed by his assistants, he adds the finishing touches. In a way, the process Hirst follows can be compared to that of the director of a film and the actors as they perform under instruction. The art critic Robert Hughes has described Hirst as functioning like a commercial brand, standing for innovation, popular and clear ideas. This is not exactly a new phenomenon, as Dali and Picasso long precede him in this practice. The real point of interest here is that the brand is artist-created, rather than company-created. As well as being an artist, Hirst is now moving into curatorial work and also has personal collections of work by artists such as Francis Bacon, Jeff Koons, and Andy Warhol.

Tracey Emin is also a well-known YBA, born in Croydon in 1963 of Turkish Cypriot origin. Townsend and Merck (2001: 7) describe her as the most famous living artist in Britain, helped in part by her use of mass media to promote her work. Once she has created her own brand of art, she also uses modern technology to communicate what she does:

> In electing to work in media such as video, to model fashion and appear in advertisements, she has gone with the grain of mass celebrity, reaching a status previously unimaginable for a contemporary British artist.

In the early days of her artistic career, Emin was the partner of one of the founding members of the 'Stuckist' art movement, Billy Childish (Alberge 1999). Constantly challenging the art establishment through public demonstrations of distaste against the annual Turner Prize, they launched an alternative art manifesto promoting traditional forms of art. Emin then rebelled against this notion, instead revelling in mass-media exposure and at one time dismissing the concept of traditional painting as a valid art form (Kent and Brown 1998). She became a Turner Prize nominee in 1999, with her artwork moving from the avant garde to the mainstream as her popularity grew. She had a somewhat traditional art education, attending the Royal College of Art. Some of her early influences included the artists Edvard Munch and Egon Schiele.

Much of her work could be described as confessional, autobiographical art as it displays a very personal narrative around a range of sensitive issues, from relationships to abortion and rape. Her first solo exhibition was at the White Cube gallery in London. Her tent installation *Everyone I have Ever Slept With 1963–1995*, was the ultimate confessional form, as it contained the names of all those people she had shared a bed with, from childhood onwards. This piece was purchased by Charles Saatchi to form part of his Sensation exhibition, which served to raise Emin's artistic reputation further. The highlight of her career so far has been the selection of her work for the Venice

Biennale 2007, with Emin only the second British female artist to be chosen for a solo show. This was also accompanied by her adoption as a Royal Academician, placing her among the upper echelons of the mainstream British art establishment. Fanthome (2006) believes that Emin's success is partly due to her ability to convey the unspeakable and push the boundaries of conventional representation. Her confessional art form also sits alongside the growth in popular culture television programmes such as *Big Brother* and *I'm a Celebrity . . . Get Me Out of Here!*, which concentrate on 'incessant performance of identity structured through first-person media speaking about feelings, sentiment and, most powerfully, intimate relationships' (Dovey 2001). It could also be argued that art in general has always contained an element of confession and unveiling of truth but that it is only in recent times that the mass media have assisted in its communication. Although this format has risen in popularity, confession has a long history since the Middle Ages. Emin has successfully helped to create the contemporary demand for this art form, which Foucault (1990) sees as a key ritual which we use for the production of truth.

CONCLUDING THOUGHTS

In the past, arts-marketing theory has drawn heavily on mainstream marketing frameworks. However, there is still a wide theory versus practice gap which fails to account for the art for art's sake philosophy, which is often at odds with the art for business' sake thrust of marketing orientation. Many artists view their art as an extension of the self, with marketing beginning from the initial conception of the idea to the construction of a market for the product. Historically, the marketing concept did fit easily within the structure of the art market with rich patrons commissioning the artist on their terms, but today artists are also seen as consumers of the art work as they produce art on their own terms. In fact, some artists have become master marketers and self-promoters, using their celebrity status to further shape demand for their work. Consumption of art differs from many other products, with aesthetic pleasure playing a large part of the process. Art is seen as a communication carrier of a variety of qualitative, intangible messages which conventional marketing frameworks cannot interpret. Another differentiating factor between the visual arts and other market sectors is that art as a product has little or no functional or utilitarian value. Some commentators frame the development of the art market in economic terms and differentiate between the pecuniary, or monetary, benefits of being an artist, with reputation, fame, and image sometimes seen as more important than financial

returns. There is also a close link between artistic practice and entrepreneurial thinking, with links between art making and intuitive vision. The artist can also be viewed as a risk-taking entrepreneurial owner/manager.

It is important to realize that art continually impacts on society and changes the way in which we think. There is still a lack of research on art marketing, and a severe lack of critical research which seeks to construct alternative ways of understanding. New visual art marketing theory needs to be built around the realization that the artist and the art work are just as much the focus of consumption as the consumer. A variety of internal, qualitative, intangible exchange relationships occur within the persona of the artist as creator and marketer. These factors cannot be interpreted using conventional marketing research techniques. Future arts marketing research should focus on the product-centred nature of entrepreneurial creativity where the personality, attitudes, beliefs, and behaviour of the artist as owner/manager are central to practising visual-arts marketing. The philosophical clash of 'art for art's sake' versus 'art for business' sake' should not be viewed as an inhibitor of visual-arts marketing progress, but rather as a catalyst for creative change. Instead of perceiving philosophical clashes as problematical, they should instead be viewed as opportunities for developing new solutions, feeding into a more appropriate theory, while also mirroring the contemporary practice of visual-arts marketing.

5

FROM MISSIONARY TO MARKET MAKER

Reconceptualizing Arts Marketing in Practice

Debi Hayes and Simon Roodhouse

OVER THE PAST thirty years, arts marketing largely evolved within the subsidized arts and cultural sector from an auxiliary activity to a strategic function which is organizationally embedded. This chapter explores this development by examining key UK policy drivers in particular, citing evidence of up-skilling and professionalization. These are mapped to an evolutionary framework proposed by Rentschler (1998, 2002) which leads to the introduction of the innovation period.

Throughout the periods identified in the Rentschler framework, modifications to the core product (artistic mission) have usually been off limits since the role of arts marketing has generally considered to be concerned with supporting the artistic mission rather than defining or shaping it (Boorsma 2006). In addition, long-standing conceptual conventions have affirmed the myth that commercial and cultural successes are mutually exclusive in the non-profit sector. Commercial success is often assumed to compromise artistic and cultural integrity (Thelwall 2007). This position has been confirmed by Caust (2003) and Nielsen (2003) who are highly critical of the adoption of commercial marketing philosophies and techniques in the arts, suggesting that this stifles innovation, resulting in homogeneity. Consequently, arts marketers, no doubt influenced by Colbert (1993) and Kotler and Bernstein (1997), have tended to pursue customer satisfaction by focusing on adaptations to the augmented product (pricing, packaging, delivery) rather than run the risk of challenging the core product's aesthetic values or creative process.

The authors suggest that arts marketing is now entering a new phase of development influenced by the introduction of creative industries public policy practice and a plethora of environmental factors which are shaping future cultural product-markets. This can be described as the 'innovation period', characterized by a shift from the arts marketer as 'missionary' to

'market maker'. In this phase the core product is no longer sacrosanct, and artists, marketers, arts consumers and audiences increasingly engage in co-creation articulated by technological developments.

Vargo and Lusch (2004) describe marketing as having an:

> inherited model of exchange [derived] from economics, which had a dominant logic based on the exchange of 'goods', usually manufactured output. This focused on tangible resources, embedded value, and trans-actions. New perspectives have emerged challenging these assumptions, focused on intangible resources, value co-creation, and relationships.

This replaces the concept of autonomous art, a modernist idea, with a post-modernist relational perspective where art production and consumption are essentially shared communicative acts (Boorsma 2005). This also places greater emphasis on networks to create value through co-production with suppliers, business partners, allies and customers. An example of this is the deliberate co-location of film and television post-production facilities in Soho, London.

> Firms choose to locate there, at very high cost, in order to benefit from rapid exchange of precisely the right goods and ideas. They also pay to remain 'in the loop' of informal knowledge exchange that is fuelled by the dense web of multiple interactions.

> (Pratt 2004: 62).

Professionalization, an integral component of the arts marketing phenom-enon, occurred in response to a growing body of knowledge, a greater level of required expertise and a range of government policy initiatives that have shaped the agendas of publicly funded organizations. The implications of these drivers for cultural organizations, arts marketing practice and organizational strategies are also discussed.

THE EVOLUTIONARY FRAMEWORK

Rentschler (1998, 2002) proposed a framework utilizing academic paper content analysis in seven relevant peer-reviewed journals. In total, 171 articles relating to aspects of arts marketing were published (1975–2000) and she identifies three distinct chronological periods. The *foundation period*

(1975–84) was characterized by the need for change in cultural organizations so that they could become 'open' to marketing. The *professionalization* period (1985–94) reflected the development of specialist expertise and skill sets and marketing departments as they became more widely established. The professionalization trajectory continued, and during the *discovery* period (1995–2000) a marketing orientation progressively embedded itself within many organizations.

Rentschler also analysed content thematically. 'Marketing as culture' articles predominate in the foundation period (64 per cent) emphasizing the need for organizations to become more customer focused and responsive to their needs, whereas articles on 'marketing as strategy' account for only 8 per cent. By the discovery period this situation had reversed, strategy articles focussing on positioning, organizational direction, and competitiveness accounted for 60 per cent of outputs. 'Marketing as tactics' concentrating on specific attributes of the marketing mix remain consistent at about 30 per cent through all three periods, although their focus has shifted over time to reflect contemporary marketing challenges arising from the policy context.

An analysis of the policy context and evidence of the professionalization of arts marketing reinforce the evolutionary process described by Rentschler following her analysis of the theoretical outputs.

POLICY AND PROFESSIONALISM 1979–2000

Arts marketing in the UK was almost unheard of prior to 1979, and activity was largely confined to providing publicity for forthcoming events and managing relationships with the press. As a concept, marketing was distrusted and felt to be at odds with the 'arts for art's sake' philosophy that had been characteristic of the subsidised cultural sector in the UK since 1945. A key impetus to the development of this function was the election of Margaret Thatcher's Conservative government which espoused monetarist, free-market economic policy. The Arts Council of Great Britain (ACGB) adopted a more interventionist approach so that they could open up the subsidy system to market forces (Kershaw 2004).

The impact of this was far reaching for many arts organizations – there were severe cuts to grant in aid, and value for money became a key criterion for assessment. This view was reinforced with the publication of Myerscough's *The Economic Importance of the Arts in Britain* (1988) which provided a methodology for valuing the arts quantitatively in social and economic terms. Around the same time other policy developments were emerging. For the first time, the concept of culture as an industry in a public policy context was

introduced. The arts, described by the Greater London Council (GLC) as the 'traditional arts', were subsumed into a broader definitional framework which included 'the electronic forms of cultural production and distribution – radio, television, records and video – and the diverse range of popular cultures which exist in London' (London Industrial Strategy 1985: 11).

The GLC, the Labour-controlled metropolitan council for London, recognized at an early stage that there was a 'strong and deep-rooted antagonism towards any attempt to analyse culture as part of the economy'. It subsequently required a move away from the traditional approach to cultural analysis, which has tended to separate culture from 'material production and economic activity'. *The Cultural Industries* (London Industrial Strategy 1985), argued strongly that, 'What is available for cultural consumption and what opportunities there are for employment in cultural production are, for better or for worse, clearly determined by economics.' Given the high levels of unemployment at the time, March 1985 (over 400,000 people were officially unemployed and a further 120,000 people wanting work in London), it is not surprising that the role of 'cultural industries' as an employment vehicle within London's economy was recognized. For example, London's biggest manufacturing sector, printing and publishing, employed 112,000 people, and the University of Warwick's Institute of Employment Research indicated at the time that literary, artistic, and sports employment would grow by 30 per cent nationally between 1980–90.

It is worth noting that the ACGB concurrently began to recognize the changing political and economic climate of the 1980s Thatcher government by reiterating the need for business planning and marketing as a means of increasing sales and attracting private finance. 'Money must be raised from other sources', and 'for this reason the financial self-sufficiency of arts organizations is an underlying theme' (Arts Council of Great Britain 1988: 2).

A general objective of the Arts Council plan was 'to expand the arts economy' by the introduction of mechanisms such as the Incentive Funding Scheme which was intended to improve earnings, encourage private giving, and increase the financial turnover of the arts economy by 'at least £15m by the end of 1991, and £25m by 1993'. Associated with this new interest in the arts economy came performance measurements, e.g. targets for self-generated income and non-ACGB funding.

The ACGB's arts economy strategy encompassed what the GLC would recognise as the traditional art forms: dance, drama, literature, music, visual arts and film. Newcomers to this portfolio were broadcasting and video, now a recognized part of the arts establishment.

William Rees-Mogg, Chair of ACGB, also advocated that arts organizations should become more self-reliant and entrepreneurial, looking to their

audiences and own resources for sustainability and growth. As a consequence, a mixed-economy funding base emerged with arts organizations striving to achieve higher returns from box-office income and an increase in their commercial revenues from catering, retail, and space hire. Arts sponsorship and the introduction of the National Lottery afforded the promise of new income streams; however, many organizations lacked the requisite expertise to write a compelling business case, and often had to resort to buying in expensive fundraising consultancy. It was against this backdrop that marketing as a function began to develop, with activities focused around publicity and communications, developing relationships with corporate benefactors, providing market research as evidence and leading on fundraising applications.

The activity of the early marketers was largely ad hoc and confined to tactical elements of the marketing mix. Rarely were they involved in strategic decision-making or in issues pertaining to the organization's core product – the marketer was subordinate to the programming function. Those marketers in the vanguard were usually untrained and recruited from other administrative or support functions in the arts. They were often of low status in the organization and poorly paid, reflecting the low value attributed to marketing activity. Few organizations recruited marketing practitioners from outside the subsidized sector due in part to the cost differential, but more significantly because arts leaders subscribed to the belief that the arts were 'special' and they considered it likely that an 'outsider' would have a skills and knowledge deficit. In retrospect, this insular, myopic perspective may have slowed the pace of professionalism, reinforcing the notion that arts marketing did not engage with decisions pertaining to the core product (Hayes and Kent 2007).

Following the election victory of New Labour in May, 1997, arts policy became increasingly instrumental, focusing on economic, social and community outcomes with associated targets. Increases in arts and cultural funding were conditional on cultural practitioners addressing four key issues: – access, excellence, education and economic value (Smith 1998). Audience development became the mantra of arts and museum practitioners in the latter half of the 1990s. This reflected a marked change in policy, emphasizing the importance of culture as an instrumental tool for achieving wider social inclusion, creating stronger communities and supporting regeneration. Newly formed marketing departments pursued with missionary zeal initiatives designed to deliver new audiences from difficult to reach non-attending minority groups. These were not always successful, as there was a tendency for organizations to adopt a 'hit and run' strategy and a short-term, scatter-gun approach, due to the limited project funding available (Hayes and Slater 2002). However, over time, cultural marketers have realised the importance of a relationship marketing perspective that balances the demands of existing

audiences with new user groups, thus reducing risk and increasing sustainability. Marketers increasingly adopted a more central and strategic role within the cultural organization in recognition of their ability to collaborate on projects and provide data to support strategic decision-making, and of their role as the primary custodian of audience relationships.

As a result, professionalization was rapid – the Arts Marketing Association (AMA) formed in 1993 to support the professional development of practitioners. Texts on arts marketing, audience development and box office systems and data were published from the mid-1990s, and regional arts marketing and audience development agencies were launched to support cultural organizations' delivery of collaborative campaigns. Higher education and training providers also contributed by introducing accredited courses and continuing professional development opportunities. The Chartered Institute of Marketing launched a specialist arts marketing qualification supported by the AMA which is rapidly becoming the gold standard practitioner qualification. As a consequence, the profile and status of arts marketers has risen and salaries have increased. In addition, analysis of recruitment advertising suggests that role specialization has occurred, with a growing demand for direct and relationship marketing, audience development and communications expertise.

THE INNOVATION PERIOD, 2000 ONWARDS

The key characteristics of the 'innovation period' are: a maturation of arts marketing strategy and processes, a greater openness to new ideas and a willingness to learn from marketing practices developed in other sectors and contexts. This has been triggered by the introduction in the late 1990s of a UK government creative industries policy which has subsequently spread across the world. In addition, environmental (including technological) change factors have impacted on supply and demand and on patterns of production and consumption, all of which create new challenges and opportunities for the arts marketer. This is best understood through an analysis of the New Labour creative industries policy – twelve years old at the time of writing – which incorporates the arts and makes no distinction between public and private.

THE CREATIVE INDUSTRIES PERSPECTIVE

Hearn *et al.* (2007) argue that:

> The term creative industries was first articulated in 1997 as a way of integrating sectors of the British economy in which creative intangible inputs add significant economic and social value. It was introduced as a public sector policy by the first 'New' Labour Government in 1998 and adopted in Europe, East Asia, and Australasia.

The term has also been taken up increasingly in the United States, typically resistant to such European and dominion trends. It is a term which sometimes is read as code for a neo-liberal cultural policy agenda and as such is the subject of increasing academic debate (Garnham 1987). However, both critics and advocates agree that the internationalization of the creative industries concept is predicated on its ability to connect key contemporary policy drivers in high-tech information and communications technologies (ICT) research and development (*production* in the new economy) with the 'experience' economy, cultural identity, and social empowerment (*consumption* in the new economy).

The cultural industries' replacement creative industry concept, generated by DEMOS (Leadbetter and Oakley 1999), and constructed as a component of the knowledge economy model, can be found in one (Cunningham 2002) of four key policy themes for the Department for Culture, Media and Sport (DCMS): that is, economic value. It is argued that the theme of economic value is a maturing of the Thatcherite ethos of efficiency, effectiveness, value for money, and market forces. Smith, the first New Labour Secretary of State for Culture, Media and Sport, reinforced this interpretation – 'ensuring that the full economic and employment impact of the whole range of creative industries is acknowledged and assisted by government' (Smith 1998) – in his attempts to promote 'Cool Britannia'.

In effect the traditional arts have been subsumed into the creative industries policy framework evidenced in the definitions employed; 'those activities which have their origin in individual creativity, skill and talent, and which have a potential for wealth and job creation through the generation and exploitation of intellectual property' (DCMS 1998b). The industrial activity sub-sectors within which this activity primarily takes place are: 'advertising, architecture, the art and antiques market, crafts, design, designer fashion, film, interactive leisure software, music, the performing arts, publishing, software, television and radio' (DCMS 1998b). The representation of these activities as the UK creative industry sector generates structural and intel-

lectual location tensions: for example, architecture relates to construction and marginally engages with the arts and antiques trade; similarly, the arts and antiques trade has little or nothing to do with interactive leisure software. However, this locus for the arts has the potential to transform its identity, the assumptions that underlie the scope of its activities and approaches to delivery. Over time, the rules and premises that previously existed will be forgotten and convergence of sectors will occur, encouraging new alignments and opening up markets which could lead to further innovation. The computer gaming industry has given rise to a new form of musical composition – the game score – which does not follow the conventional linear narrative associated with film scores and has the additional challenge of engaging with the 'gamer' as both audience and participant. Increasingly this genre and its inherent challenges are inspiring established composers such as Philip Glass and Hans Zimmer to become involved in game development at the conceptual stage (Entertainment Software Association 2008). Similarly, arts marketers are recognizing that alignments with other sectors are important for achieving wider reach, accessing new audience groups, and, critically, as a means of deriving additional income from previously generated content. The national museums have created mini versions of blockbuster exhibitions to tour regional flagship locations (e.g. Meadowhall shopping centre and the O2 venue) as a means of extending their sphere of influence.

Of particular note in this definitional discourse is the equitable inclusion of both public- and private-sector activity in public cultural policy by re-designating cultural activity as creative industries and engaging with convergence arguments generated through advances in technology (Flew 2002; Cunningham *et al.* 2003). Fundamentally, this growing re-conceptualization facilitates a reassessment of the traditional forms of policy intervention in support of the arts and culture (Roodhouse 2002). Consequently there has been a trend towards reducing grant-in-aid funding to a limited number of arts organizations and increasing the project funding to deliver against specific objectives, open to a wider range of organizations and collaborations spanning the public and private sectors that could include applications from creative business and charitable organizations.

As elaborated by Cunningham (2002), the term 'creative industries' offers a workable solution that enables the creative arts to become enshrined within a definition that breaks down the rigid, restrictive, and elitist long-standing arts definitions to create coherence through democratising the arts in the context of business. In this view, creativity sits alongside enterprise and technology as a sector of economic growth through the commercialization of creative activity and intellectual property. Cunningham confirms this:

'Creative Industries' is a term that suits the political, cultural and technological landscape of these times. It focuses on the twin truths that (i) the core of 'culture' is still creativity, but (ii) creativity is produced, deployed, consumed and enjoyed quite differently in post-industrialized societies.

(Cunningham 2002: 2)

Hearn *et al.* (2007) articulate the connection between the creative industries policy and innovation:

By creative industries policy we refer to policy which directs governments in attempts to stimulate or grow the creative industries regionally or nationally. Such efforts are often 'whole of government' and involve agencies concerned with industry development and innovation as much as the arts and culture.

According to the National Endowment for Science, Technology and the Arts (NESTA) (2009), the national agency responsible for promoting innovation in the UK, virtually all Regional Development Agencies (RDAs) have prioritized the creative industries. For example, the North West RDA is supporting the development of a digital and media cluster, with the BBC having a leading role, at Mediacity in Salford. It is hoped that, once complete, this cluster will support the wider growth of the region, contributing an estimated £1bn to the UK economy over the next five years. The DCMS has also committed to setting up a network of RDA beacons to stimulate further creative industries development in other regions.

This, then, is a significant move from the traditional arts definition established by the Arts Council of Great Britain and successor bodies which, over time, has become increasingly illogical and unsustainable. The shift towards an economic re-conceptualization of the creative industries implies a democratization of the arts (Roodhouse 2002) and opens the door to seriously engaging with the arts as business. This may have the effect of liberating the subsidized sector because it avoids artificial distinctions being drawn between public and private operators and encourages organizations to adopt an entrepreneurial and innovative perspective that maximizes the potential of their creative content. They will also have greater freedom to form strategic alliances within and beyond the creative industries sector and could benefit from regional investment strategies, in effect a reduction of state interference and control from the approved cultural agencies.

IMPLICATIONS FOR ARTS MARKETING

Analysis of marketing practices in creative industries businesses and the sub-sidized cultural sector reveals significant differences in philosophy, approach and customer orientation. These are summarized in Tables 5.1 and 5.2.

Commercially focused, generally private-sector, creative businesses adopt 'market making' strategies, with decisions concerning the creative product and its exploitation at the heart of their business model. Fundamentally these are predicated on the careful leveraging of core creativity, innovation and intellectual capital into entrepreneurial activities that are scalable and able to achieve profitability. This requires that those businesses recognise the opportunities arising from technological innovation, are sensitive to cultural trends and able to develop an offer that fits with the lifestyle and aspirations of their customer base. In addition, a rigorous assessment of potential demand and consideration of impacts arising from the competitive landscape informs the business case, supports entrepreneurial risk taking and adaptations to the existing business model. Equally, the commercial sector has certainly not ignored the development of new audiences; very often a non-traditional group has provided the impetus for market development as the case of Classic FM demonstrates. The radio station deliberately targeted a broad audience and achieved a listener base of 6.8 million a week with representation from all

Table 5.1
Arts marketing: philosophy and approach

	Commercial	*Subsidized*
Entrepreneurship	Valued – critical to success	Undervalued – a means to an end
Marketing function	Central to all strategic decisions	Peripheral/supporting the artistic mission
Objectives	Profitability through building markets and creative capital	Accruing cultural capital and delivering against instrumental policy objectives
Key driver	Survival	Balancing demands
Product strategy	Innovation and adaptation to create and meet market demand through scalable solutions	Balancing preservation of the canon with innovation
Customer focus	Democratic – serving selected and defined groups	Mediating between artists and diverse audience groups

Table 5.2
Arts customer orientation

	Commercial	*Subsidised*
Target audiences	Selective, usually predisposed to the offer or art form (soft)	Multiple: soft and hard (difficult to reach and disenfranchised)
Priority	Developing and adapting the product offer to maximize customer value	Delivering the artistic mission and achieving social and community outcomes
Proposition	Varied: wide range of cultural/creative products and services spanning high/low arts spectrum	A narrower range of cultural products and services focusing on the high end of the spectrum
Relationship	Building loyalty by delivering customer value; Engagement/co-creation	Addressing needs of existing and new audience groups; overcoming conflicts
Removal of barriers	Structural	Attitudinal/emotional

demographics by presenting classical music using formats and styles more usually associated with popular music (Brand Republic 2003). Over the years it has diversified the core product with a range of books, recordings, a magazine, live events, and even a range of musical instruments. The station is also committed to an educational mission and has established partnerships with orchestras such as the Liverpool Philharmonic, provides support for the National Youth Orchestra, sponsors the Classic FM Music Teacher of the Year awards, and organizes weekends at the Purcell School for young people to play alongside professional musicians. In turn this has delivered a solid youth audience to the station – estimated at 0.5 million a week.

By contrast, marketers in the subsidized cultural sector have deliberately not engaged with product innovation or adaptations, consequently fewer models for exploiting commercial outputs from artistic production have been developed. Instead they have focused on building relationships with an increasingly diverse range of customer groups to achieve the instrumental policy objectives of the public funding agencies; however, the evidence to support the impact of these interventions is limited. Whilst these actions may have enabled funders to tick boxes, it is unlikely that they will have made a substantial contribution to developing or making markets since that requires product innovation or tailoring products in harness with effective customer engagement strategies.

Since the current funding model is not likely to be sustainable in the long term there is increasing pressure on the subsidized arts to become more entrepreneurial in their outlook. Thelwall (2007) asserts that they ought to consider developing business models and processes as a means of deriving additional income and satisfying the needs of a wider range of customers. She distinguishes between first- and second-order activities (FO/SO) – those which are highly dependent upon human labour and specific resources, in contrast with those that are less dependent, can break the connections to human capital, physical assets and geographical limitations and are scalable. In her view subsidized organizations should aspire to a product portfolio that balances both. An example would be the live performance of a chamber orchestra (first order) and the CD recording (second order). This represents a shift in paradigm for the arts marketer, requiring a closer product orientation, greater market knowledge, expertise in the product development process and a complete commitment to customer focus in the development of second-order lines of business.

Many of the opportunities for second-order development arise as a consequence of social, technological and cultural shifts. Art forms are in a constant state of flux – expanding, contracting and morphing into something new. These trends present opportunities for new product development, interdisciplinary working and forming new partnerships with commercial organizations which need not undermine the artistic integrity of the organization or its mission, since profound and meaningful experiences can be found in any art form or genre, regardless of profit orientation.

Arts customers are increasingly sophisticated and eclectic in their consumption patterns. The age of deference is over – the power of the critics and authoritative experts who informed the canon has waned (Joss 2008). The aestheticization of society has resulted in higher levels of cultural participation, confidence, and awareness, and this had led to debates concerning the role and impact of the consumer as a co-creator in the creative process.

Boorsma (2005) adopts a relational perspective which presumes that production and consumption are communicative acts and the value emerges in the confrontation with an audience. This process gives meaning to the artefact by means of their imaginative powers – as such, the consumer completes the work of art. She is concerned with the arts consumer as co-creator in the total art process but not as a co-designer of the product in terms of its form. Boorsma reflects on the role of arts marketing in achieving this by:

- emphasizing the primacy of co-creation of the artistic experience as the core customer value with social and educational roles of secondary significance;

- focusing on the development of services that assist art consumers in acquiring the specific skills and attitudes for performing this role;
- suggesting that the selection of arts consumers should be driven by artistic objectives with an optimal mix of arts-committed consumers and non-specialists, since both have a specific role to play;
- asserting that performance measures should focus on the contribution to the artistic objectives although she acknowledges that such methodologies are as yet underdeveloped.

Traditional lines of demarcation between audience and artist are blurring, facilitated by technologies that provide an environment in which co-creation can intensify. In the past, the arts relied on the assumption that the content provider knew best, but in the future creative control will be more democratic. Direct links between artist and audience are multiplying – artists regardless of genre have websites that provide a mechanism for access and dialogue, questions, and feedback. Individuals are engaging with culture in many new ways: they are able to modify creative works to personalize and customize, create their own content, file-share with a like-minded community, and adopt a critical perspective through blogging and twittering. This shift in the balance of power has implications for the marketer in terms of content creation, consumer behaviour, protecting and exploiting intellectual property, public engagement, and shaping the business models that evolve.

Broadcast media, print and digital formats are overtaking live events in presenting and distributing culture. Media convergence is driving the development of mobile technologies and as a consequence experiencing art becomes freer of time and place. The centre of excellence is no longer necessarily the arts venue – the private space such as home offers flexibility and choice for arts consumers. The range of engagement devices has proliferated and now includes blogs, fanzines, and social networking channels which provide consumers with the opportunity to promote and critique the artistic product as never before.

As a consequence the live performance is venerated – a special event which can be intense and memorable because it is a collective experience that is often shared with friends involving all five senses. This has implications for the design of innovative, multi-purpose cultural venues, since they need to be flexible, adaptable, and capable of housing the spectacle that it would be almost impossible to present in any other way. Much has been written about the design and marketing of the experience economy and whilst Pine and Gilmore, the originators of the concept (1998), use the metaphor of theatre to explain their ideas, arts marketers have been slower to recognise the implications of this for their practice than their counterparts in the wider leisure industry.

Exceptions to this have been the visual arts and national museums which have benefitted in recent years from investment in excellent venues, concepts and presentation informed by market research, and presentational techniques supported by technology. This has succeeded by revitalizing the offering without undermining curatorial integrity.

CONCLUSIONS

The innovation period signifies change, as conventional practice is disrupted and demand for new solutions increases. There will be a need to confront basic tenets that underpin the practice, particularly in relation to responsibilities for determining the shape and content of the core creative product. This will involve addressing the concerns of critics and demonstrating that involvement in shaping and making markets need not undermine the aesthetic contract or threaten artistic integrity. As custodians of the audience franchise, arts marketers could argue that they are well placed to support co-creation and negotiate new relationships with their peers in programming and education within the wider policy framework of the creative industries. In addition, forming successful new relationships, partnerships and alignments with organizations that are able to contribute to the entrepreneurial success of the subsidized cultural sector is essential. This could include media owners seeking innovative content, financiers with social investment agendas and a myriad of creative industries businesses where there are opportunities for strategic alliances or joint ventures. Keeping pace with, and manipulating, technology will also be critical to the arts marketer in this innovation period.

The professionalization trajectory for arts marketers, then, will need to be adjusted to, and will encompass continuing professional development opportunities that enable learning from marketing practice in other sectors. The profession needs to be less myopic and recruit 'new blood' to ensure that the cultural sector has access to a talent pool that can introduce new ideas and fresh approaches to deliver cross-fertilization of ideas and practice rather than retrenchment and protectionism.

6

CONVERSATION, COLLABORATION AND COOPERATION

Courting New Audiences for a New Century

Angela Osborne and Ruth Rentschler

THIS CHAPTER ADDRESSES the impact of a twenty-first-century multi-cultural society on audiences and arts programmes. Australia has been selected as the case study to examine the nexus between multicultural audience development and multicultural arts product. The chapter commences with an examination of the literature in scholarly papers and policy documents on developing new audiences. It then presents a model for generating new knowledge and new relationships for these new audiences. New audience development in this context is described as taking entrepreneurial risks usually associated with the periphery of artistic production and making these risks mainstream. Using over fifty interviews and eight case studies conducted in two states of Australia, we provide a well-tested and integrative model of how to develop new audiences for a new century. The chapter concludes by demonstrating that an understanding of audience expectation in multicultural artistic delivery presents a powerful value proposition in the arts.

INTRODUCTION

I guess being from a non English speaking background it's really important for me to tell you about this program because that's where I'm from! Doing that [programme delivery] in a multicultural way is extremely important to the public and also for communities to engage with a new venue here, new place, and also it's really important for audience development.

Arts Administrator

This quotation illustrates the disparity and discontinuity within Australia between access to opportunity for audiences seeking to participate in the arts, many of whom are performing artists, and the nature of that market for some. Over the past thirty years, two concurrent phenomena have occurred: first, Australians have sought self-expression by becoming co-producers as audience members; and second, the mix of the Australian population has substantially changed while the mix in arts audiences has changed little.

Making the arts accessible to diverse audiences within Australia is important, as not only is it postulated as a way of creating social harmony, but it also has the potential to revitalize the arts sector in order that it stay relevant to audiences. As such, it is a form of audience development. In the context of multicultural arts, assessment of audiences has traditionally consisted of segmentation analysis of goers and non-goers to arts performances, events and exhibitions, access opportunities and barriers to participation. Measures have been more often quantitative than qualitative, identifying levels and types of attendees and non-attendees (Kapetopoulos 2004; Madden 2005) as well as the challenges associated with audience development. Qualitative measures are critically important to decision-making for policy and practice in audience development, at both government and organizational levels. It is through the analysis of qualitative data, in which arts participants' perspectives are probed, that key themes regarding what is important to the audience can be correctly ascertained.

This chapter examines the role marketing innovation plays in attracting new arts audiences and thus changing perceptions of capabilities in the arts and cultural field in Australia. It answers the research questions: How can we develop the arts so that audiences are more reflective of the multicultural community that Australia has become? How do we best assess the needs of new audiences in arts and culture? What actions can cultural leaders take in organizations to assist audience development? The method of analysis is qualitative; it uses case studies and in-depth interviews from three studies on arts participation and arts audiences in Australia. The focus is on diversity in arts audiences and studies that illuminate the field from this perspective.

In relation to new audiences, people engage with the arts in a range of ways from active participation, such as through paid employment, volunteerism, and individual arts practice, to audience attendance and production of cultural products (i.e. as artists). Audience development entails enticing people to attend. It is in this sense that we refer to diversity in arts audiences. Diversity in audiences refers to the full diversity of the Australian population being reflected in arts audiences. Diversity refers to the quality, state, fact, or instance of being different in character or feature; of being not alike. In this chapter, it refers to cultural and linguistic heterogeneity within the broader

Australian community. While diversity is often viewed as how individuals differ, it is more appropriate for the purposes of this chapter to view diversity within the context of democratic pluralism. Democratic pluralism refers to a society in which the rights of all groups to participate as full and equal members of society are safeguarded and protected within a framework of citizenship (Jayasuriya 2009). It recognizes the range of differences that exist between individuals and within communities, such as age, physical and intellectual ability, gender and socio-economic background. So, for the purposes of this chapter, diversity refers to 'the range of commonalities and differences between members of society, brought together in a variety of ways most suited to their needs' (Linnehan and Konrad 1999).

Australia's cultural diversity could be viewed as one of our most important national characteristics. Australia has accepted migrants from all over the world for the last thirty years (Lopez 2000). The 2006 census data shows that some 22 per cent of the Australian population was born overseas (Australian Bureau of Statistics 2007); the number of Australians who have a culturally and linguistically diverse background is far greater. For example on census night, 2006, almost half the population of Australia reported one or both parents as born overseas and roughly 15 per cent of the population reported speaking a language other than English at home (Australian Bureau of Statistics 2007).

WHO IS THE AUDIENCE?

Audiences are increasingly interested in diversity of experience. Publications on developing new audiences for the arts are written from a variety of perspectives. There is the ideological perspective of using the arts as a mechanism for social inclusion. This is an instrumentalist approach that does not always use the extant empirical marketing literature as the basis for discussion, but rather uses government social policy as the means for implementing a social change agenda (Gray 2007). There is the arts marketing literature that is increasingly empirically based on social sciences research with a grounding in psychology of behaviour and human motivation. Sometimes there is a mix of both ideological and social and behavioural sciences approaches within the one study; this is the case in both academic literature and industry literature (see, for example, Kapetopoulos 2009, or Rentschler *et al.* 2008). Each of these perspectives is addressed in turn.

Publications on audience development related to the ideological perspective of social change through the arts can either be research based or conceptual. There has been much research undertaken, both in Australia and internationally, into the state of multicultural arts over the last decade or so (see

for example, Arts Council England 2005, 2008; Creative NZ and Auckland City Council 2009; Creative Research 2007; Dawson 2007; Kapetopoulos 2004 and 2009). The majority of these studies focus on audience development. In brief, the studies found that, although there are definite measurable economic outcomes to be gained from prioritizing diversity (Australia Council 2004), funding organizations should not focus too heavily on measurable outcomes. Rather, projects' success should be measured in participation rates and in less easily quantifiable measures such as community well-being (Mulligan *et al.* 2006). The measurement of arts programmes is a perennial debate which has consumed arts workers. The issues of quality and excellence have dogged implementation of arts and cultural policies aimed at diversifying both the arts sector and the government bodies which administer to the sector (Blonski 1992). Measurement of success and effectiveness of arts programmes in terms of community well-being presents a challenge for arts administrators, policy makers, and practitioners alike. Funding bodies are subject to stringent conformance and performance measures, and hence those arts organizations which access funding are likewise required to provide measurable outcomes for their activities. Research on the relationships between art and well-being is inconclusive but often heart-felt. While outside the scope of this chapter, these perspectives underpin audience development activities.

Authors of empirically based marketing literature grounded in psychology and human and cognitive behaviour have been active in the area of developing audiences. At the national level, the Australia Council has produced literature which covers a range of audience publications, including regional participation, indigenous participation, cultural diversity and arts and disability, to name a few identified by the authors in their research (see, for example, Rentschler *et al.* 2008). In its attempts to address this important issue, the Australia Council held a series of seminars and workshops in 2007 with multicultural arts advocate Donna Walker-Kuhne. Walker-Kuhne's (2005) message is simple: audiences will come if they feel that they will be welcome, if they feel they have a place, and if the programming is culturally relevant to them. While the message is simple, implementation is less so, if marketing principles underpin it, as the rest of this chapter seeks to demonstrate.

The Australia Council has produced a number of informative and educational research papers in this genre – practical and informative guides aimed at assisting arts organizations to undertake market research, to understand the market and the implications of operation within that market, and to develop marketing strategies. For example, the Australia Council produced and published *Who's My market? A guide to researching audiences and visitors in the arts* (Close and Donovan 1998), *Marketing strategies for arts organizations* (Steidl and Hughes 1999), and *What's My Plan?* (Dickman 2000). Most

recently, the Council produced a toolkit, *Adjust Your View* (Kapetopoulos 2009), for arts organizations specifically on the subject of improving diversity in Australian audiences. The Australia Council also held an online forum in 2005 on the subject of developing diversity in audiences; a synthesis of the forum is available on the Australia Council website's Research Hub. The forum raised many questions and identified common themes that arts organizations around Australia are facing to improve diversity in their organizations. Topics included the need for cultural diversity in decision making, market research approaches to leadership in the arts and its ramifications for relationship-building, programming and innovation. The forum highlighted the willingness and enthusiasm of arts organizations to understand how to develop new audiences and the significance of so doing.

These three perspectives suggest that the perception of who is the audience and the relationship of the audience to the make-up of the general population is changing. In arguing the case, authors may not be purist in the point of view they adopt in their studies. There are four key conclusions to be drawn from the literature.

First, the literature suggests that arts organizations can promote and champion social change (Haynes 1999; Newman and McLean 2004). They can do this by promoting the value of difference, the positive contributions marginalized groups can make, and by raising the profile of the arts in the wider community. However, evidence from research suggests that this approach will not diversify audiences from untapped markets, unless it is accompanied by other strategic activities. Evidence gathered through our research suggests that arts organizations must engage in targeted, strategic engagement with communities which they wish to court.

Second, there are government policies on developing audiences that do not always take heed of the lessons from the social sciences literature base. Furthermore, arts policy is often developed with desired outcomes in mind which address perceived social need (Gray 2007); it is often relegated to the position of an effective tool with which to enact broader governmental intention (Gray 2008). This causes conflict in objectives for arts organizations seeking to develop audiences. Instrumentality in arts policy is often not well received by artists and arts academics alike (Caust 2005); the fear being that to emphasize the instrumental utility of the arts is to undermine the intrinsic value of the arts to society (Caust 2003). Policy can often be perceived as conflicting with existing directives (Blonski 1992); lack of clarity of purpose and motivation can lead to poor implementation and a failure to meet policy objectives.

Third, there is still a need to develop skills and knowledge of arts participation and audience development within an inclusive framework of

government policy. There is a need to understand how the blurring of traditional boundaries – between work and leisure, local and global, producer and consumer (Livingstone 2005) – have impacted on audiences' participation in the arts. New technologies have altered the ways in which audiences access the arts (Bartak 2007) and the ways in which artists and others disseminate their cultural product (Johanson 2008). Audiences are regularly viewed in terms of their capacity to become co-producers of works (Boorsma 2006; Deck 2004; Livingstone 2005) and as more than capable of making relevant and useful judgements of quality (Boerner and Renz 2008) and authenticity (Radbourne *et al.* 2009).

A fourth point noted was that authenticity is crucial – for audiences, artists, and the achievement of stated government goals of inclusion (Radbourne *et al.* 2009; Rentschler and Radbourne 2008). Authenticity is understood to be associated with reality, truth, and believability. In this context of arts participation and arts audiences, authenticity is the accuracy or truth of the performance and performers depicting the artistic product, as perceived by the performers and the audiences. It represents values, attitudes, behaviours, beliefs, and social meaning. It is a vital building block in relationship marketing; providing connections with communities must be based on authentic interaction or risk damaging the relationship rather than augmenting it (Rentschler and Radbourne 2008).

Australian studies found a general under-representation of people from non-European countries in arts participation and arts audiences (Australia Council 2004), while the population originating from these areas is growing. It is this imbalance that audience development seeks to redress. It can be addressed by changing programming, changing marketing, changing relationships, and developing authentic experiences. In research undertaken in the United Kingdom it has been noted that diverse communities became more represented in audiences when arts programming was more diverse (Arts Council England 2003). It was noted that in order to attract a diverse audience, the relevance of culture to individuals and community groups must be fully understood in order to encourage engagement with the arts (DCMS 2007). This view is echoed in US-based research projects (Walker-Kuhne 2005).

Innovative marketing strategies and practices help to not only identify arts organizations' current audiences and their preferences (Clopton *et al.* 2006; Stafford and Tripp 2001), but also help to develop audiences (Bussell and Forbes 2006; O'Sullivan 2007). In the arts, it is not uncommon to include product development as part of marketing (Rentschler 1999). Awareness of how programming decisions have a direct impact on the diversity of their audiences (Ksiazek and Webster 2008; Kushner 2003; Walker-Kuhne 2005), audience needs and expectations (Horn 2006; Mencarelli and Puhl 2006),

and creating and maintaining connections with members of the audience communities is seen as crucial to arts organizations (Chong 2005). New technologies have also had an impact on the ways in which organizations market themselves to prospective audiences (Pope *et al.* 2009; Stater 2009).

The contract between audience and organization becomes more than a marketing exchange. It builds a relationship, which is defined as an association or connection between two parties that benefits both of them by creating trust in the quality of services offered (Garbarino and Johnson 1999; Shirastava and Kale 2003). With particular relevance for the arts, building relationships is about creating links between producers, distributors and consumers of art – whether contemporary art, performance art or event (Bussell and Forbes 2006; Chong 2005). Relationship marketing and audience retention have implications in terms of authenticity. The importance of this matter is predicated on the view that the search for authenticity is one of the main drivers for building relationships and retaining audiences for cultural events (Radbourne *et al.* 2009). It is also predicated on the view that the arts represent a dynamic and increasingly important arena for expressing identity. It is audiences which provide the basis for building relationships. Audiences can be formed from local (community) and visitor segments of the market. Building relationships with diverse cultural audiences can develop audiences, as Rentschler and Radbourne (2008) have shown. Relationships are built in part through the presentation of relevant product, and in part by the use of strategic integrated marketing techniques. It is through addressing both of these elements that arts organizations will ensure that they not only behave responsibly in terms of the relationships they create with audiences, but also guarantee that the product offerings are aligned with audience expectations, thus building trust through audience development.

To summarize, some authors discuss the need to diversify audiences for intrinsic reasons, as an expression of social harmony and an accurate representation of Australia's multicultural society. Other authors expound the extrinsic value of diversifying their audiences, identifying potential economic benefit, skills transfer, and knowledge generation that could derive from audience development. Still other authors cite social inclusion and societal cohesion as being positively impacted by audience diversity. New and innovative methods of marketing and market segmentation are themes found in the literature; relationship marketing is seen as the most effective method of enacting innovation in attracting new audiences to the arts.

Our contribution draws together the material from the literature with research conducted by the authors. Evidence gathered suggests that giving prominence to the development of strong and genuine relationships with the communities that make up the arts organization's market has immediate and

positive flow-ons through the creation of an authentic experience, audience development, and product development. Community consultation is seen as the most effective method of discovering who the potential audience may be, what their preferences are and how best to market new products to them. As arts organizations vary widely in terms of size, capacity, structure, purpose, and funding, we do not argue for a 'one size fits all' solution to diversifying audiences. Rather, we recommend that each organization adapts their strategies to suit their market, adjusting aspects of their activities according to identified characteristics of their desired audience.

FOUR DIMENSIONS FOR DIVERSIFYING AUDIENCES

From the analysis above, we identified four dimensions of activity that arts organizations need to address when attempting to diversify their audiences. The most important of these dimensions, and in fact the dimension through which other dimensions can be addressed, is that of *relationship development*. It is no longer sufficient for arts organizations to provide an artistic monologue which audiences are welcome to attend and passively hear. Arts organizations must seek to engage communities in a conversation which all parties are invited to participate in. Relationship development is necessary in order to forge a creative network comprising arts providers, audiences, and artists. The authors have found that relationship development provides a sound basis from which to attend to the other dimensions. Relationship development is a means of developing networks, as part of the suite of network creation activities that arts organizations may undertake.

Once genuine relationships have been created between the arts organization and the communities, the task of creating an *authentic experience* provides a platform for dialogue. Similarly, *audience development* and *product development* are facilitated by the mutual understanding that is fostered through the process of relationship, network, and partnership creation. Table 6.1 shows the elements of the dimensions. Each of the dimensions is then discussed, with data provided from our studies in the field.

RELATIONSHIP DEVELOPMENT

Forging relationships with communities and their organizations is one way for arts organizations to connect with wider communities who form part of their extended audiences. Relationship development is seen to be a means of collaborating and cooperating with communities. Further, it ensures

Table 6.1
Dimensions of relationships, experience, audience and product development

Dimensions of development	*Organizational perspective*	*Audience perspective*
Relationship development	• Initiate genuine relationships with communities • Respond to communities in a culturally appropriate manner • Engage in open dialogue • Build partnerships with community leaders • Encourage and facilitate community ownerships of the arts • Commit to a long-term sustainable process of negotiation, exchange and engagement • Be congenial hosts	• Be open and receptive to creating genuine relationships through the arts
Authenticity of experience	• Create an experience that – Transfers knowledge to the audience – Enables the audience to experience a sense of collectivity – Is located in an accessible and culturally relevant venue – That has social meaning through an approach which ensures accessibility, provides access for all stake-holders to decision-making, and delivers the message in tandem with the presentation – Displays sincerity and recognizes the identity of participants – Provides opportunity for self-actualization	• Engage in a self-actualization experience • Recognize audience's potential role as co-producer of the experience

Table 6.1 continued
Dimensions of relationships, experience, audience and product development

Dimensions of development	Organizational perspective	Audience perspective
Audience development	• Identify and create the right point of entry for each audience member • Identify audience segments to target • Market to those segments in new and culturally appropriate ways • Demonstrate the value of the arts	• Be open to experiencing the arts • Be open to learning about the arts
Product development	• Remain open to unexpected opportunities, both in the arts and in other sectors • Create new products and product extensions in consultation with stakeholders and communities • Market products in new and culturally appropriate ways	• Provide constructive and honest feedback

Sources: Chong, 2005; Chronis and Hampton, 2008; Radbourne *et al.*, 2009; Walker-Kuhne, 2005

that the product they wish to present meets the expectations and the needs of audiences (Rentschler and Radbourne 2008; Walker-Kuhne 2005). Relationships that enage with communities communities in the spirit of the congenial host who wishes to know and understand the other members of the community, are more likely to succeed. Consultation with community organizations further allows marketers to determine which will be the most effective method of delivering the message about the product in a timely and appropriate manner. For example, an art-centred approach to gallery research has meant that this emerging way of seeing audience as part of the gallery could be further developed. Connections between art and audience lead to a mutual understanding of the role of each.

The value of partnerships was mentioned by some interviewees. In small organizations, it was recognized that building relationships with people in other organizations was often a way to 'get things done'. This means that a partnership can be an effective means of achieving goals:

More and more we recognize that we are a small organization and we can't do anything by ourselves. We're looking towards developing strategic partnerships with other organizations in the area. We work with community. And we feel that if we build those relationships that we really could benefit from others' experience.

Regional Arts Administrator (16)

I think we were starting to build that whole approach of working in theatre programmes, public programmes and the working with outside organizations.

Arts Administrator (8)

I think that relationship building, it's something that has got a lot of room to grow and be very successful.

Arts Administrator (12)

Well, as my role is bringing together marketing campaigns, and you have to have a really good understanding about the audiences that you're going out to.

Arts Marketing Officer (2)

Arts administrators and artists identified the potential for flow-on effects from relationships in terms of better relationships with other sectors and communities. Also noted is the capacity for relationships to impact on perception about an organization.

What I have been amazed by, I think, is the number of new relationships we built out of this programme with different communities, with different bits of the arts sector, with state government, the multicultural commission, Arts Victoria, the DPC, the Australia Council and just keep sort of cascading on. I get the sense that in a number of those areas people's perception of what the [organization] is and what it means to them has changed a little bit as well.

Arts Administrator (19)

Relationship development is far from inexpensive. In the words of one Arts Manager: 'It's not just the cheap seats, but the A-reserve seats as well.'

The manager was referring to the fact that many arts organizations try to achieve diversity 'on the cheap'. The community arts sector has long been the locus of 'multicultural' arts programming (Hawkins 1993); given the cultural diversity of Australia's population, we argue that it is time to make diversity

manifest in all strata of the arts, including those arts programmes which have typically been viewed as 'elite'.

The authors are aware that audience development incurs significant costs for arts organizations (Rentschler *et al.* 2002). Costs include discovering and selecting a target market, tailoring marketing material to new audiences, developing a culturally appropriate message, creating meaningful links with communities, and developing new product. Managing the risk of investing in audience development is an issue that arts administrators are keenly aware of. Arts organizations may have to adapt their evaluation mechanisms to capture the success of their activity.

> There has to be a much greater acceptance of risk and how to manage it and to do it in a way that is timely and clear to people.
>
> Arts Administrator (4)

> Is that the only measure? That everything we do has to have a huge audience? I don't think so, I think what we're doing here with the smaller communities, we should accept that the best possible outcome could be 150 people and we've achieved huge success.
>
> Arts Administrator (16)

> For example the Caribbean, even the small scale of the community I think it was still important to do, to deliver for newcoming people.
>
> Arts Administrator (8)

Likewise, forging relationships in an arts context with a variety of people with a variety of skills and objectives is a far from simple task. The time and effort required to invest in building the relationship is significant.

> Working with multiple stakeholders who have got different skill levels, that's been quite an education.
>
> Arts Administrator (5)

The results, however, can be worth the risk and cost.

> I think for the first time in a very long time the [organization] opened up to new audiences and actually created new ways of working. I think that the programme was highly successful, I've never seen such diverse audiences – culturally diverse as well as the demographic and age, it was extraordinary.
>
> Arts Administrator (12)

I'm meeting with [arts administrator] and the Turkish community at a Turkish restaurant to talk about ongoing relationships with one of the artists so it's having a life beyond the programme; the connections and networks have been invaluable for [us].

Arts Administrator (8)

AUTHENTICITY OF EXPERIENCE

Authenticity is seen to be a vital element in the development of relationships with communities. It is further seen to be a crucial indicator for the successful branding of a product (Beverland 2005). Peterson (2005) argues that authenticity is socially constructed by those involved in the discourse or experience. In an arts context, authenticity is the accuracy or truth of the performance and performers depicting the artistic product, as perceived by the performers and the audiences (Chronis and Hampton 2008).

The arts are a form of expression; artists produce works which seek to impart something to their audiences. The arts are also an avenue for social engagement. Experiencing the arts should provide audiences with a sense of a collectivity, an opportunity for self-actualization, and a chance to learn something new in an accessible and culturally sensitive manner (Walker-Kuhne 2005). An authentic experience engages the audience with the work; it does so by developing product which recognizes the identity of the audience and is sincere in its approach.

Identifying community opportunities that are inclusive for people and people gaining something meaningful from participating in the activity, that is not just attending but being involved in every aspect.

Regional Arts Manager (9)

The quote also illustrates that an essential part of developing the creative relationship between audience and art work is predicated upon the arts organization having a clear understanding of the context in which they operate; knowledge about the arts activities in the region must be matched with informed knowledge about potential audiences and their preferences. The notion of the audience as co-producer is one which is gaining salience in arts marketing discourse (Radbourne *et al.* 2009). Co-production entails the joint creation between artist and audience of the performance, so that both groups have a stake in outcomes. Co-production is central to notions of authenticity: the idea of viewing the audience as co-producer highlights the reflexive relationship between performance and audience.

What government departments need to realize is that by funding the arts, especially culture they will end up getting value out of it, we find that especially with our Pacific culture as the children get part of the culture they don't go on to make as much trouble in the community.

Artist (38)

Access for all stakeholders to decision-making is crucial to the development of a strong and fruitful relationship. Transferring knowledge is an important component of providing an authentic experience. By this we mean that an authentic product has cultural and social meaning, and is delivered in such a way that the accessibility of the message is assured.

AUDIENCE DEVELOPMENT

Audiences derive from the community. Arts organizations are located in the community which they wish to target. Desk-based arts marketing is a less relevant approach to ensuring that the full range of diversity of the Australian population will be represented in arts audiences. Data-based arts marketing is an effective method of reaching communities. Linking data-based marketing with community engagement and consultation, by getting out into those communities and meeting key members, provides the opportunity to connect and record information from those communities. Audience development is inclusivity in action.

Inclusion for us is more about getting all different types of people, their demographics, from all different types of communities to come into the Centre, so it doesn't matter what their financial status is, it doesn't matter what their ethnic background is, what their beliefs are, it's about getting them to come into the Centre and to enjoy the arts.

Regional Arts Marketing Officer (22)

In order to attract new audiences, arts managers and administrators need to be open to reviewing their current methods to see if there are new models or strategies which may best serve their intent.

What we were agile enough to do in particular in the music was fairly quickly understand that the sort of marketing strategies that we had in place weren't going to work for this market.

Arts Administrator (15)

In the instance quoted above, the organization developed a radical model with which to organize its marketing campaign of a diversified programme of local, national, and international artists from 23 nationalities which attracted some 160,000 visitors. The core organization was surrounded by satellite organizations comprising business networks with which the core organization had loose affiliations. These satellite organizations were given the responsibility for various aspects of the marketing of the programme. Central to the decisions which led to that marketing model was the underlying strategy of the core organization to meet audiences' needs through audience and product development (Rentschler 2006). Adopting an audience-centred approach that was flexible and capable of adapting to meet changing contexts and participants was crucial to the success of this programme. The programme attracted State Government awards for both its arts offerings and it contribution to multicultural relations (Rentschler and Radbourne 2008).

It is important to demonstrate the value of the arts to communities. Arts organizations can identify and create the right point of entry for each audience member; this is related of course to the notion of creating authentic relationships which will enable the organization to correctly identify which product would be of interest to which audiences. Creating works which specifically speak to particular communities through a process of community engagement creates a positive exchange between stakeholders, contributing to the long-term sustainability of the organization.

> I don't mind if it is painting or whatever but bring people in to find the art form they like and they will not go out and cause trouble.
>
> Artist (19)

> Being able to use a diversity of venues is an important theme that is critical to the success of the project because sometimes those things, sometimes you are wanting smaller [venues].
>
> Arts Administrator (2)

Culturally appropriate, possibly new, ways of marketing to communities might be required.

> ... the Africans and the Arabic Middle Eastern communities have their own way of getting the messages across that aren't necessarily media. So they have churches, mosques, community organizations.
>
> MC, foyer programme (25)

> I thought it was really important for all the shows that were put on to have a fairly large percentage of budget associated with the ethnic press, because that's the audience . . . the show's coming from their countries, and we wanted to attract them.
>
> Arts Marketing Officer (27)

The above quote confirms that organizations which are successfully engaging with new audiences are those which are willing to implement new approaches to marketing, including delivering the message about the product offering to communities in a culturally relevant manner.

> It was about working out the different audiences for each of those – so for the music concerts, talking to the Middle Eastern community and Turkish people, so working out what different communities we need to go to, how we get out to them, working very closely with MAV on that, and doing a lot of advertising campaigns and editing media.
>
> Arts Marketing Officer (2)

> We've worked on very targeted, targeted campaigns, while still having a very broad campaign to attract the general public, so advertising in the [national daily broadsheet newspaper], and doing radio adverts on [community radio] and that kind of thing, so getting out to music lovers and that sort of audience.
>
> Arts Marketing Officer (1)

New technologies also may be useful to arts organizations for audience development. Much has been written about the aging of traditional arts audiences. Linking traditional, more corporate, art marketers with new-generation, funky, marketers – usually located outside the organizational structure in a small, free-wheeling group – using Twitter and Facebook can provide the impetus for access to diverse audiences. For example, traditional marketers who are prepared to concede control of the marketing function to independent marketers, when seeking diverse audiences for a particular performance, mean that marketing becomes part of the conversation about that performance. Marketing is starting to be used as a resource in this way. Hence, marketing also becomes part of co-production. It is one way that staying up to date with technologies used by new audiences can impact success in diversifying audiences.

PRODUCT DEVELOPMENT

Product innovation is best understood within the context of relationship marketing. Product innovation requires a nuanced understanding of the cultural and socio-economic context in which the organization operates. Arts consumption is inherently experiential: audiences are transformed by their experience of the product (Gilmore and Pine 1997). Consumption of arts experiences evokes a range of responses in the audience; for example it is common for audience members to imagine that they are one of the characters in the performance (Hirschman and Holbrook 1982), highlighting again the importance of authenticity in relation to the audience. Furthermore the relationship between the consumer and the product or organization has a cumulative effect on future consumption (Chong 2005). In practice, this means that arts organizations must seek to capitalize on successful products in order to 'keep the ball rolling'. It has been shown that audiences are more likely to attend performances, shows, and exhibitions if they are able to appreciate the product which they are experiencing; their appreciation is a function of past attendances which have built up an understanding and a context within which to experience the arts (Chong 2005).

> They are all still small creative developments that are still works in progress, but they sort of sit within the general programme and each of those developments have had a public showing. We're trying to develop some of that work long term so they would actually fit within [our] programming maybe within a year or two years time. I reckon out of those six there would definitely be two of them that we'd be interested in continuing to develop longer term.
>
> Arts Administrator (3)

Organizations need to be alert to the possibilities for new product development or product extension. Through consultation with communities, organizations can discover if audiences would rather participate in a new take on an old classic, such as the 2009 Melbourne season of the Australian Bell Shakespeare production of *Pericles* which features Japanese drumming. Or perhaps audiences would prefer to engage with a wholly new work that has been developed specifically for them.

> Do we want to be overt and have a show called Africa, or do we want to have a collaborative sort of thing where some of the outcomes emerge?
>
> Arts Administrator (33)

Arts managers can base their programming decisions on the outcome of conversations with communities so as to provide for them products which they wish to experience. In this way, co-production in product development can lead to innovation through product extension (as in *Pericles*) or to entirely new products (such as a contemporary dance piece).

CONCLUSIONS

To conclude, let us return to our initial questions: How can we develop the arts so that audiences are more reflective of the multicultural community that Australia has become? How do we best assess the needs of new audiences in arts and culture? What actions can cultural leaders take in organizations to assist audience development? In short: arts organizations need to build relationships with communities. It is through open and honest dialogue, in which all participants have equal status as stakeholders, that organizations and communities will learn about one another. It is through this mutual under-standing that arts organizations can ensure that they are meeting the needs of diverse audiences, staying abreast of audience interests, and providing the kind of product that audiences want to experience. This endeavour represents a cost to arts organizations. It is recognized that it may pose problems for smaller organizations to approach audience diversification using this method. However, focused, targeted and authentic attention to one community, iden-tified market or product segment one at a time will derive positive benefits for the organization which can be built.

Relationships with communities form the framework within which authenticity, product development and audience development are developed. Our research has confirmed findings from the academic and industry literature that in order to court audiences, arts organizations must engage authentically in collaboration, consultation and conversation with the communities which make up their community.

Chapter

7

WORKING WEEKS, RAVE WEEKENDS[1]

Identity Fragmentation and the Emergence of New Communities

Christina Goulding, Avi Shankar and Richard Elliott

POPULAR MUSIC IS one of the most ubiquitous forms of contemporary culture. This paper looks at the phenomenon known as rave or dance culture in Britain. It examines the nature of the consumer experience at a dance club through the use of a two-stage methodology. Based on observations and the collection of phenomenological data, the findings suggest that the experience is linked to a series of behaviours, which are related to fragmentation and identity. These include narcissistic identity, the emergence of new communities, the need for escape, engagement, and prolonged hedonism. This chapter examines these concepts in relation to postmodern consumption. In particular, an evaluation of postmodern theory and its focus on fragmentation and the project of the self is offered by arguing for a return to 'community'.

INTRODUCTION AND BACKGROUND TO THE RESEARCH

In today's mediatized society it is possible to argue that our ability to construct and maintain our identity(ies) is aided by the symbolic resources which we have at our disposal (Sarup 1996). Literature, advertising, brands, television soap operas and romantic fiction are all examples of some of the symbolic resources that people draw on and have formed the basis for a number of studies (Radway 1984; Ang 1985; O'Donohoe 1994; Elliott and Wattanasuwan 1998). To this ever burgeoning list of popular cultural products we would like to add 'rave' and what has come to be known as 'dance' culture.

The sound and imagery of rave has impacted upon numerous aspects of popular culture, from hybrid variations of the music through to fashion, and

ultimately advertising and communication. Moreover, it might be argued that it is an experience which has influenced the behaviour of a significant group of consumers. The broad aim of this research was to explore the nature of the rave experience from a phenomenological perspective, which results in more critical insights by allowing the informants to dictate the shape of the theoretical framework, rather than limiting the analysis to a set of pre-existing theoretical propositions (Thompson and Haytko 1997). The paper draws on research conducted at one of the rave super-clubs in the UK, which is used as a case for analysis.

The term super-club has been used to define the position in the club scene hierarchy. Those at the top of the hierarchy include, for example, Ministry of Sound in London and Birmingham, Miss Moneypenny's in Birmingham, and Cream in Liverpool. All of these clubs have a well-established history, have clubs in rave destinations such as Ibiza, Cyprus, Thailand, and, in the case of Cream, a regular input into events at the nightclub called Pasha in Buenos Aires, the latest 'chic' rave destination. Furthermore, they attract the top DJs such as Sasha, John Digweed, and Paul Oakenfold and have a wealth of CDs mixed at, and called after, the respective clubs. These clubs are aspirational in their appeal; there is a status associated with having been to them, which marks them apart from the hundreds of regular dance venues that proliferate throughout the country. However, whilst rave or 'dance' culture has attracted considerable attention from cultural theorists (Redhead 1993, McRobbie 1994, 1995, Thornton 1996, Reynolds 1998) and sociologists (Measham *et al.* 1998, Moody 1998), who position their analysis in relation to youth, class and to a certain degree deviance, the phenomenon has largely been ignored by consumer researchers, despite its longevity and importance as a global consumption experience, and a localized sub-cultural activity. This paper examines traditional approaches to sub-cultural theory and highlights some of the problems of applying what might be described as neo-Marxist analysis to contemporary subcultural consumer behaviour. As an alternative, a post-modern perspective is proposed, which offers insights into the fragmented and temporary communal life that characterizes the rave experience.

SUB-CULTURAL THEORY AND THE NEED FOR ALTERNATIVE FRAMEWORKS

The study of sub-cultures has a well-established history within the social sciences. In Britain, possibly the most influential work to date has emanated from the 'Centre for Contemporary Cultural Studies' (CCCS), which was established in the 1970s at Birmingham University. Much of this work

was, and still is, grounded in the Chicago School of critical analysis, exemplified in the work of, for example, Hall and Jefferson (1996), Willis (1996), Clarke *et al.* (1997/1975), and Hebdidge (1997/1979). The position adopted by these scholars is to locate sub-cultural movements within a framework of social resistance and reaction against dominant hierarchies of control. Historically, this perspective has been used to explain the emergence of such sub-cultures as the 'Teddy Boys' (Fyvel 1997/1963), punk rockers (Frith 1997/1980), and drug cultures (Willis 1990, 1996). Most of these studies identify social class and particularly the powerlessness of the working class as the main catalyst for the developments of these sub-cultures.

However, this is a position that has not escaped criticism with regard to contemporary movements and alternative lifestyles. For example, Bennett (1999) provides a comprehensive critique by pointing out that working-class resistance and the implied normalization of deviance are not sufficient to explain the nature of sub-cultural experiences in what might be termed postmodern society. Essentially, they do not account for the pluralistic and shifting sensibilities of style that have increasingly characterized post-second world war sub-cultures. On the contrary, these scholars have tended to use structuralist accounts to explain behaviours which are effectively examples of consumer autonomy.

Increasingly, sub-cultural spaces are becoming sites of creativity and self-expression for both male and female participants from all social backgrounds. Furthermore, Bennett's call for alternative frameworks of analysis appears to be timely, given the pluralistic nature of contemporary style and behaviours which characterize the plethora of sub-cultures, whether music, fashion, experience or symbolically based, which exist in modern society. Today, sub-cultural activity is recognized as important for the construction and expression of identity, rather than as cells of resistance against dominant orders. As such, this activity involves acts of consumption, and the significance of this has not been lost on the marketing community. For example, Schouten and McAlexander's (1995) ethnographic study of 'new biker' behaviour and the consequent product constellations emanating from the Harley Davidson, has introduced the 'sub-cultural' consumer into contemporary marketing thought.

In addition to the intrinsic value of studying such behaviours, Sanders notes that:

> there are a variety of reasons why the examination of such socially marginal commercial activities might be of concern to consumer researchers. Disvalued social activities are typically embedded in sub-cultural groups which provide norms and values which direct and shape patterns of cultural choice.
>
> (Sanders 1985: 17)

It is also important to recognize that sub-cultural choices are also consumer choices involving fashion, leisure, and a wealth of accessories, which speak symbolically to members of the group. In other words they represent a form of what Thornton (1996) refers to as 'sub-cultural capital'. Moreover, although some researchers have suggested that rave is a working-class phenomenon (Redhead 1997), this is open to question. What differentiates rave from other sub-cultures is that it is neither class nor age biased. In fact, rave attracts individuals from all walks of life and social position. Furthermore, it is not reactionary, as was the case with the rebellion of the working-class 'Teddy Boy', and the politicized, middle-class 'hippie' movement. Neither is it a constant part of the individual's lifestyle. Punks, for example, adopted a highly visible and distinct code of dress and ideology which permeated everyday life. In contrast to this, rave, for the majority, is a 'weekend' culture of hedonism, sensation and escape, and has parallels with the life-mode communities described by Firat and Dholokia (1998). These communities are based on temporary experiences, evident in the example of cyberspace groupings, whereby individuals are free to construct experiences without withdrawing from mainstream society or committing to the community. Rave offers the same kind of freedom. It provides an opportunity to forget mundanity, dress to impress (Redhead 1997) and engage in fantasy. It is part of what might be termed the trend towards compartmentalized lifestyles whereby one identity (the responsible worker) is shed and another adopted. The rave website 'Peace, Love, Dancing and Drugs' (1997) comments:

> Outside of a rave, ravers appear normal. Many have jobs in technological fields like computer programming. Many are college students. Raving is not an all the time culture as the hippy movement was and is. Rather raving is a temporary activity separate from the daily lives of the individuals.

Similarly, rave provides a venue for collective engagement with new social groups who meet to experience the dance sensation, but are not necessarily core to everyday social interaction. As such, rave might arguably be viewed as an example of the fragmented and compartmentalized nature of postmodern life.

CONSUMER SOCIETY AND THE POSTMODERN DEBATE

Essentially it may be argued that there are two perspectives on postmodern society. The first perspective views society as dystopian and alienating, with

fragmented consumers seeking compensation through the consumption of signs, spectacles, and the superficial, and is particularly associated with the work of Baudrillard (1988) and Jameson (1990). The second perspective adopts a more optimistic view of the postmodern consumer, interpreting, for example, fragmentation as a potentially liberating force which frees the individual from conformity (Firat and Venkatesh 1995). However, realistically, there are signs of both characteristics evident in everyday life. One is never (or rarely) totally alienated and manipulated, but at the same time, 'liberation' comes with its consequences. The results of this study certainly appear to indicate that both perspectives have a place in the consumer experience, and that one can be used to compensate for the other.

With regard to the first position, particular attention has been paid to the nature of the individual, the alienating effects of society (Yalom 1980) and the search for identity or a meaningful self (Wiley 1994). Prevalent in much writing is the idea that we have witnessed a moral, social and identity crisis over the past decades which, coupled with the demise of community and the loss of traditional family networks, has resulted in feelings of emptiness and loss (Cushman 1990). In essence, there is a depthlessness and a focus on a superficial and surface 'reality' (Eco 1987; Jameson 1990). Such characteristics are said to be endemic in postmodern society which has been described as 'consumer society' (Baudrillard 1988) and 'society of the spectacle' (Debord 1967) and the media (Venkatesh 1992). According to Featherstone (1991: 96), today there is an emphasis on 'the spectacular, the popular, the pleasurable, and the immediately accessible', a summary which aptly describes the contemporary rave/club scene.

With regard to the individual, those who adopt the nihilistic view suggest that the postmodern condition is characterized by identity confusion (Kellner 1995) and the fragmentation of 'self' (Jameson 1990; Gabriel and Lang 1995; Strauss 1997). On the one hand, those who have been stripped of role and identity constitute Cushman's (1990) 'empty self'; on the other, individuals whose lives have become crowded by the pressures of work and invaded by new technologies such as mobile phones, e-mail and faxes, are suffering what Gergen (1991) describes as personal saturation. The human being that emerges is confronted with endless choices which in turn lead to confusion over multiple roles and responsibilities, or what Gergen (1991) refers to as 'multiphrenia'.

This position represents a pessimistic view of a decentred alienated subject. Conversely, within the field of consumer research there is growing acceptance of the notion of postmodernism as a liberatory force (Firat and Venkatesh 1995). Fragmentation is one of the central themes of postmodern approaches to consumption (e.g. Brown 1995; Firat and Venkatesh 1995; Firat *et al.* 1995;

Firat and Shultz 1997). Fragmentation consists primarily of a series of inter-related ideas; the fragmentation of markets into smaller and smaller segments, and therefore the proliferation of a greater number of products to serve the increasing number of segments; the fragmentation and concurrent prolif-eration of the media; and the fragmentation of 'life, experience, society and metanarratives' (Firat and Venkatesh 1995). Examples of the latter include increasing rejection of political authority, increasing political instability, disintegrating social institutions (the church, marriage, family, and work-place), and the fragmentation of the self. As the traditional institutions that formally provided the basis of identity disintegrate, consumption as a means of constructing and expressing identity becomes ever more dominant. Lee (1993) traces the rise in postmodern thinking about culture up until the mid 1980s, the decade where the image attained an unprecedented importance. Along with changes in technology and the media there was a greater emphasis on style, packaging, the aesthetic form, and the 'look'. The 1980s also saw the rise of new social groupings such as the 'yuppie', the 'career woman', 'the new man', and the 'lager lout'. At the centre of all of these was consumption. Consequently, the postmodern self is characterized as Homo consumericus 'a creature defined by consumption and experiences derived therefrom' (Firat and Shultz 1997: 193). Firat *et al.* (1995: 52) comment, 'In customising oneself to (re)present marketable (self-)images, the consumer is interacting with other objects in the market to produce oneself . . . consumption is increasingly becoming a productive process, goal orientated and purposeful.'

Consumption, therefore, becomes a means through which individuals can creatively construct and express the multitude of identities that are open to them. Firat and Venkatesh (1995: 253) suggest that fragmentation means, literally, the breaking up into parts and erasing of the whole, single reality into multiple realities, all claiming legitimacy, and all decoupling any link to the presumed whole. They go on to suggest that the individual is free to experi-ence the height of emotional peaks without connecting the experience to a logical and unitary state of being (Firat and Venkatesh 1995). Kellner (1995) proposes that today, more than ever before, self-consciousness comes into its own as it becomes possible to reflect on the increasing number of roles the individual has to cope with, and to select one's identity as life's possibilities expand.

Nevertheless, postmodern liberation has its problems for the individual, as this freedom comes with a price attached. The increase in possibilities carries with it a greater focus on others, for as the number of possible identities expands, one must gain recognition to assume a socially valid and recognized identity (Thompson and Hirschman 1995). Consequently, we might ask: is rave part of the postmodern experience? And how does this experience relate

to the construction and expression of identity? If we summarize some of the key points relating to the postmodern condition, namely, a search for identity, fragmentation of the self, loss of the social in the traditional sense, a need to find alternatives to socially validate identity and a search for stimulation through immediately accessible experiences, it is possible to suggest that rave is a postmodern phenomenon. In other words, it is possible to consider rave as an experience that helps individuals and groups create meaning out of confusion by offering an alternative way of being which allows for the construction of, and the management of, the self. The following aims to give an insight into the nature of rave or dance culture in order to illustrate some of these observations.

FROM RAVE TO DANCE CULTURE

The UK's dance culture can be traced back to the late 1970s American club scene of New York, Chicago, and Detroit. More importantly, the people at the heart of dance culture's origins were black Americans. And even more importantly they were gay, black Americans. As black Americans, they were generally economically and socially disadvantaged and as gays, they also suffered social exclusion from their own communities. Unable to express themselves in terms of who they were, or wanted to be, they had to actively create their own culture in order to provide an outlet for their self-expression. This culture revolved around the active re-processing and re-mixing of musical styles to create their own – symbolic creativity in action (Willis 1990). This was further fuelled by the ingestion of newly available drugs like MDMA, more commonly known as ecstasy (3,4-methylenedioxymeth-amphetamine). The combined effect of the music and the drugs enabled them to 'escape' from the 'real' world into one of their own creation. Despair and isolation had been replaced by hedonism and a sense of community and belonging. According to Rietveld (1998: 25), house music 'started as an effect of the positive power of community . . . it was also the negative power of racial and sexual segregation'. As such the origins of rave had greater relevance to the conceptual positioning of the neo-Marxist CCCS, than they do today.

As in the case of so many subcultures there was an eventual diffusion effect, whereby the musical styles, fashion, and dance gradually found their way into more mainstream culture. The Paradise Garage, a well-known New York venue, adopted the music, the style and the drugs-without-drink policy of the gay, black clubs of Chicago and Detroit and soon began to attract a wider audience than the original gay black community. According to Jowers (1999: 384), DJs experimented with new techniques to heighten the euphoria of the

dancing bodies they 'controlled': 'The desires and resistances of the club scene were encoded in the music, enabling their diffusion to a wider culture where questions of personal and cultural identity maintenance became increasingly pertinent.'

News of the experience spread, instigating in turn copy-cat clubs which appealed to style innovators keen to experience a new scene. Hebdidge (1997/ 1979) talks about the adoption process whereby what was once considered deviant becomes familiar and marketable, giving rise to a process of recuperation which has two characteristic forms. First, is the 'commodity form' or the conversion of sub-cultural signs (dress, music, etc.) into mass-produced objects. And second is the 'ideological form', or the labelling and redefinition of deviant behaviour by dominant groups such as the police, the media and the judiciary.

In Britain, rave exploded onto the scene in 1988 (McRobbie and Thornton 1995; Measham *et al.* 1998; Sellers 1998). It was spearheaded in the mid-1980s by the club scene on the Spanish island of Ibiza, where thousands of young British tourists were exposed to the 'twelve hour clubbing cycle' (Bennett 2000). When rave was imported to the UK, it marked the grand arrival of a new style of music, fashion, nightlife and a new found direction for thousands of ordinary people (Wayne 1998).

Rave culture began as underground, often illegal, occupations of places such as fields and disused warehouses for the purpose of dance, house music, or more commonly rave. Every weekend hundreds of thousands of young people desperately searched the country for massive illegal parties. Promoters meticulously planned each military-style operation with great precision and cunningness, the main objective being to evade police exposure by adding an element of surprise (Wayne 1998). News of such events was spread by word of mouth, they were secret, they were seductive in their hidden appeal and they were places to express identity and communicate with similar others. What distinguished raves from mainstream culture was an emphasis on social bonding, the collective dance experience, a communal state of euphoria and the 'happy' vibe (Measham *et al.* 1998). This, however, quickly became associated with an increase in drug taking on a massive scale by providing a location and context for drug use (Blackman 1996). Nevertheless, what McRobbie and Thornton (1995) describe as a moral panic incited by the media actually became a routine way of making youth-orientated cultural products, like ecstasy, more alluring. Consequently, rave was marketed as one of the most controversial sounds of 1988 (McRobbie and Thornton 1995). As a result of much bad press, and the definition and redefinition of the mutating types of music associated with rave culture (McRobbie 1995), the term rave has now largely been superseded by the label dance, in order to cover

the specific widening genre that includes, amongst others, 'house', 'happy hardcore', 'garage', 'techno', 'drum 'n' bass', and 'jungle music' (Measham *et al.* 1998).

Today 'house' or 'rave' is no longer the music and dance of the dis-empowered. However, whilst the audience for rave has become more diverse, some of the core values such as the notion of escape, hedonism, free self-expression, and, importantly, the idea of the community remain central to the experience. It is possibly this notion of community that has helped to sustain its existence. As one raver reflected in a nostalgic account of the early days in England:

> Raves emphasised the ecstatic acid house ideal: It was people who counted above everything. A rave was always about community, joining you to the four or five friends who made up your carload, to the ten or twenty cars that realised they were all heading the same way, to the hundreds of thousands of people who shared a dance beat . . . shared an experience of communion like no one had before.
>
> (Unsourced quote,
> *Ministry of Sound Magazine*, October 1998)

QUESTIONS AND METHOD

The following account is based on an analysis of one of the super-clubs located in the West Midlands in the UK. It is the product of many years involvement in the development and promotion of rave on the part of three brothers. All three have been heavily engaged in catering to the needs of the 'rave' generation from the outset and are now responsible for a branded empire which hosts venues in Britain, Cyprus and Ibiza, worth several million dollars per year.

The key questions driving this research were very simply, why do people go to rave clubs and what is the nature of the rave experience, from the perspective of the ravers themselves? Having gained an insight into the nature of the experience, our aim was to examine the findings in relation to contemporary theory. Of particular interest were the concepts of identity, sub-cultural communities, fragmentation and the creation of meaning through consumption experiences.

In order to illuminate these ruminations a two-stage methodology was employed. Observations were recorded manually through the use of memos (Glaser and Strauss 1967). These were taken at different stages of the evening,

at various locations (i.e. outside of the club, the club room and the chill out room) and for general descriptive purposes. They provided a source of field notes and were used to offer a sense of re-orientation during the analysis stage. In effect, this section is largely descriptive. It sets the scene and acts as the background for the behaviour which takes place within the confines of the club.

The second stage of the research utilized interview data in order to develop an account of the 'lived' experiences of the users themselves. The research employed phenomenology as a methodological framework to collect data, which allowed the informants to tell their own stories. These formed the basis of our interpretation of the experience in the dance club.

STAGE ONE: A PARTICIPANT OBSERVATION ANALYSIS

THE CLUB

Whilst there are numerous rave clubs in Britain which have more in common with more mainstream, hi-tech, sophisticated nightclubs, and are a far cry from the early warehouse scene, the organizers of the venue used in this research do not have a permanent base. Rather, they lease premises for the weekend, on a rolling basis, promoting the brand name rather than the physical club. At the time of writing, the raves were being held in a club located in a very dingy, industrialized part of the city, full of warehouses and factories, with few bars or restaurants. However, rather than deterring people from coming, this 'authenticity' only served to remind clubbers of the early days when the scene was fresh, exciting, and liberating. Moreover, the organizers have managed to achieve both notoriety and an image of exclusivity. In a recent newspaper poll, the doormen were voted the worst in the country, while at the same time the club (on the nights leased by the organizers) was voted the hardest to get into in Britain. This, however, was not considered bad publicity. On the contrary, it only served to increase the number of hopefuls trying to get in. On an average Saturday night, from around eight thirty onwards, there are queues of people, attracted from across the country, willing to wait in line for up to three hours. Indeed the physical location is of little importance. The venue has developed as a powerful brand over the years, attracting a loyal core of customers who are willing to travel to wherever the event is taking place. The following is taken from a memo describing the club.

RESEARCHER'S MEMO ON OBSERVATIONS
OF THE PROCESS

The club attracts a wide cross-section of people, ranging in age from around eighteen to forty. All are dressed well, the younger ones in clothes designed to make a statement and get them noticed. For example, swimwear, tight shorts, and even fancy dress, such as one man dressed as a French mime artist, another as a half-naked Satan, and still more wearing such accessories as 'bunny ears'. The older clubbers wear labels such as Patrick Cox footwear, and Vivienne Westwood dresses and shirts. The more outrageous ones vie for attention while waiting in the queue, juggling balls, chasing people with a fork (Satan), exposing very brief underwear/outfits, or blowing whistles. The whole thing creates a carnival atmosphere which appears to heighten the sense of anticipation of what is to come. It is also interesting to note that the club operates a three-queue system. The first queue is for people who are not sure if they will gain entry or not. This line is subject to the inspection of the 'fashion police' who patrol up and down selecting individuals on the basis of good looks or extreme fashion. These are then taken to the front and allowed entry. Others have to wait their turn and many are turned away when they reach the door. Loyalty disappears at this point as friends leave friends standing outside whilst they disappear into the club. The other two queues are for paying guests (queue two) and non-paying friends (queue three). There is an element of spectacle about the whole procedure. The queuing system alone is an act of theatre with performance, role play, and celebrity. The privileged few, the non-paying guests, are ushered through a central barrier, up the steps and into the club room, watched by a crowd who are unsure of their fate at the end of the line. Once inside the atmosphere changes. Clubbers are greeted by a tall transvestite who hugs them and sees them through into the club room. The first thing that strikes you as you walk in is the feeling of being hit by a blast of music, the volume so loud that you can feel the vibration through the floor. At one end of the club are two bars, one selling alcohol which was virtually empty, the other only water and high-energy drinks. There are few chairs and no tables. The whole focus is on the dance floor which occupies the majority of the space and is crammed with heaving bodies all frantically dancing, keeping time with the increasing speed of the repetitive rhythm of the music. Dotted around the dance floor are podiums upon which the more flamboyant dance, showing themselves off to the crowd. The room itself is dark, lit only by lasers and strobe lights which are activated by the beat of the music. The whole effect is hypnotic. Some people dance for hours, pausing only to drink water to avoid dehydration. Throughout the night the DJ works the audience, altering the music as the evening goes on, varying

the tempo from frenetic to a slower more laid-back beat as the evening draws to a close. Towards the end of the evening several people disappear to the chill-out room. Here the driving beat of house and rave are replaced by softer music. Low comfortable sofas and cushions are spread around the room, the lighting is dim and the overall ambience assists in the process of 'chilling out' ready for departure, either for home or for another venue.

THE EXPERIENCE AS A 'RITE OF PASSAGE'

Essentially, one might describe the process as an act of transition, from being an 'outsider' to becoming a member of an exclusive community. Many are willing to stand in line for hours and subject themselves to personal inspection and evaluation, only, in a number of cases, to be rejected. Those on the other hand who are selected, are made to feel special, different, individual, and worthy of notice. The threat of exclusion found on the 'outside' is replaced by a process of acceptance and inclusion, the successful completion of a 'rite of passage'. In order to provide a theoretical context it is possible to draw on the work of Turner and Turner (1978) with regard to the process of engagement and the ritualistic disengagement from the real world.

1. *Pre-liminal rites*: A separation from the ordinary world, entry into the world of play through dressing up and dropping the trappings of every-day life. A journey from home which involves rites of separation which correspond to a separation from reality. Such activities may include dressing to go out, planning the look, arranging to meet others, and deciding on the club.
2. *Liminal rites*: The welcome centre or entrance. Here the customer passes over the threshold into a 'womb' like state where there is a levelling or stripping of status. This relates closely to the process of getting to the club, queuing, anticipation, excitement, carnival, entering another world, and becoming a different person.
3. *Post-liminal rites*: An alternative or more liberating way of being socially connected and a way of being detached from social structure. In the dance club there is an emphasis on common experience and a common emotional bond encountered through dance and communal identity.

However, these are observations and it is recognized that the problem with observational understanding is its inability to open up the meaning of an individual's lived experience for the observing individual (Costelloe 1996). In isolation, observations do little to explain what is happening and why people continue to come. Therefore, having stated that the aim of the research was to

gain an insight into the nature of the experience from the perspective of the user, the second methodology employed is borrowed from Thompson's (1997) description of the phenomenological process.

RESEARCHING THE EXPERIENCE: A PHENOMENOLOGICAL APPROACH

The goal of phenomenology is to enlarge and deepen understanding of the range of immediate experiences (Spiegelberg 1982). Merleau-Ponty (1962: vii) suggests that the results of phenomenological enquiry should be 'a direct description of our experience without taking account of its psychological origin'. Phenomenology is a critical reflection upon conscious experience, rather than subconscious motivation, and is designed to uncover the essential invariant features of that experience (Jopling 1996). It has also been heralded as a critique of the positivist position which views social reality as a system without any respect for the grassroots of everyday interests (Srubar 1998). Accordingly, the aim of the researcher is to construct a model of the sector of the social world within which only those events and behaviours which are of interest to the problem under study take place (Costelloe 1996). With this in mind, only those individuals who regularly attended rave venues were considered for interview, a tool chosen because:

> . . . in social research the language of conversation, including that of the interview, remains one of the most important tools of social analysis, a means whereby insight is gained into everyday life, as well as the social and cultural dimensions of our own and other societies.
>
> (Bloch 1996: 323)

SAMPLE

Whilst most studies tend to concentrate on rave as a youth-centred phenomenon (McRobbie 1995; McRobbie and Thornton 1995), this is not necessarily the case. There are a significant number of individuals who have followed the development of the scene throughout its evolution in Britain. Moreover, many of the organizers and top DJs are in their forties, further reflecting the fragmented nature of this movement. We eventually managed to complete interviews with 23 informants. The sample included a cross-section of individuals in terms of age (range from 20 to 40) which is actually representative

Table 7.1
Profile of informants

Name	Age	Occupation
Jane	20	Student
Mark	20	Office worker
Ian	21	Builder
Sash	21	Model/promotional work
Jack	22	Travel clerk
Samantha	23	Shop worker
Toby	23	Disc jockey – rave and house
Sally	23	Shop worker
Michael	23	Computer programmer
Jo	24	Advertising agency-design
Stuart	26	Building-society manager
Veronica	26	Window dresser
Wayne	28	Furniture designer
Neil	30	Director of a computer firm
Stuart	34	Recent graduate
Debra	34	Teacher
Tracey	35	Green marketing executive
Alyson	35	Recruitment executive
Susan	37	Lecturer
Mark	37	Retail manager
James	38	DJ and promoter
Steven	40	Management consultant
Michael	40	Company director

of the clientele of many 'rave' clubs. Each interview was conducted in a private house, lasted between 40 and 60 minutes, and was tape recorded. Whilst there were difference in terms of lifestyles, occupations, responsibilities, other leisure activities, and everyday experiences, there was surprising similarity across all the informants' description of the rave experience. One factor that did stand out was that rave culture is primarily the domain of the 'unattached'. Whilst many were in relationships, none had children and consequently energies were focused on other priorities. Table 7.1 presents an overview of the informants who took part in the research.

INTERPRETATION OF FINDINGS

As a means of interpretation, Thompson (1997) in his analysis of consumer experiences, advocates part to whole analysis of participant accounts by proceeding through an interactive process of description, informants' stories

and theorizing. In order to illustrate the interpretive process, a description of one of the informants is presented next. The description relates to Sash, a regular on the dance and rave scene.

SASH'S STORY

Sash is twenty-one years old and has been on the club scene since she was sixteen. She lives with Toby, a DJ, who travels the country playing and mixing house and rave music. They have been together for about two years and regularly attend clubs. With regard to her work, she is a part-time model, but works primarily on promotions which include car shows, furniture exhibitions, and clothes shows. Sash offered a fairly typical account of her experiences. She was keen to talk, was lucid, and expressed herself without inhibition. Sash was born in Birmingham but has lived and worked inter-mittently in London. One recurring theme across all of the interviews was the ability to compartmentalize work and leisure, and in this Sash was no exception. Her working life and social life were perceived as two distinct and separate realms. When discussing the weekend, Sash described an almost ritualistic act of transition, from getting home, discarding the week's para-phernalia, and trying out a variety of looks until the right one was found. She discussed experimenting with different identities, which included sophisticated designer dresses (the vamp), micro minis and exposed under-wear (the flirt), or sporting beachwear (the serious raver). In contrast to what she normally wears in the week, her clothes and make-up are designed to attract attention and are minimalistic and overtly sexual. However, although attracting the attention of the opposite sex is important, meeting a partner is not. Consequently a large part of the experience could be described as narcissistic.

Once an image is found, the next stage is to arrange a meeting place with friends. This may be at a house or flat, or in one of the many 'feeder' bars. She described how sometimes, to set the mood, a tab of 'e', or the occasional line of cocaine might be taken before moving on to the club. In terms of the criteria for choosing a club, she has a hierarchy by which individual clubs are judged and ranked, according to: the difficulty of getting in; the status of having been there; the music that is played; the DJs that play at the club; dress codes; and international and national reputation.

INITIAL INTERPRETATION

Essentially, the experience appeared to be linked closely to issues of identity and self-expression. There was also a strong desire to be perceived as individual, having a 'look' whilst at the same time conforming to the norms of the group. In the rave scene, clothes are considered symbols, or badges of acceptance, and there are a series of behavioural codes which must be adhered to in order to maintain this acceptance. The appearance of 'being in control' is also important and consequently there is a search for release through means that do not involve the consumption of alcohol which takes away this control. The combination of the music, the energetic dancing, the energy and confidence-giving drugs, and flights into fantasy through the imagination, appear to heighten a sense of freedom and escape, and are contrasted with the anxieties and pressures of everyday life. This offers an alternative way of being, which is prolonged as long as possible. In essence, these themes summed up the core of the experience, and were found to recur in the stories of most of those interviewed. The following represents a theoretical explanation of the identified themes, beginning with the concept of identity.

IDENTITY AND NARCISSISTIC EXPRESSION

Within the field of consumer behaviour there is growing acceptance that people actively construct who they are, or want to be, from the symbolic resources that are available to them (Firat *et al.* 1995). A central theme emerging from the data was that of 'making a statement'. This was very much linked to the projection of a particular kind of image that was largely judged in terms of symbols such as clothes, knowing about the right kind of music, and generally having the 'look' to gain access and be accepted in the dance club. Kellner (1992: 174) suggests that, 'an affluent image culture . . . creates highly unstable identities while constantly providing new openings to restructure one's identity'. Thompson and Haytko (1997: 21) discuss the development of a sense of identity through fashion discourse in particular social settings, where the theme of "who I am' is constantly defined through perceived contrast to others'. Within the rave sub-culture, symbols such as smiley T-shirts, beachwear, whistles, dummies, and florescent paraphernalia (Redhead 1997) are all used to define membership.

In this context it is possible to draw on the work of Thornton (1996) who reworks Bourdieu's (1984) ideas of economic, social, and cultural capital. She introduced the term 'sub-cultural capital' with regard to club culture, by which she means that 'sub cultural capital confers status on its owner in the

eyes of the relevant beholder' (Thornton 1996: 11). Increasing one's sub-cultural capital or 'hipness' or 'coolness' is a prime motivator for people within this subculture and is indicative of the fragmentation of values concerning the criteria for judging acceptance in this context. Being 'in the know', using appropriate language, buying, creating or wearing the right clothes and buying, creating, listening, and dancing to the 'right sort of music', are all ways of increasing an individual's sub-cultural capital, a point reinforced by a number of informants.

> My clothes make a statement, they're about me, they say who I am. I would just die if I walked in and someone else was wearing the same thing.
>
> (Sash)

> If I were to describe me and my friends I would say that we are all very image conscious, and that usually comes down to clothes. We like nice things. I know if I wore a suit from Top Man [part of a High Street retail-ing chain] they would all take the piss. Everyone I know spends quite a bit on clothes and going to the right places . . . but we earn decent money so why not . . . for a start you wouldn't get into half the places if you weren't dressed right.
>
> (Mark)

Gabriel and Lang (1995: 73), drawing on Freud's (1921) theory of 'narcissism of minor differences', suggest that:

> Under the regime of the narcissism of minor differences, signs become essential differences and, therefore, essences. This is how small differences become big differences. Being able to read such differences is vital since these differences become sources of in-group solidarity and out-group hostility.

For example, in the following quotes, Veronica prioritizes the designer over the look, whereas for Sash 'the look' is all important, but for Mark it is all about getting into the club in the first place. Although these may appear minor differences for these people they are very important.

> Clothes are very much part of the culture. It's quite funny when you think about it, someone can walk in and you think what they are wearing is awful and then they tell you, oh I don't know it's Katherine Hammett and all of a sudden everyone loves it. It's like that.
>
> (Veronica)

A friend of mine got married not long ago. She went down to London to get her outfit, a dress with a feather boa. Everyone at the wedding wore black, and most of the conversation was about the clothes everyone had on, not the wedding or anything like that.

(Sash)

When we go to places like ******** it's a bit of a buzz. Half the fun is going in. We know the organizers so we're usually on the guest list if we phone up . . . it may sound like posing but it's great to be able to swan in, in front of all those people waiting in the queue not knowing if they'll get in or not.

(Mark)

However, there was also evidence that taken to the extreme, such narcissistic indulgence could result in a decline into dysfunctional behaviour or an over-obsession with appearance that has potentially damaging effects. This is illustrated in James' description of his friend's behaviour:

My God! I know one guy who is so image conscious that when his partner became pregnant he made her take laxatives and diet so she wouldn't look fat. He didn't want his friends to think he was seeing an overweight girl, can you imagine it? When the baby was born he bought it a Versace leather jacket. It cost him £500 and it had grown out of it in a month.

(James)

Such statements appear to support the dystopian view of a superficial and depthless society where the emphasis is on spectacle (Venkatesh 1992), and surface reality (Eco 1987; Jameson 1990). It might be argued that the dance scene exemplifies this, particularly with its emphasis on being beautiful and looking good – a form of individualistic self-obsessed narcissism which is legitimized in the context of the group. Maffesoli (1996: 77), for example, suggests that 'the cult of the body and other forms of appearance have value only in so much as they are part of a larger stage in which everyone is both actor and spectator'. This is the other side of the story, which challenges the idea that society is becoming more individualistic (Hall *et al.* 1994; Strauss 1997). What emerged from the data was that although there are clear signs of individualism, these behaviours are in fact socially grounded. What the club environment offers is a location for the creation of new social forms of interaction, or alternative communities, which although temporary, have the effect of anchoring the individual and provide meaning to their experiences.

THE EMERGENCE OF NEW COMMUNITIES

Maffesoli (1996) talks about the rise in what he terms 'neo-tribes' or the transitory group, which is neither fixed or permanent, but involves a constant back and forth movement between the tribe and the masses. Indeed it is this tribal affiliation which serves as the backdrop to the many contemporary movements we are witnessing today, especially where the development of new lifestyles based on acts of pure creation are concerned. Accordingly, these 'neo-tribes' may be 'effervescent, ascetic, oriented toward the past or the future; they have as their common characteristic on the one hand, a breaking with the commonly held wisdom and, on the other, an enhancing of the organic aspect of the social aggregation'(Maffesoli 1996: 96). These groups are held together by a certain ambience and a state of mind. Solidarity is expressed through lifestyles that favour appearance and form, and nowhere is this more evident than in the dance club or venue. According to Nixon (1992) identification involves an act of self-recognition in an image, a representation or form of address. Narcissistic identification is about the establishment of a monitoring relationship in the interplay of 'self ' and other. Langman (1992) continues the analysis by suggesting that identity is dependent upon the specifics of gender, parental socialization, values and practices. But it is also provisional and dependent upon class, subculture, and the general environment of the social group where selfhood is recognized and confirmed. Shields (1992) proposes that consumption spaces are spaces of sociality, where the status of the individual is encoded in favour of the group. They are places where personas are 'unfurled' and mutually adjusted. The performance orientation towards 'the other' in these sites of social centrality and sociality draws people together one by one, such that 'tribe-like but temporary groups and circles condense out of the homogeneity of the mass' (Shields 1992: 108). There was evidence to support this view in the findings of this research where the monitoring of identity was largely dependent on group approval and acceptance. Elliott and Wattanasuwan (1998: 133) propose that, 'the development of individual self identity is inseparable from the parallel development of collective social identity'. Jenkins (1996) calls this the 'internal-external dialectic of identification' and suggests that self-identity is validated by social interaction, or what Kellner (1992) refers to as 'mutual recognition'. For example, Thompson and Haytko (1997: 26) argue that 'fashion meanings can be used to foster a sense of standing out, or they can be used to forge a sense of affiliation with others and to foster a sense of belonging'. Club culture, music, dance and fashion help people to make sense of their world and their place in it. On reflection, the findings appear to support Maffesoli's (1996) argument that society, rather than becoming more and more individualistic, is in fact seeing a return to the concept of community. For example:

Going to a rave is like going to a massive party where everyone is on the same wavelength. Dancing kind of draws people together, not in any kind of sexual way, it's just like you're all sharing the same kind of feelings, you've got this one thing in common.

(Susan)

Once I'm in there it's just like a big family party atmosphere. I want to dance straight away . . . you can let your imagination go wild, be a different person, there's something exhilarating, dancing till you nearly drop.

(Neil)

You hear about the happy vibe and it's true . . . you go to a club and everyone is really solid . . . you're dancing away and the next thing you know you're talking to a complete stranger as if he's your best friend.

(Stuart)

Building on the work of Maffesoli (1996), Cova (1997) discusses how neo-tribal formation is aided by consumption practices. However, what links members of rave neo-tribes is not a formal code, as with the music based sub-cultures of the 1960s and 1970s, but rather 'shared emotions, styles of life, new moral beliefs, senses of injustice and consumption practices' (Cova 1997: 301). In this context, the shared emotion is not the result of verbal communication. Indeed there were accounts of clubbers going to a rave and not talking until they left. For example:

You don't go to a rave to talk, you don't need to. It's strange, but I can spend all night dancing, mingling with people, feeling close to them, sharing something without saying a word. The funny thing is that if I met many of these people away from the club scene, I wouldn't know what to say to them. I think what it is, is the whole thing, the music, the dancing, lifts you onto another plane where everyone feels the same, we're all equal.

(Alyson)

Jowers (1999: 387), in discussing the nature of music and its lived experience proposes:

within the deeper trajectory of electronic dance music an intensifying focus upon the sheer materiality of sound has appeared. Vocal sounds are pulverized to reveal what is always and necessarily elided in most

communication, the fact that we communicate by way of the properties of sound waves of varying frequency.

The dance club represents a hyper-real environment where communication is based on an understanding of codes and signals. Jowers (1999: 387) goes on to illustrate this suggesting that in the dance club:

> the voice recedes into the soundscape, morphing into signals towards noise, away from code. Fragments released from their moorings, become part of a strange inter-text, into which are read ever shifting meanings as these shards are repeated, appearing in ceaselessly altering combinations. Potential meanings proliferate.

Consequently, it is the shared consumption of music and an appreciation of its inherent semiotic meaning, and its ability to link individuals together, that not only validates the individual's self-identity but also helps to coalesce and create a neo-tribe. As indicated by Alyson in the previous quote, this juncture may only be temporary and transitory, where shared values exist only for the duration of the experience. The club setting provides many contemporary consumers with an environment which links them with others who share something that is mutually valued. However, whilst the group may provide the context for the expression of identity and communal bonding, the nature of the experience is also linked to other stimuli such as the laser light shows, the ingestion of drugs like ecstasy and cocaine and the nature of dance itself. These are the things that produce a common bond and a sense of affiliation. They also heighten the sense of being 'high' and escaping from reality.

THE NEED TO ESCAPE – WORKING WEEKS, RAVE WEEKENDS

According to Zukin (1991), the features and experiences of leisure sites include spatial practices of displacement and travel to liminal zones. These zones are thresholds of controlled and legitimate breaks from the routines of everyday, 'proper' behaviour. Shields (1992) further proposes that such zones become quests, and searches for, alternative social arrangements. Yalom (1980) suggests that individuals will strive to give their lives purpose by engaging in specific behaviours which will provide a sense of autonomy. This is achieved through a mix of behaviours and signals. In the context of the dance club, there is a contradiction between overt sexuality and child-like innocence. For example, both men and women wear very little, partly because of the heat

generated through dancing but also to show off their bodies. Nonetheless, the sexuality of the clothes is counteracted by the accompanying child-like paraphernalia associated with rave, such as whistle blowing and dummy sucking. According to McRobbie (1994: 169):

> In rave and the club culture which it often overlaps, girls are highly sexual in their dress. . . . The tension in rave for girls comes, it seems, from remaining in control, and at the same time losing themselves in dance and music. Abandonment in dance must now, post AIDS, be balanced by caution and the exercise of control in sex.

This emphasis on child-like innocence and a refusal to grow up are significant cultural values (Redhead 1993). It is further supportive of Firat and Venkatesh's (1995) argument that the 'postmodern subject is willing to live with the paradoxes that may arise from the fragmentation, the free juxtaposition of objects (therefore even of opposites) in the bricolage' (pp. 253–54). Referring to Gergen (1991) they go on to suggest that 'postmodernism permits us to conceive of the individual as engaging in non linearities of thought and practice, in improbable behaviours, contingencies and discontinuities' (p. 255). For many the experience was one of fantasy and escape, of dressing up and make-believe and quite often a contradictory need to stay in control, whilst at the same time wanting to disengage from reality. This of course might be read as a conscious or unconscious reaction to the alienating condition of postmodernity.

> You have enough hassle all week at work. What you want to do at the weekend is break free of all that, go a bit mad, get it all out of your system, dancing is like a release, you can lose yourself . . . On Friday the fun starts early. Usually a group of us will meet up, sometimes at my flat, or someone else's. We might drop an e, or occasionally a line of Charlie [cocaine] just to put us in the mood.
>
> (Sash, on losing control)

> I do drink, but not at a club. People go to dance not to prop up the bar . . . it's a different experience . . . you try dancing for an hour to house, jungle or rave, you get high on that alone . . . With e or coke you can do it, you're not falling around drunk. You're in control, you can dance all night if you want to.
>
> (Sash, on staying in control)

> I've always had the ability to 'make a mess of myself' yet I take my responsibilities seriously. I've rarely been the first to bed. I've never lost

control clubbing. I tend not to lose control completely in any aspect of my life. Clubbing is the same. I don't do drugs, and rarely drink much. I know if I go clubbing I can escape for three hours or so. But I'm aware that I'm 'on duty' from 8.00 am the next day. I can cope with sleep deprivation more easily than heavy hangovers.

(Wayne)

I don't drink at clubs. If I have two vodka and red bulls in four hours that's my usual limit. You adapt to different situations. If I go to the pub I will drink lager usually, if I go to restaurant I'll drink wine, but if you were drunk at a rave it just wouldn't work, you'd be on a different wave length to everyone else, so what's the point.

(Mark)

The unstated code of alcohol avoidance, and consequently 'beer monsters' (young men who make it their mission to get as drunk and loud as possible at the weekend) helps to secure the atmosphere by combating the heightened aggression normally associated with drinking (McRobbie 1995; Hesmond-halgh 1998; Measham *et al.* 1998). For example, one informant, Steven, a forty-year-old management consultant who has recently completed a Master's degree, described how he would experience stress through overwork. In order to relieve it he would go to a rave, dance solidly for four hours, completely abandon himself to the music and leave feeling exhilarated. The dance club is a hyper-real environment where individuals can escape and get high on dancing. In effect people feel safe. The same informant talked about how he would often go to a club alone, something that would have attracted attention in the popular discotheques of the 1970s and 1980s. In dance clubs, however, the fact that someone might just want to dance is considered perfectly normal. To quote:

You don't get gangs of blokes propping up the bar looking at you as though you're some kind of deviant. Everyone's just there to have a good time.

(Steven)

However, not all were able to fully escape without the use of some form of stimulants. In this context, alcohol is the equivalent of losing control, so the 'high' is experienced through dance and in some cases through the use of drugs which enhance confidence and boost energy without feelings of intoxication. At raves, the drugs of choice are ecstasy or cocaine. These are associated with a 'feel good' factor, whilst avoiding any mind-altering

experiences such as those associated with LSD, or the introversion and introspective properties of cannabis.

> Now and again I might do a line of coke before I go out, but that doesn't really effect you, it just wakes you up . . . it tells me the weekend has arrived. At the moment there's a lot going on that I want to forget about . . . at work they're talking about redundancy so there's that hassle . . . of course you've got to think about the mortgage and bills, but you need to get away from all that stuff, forget it for a while and switch off. Rave is certainly one way of doing that. You can be a different person . . . you can get on a real high, feel really loved up, you want to kiss everyone and dance for hours.
>
> (Alyson)

According to Mick (1996), as consumer research becomes more societal in nature, an important area to pursue is the negative or 'dark' side of consumer behaviour. It is well documented that the nature of the experience and the encompassing atmosphere provide a context for drug taking and escapism, and have been associated with the 'happy vibe' (Measham *et al.* 1998). Singer (1993) suggests that cocaine users employ a form of self-medication against a depressed mood and usually have large discrepancies between actual and ideal self experiences. Nonetheless, in relation to dance, drug taking is seen as context specific and often divorced from the routine activities of everyday life:

> I don't take drugs in the week, in fact quite the opposite. I go to the gym nearly every day, I'll go running in the morning and cycling whenever I get the chance. No, it's a social thing . . . you take a line of Charlie and you don't get high, you just feel totally confident, you know you can't say the wrong thing, and nothing fazes you. It's not like drink where you think you're really amusing, but really you sound like a gibbering idiot.
>
> (James)

However, in nearly all cases there were clear demarcation lines in terms of the perceptions of those who do use drugs habitually:

> If you're that kind of person you can like it too much. Imagine going to work and feeling on top form, no one can get the better of you. That's when it becomes hard to give it up, when you have to face the world as you are. I've seen it happen to people. They become dependent and end up

wrecked. That's not for me. I like a good time but I know when to call it a day, it's strictly for the weekends.

(James)

In the context of the dance club, what the experience offers is a temporary form of escape, a feeling of being 'loved up' and a setting for artificial and fleeting affection through communal identification. In effect there is a dis-engagement from everyday life and a segregation of activities. The dance club might be described as a hyper-real environment where individuals can escape and get high on dancing and the atmosphere, aided in some cases by the use of stimulants which allow the user to remain in control, whilst at the same time losing any inhibitions. However, much of the experience takes place in the imagination and is governed by the beat of the music and a sense of engagement with it.

ENGAGEMENT

According to Campbell (1987) modern hedonism is characterized by a shift in concern from emotions to sensations where what is sought is more often to do with the imagination.

If you go to a club you don't go for the conversation, there's not much chance of that anyway. You get into the music and although you're with other people, dancing is very personal, it's about what's in your own head . . . The music is just a blend of rhythms, it's all a variation on a theme, but it's part of the experience . . . you don't need to worry about too many changes, or words, it just gets faster or slower.

(Sash)

In clubs the beat of the music is repetitive and hypnotic, devoid of lyrics which may require thought and analysis, or according to Redhead (1993) a form of mindless indulgence. The emphasis is on a feeling of well-being, in a climate where everyone is experiencing the same emotions.

Why do I like it? I love the energy of the music. I'm into aerobic exercise, running and so on. I get a kick out the physical experience, and I use it to mentally chill out and subconsciously 'problem solve'. I can lose myself in the music and atmosphere. I love the vibe, friendly . . . camaraderie, no edge/agenda, just people doing their own thing and enjoying it.

(Steven)

However, whilst the music, on first analysis, may appear depthless, and the emphasis on mindlessness or 'not having to think', it is far from void of meaning. According to Hesmondhalgh (1998), one of the key features of dance music as opposed to many other sectors of the music industry, is its lack of a star system. This allows for concentration on the music itself, rather than on personalities. He suggests that this reflects a lack of interest in rock notions of authenticity, sincerity and integrity, and a preference for other values such as immediacy, sensuality, and pleasure in secrecy and obscurity. However, this view is open to serious challenge. Within the rave scene the DJs are the new stars, commanding excessive fees for appearing in clubs and bringing with them loyal fans who can describe in great detail the various styles and mixing methods of the top performers. Moreover, the music itself is splintered into various genres, which become the trademark of the more accomplished DJs, each of whom attract a distinct following.

> You really get involved in the whole thing . . . people who don't know about dance music think it's all the same, just one drawn-out beat, but it isn't . . . there are ways of mixing the music and each individual DJ has his own style and identity.
>
> (Sash)

> I do recognize the different music styles, although I didn't to begin with. . . . I'll travel if there's a particular DJ playing in a club in London or Manchester. I'm not fanatical, some people follow their favourite DJ all over the place, they get hooked on a particular style, and let's face it, it's the DJs who are the kings in those sort of clubs, not the artists, they can work the audience, create the atmosphere without saying a word.
>
> (Mark)

> Clubbing is pretty conservative. My partner and I have gone to a couple of ecstatic dance sessions. Here dance style is more freeform . . . there is no dress code or music code. Personal values set the tone of behaviour. This is different to 'clubbing'. With the latter one might be able to participate as an individual, but there are some pretty constraining protocols, which I like. As the past twelve months have evolved, I've become more choosy in what I term good dance music. I've formed opinions on the various DJs, got more into the fashion around dance. I now use a kindred clubbing soul to advise on club-orientated design treatments for my web sites, corporate identity etc. I'd love to dj. A pal and I agreed djing as an objective for me this year.
>
> (Steven)

In 1989, 'house' was the all encompassing term for rave music. Nevertheless, in the years that followed, not only has 'house' music's primacy been challenged by rival terms such as 'techno' and 'hardcore', but 'house' itself has started to splinter into an array of pre-fixes – 'tribal', 'progressive', 'handbag' and so forth (Thornton 1996). Each of these different strata of music has spawned slightly new attitudes, clothing styles, and forms of expression. In effect they have become sub-cultures of the larger all-encompassing club culture which further reinforces the concept of fragmentation as noted by Bennett (2000: 75),

> Contemporary urban dance music now includes forms such as techno, garage, ambient, and jungle, in addition to house which has itself become fragmented, including deep house, piano house, hippy house and hard house.

Garage music, for example, harks back to the original sounds of Detroit, with its laid-back snare-driven rhythm laid over diva vocals. It requires a cooler, less energetic stance and is still the sound of the trendy wine bars which favour people interested in doing little other than standing by the bar drinking, talking, and generally trying to look good. Garage attracts upwardly mobile 'mature' white clubbers who revile club culture as juvenile (Strongman 1999). 'Hardhouse', on the other hand, a style more related to the acid house of ten years ago, is heavily drum oriented, with synthy breakdowns and build-ups. This is the style favoured by so many of the super-clubs. Consequently, the degree to which we can describe the musical experience as mindless has to be questioned. Mindlessness was counteracted by descriptions of total inner absorption congruent with Csikszentmihalyi's (1992) account of flow. This concerns conscious effort and the direction of psychic energy to produce a feeling of well-being. A flow experience involves complete immersion in an activity and demands real involvement. According to Campbell (1987: 60), 'to search for pleasure is to expose oneself to certain stimuli in the hope that they will trigger a desired response'. Once this response was achieved, the emphasis moved to maintaining it for as long as possible.

PROLONGED HEDONISM

The idea of prolonging the experience is a legacy of the early parties which were renowned for continuing through the night and into the next day. As McRobbie (1994: 171) remarks:

one of the attractions of rave is that, unlike the concert or 'gig' it goes on, it doesn't stop. This hyper-reality of pleasure, this extension of media produces a new social state, a new relationship with the body, the pleasures of music and dance.

Whilst most clubs close their doors at approximately 2:00 a.m., the majority of the informants described a reluctance to go home, a desire to continue the experience, and to forget about the problems of 'the real world'.

After the club we will normally go back to someone's house or flat . . . we've been known to stay up all night, the next day, and then go out again the following night.

(Jack)

It's like you don't want it to end. We will always find somewhere to go. My place usually. We went through a phase of going to a club, going back to someone's house or flat and then heading into town to a pub on the outskirts of the market that opens at 7.00am for the market traders. We didn't go there to drink, just to be somewhere with each other. God knows what they must have made of us, all dressed up and hyper from the night before.

(Susan)

When I go out I never want to go home, I like the party to continue. Usually someone will know of something going on afterwards . . . I remember once not going to bed for three days.

(Michael)

One of the best nights I have ever had was last New Year's Eve. The organizers of '*******' had the whole night sorted. Everyone had tickets to go to their bar in the city centre. This stayed open until about eleven o'clock. After that buses were laid on to take us to the club where we saw the New Year in. That was absolutely amazing. The whole place was completely packed, everyone was totally loved up, dripping in sweat from dancing, hugging, and kissing each other at midnight, just one great communal vibe. I can't quite describe the feeling. I mean they talk about the happy vibe but I suppose that's basically what it is, you're dancing around with this great big smile on your face and you want it to go on for ever. Anyway, at 3:00 am we all left the club and got on the coaches for the opening night of their [the organizers] club in Leicester [a city

approximately fifty miles away]. Everyone was hyped up and the driver even had the music blasting out of the speakers on the coach, keeping everyone in the mood. When we got there the club was in full swing, there were some really top DJs so we just blended in, everyone dancing like lunatics. It went on until midday the next day when the buses picked us up to go back home. Some people were still buzzing, others looked like zombies, but I don't think anyone wanted it to end.

(Samantha)

Moody (1998) talks about the 'weekender' where the clubber returns to boring, repetitive, low-paid, low-prestige, no-future jobs. However, whilst the concept of the 'weekender' is generally true, the assertion that clubbers are escaping from 'no hope' lives bears little relation to our research. Our findings show that many of those interviewed were professionals or involved in occupations which carried responsibilities. Consequently, for most it was the opposite, a need to escape from the pressures of everyday life and engage in experiences that are distinct and separate from routine; a reaction against Gergen's experience of multiphrenia, or personal saturation. . . . The immersion of self in this hyper-real but secure environment contrasts sharply with the pressures often faced in everyday life and consequently there is a desire to extend the experience for as long as possible. However, ultimately it is an artificial release which offers only a short-term solution and the implications of this may result in greater disaffection, as summed up by Stuart who has the last word:

Sleep was an alien concept to me at the weekend. I mean I'd be e'd out of my head, totally loved up, so there was no way I'd want it to end . . . I just wanted it to carry on . . . however, when you come down, you come down with a bang. On Monday morning the depression would hit and you think you have a whole week of work and real-life problems to face before you can do it again. But I've made a decision that it's got to stop, I know that it's not quite right, not quite healthy.

(Stuart)

CONCLUSION

The aim of this research was to gain an insight into the experience of 'rave', a phenomenon that has existed in Britain for over a decade. The findings suggest that this experience is closely linked to issues of identity, the emergence of new communities, escape, engagement, and prolonged hedonism. The

literature suggests that the postmodern individual is characterized by identity confusion and a sense of rootlessness brought about by the demise of traditional notions of authority and community. However, while there were clear signs of alienation, congruent with the 'dystopian' view of the postmodern consumer, evident in the desire to escape from reality and prolong the experience, there was also evidence to support the affirmative or liberatory position of the postmodern consumer, illustrating that the two sides of the argument actually co-exist side by side. Consequently, rather than succumbing to feelings of isolation and anxiety, there was an active quest for alternative social arrangements and new communities based around common bonds and experiences. On face value it might look as if rave is merely an extension of the hippy movement with its emphasis on community and shared behaviours. However, our findings support Markus and Nurius' (1986) proposition that we have multiple selves and identities. The fragmentation and compartmentalization of working weeks, rave weekends is one example of this whereby the responsible worker role, complete with the pressures of everyday life, is abandoned at the weekend in favour of the self-expressive hedonist. This is not only a mental state but a physical manifestation of what might be termed an 'alter personality' reflected in the body practices of the individual. The suit is replaced with shorts, lycra or swimwear, the early to bed early to rise rule becomes a code of not sleeping, and the abstinence of stimulants, the emphasis on health and fitness and hard work at the gym, gives way to the consumption of energy- and confidence-boosting drugs. This behaviour supports the notion that 'in this world of shifting images there is no single project, or no one lifestyle, no sense of being to which the individual needs to commit' (Firat and Venkatesh 1995: 253).

The fragmentation of this scene is further reflected in the music into ever more specific genres and the emergence of sub-cultures within sub-cultures each with their own symbols, dance, and identities. Furthermore these identities are socially grounded. Virtually all informants described not only an experiential separation from the routines of the week, but also a social segregation whereby there was little integration or social interaction between working colleagues and weekend friends. On the contrary, these people often only come together at the weekend, having little in common outside of the venue. They congregate to engage in a collective experience, to form a temporary community, which disperses after the experience is over. The notion of community has always been a central feature of rave, but unlike earlier subcultures it is not based on a lifestyle commitment. It might be viewed as part of the liberating force of postmodern fragmentation as described by Firat and Venkatesh (1995: 253) which frees the individual from 'one sense of experience of being'. It is part of the acceptance of paradoxes where no one

perspective is privileged and where the 'juxtaposition of contradictory emotions and cognitions regarding perspectives, commitment, ideas and things in general' are part of the emancipatory condition of postmodern fragmentation.

SOME TENTATIVE AREAS FOR FUTURE RESEARCH

By confronting the 'speculative approach' (Shields 1992) adopted by post-modern cultural theorists with empirical data of lived experience, we suggest that some key themes emerge that require further consideration.

THE SELF AND THE BODY

Although there has recently been a renewed interest in the role of embodied self in the sociology of consumption (e.g. Featherstone *et al.* 1992; Falk 1994) this has rarely been supported by empirical data. Ironically, one of the few works which connects what people actually do with their bodies with cultural theory is Mauss (1979/1936), who more than half a century ago showed that even the fundamental act of walking was influenced by nationality, gender, and age. As Shields (1992) points out from a theoretical stance, the body is never exposed and without an identity. The individuals in this study demonstrate consciousness and agency in relation to their utilization of the body to structure and communicate self-identity in their consumption of popular culture.

LIVED EXPERIENCE AND MATERIALITY

A critical distinction between lived experience and mediated experience as influences on the project of the self has been made by Thompson (1988), who following the phenomenological tradition, characterizes lived everyday experience as immediate, continuous, and pre-reflexive. Although postmodern perspectives privilege mediated (hyper-real) experience over the mundane quotidian, as Elliott and Wattanasuwan (1998) point out, signification through the media is likely to be much less potent than signification through actual behavioural experience. There is considerable empirical evidence that attitudes formed through direct experience are stronger, more accessible, held more confidently and are more predictive of behaviour than those derived from mediated experience. Smith (1994) argues that perhaps the 'postmodern

perils of selfhood' apply only to the 'middle-class life world' inhabited by academics and philosophers and that 'it is essential to remember that for the great majority of people, the existential perils that trouble the elite are eclipsed by real perils of survival and damage control'. The individuals in this study evince no signs of being overcome by the mediated aspects of the dance/rave experience; rather they are grounded in the materiality of the moment, enhanced by their practices of the body. A consumer act of creative consumption that would benefit from further research.

NOTE

1 This chapter is a reprint of a journal paper which appeared in *Consumption, Markets and Culture*, 2002, Vol. 5 (4), pp. 261–84.

Chapter

8

GENERATING AESTHETIC EXPERIENCES FROM ORDINARY ACTIVITY

New Technology and the Museum Experience

Dirk vom Lehn

The mark of our time is its revulsion against imposed patterns.

(McLuhan 2001: 6)

Museums, galleries, and science centres are experiential environments. They provide people with resources to have memorable experiences. These resources include works of art like paintings and sculptures as well as hands-on and computer-based interactives and highly advanced installations. It is largely assumed that these resources form the basis for the 'museum experience' (Falk and Dierking 1992). Research in this area often considers the museum experience as being a response to a prearranged setup of objects and information resources. It is designed to provide managers, curators, and designers with information to enhance the effectiveness of exhibits in attracting and holding people's attention and in communicating to them. In recent years, this information has been used to inform the development and deployment of new technology designed to influence and enhance people's experience of exhibits and exhibitions.

Curiously maybe, museum marketing research often focuses its efforts on understanding the socio-demographic structure of the museum audience and on people's reported museum experience whilst ignoring 'the point of experience' (vom Lehn 2006), that is the actual situation in which people encounter, examine, and make sense of exhibits. This area of research has largely been left to the educational and learning sciences although it would seem that marketing can make substantial and conceptual contributions to the understanding of people's experience of exhibitions. Whilst people may visit museums to learn from exhibits they also come for many other reasons than to have learning experiences. With its interest in consumer behaviour,

marketing research can provide research methods as well as conceptual distinctions derived from studies in retail settings and other areas to inform the design of museums and research on visitor behaviour. Experiential marketing, with its interest in the creation of memorable and extraordinary experiences, could offer museum managers and designers insights from experiential shopping and entertainment environments. Yet, save for a few exceptions (Goulding 1999a), these avenues have rarely been explored.

This chapter attempts to link recent developments in visitor research, exhibition design and marketing research. It uses video-recordings of conduct and interaction in museums to explore how visitors orient to, use, and make sense of exhibits and interpretation resources provided by museums. The analysis particularly focuses on how the experience of exhibits is produced in social interaction between visitors. It examines how people embed interpretation resources and systems like conventional text, Personal Digital Assistants, information kiosks, and more advanced sensor-based systems in their interaction at exhibits. The data have been gathered in various museums in the UK.

MUSEUM VISITORS AND MUSEUM EXPERIENCE

Marketing research has shown relatively little interest in people's experience of museums. Only fairly recently have arts and museum marketing emerged as distinct fields of research that investigate the relationship between cultural institutions like museums and their audience. Studies differentiate visitors and non-visitors by applying concepts like social structure and lifestyle (Kirchberg 1996, 1999; Slater 2007) and by investigating the relationship between museums and audiences with specialized interests like tennis and rock music (Kellett 2007; O'Reilly 2007). Marketing research, however, often stops at the museum door and rarely examines the experience of exhibits and exhibitions. The little research that is concerned with people's museum experience is largely based on interviews (Goulding 1999a, 2001) and neglects the study of visitors' action and interaction on the museum floor.

Studies of visitor behaviour have largely been left to evaluators and museum consultants. These studies primarily measure people's behavioural and cognitive response to exhibits. They use quantitative measures or indices to assess the effectiveness of exhibits in attracting and holding people's attention and in communicating information to them (Shettel 1968, 2001; Serrell 1998). In recent years, visitor research has increasingly pointed to the importance of social interaction and talk for people's experience and understanding of exhibits. It suggests that people's learning from exhibits largely

arises in and is 'scaffolded' by their interaction with others (Leinhardt *et al.* 2002; Paris 2002; Leinhardt and Knutson 2004). They also have begun to explore the impact of computer systems on people's experience of exhibitions. They argue that computer systems increase the 'attraction' and 'holding' power of exhibits and contribute to people's learning from museums (Shettel 1976; Screven 1976; Serrell 1992, 1998; Schulze 2001; Yalowitz and Bronnenkant 2009). The focus on behavioural and cognitive aspects of the museum experience has informed experiments with the deployment of novel systems to enhance people's experience. One important example in this regard is the deployment of 'video-tracing' systems in science and art museums by Stevens and colleagues. The 'video-traces' are shown to visitors in a video-booth to encourage them to revisit and comment on their experience of the exhibit. The system has been quite successful not only in engaging people with exhibits but also in encouraging people to reflect on their experience of exhibits in interaction and discussion with others (Stevens and Hall 1997; Stevens and Toro-Martell 2003).

Over the past few years, a small body of video-based ethnographies has arisen that explores people's conduct and interaction in museums. These studies investigate how social interaction influences the ways in which people use and make sense of exhibits and interpretation resources. Whilst some of these studies are primarily interested in the content of visitors' talk at exhibits (Leinhardt *et al.* 2002; Paris 2002; Leinhardt and Knutson 2004), a growing body of research explores how people examine exhibits like works of art, hands-on interactives or funny mirrors to create experiences for each other (Katz 1996; Hemmings *et al.* 1997; Heath and vom Lehn 2004; vom Lehn 2006). In this chapter I wish to contribute to this body of work and complement ongoing research in museum marketing, cultural consumption, and visitor research by focusing on the ways in which interpretation resources feature in their collaborative examination of exhibits. Before I turn to the analysis of a few video fragments I will briefly discuss the method of data collection and analysis.

DATA COLLECTION AND ANALYSIS

In marketing and consumer research there is a longstanding tradition of using interpretative methods to study consumer behaviour and the shopping experience (Goulding 1999b; Beckmann and Elliot 2000; Carson *et al.* 2001). It also increasingly deploys videography and other forms of video-analysis to study people's behaviour at the point of sale (Belk *et al.* 1988; Belk *et al.* 1989; O'Guinn and Belk 1989; Underhill 1999; O'Reilly and Larsen 2005). They

reveal the potential of video-recordings as a technique to understand people's conduct on the shop floor and unpack the activities that constitute shopping, such as walking through shopping aisles, glancing at products, inspecting objects, looking back and forth, and so on. By subjecting video-data of people's conduct to scrutiny, the researcher can unravel these packages of activities and uncover how the design and layout of shops may influence people's behaviour at the 'point of sale' (Phillips and Bradshaw 1993).

This chapter contributes to this body of research by using video-recordings for the study of cultural consumption in museums. It analyses video-taped fragments gathered in science centres, museums, and galleries in London and elsewhere in the UK. The recordings have been produced as part of a small programme of research concerned with new technology in museums. For the purpose of data collection conventional stationary camcorders were set up on tripods near the exhibits but in a way that people were not drawn to them. The researcher did not stand behind the camera but observed the events in the galleries, took field notes, drew sketches of the exhibition, and gathered other material such as the content of exhibit labels.

Altogether the body of data comprises approximately 600 hours of video-data and numerous days of fieldwork. It involves several hundred visitors including people of different age groups, gender and educational background, individuals as well as pairs, groups and families and people with various degrees of technical knowledge and understanding. The analysis employs qualitative social scientific methods including ethnography coupled with a detailed analysis of the video-data (Silverman 1997; Heath *et al.* 2009). It uses an analytic and methodological framework developed in Ethnomethodology (Garfinkel 1967) and Conversation Analysis (Sacks 1992). This framework is designed to help reveal the social and sequential organization of people's vocal, bodily and material action. It draws attention to the situated and interactional production of the sense and meaning of objects and artefacts. Whilst in the past the analysis of video-data has primarily focused on inter-action and collaboration at the workplace (Heath and Luff 2000; Luff *et al.* 2000), more recently it has begun to explore conduct and interaction in public places, auctions, and museums (Hemmings *et al.* 1997; Katz 1999; Hemmings *et al.* 2000; vom Lehn *et al.* 2001; Heath and Luff 2007; Llewellyn and Burrow 2008).

Video-based studies of conduct and interaction in museums have begun to investigate how people look at, examine, and make sense of exhibits, including paintings and sculptures and mechanical hands-on interactives as well as computer exhibits and novel, computer-based information systems (Meisner *et al.* 2007; Heath and vom Lehn 2008). The analysis principally is concerned with visitors' conduct and interaction at exhibits, including their talk, visual

and tactile actions. It draws on the growing body of research concerned with the social and interactional organization of human conduct. Its analytic attention is with the resources, the practices, and the reasoning that participants rely on in the production of social actions and activities and in making sense of the conduct of others. The analysis proceeds 'case-by-case' and involves the transcription of participants' talk and bodily action and the detailed examination of the interactional character of particular actions and activities. By comparing and contrasting actions and activities between various fragments, the analysis identifies patterns of conduct and interaction (Heath *et al.* 2009; vom Lehn 2010).

REVEALING EXHIBIT FEATURES

Studies of visitor behaviour often consider 'the museum experience' as consisting 'of a series of encounters with individual exhibits' and ignore the social and contingent organization of museum visiting (Lawrence 1993: 121). They are primarily concerned with the 'learning outcome' of the encounter with an exhibit whilst ignoring the actions and activities through which the experience of an exhibit is produced. The little research that is concerned with social interaction and talk principally focuses on the relationship between the content of talk and exhibits whilst ignoring the circumstances in which talk and interaction arise at exhibits. It considers exhibits and the material environment as external and independent from people's action and interaction. And it suggests that exhibits are environmental factors stimulating actions that provide the basis for cognitive development and learning.

Video-based research in exhibitions, however, argues that the relationship between exhibits and action is far more complex and dynamic than can be uncovered by conventional methods used in visitor research. It suggests that people systematically embed aspects of exhibits in the social organization of their actions. For example (see figure 8.1 overleaf), Anne and Joseph have arrived at a large glass-tank in the entrance area of the 'Challenge of Materials' gallery at London's Science Museum. The exhibit is designed to introduce visitors to the notion that 'materials' are not only solids, such as fabrics, but also liquids and gases. Four pillars equipped with buttons stand around the tank; by pressing a button air and fluids move within cones and pipes within the tank.

The pair look at different parts of the tank when Anne notices the writing along the glass surface. She leans over and reads the text aloud, 'can be solid liquid or gaseous . . . babyoil water and air'. As Anne voices the word 'water' she lifts her body up and turns to her companion while she points with her

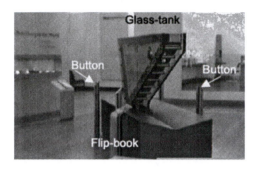

Figure 8.1
Glass-tank at 'Challenge of Materials' gallery

right hand to the corresponding words printed onto the tank (line 3 – 4, figure 8.2, p. 110). Her utterance coupled with the bodily orientation and gesture displays the progressive discovery of the text printed on the tank. Her bodily and visual turn to the left occasions Joseph who has observed his partner's actions on the tank to turn to the exhibit and a moment later voice the noticing of an object in the tank that looks like 'mercury' (line 6 – 8). The sequence through which the two participants progressively notice and reveal for each other features of the exhibit arises after Anne and Joseph have looked at the tank for a short while. Anne walks from the left to the right alongside of the tank and reads aloud 'babyoil water and air' followed by two gestures at different locations on the tank, 'there there' (line 1). Her discovery and reading of the text encourage Joseph to voice his discovery of bubbles that look like 'quicksilver' and another object that might be 'babyoil' (line 2). His uncertainty about the nature of the liquid inside the tank encourages Anne to return to the text printed on the glass-tank. She reads it out to obtain and provide information that might be helpful to attend to Joseph's question.

Exhibit features are noticed and experienced in and through social interaction. As participants examine exhibits they use visual and bodily actions coupled with talk to share their experience of exhibits with others (vom Lehn 2006). Thereby, participants draw on material and information resources they find in the environment. For example, Anne and Joseph use the material and informal resources provided by the museum to explore the exhibit. What they look at, for how long and how they see it is not defined or even prefigured by the museum managers and designers but it contingently emerges as the pair act and interact at, and around, the exhibit. The couple approach the tank without having read the small booklet placed on a stand nearby and inspect and notice some of its features as they glance across it. They use the information printed on the tank as well as knowledge about the properties of materials to support their examination of the exhibit. Anne's reading of the text as well as Joseph's description of the silvery bubbles rising up a set of thin pipes as 'mercury' informs the participants looking at the different aspects of

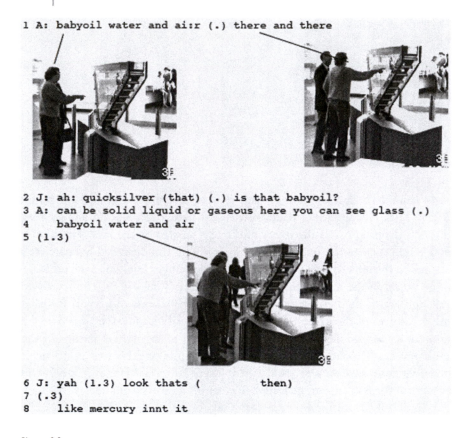

```
1 A: babyoil water and ai:r (.) there and there

2 J: ah: quicksilver (that) (.) is that babyoil?
3 A: can be solid liquid or gaseous here you can see glass (.)
4    babyoil water and air
5 (1.3)

6 J: yah (1.3) look thats (         then)
7 (.3)
8    like mercury innt it
```

Figure 8.2
Joseph and Anne at glass-tank ('Challenge of Materials')

the tank. Features of the exhibit depicted in the booklet, such as the function of the pillars equipped with buttons standing around the tank as well as the fact that the silvery bubbles are not mercury, remain unnoticed.

ENHANCING INTERPRETATION

We can begin to see the dynamics and complexity of the relationship between the design and production of exhibitions and their consumption by people who encounter and examine them in situations that contingently emerge and are not planned for by museum managers and curators. Museum managers and designers are often surprised and disappointed to learn about the idiosyncratic ways in which visitors examine and make sense of exhibits; visitors being guided by their personal needs, associations, biases, and fantasies rather than

by institutional recommendations (Baker 1998). New technology like mobile devices and stationary touch-screen systems is being deployed to address some of these issues. It is hoped these devices and systems will draw and hold visitors' attention with particular exhibit features and communicate curatorial information to them (Bloom and Mintz 1992; Thomas and Mintz 1998).

In recent years, museums have begun to experiment with Personal Digital Assistants (PDAs) and mobile phones as interpretation devices (Exploratorium 2001; Phipps, Rowe, and Cone 2008; Wilson 2004). These devices are personal technologies designed for the use and information retrieval by individuals. Information is delivered through a small screen and one- or two-eared headphones making the sharing of information difficult. People, however, often visit and explore museums with companions. For example:

> Mia and Hans, both from the Netherlands, walk together through a contemporary art exhibition. They both use a PDA and wear two-eared headphones. As they progress through the gallery they find it increasingly difficult to talk. Hans removes his headset and discontinues the use of the PDA while following his partner through the exhibition. As they arrive at a text-panel Mia stops the device that delivers information about the piece and discusses the content of the text-panel with Hans. A few moments later they jointly move on. Later in their visit Mia uses the information she obtains from the device to talk with her friend by providing him with snippets of information she has just heard over the headphones. She not only voices what she hears but translates it into Dutch for him.

The design of PDAs, their small, reflective screens and the need for headphones undermines opportunities for talk. The abandoning of one device by a pair of visitors and the voicing and translating of information delivered by the

Figures 8.3 and 8.4
Mia and Hans with
PDA

device are examples that illustrate people's difficulties in combining the use of PDAs in their interaction with others (cf. vom Lehn and Heath 2005). In recent years, mobile devices have been further developed and experimented with to develop ways for the sharing of information between visitors. The Sotto Voce system is a prominent example in this regard. The PDAs are networked allowing individuals to see what their companion is currently looking at on her/his device. This system proved promising in delivering information to visitors and encouraging them to talk and share information with each other (Aoki *et al.* 2002). Whilst in the light of the arrival of the iPhone and other WiFi-capable devices, mobile systems have become increasingly popular with museum managers, information kiosks still pervade many contemporary exhibitions. They are deployed to provide visitors with multi-media information about stationary exhibits. They often encourage visitors to engage in a quiz or a game, or they offer them information that the exhibit itself cannot offer.

Consider for example the information kiosk deployed in the Victoria and Albert Museum near a washstand designed by William Burges (figure 8.5). When James and his mother, Gaby, arrive at the kiosk she touches the screen and they both watch the video-clip showing the nineteenth-century washstand at work. As the clip runs, Gaby provides additional information about the working of the washstand not contained in the video. Some of the information is provided in response to James' questions, 'is it boiling hot?' (line 7) or '(there) in the bottom' (line 10). After a short while, Gaby steps forward and looks into the porcelain bowl that is illustrated with blue carp. She says, 'yes there are' (line 17) in response to James's statement, 'there are fish (.) in the bowl?' The boy's question has encouraged her to leave the kiosk and step close to the washstand to have a look into the bowl. A moment later, as she looks into the bowl she confirms the existence of fish occasioning James also to leave the kiosk and step forward. They both briefly stand side-by side and look into the bowl. As Gaby moves back to the kiosk a man who has been standing behind the pair, possibly overhearing their noticing of the fish in the bowl, steps forward and glances into the bowl. Gaby then returns to the kiosk followed by James, and they both continue to watch the video. James now stands to Gaby's left and they both continue to watch the video-clip to the end.

People rarely watch the clip that lasts only three minutes from start to finish. They often leave the kiosk to inspect some aspects of the washstand in detail or go elsewhere in the gallery. As people leave the kiosk to view the exhibit they unavoidably miss parts of the video. The location of the kiosk and the linear structure of the video-clip do not permit a simultaneous information retrieval from the kiosk and an inspection of the washstand.

```
 1  G:  the sistern on the top (.) filled with water=so a maid will
 2      come and fill that up (.) cause theres no running water then
 3      yah (.) (let) in wa:ter yes? Look >look< (.) then you turned
 4      on that
 5 (.3)
 6      yah? Look
 7  J:  mhm (.6) is that boiling hot?
 8  G:  no just one temperature whatever is in the top of the tank
 9      there yah
10  J:  (there) in the bottom?
11  G:  no in the tank [in the top there where it was sto:red
12  J:                 [oh yah                                 I see:
13 (1.3)
14  J:  look there are fishes (.) in the bowl?
15  G:  mhm:
16 (1.3)
17      oh yes there ar:e
18         (1)
19  J:  mhm
```

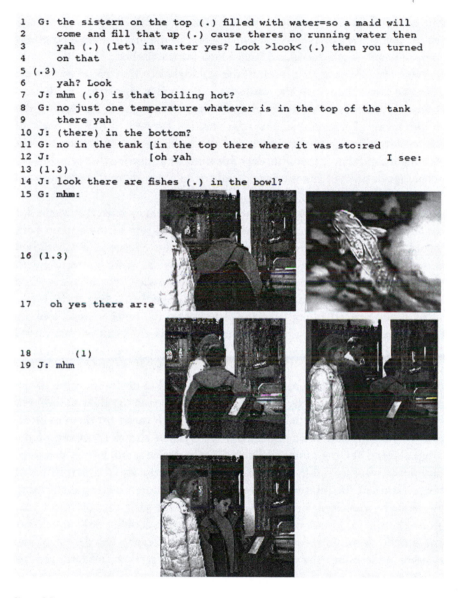

Figure 8.5
Gaby and James at Burges' 'Washstand' in the V & A

The leaving of the kiosk is often occasioned by aspects of the washstand highlighted in the clip. A pair of visitors rarely leave the kiosk together to examine the washstand but a member of the pair turns away from the screen and moves to the washstand whilst her/his companion continues to watch the

clip. Standing at the washstand, participants often call companions over to see for themselves, or their display of interest in the original piece occasions companions to step forward and have a look for themselves.

Whilst people have an interest in the original piece they spend more time with the kiosk than with the washstand. The video shows the washstand at work revealing aspects of the piece that are not accessible by viewing the exhibit alone. For example, the relationships between different parts of the washstand, such as the cistern and the bowl, cannot be retrieved from viewing the exhibit. It therefore does not come as a surprise that occasionally people touch parts of the washstand and try to move them (Heath and vom Lehn 2004).

Stationary systems like information kiosks are very powerful media for conveying multimedia content to visitors. The position of the system with regard to an exhibit determines where people stand to engage with the original object and how much they can see of the original piece while interacting with the system. The structure of the content influences what people look at while they are engaged with the kiosk. For example, when the system at the washstand shows water flowing from the cistern into the bowl, visitors look up from the screen to the exhibit; and when the fish in the bowl are mentioned they show an interest in the exhibit, whilst however being resistant to leave the ongoing streaming of the video to look at the bowl. Mobile systems like PDAs or mobile phones are increasingly deployed to deal with some of the problems of stationary systems. In particular, people can use them at different locations close by the original exhibit. This makes it easier for them to interweave the information retrieval from the system and the viewing of the original piece. Yet, the content delivered by the device is still largely delivered in a linear way; its tight structure contrasts with the social and contingent organization of the interaction through which visitors examine the exhibit. When using mobile devices, people consider their visit as a museum tour guided by the information delivered by the system, looking only at exhibits and exhibit features mentioned by the device. Because the design of the systems undermines the emergence of social interaction and talk, visitors rarely interfere with the linear retrieval of information from the system. However, in some instances people show their frustration with the tight organization of the information delivery and abandon the use of the device.

DE-LINEARIZING PARTICIPATION

In recent years, museums have begun to deploy large projections coupled with sensor systems that capture people's movements in their exhibitions. These

exhibits display images or text that can be manipulated by moving the body in front of the picture, the body movements making up the interaction with the system. One such exhibit was displayed at an exhibition entitled 'John Constable: The Great Landscapes' at Tate Britain in summer 2006. The exhibition was the first occasion to see Constable's six-foot landscape paintings together. They include such famous works as 'The Hay Wain' (1820–21), 'Hadleigh Castle' (1829), and 'A View on the Stour Near Dedham' (1822). Alongside the 'six-footers' the exhibition provided access to the preliminary full-scale compositional sketches that Constable produced when planning the exhibition pictures. The display of the finished exhibition paintings beside the preliminary sketches allows visitors to obtain an understanding of Constable's working practice and techniques.

The curator responsible for the interpretation of the exhibition commissioned an interactive installation called the 'X-Ray Examination'. The installation was deployed in the final room of the exhibition. It was a life-size projection of Constable's sketch of 'Salisbury Cathedral from the Meadows' (1831). The projection of the sketch can be video-mixed with the X-ray of the painting to analyze the artist's *pentimenti* (the underlying images beneath overpainted alterations). It is connected to a conventional Pentium PC and a basic black and white CCTV camera located underneath the projection screen (Figure 8.6). As the camera captures people's movement in front of the projection, bespoke software translates people's movements into changes in the picture. The curator hopes the X-Ray Examination 'allows for exciting and intuitive exploration of the changes that Constable made in the sketch' (quoted from Design Brief).

People explore the exhibit by moving in front of the projection and gradually learn about its functionality. The discovery of the functionality of the exhibit encourages them to further examine the relationship between the

Figure 8.6
The X-Ray Examination

sketch and the underlying X-Ray image. They move their bodies in different ways in front of the projection and wave their arms to make visible different aspects of the X-Ray image. Thus, they gradually discover differences between the finished sketch of the painting and the black and white X-Ray picture. As people examine the exhibit, other people, companions and strangers, are in the same space and also view and examine the projection. In many cases, differences between the sketch and the X-Ray are discovered when a companion's or another person's movement reveal a feature in the X-Ray that is not visible in the sketch. For example, after having viewed the projection with her mother for some time a girl makes a step forward triggering a visible change to the projection. A boy sitting on the river bank appears where in the sketch there is a bush. She stands still for a few moments and looks at the picture when her mother points out a figure sitting by the riverbank. The girl looks to the projection and then again steps forward causing other parts of the projection to change. Having discovered the effects their actions have on the projection the mother encourages her daughter to move with her in front of the projection to examine the picture.

The analysis of the video-recordings and observations reveals that people often arrive near, examine, and make sense of the installation with others. The interaction with the system is made up of a two-part sequence of user-action

Figures 8.7, 8.8 and 8.9
Mother and girl at X-Ray Examination

and system-response; actions in front of the projection trigger changes in the picture and may encourage the user to produce further actions to further explore the installation. In contrast to conventional touch-screen systems and such like, however, this system provides resources for more flexible ways of participation. The system does not prefigure what people look at, for how long and in what sequence, but it allows for contingent forms of exploration and enquiry, not dissimilar to the way in which people examine 'conventional' paintings (Heath and vom Lehn 2004). People's actions arise in light of the appearance of exhibit features in the projection in front that may have been triggered by their own body movements or those of others. The visibility of actions and their relationship to changes in the projection makes it possible to experience the exhibit not only by interacting with the system but also by observing the interaction of others.

The events around the projection attract large numbers of people to stop and participate. Whilst some people stand at some distance to the projection observing the events, others move close up and try to become involved themselves. As the space in front of the projection fills up with people it becomes increasingly difficult to differentiate whose actions affect the picture in front. Indeed, people themselves find it more and more difficult to identify the effects their actions have on the projection. Because the system is sensitive to all kinds of movements in front of the projection various parts of the image are ongoingly changing. To differentiate how their actions are related to changes in the image people elaborate or embellish them. For example, they stretch their arms up in the air or wave with paper-cards to evoke visible changes in the projection.

The embellishment of their actions enables people to differentiate the impact of their actions on the projection from those of other people interacting in the space in front of the projection at the same time; interaction in front of the projection that is visible to others can gain relevance for their experience of the exhibit. Thus, actions produced by an individual at the exhibit to generate an experience of the projection become critical resources for the ways in which other people who happen to be in the same space make sense of the installation. And indeed, people often design their actions at the projection in a way that they create opportunities for discovery and surprise. For example, after having noticed a hidden feature in the X-Ray a visitor draws a companion to a particular area of the screen before producing an action that reveals that feature to her/him.

Exhibits and installations that involve large projections operated by unobtrusive sensor interfaces like the X-Ray examination provide multiple visitors with resources to simultaneously examine their features. The installations are operated by virtue of bodily movements produced in range of the

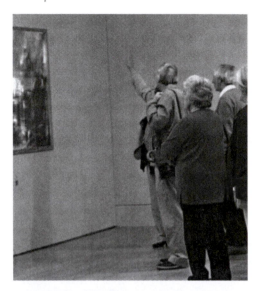

Figures 8.10 and 8.11
Embellishing actions at X-Ray
Examination

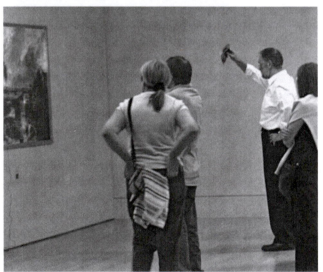

interface. These movements can be designed in ways that are noticeable for others and that may raise others' interest in both the action and the corresponding events on the screen. Thus, the experience of such installations arises in and through people's actions and interactions at and with the exhibit. The action and interaction at the installation use the features of the exhibit to generate resources that serve as the basis for co-participants' experience of it.

DISCUSSION

This chapter makes substantive and methodological contributions to new developments in arts marketing. The analysis points to the relationship between museum visitors' verbal and bodily actions and the material and informational environment. It highlights the fact that the practical work of curators and designers as well as that of system designers and programmers does not prefigure people's actions and experience of the systems and the museum. Actions and experiences arise in dynamic and contingent circumstances not designed for by managers and curators.

Computer systems and devices are designed and deployed to address museum managers' and designers' dissatisfaction with people's response to exhibitions. They provide dynamic multimedia content and involve visitors in long-lasting sequences of action that, designers hope, are pre-structured by the design of the system. The analysis begins to illuminate that people encounter and use these systems with others and embed information they retrieve from the system into their interaction with others. Thus, information resources provided by the museum are used to move forward the conversation with others, often not in the way anticipated by managers and curators.

The emergence of people's experience of the X-Ray examination contrasts with the way in which people's experience of touch-screen systems arises. Many mobile and stationary touch-screen systems try to pre-figure or even pre-structure people's actions and experience by involving them in tightly organized two-part sequences of user-action and system-response. We have seen that the linear structure that the designers of these systems try to impose on people rarely coincides with the contingent organization of social interaction. The designers of the system have little influence on the information that participants draw from the system and bring into the interaction with others (cf. Heath *et al.* 2002; Heath and vom Lehn 2008).

Video-data allow researchers access to the processes of actions and interactions through which people experience and make sense of systems and devices in museums. However, a suitable analytic and methodological framework is required to deal with the complexity of audio-visual recordings. This chapter explicates the analytic opportunities offered by video-recordings when they are coupled with a suitable analytic and methodological framework (cf. Heath *et al.* 2009). Whilst initially providing a detailed account of the sequential organization of people's examination of a sculpture displayed in a science museum the analysis later used video-recordings to support ethnographic observations of people's use of technologically advanced systems and installations in art museums.

Aside from these substantive and methodological contributions this chapter also makes a small conceptual contribution to debates in marketing about the co-creation of experience and value (Battarbee and Koskinen 2005; Lusch and Vargo 2006). These debates often start from differentiating the positions of producer and consumer whose perspectives converge in the act of consumption. The present analysis suggests that the experience of exhibitions arises in interaction between visitors who make use of the resources provided by museum managers, curators, and designers. The experience is not generated in and through a co-production between producer and consumer but through processes of interaction between visitors with and around exhibits and interpretation resources; processes on which exhibition designers and managers have little or no influence. Further research is required to illuminate the systematics of the interactive relationship between the material and informational organization of exhibitions and the social organization of people's action and interaction. Here, I have only begun to explicate some of the conceptual and methodological problems.

ACKNOWLEDGEMENTS

I would like to thank the staff at the various museums that have supported the research over the past few years, in particular Kate Steiner and Alex Burch (Science Museum), Christina Bagatavicius and James Davis (Tate Britain), Jane Burton (Tate Modern), and Juliette Fritsch (Victoria and Albert Museum). I also would like to thank the design company AllofUs for their advice and the editors of this book for their comments on a draft version of the chapter. Furthermore, I would like to thank my colleagues at the Work, Interaction & Technology Research Centre (King's College London) for their help with the analysis of the data. Most of all, I am are grateful to the visitors for participating in the study.

9

FROM LUXURY TO NECESSITY

The Changing Role of Qualitative Research in the Arts

Lisa Baxter

INTRODUCTION

T HIS CHAPTER IS written from my perspective as a practising arts marketing and qualitative research consultant with over fifteen years experience in the cultural sector. Throughout the early years of my career as a venue arts marketer, I became increasingly frustrated with the cyclical treadmill of 'selling' cultural product. I was drawn to a career in the arts because of my passionate belief in the value of cultural engagement, and yet mainstream arts marketing seemed 'soulless' and out of touch with the 'value' of its cultural product offer. What changed the course of my career – and it was truly a light bulb moment – was the realization that in order to develop and grow audiences, it is essential first to seek to know and empathize with them. Thus began my journey into 'qualitative consultancy'; the marrying of qualitative research insight with marketing consultancy.

Having specialized in qualitative consultancy for ten years now, including work for national touring companies, regional producing theatres, festivals, museums, and galleries, I find myself both excited at recent developments in cultural policy – which place increasing importance on the audience-as-individual – and frustrated with the slow rate at which this thinking has permeated through to frontline organizations.

The aim of this chapter is to explore why qualitative research has a vital role to play in informing arts marketing practice, today more than ever. I begin by exploring significant developments in thought leadership regarding the arts and audiences, touching on associated social, cultural, and technological shifts and the degree to which the arts are being left behind. I then explore the differing degrees and depth of insight which qualitative research can deliver and the ways in which it can contribute to equipping arts organizations for

twenty-first-century audiences. The chapter includes three illustrative case studies from my recent practice, namely, Queen Street Textile Museum (Burnley), Huddersfield Contemporary Music Festival, and Magna Science Adventure Centre (Rotherham).

PUTTING PEOPLE FIRST – A SHIFT IN THE CULTURAL FOCUS

Recent shifts in cultural policy thinking, fuelled in part by Holden (2004, 2008), Hewitt (2005), McMaster (2006) and Knell (2008), have generated awareness that to create and market 'great art for everyone' (Arts Council England's mission 2008–11), arts organizations need to acknowledge, listen to, converse with, seek to understand, and involve the public. Arts Council England has already taken significant steps, through its *Arts Debate* (Bunting *et al.* 2008), *Taking Part Survey* and *Audience Insight Research*, to relocate audiences to a more central position in their policy making.

Despite this potentially fertile ground for qualitative research to take root and grow, the limited understanding and appreciation of its role and value at an organizational level means it is perceived by many as an expensive luxury rather than an essential business tool. This consigns it to the periphery of arts marketing practice. As a result, there is a risk of stagnation in arts marketing, with organizations clinging to the traditional whilst only tinkering with the new.

A WORLD OF ARTS MARKETING WITH NO QUALITATIVE RESEARCH

Let us begin by imagining a world of arts marketing devoid of qualitative research. In such a world, cultural producers and programmers would create and programme work according to their own artistic predilections with scant consideration and superficial knowledge of the needs, tastes and desires of their audiences. Arts marketers would churn out high-volume communications describing and 'selling' events rather than trying to evoke their intended experience and impacts. Arts brands would be one-dimensional reflections of how an organization wanted to be perceived rather than resonating with people's identities, values or beliefs. Customer loyalty would be measured purely by the value, frequency and numbers of *'derrières on chairs'* rather than the degree to which organizations have won hearts and minds. Customer Relationship Management (CRM) would rely solely on the

interrogation of box-office data and manipulation of purchase behaviour rather than on the building of genuine relationships.

This imaginary world is not so far from recent reality. However, it would be incorrect to suggest that qualitative research has made no appreciable impact on arts marketing. In fact, in recent years, there is a burgeoning demand for qualitative research from arts organizations. Whilst this demand is gathering momentum it still represents, however, a minority of the UK's arts organizations.

The UK's regional audience development agencies have, for a number of years now, embedded qualitative research into their service offer, enabling more arts organizations to access audience insight. Some of the UK's major arts institutions such as Wales Millennium Centre, National Museums Scotland and the Natural History Museum have, or are about to implement, major programmes of qualitative and quantitative research to inform, for example, brand development, audience segmentation systems and experience management initiatives. National touring companies such as Northern Ballet Theatre are turning to qualitative research to access insights about audiences in order to refine their strategic communications, inform campaign planning with receiving venues and understand the nature, degree and depth of '*their*' audience loyalty. This is crucial because whilst touring companies may not have a direct relationship with audiences (the primary customer contact is normally through the receiving venue), audience loyalty may reside with the touring company and not the venue. Accessing insights into where the audience affiliations lie in the 'relationship triangle' that is audience–venue–touring company is critical in leveraging sales though appropriate and resonant messaging from the correct source (i.e. the venue or the touring company). Furthermore, programmers and artistic directors – at organizations such as Imperial War Museum North (Salford), Sound and Music (London), Manchester Art Gallery and Watford Palace Theatre – are using qualitative research to provide evidence-based insight which informs leadership agendas and helps to deliver change.

Moreover, the professional body for arts marketing practitioners, the Arts Marketing Association (AMA), is focusing increased attention on the subject of audience engagement. Its 2008 conference on qualitative research was followed in 2009 by one entitled 'Exploring Artistic Excellence and Public Engagement', which explored the need to enter into more meaningful dialogue with audiences in order to break down the physical and perceptual boundaries of our cultural institutions. In January 2009, the AMA hosted a symposium of thought leaders within arts-marketing and cultural policy which acknowledged 'the role of marketers (and indeed arts organizations) as the broker between the art and the audience and the crucial need for both

artistic development and audience development to be driven by insight' (Aldridge 2009: 11). However, at grass-roots level, the majority of arts organizations have not yet embedded qualitative research as a key marketing practice. In order to understand why qualitative research is essential to a successful arts marketing function, it is necessary to examine the current environment for the arts.

THE OPERATING ENVIRONMENT FOR ARTS ORGANIZATIONS

Arts marketers live in exciting and highly challenging times. The world is changing, and with it, the way people buy into products and experiences. Business and communications models that support those products and experiences need to change too, if arts organizations want to survive (Zaltman 2003; Smith *et al.* 2005; Jenkins 2008; Andersen 2007).

As a largely 'institutionalized' sector, arts buildings are losing purchase against the tide of digital, street, portable and in-home cultural outlets which offer people attractive, engaging, convenient, cultural alternatives at a time and place that suits them. Arts audiences today are very different from the ones for which theatres and museums were built. They require a more active, personalized arts consumption experience than the predominantly passive, formal model that is on offer. Why? Because the proliferation of cultural choice, distribution channels, modes of consumption and engagement, has undeniably altered people's relationship with culture. Rather than passively consume a pre-prepared diet of arts product, they are actively curating their own cultural menu in a way that chimes with their personal identity creation and lifestyles. This blurring of boundaries between cultural producer and consumer brings with it a fundamental shift in the balance of power. Arts organizations are experiencing fast-diminishing authority in the face of this new wave of empowered, culturally switched on, creatively self-actualizing consumers.

In response to this changing cultural landscape, Lynne Connor, in her report entitled *Arts Experience Initiative* (2008), argues the need for experimentation with 'a range of audience-centred programming that reframes the one-way delivery model', and reports how, through qualitative audience engagement, new methods of empowering and 'activating' today's audiences can be achieved through audience-centred programming.

My concern is that the arts marketing community is not keeping pace with the impact of these changes in our cultural landscape. The arts-production machine is bogged down with bureaucracy, politics and economic challenges.

It, too, runs the risk of becoming increasingly marginalized and irrelevant within a cultural marketplace that is fizzing with energy and creativity.

According to Diane Ragsdale (2008), we have a lot of catching up to do:

> Many arts organizations appear to be . . . working from outdated mental maps of the cultural landscape, outdated conceptions about the value of their organization to the community, outdated ideas about who lives in their communities, what those individuals value, and what role the arts do or do not play in their lives.

In addition, marketing is viewed today rather more cynically than it used to be. Consumers do not always want to be told what to see and do or where to go any more. Marketing messages are no longer taken at face value. The era of top-down messaging is over. In effect, 'millions of regular people are the new tastemakers' (Anderson 2007). Word of mouth and 'word of mouse' are king. People are discovering things for themselves through search engines and spontaneous viral communications. They are responding far more to their network of peers than to conventional 'marketing messaging'. Put in more prosaic and familiar terms, it's no longer good enough simply to put a sales message under the noses of people who live in the right postcode, have attended a similar event or expressed a general interest in, let's say, classical drama. According to Smith *et al.* (2005: 12):

> Today's networked consumers are re-engaged with other consumers in conversations that are instantaneous, hyper-linked and highly informed, and becoming more so every day. Because people are able to talk to other people so much more easily, product owners and interested buyers often know more about the product than the company that makes it. Because people have the ability to control the media they use, new expectations and new relationships rule the marketplace.

They argue the need for a move away from the traditional '4 Ps' of marketing – Price, Promotion, Product, Place – which in their view is essentially marketing-process-driven, towards increased customer-centricity.

Similarly, arts organizations need to recognize that the usual formulae, for what Godin (1999) refers to as 'interruption marketing', are becoming increasingly redundant. There needs to be a shift away from 'push' marketing to 'pull' – creating relevant, resonant offers, authentically communicated, that magnetize attention and draw people to the arts because the specific arts/cultural experience offer strikes a chord with something in them – a belief, a need, a value.

And yet, too many arts organizations appear to be still in thrall to an aging, diminishing population of largely habitualized audiences who represent the 'old school' consumer at whom a large proportion of particularly 'institution-alized' live arts product is aimed. The marketing function in relation to these audiences is informed by pure economics: striving for customer retention, moving audiences up the 'relationship ladder' through incentivization, added-value and subscription packages, exploiting the Pareto effect for all it is worth for maximum return on investment. I would argue that this purely economic-centric approach to arts marketing will, in the long run, yield ever diminishing returns because this 'old school' attender and their accompanying lifestyles are slowly becoming extinct.

But, what has all of this to do with qualitative research?

TIME TO GET PERSONAL

We live in a society of living, breathing, thinking, feeling individuals whose needs, tastes, preferences and behaviours cannot be fully predicted with the rather blunt instruments of purchase patterns, art-form preferences and demographic or psychographic categories – although it is a good place to start. According to, amongst others, Smith *et al.* (2005: 12–13):

> People are not marketing constructs. They live rich lives lush with con-nections, commitments, dreams, aspirations and everyday practicalities. The most powerful brands are those that resonate with people in their lives, not those that talk down to people as if they were a category user or a media demographic.

In his influential report *Supporting Excellence in the Arts* (2008) McMaster asserts that '. . . too many arts organizations are trying to second-guess what their audiences want and are therefore cheating them out of the deepest and most meaningful experiences'. He adds that for art to be excellent it needs to be relevant. His solution of peer review, however, falls short of placing the audience experience at the centre of the debate (it is after all about the arts being relevant *to the audience*). If arts organizations wish to produce and market the arts in a way that is relevant to twenty-first century Britain, they need to 'get up close and personal' with their existing and potential audiences.

By 'personal', I do not mean writing a direct mail letter to an opera attender telling them they hoped they enjoyed the recent production of *The Barber of Seville* and enquiring whether they might be interested in *The Ring of the Niebelung*. Personalization can and must go much deeper than this.

Over the past few years, this concept of 'meaningful dialogue' with audiences has taken hold. In 2005, former ACE Chief Executive, Peter Hewitt, wrote (2005: 17):

> We've put considerable resource (with considerable success) into 'audience development' – but this has been more focussed on persuading non-attenders to attend than meaningful dialogue between those who provide and those who go.

In 2008, John Knell in his report for ACE entitled *Whose Art Is It Anyway?* took this idea further. Knell called for this 'dialogue' to go beyond empowering arts organizations to tailor and personalize their cultural offer, arguing the need for it to inform arts marketing:

> This requires them [arts organizations] to develop strategies for marketing, customer relationship management and audience development which start with the personalized needs of customers, not the current capabilities and traditional strategies of arts organizations.
>
> (Knell 2008: 10)

In order for arts marketing to thrive, the arts marketing community needs to renegotiate its relationship with the audience and potential audience. Arts marketers should be the 'connective tissue' between the public and every facet of an arts organization's operation. Only then can they build brands, shape experiences, craft messages and develop relationships that truly resonate with their publics. Only then can they become relevant and occupy a meaningful position in their audiences' lives. A key way to achieve this is through genuine dialogue with their audiences and communities, and one of the ways to achieve this is through qualitative research.

THE FUTURE IS BRIGHT, THE FUTURE IS INSIGHT

So, what can qualitative research offer the arts-marketing community? Put simply, it is a vital element of audience intelligence management, delivering actionable insight that places muscle, tendon, sinew and a beating heart into the skeleton of quantitative data, bringing audiences alive in a way that empowers arts marketers to be ready for twenty-first-century audiences.

Qualitative research can deliver an understanding of how an arts organization is perceived, flesh out the motivational triggers and barriers to attendance from different audience groups and explore the degree to which

arts marketing persuades and arts brands appeal. It can help arts marketers understand people's personal cultural/leisure map, the arts provider's place in it and where they sit in relation to the competition. The resulting insights can be applied in various ways: for example to inform strategic and tactical marketing, copy writing, brand development, market positioning and audience development initiatives designed to minimize practical and perceptual barriers to arts engagement.

To give you an example, I recently undertook some qualitative research for Queen Street Textile Museum in Burnley, a highly evocative site with the original working machinery still in place. The aim of the research was to understand how to improve the museum's appeal and visitor experience from within the local non-visiting population. Participants were carefully screened to ensure specific representation from previous visitors and non-visitors, as well as from those who did and did not have a connection with the local textile industry. They were invited to visit the museum and to take part in subsequent focus group discussions.

The research revealed that, for the initiated visitors (i.e. those who had an industry connection), the museum's appeal was high. Participants expected an experience that resonated with their living memory of the textiles industry. In many cases, the museum over-delivered on this expectation because of the depth and vibrancy of the experience it offered: nostalgic, emotional, familiar and bitter-sweet depending on the participants' positive/negative associations with the industry.

> We went into the warehouse which was very very quiet and then we went into that viewing area and . . . all that noise and all those looms, it just whipped up my back, this happiness, happy memories. Then . . . there was a whole case with little holes in and they were full of shuttles and I thought 'No-one will use them again', and I felt like crying. So I was very happy and very sad.
>
> (Female research participant)

With non-visitors, the museum's appeal was extremely low, in part due to lack of knowledge of the experience it was offering. Those with a textiles industry connection were 'bowled over' by their unexpectedly personal, moving and sensory experience (the sights, sounds and smells of the building and machinery) and the degree of empathy they felt towards the workers. Those without industry connections found the museum experience interesting but remote. In their view, it presupposed prior knowledge of the textile industry which prevented them from fully engaging with both the story of cotton making and the lives and experiences of those who worked there.

The research enabled both keepers and marketing staff to understand more fully the many dimensions of the visitors' expectations and experiences, depending on the visitor perspective. Queen Street Textile Museum is using these insights to drive an audience development strategy that seeks to augment the museum's appeal through heightened expectation management (by communicating the powerful multidimensional nature of the visitor experience there) and improved on-site experience management (through refined interpretation geared towards visitors with different degrees of knowledge of the textile industry).

As valuable as this research is, it demonstrates just one facet of qualitative research's rich offering: obtaining insight through direct questioning about audience perceptions of a venue and its experiential offer. But there is much more to qualitative research than this. A shift in the research perspective can yield riches.

THE ERA OF 'AFFECTIVE ECONOMICS' AND THE ROLE OF QUALITATIVE RESEARCH

For a long time arts providers' focus of enquiry has been incredibly solipsistic. It's all been about them. What do audiences think of them? What do they like, don't like about them? Why do they attend, not attend? What can they do to make audiences cross the threshold, come again, come more often? Common sense suggests that if arts providers want to engage with people, they need to show an interest in what *they* think, not simply be obsessed with what audiences think of them.

A recent study by WolfBrown (2009) looks at the whole spectrum of cultural engagement and the relationship between personal cultural engagement and attendance at traditional museums, concerts and other attractions. The high degree of correlation between the two indicates the potential in taking the public's personal cultural interests and practices as the starting point for engagement and dialogue, not the arts product offer. By first understanding what makes our audiences tick, they can begin to communicate with them in a way that is genuinely relevant, meaningful and persuasive.

In his book *Convergence Culture* (2008) the business author and academic Henry Jenkins coins the phrase 'affective economics', persuasively making the case for a marketing practice informed by the emotional underpinnings of consumer decision making:

> This new 'affective economics' encourages companies to transform brands into what one industry insider calls 'lovemarks'[1] and to blur the line

between entertainment content and brand messages. According to the logic of affective economics, the ideal consumer is active, emotionally engaged, and socially networked. Watching the advert or consuming product is no longer enough; the company invites the audience inside the brand community.

(Jenkins 2008: 20)

Coined by Kevin Roberts, CEO Worldwide of Saatchi & Saatchi, as an alternative to trademarks, the term 'lovemarks' is intended to denote brands that 'reach your heart as well as your mind, creating an intimate, emotional connection that you just can't live without' (www.lovemarks.com).

Jenkins hits the nail on the head when he observes that a key obstacle to affective economics is the dominant economic imperative for quantifiable results which is wholly at odds with the apparent soft, touchy-feely and unquantifiable properties of qualitative consumer insights:

> . . . companies still struggle with the economic side of affective economics – the need to quantify desire, to measure connections and to commodify commitments – and perhaps most importantly of all, the need to transform all of the above into return on investment (ROI). These bottom-line pressures often deflect attempts to understand the complexity of audience behaviour even when such knowledge is desperately needed by companies that want to survive in the coming decades . . . It is still a world where what can be counted counts the most.
>
> (Jenkins 2008: 62)

In 2003, Steve Heyer, former President and CEO of the Coca-Cola Company, proclaimed a new vision for the future of marketing informed by resonant ideas that create value by linking consumers emotionally with brands:

> . . . creating value around this bottle is the secret formula of Coca-Cola's success. Coca-Cola isn't black water with a little sugar and a lot of fizz . . . Coca-Cola isn't a drink. It's an idea. Like great movies, like great music. Coca-Cola is a feeling.
>
> (Heyer 2003)

A great marketing concept. However, in real terms, Coca Cola *is* a soft drink 'with a little sugar and a lot of fizz'. The contradiction here is that the 'emotional value' associated with Coca-Cola is not intrinsic to the product. Through sophisticated brand management, emotional value is overlaid onto the product in such a way that, over time, it and the product have become synonymous – for some.

However, what better product to sell 'affectively' than the arts. The arts transform, entertain, move, delight and provoke. The nature, depth, richness and quality of these experiences *for their own sake* constitute the arts' uniquely authentic 'product' offer. Arts marketers ought to be at the vanguard of the dominant experience economy because they have the ultimate experience offer. By exploring the impacts, perceived benefits and associated values of those experiences and understanding how they fit into people's lives, arts marketers can create a more insight-driven, people-focused arts marketing community that can generate genuine buy-in. This is where qualitative research has real value. However, if we want to market the arts 'affectively', more advanced qualitative research methods need to be employed to tap into the deeper aspects of consumers' lives that affect their decision making.

QUALITATIVE RESEARCH IS NOT JUST ABOUT ASKING QUESTIONS

One of the myths surrounding qualitative research is that it involves asking consumer groups a series of pre-determined questions to which the client requires answers. Whilst this is true to a degree, reliance on a question-and-answer approach presupposes that the client has precise knowledge of what the issues are in relation to the research question. It precludes the possibility of a more open, non-directive investigation of the research subject, and may prevent potentially significant themes from spontaneously emerging which could be investigated further, bringing new knowledge to light.

Moreover, qualitative research has a far more sophisticated role to play in generating insight. Figure 9.1 helps illustrate the essential differences between a cognitive approach to qualitative research, and one which seeks to bring to awareness deeper, hidden meanings.

The bottom left quadrant of the matrix is the realm of the traditional focus group where a researcher would explore what audiences know, think and remember about the research question. This approach relies on left-brain thinking; logical, sequential, analytical and judgemental. This can and does yield interesting and useful information. However, there is a danger that the responses could be influenced by partial memory (for example not being able to recall significant habitual or spontaneous events or behaviours), cognitive filters such as selective memory (sharing only what they think the researcher believes important) and peer pressure (succumbing to social mores, wanting to project an idealized self and the desire to simply 'give a good answer').

In order to address some of these drawbacks researchers might employ smart elicitation techniques designed to circumvent top-of-mind conditioned

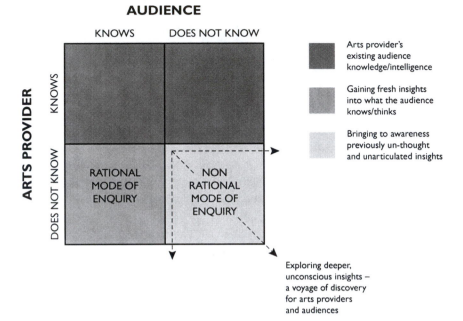

Figure 9.1
Modes of enquiry matrix

responses; pre-tasking to generate informed research participation rather than 'knee-jerk' responses; adept reframing of the research question that throws a 'curve ball' at participants, encouraging them to avoid the obvious or stereotypical answer; or facilitation techniques that develop a conducive, positive group dynamic where mutual trust and respect are engendered and the research participants feel empowered to speak their truths open and honestly without resorting to self-censorship.

However, a reliance on eliciting cognitive responses from research participants can curb the depth of insights produced; a limiting factor when trying to explore less tangible lines of investigation such as brand resonance, the intangibles of an arts experience, the hidden drivers behind decision-making or the subtle dimensions of a person's relationship with the arts. In these cases audiences may not necessarily have the self-awareness or command of language to articulate relationships, experiences or feelings of which they may not be consciously aware. Qualitative researcher and author Wendy Gordon writes:

> People are not always aware of the relationship they have with brands and services. They simply feel 'good', 'bad', or 'indifferent' about the myriad

of brand and service choices that face them every day. They will give various reasons for choice if asked: price, promotion, value, habit, change, recommendation or reputation. They will not be aware of the deeper emotional ties that have been forged with a brand or the extent to which it has come to have symbolic value in their lives.

(Gordon 1999: 163)

Smarter methods need to be employed to take the research inquiry beyond 'harvesting' conscious information to 'mining' for beyond conscious insights. One of the most rewarding challenges of qualitative research is identifying how to 'go in deep' and access the more intuitive, emotional, feeling part of the brain. This takes us to the bottom right quadrant of the diagram/matrix.

In this realm, experienced researchers employ a variety of projective techniques designed to bring to awareness latent, unmediated insights and explore abstract concepts and feelings differently by tapping into right-brain thinking. This technique might include personification, designed to explore brand dimensions, and other types of metaphor work (see, for example, Zaltman and Zaltman 2008) that enable participants to access feelings, experiences or concepts intuitively rather than rationally. The aim here is to help respondents bring to awareness feelings and images that they might have trouble accessing and articulating if asked in a standard question-and answer format. Bystedt *et al.* (2003) ask:

Why do metaphorical techniques allow us to go beyond the surface? . . . One possible explanation is that the metaphorical process – that of making connections – taps into the right side of the brand. This is the creative side of the brain, where feelings and visual imagery reside. Thus, metaphorical techniques assist respondents in accessing emotions, perceptions and imagery, allowing them to verbalize rich information that adds insight and understanding to the topic under discussion.

This is where true insight value resides. Through these 'deeper' qualitative research methods we might, for example, gain an understanding about what role the arts or a specific cultural offer plays in the creation and expression of a person's multiple social and personal identities; or attain a sophisticated perspective on people's attitudes, perceptions and needs in relation to the arts and begin to appreciate the degree to which the arts resonate with their beliefs and values. It is insights such as these that are used to attune arts organizations to their audiences and constituent communities in order to refine brands, proactively shape the arts-experience offer, and create truthful, persuasive messages that put the audience, not the product, first. Using

that knowledge we can build stronger, more meaningful relationships with our audience, positively shaping their arts experience and influencing arts engagement and purchase behaviour.

HUDDERSFIELD CONTEMPORARY MUSIC FESTIVAL – A CASE STUDY

In 2008, I was involved in one of Arts Council England's *Thrive!* projects with Huddersfield Contemporary Music Festival (HCMF). This annual two-week event, in its thirtieth year and under the auspices of a relatively new artistic director, wanted to inform this major programme of organizational and audience development, in part, through an extensive programme of qualitative and quantitative research. My role as qualitative research consultant was to investigate the place and value of HCMF in attenders' and artists' cultural lives, the ways in which HCMF's location in Huddersfield impacts on their experience and explore audience expectations and their subsequent experience of HCMF 2008, within the context of a braver, more risk-taking programme of contemporary music.

Reconvened focus groups were held before and after the Festival with Recent Attenders (defined as first-time bookers the previous year) and Regular Attenders (defined as repeat bookers). One-off groups were also held with attenders from outside the West Yorkshire region to explore the ways in which HCMF's location in Huddersfield town influenced their Festival experience.

The research methodology included fulfilment maps, brand metaphors combined with graphic ideation and personal Festival diaries. The fulfilment maps were a mind-mapping exercise where participants mapped out their expectations prior to the Festival, and then overlaid the maps with their subsequent experiences afterwards. For brand metaphors, drawings were used in order to facilitate intuitive right-brain thinking about brand personality and experience. Each participant was invited to keep a personal diary of their HCMF experience, fully briefed on the elements of experience they needed to record. These were then used as 'concrete' examples with which to support the fulfilment map exercise.

The insights gained through the research were rich and deep. We were able to locate the status of contemporary music as a genre in participants' cultural lives, together with the specific positioning of and value placement on HCMF within that. We learned how different types of attender listened to and 'received' an art form that offers a particularly challenging listening experience. The research provided insight into how different degrees of tolerance to 'ear-stretching' depended largely on a person's journey into and relationship

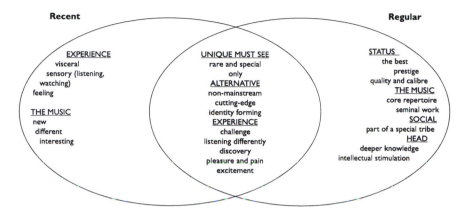

Recent

EXPERIENCE
visceral
sensory (listening,
watching)
feeling

THE MUSIC
new
different
interesting

UNIQUE MUST SEE
rare and special
only
ALTERNATIVE
non-mainstream
cutting-edge
identity forming
EXPERIENCE
challenge
listening differently
discovery
pleasure and pain
excitement

Regular

STATUS
the best
prestige
quality and calibre
THE MUSIC
core repertoire
seminal work
SOCIAL
part of a special tribe
HEAD
deeper knowledge
intellectual stimulation

Figure 9.2
Motivational triggers in HCMF audience

with contemporary music, as demonstrated by this verbatim from a regular Festival attender:

> When I listen to music it almost doesn't matter to me whether I think it's good or bad. It's to do with listening . . . sometimes I listen to music as if a stranger were talking to me with a different point of view. You have to open up and listen to them, and open your heart and think maybe they know things that I don't and that's part of the listening.

Differentiated motivational drivers were identified (see Venn diagram in Figure 9.2), which provided a valuable attitudinal, behavioural, motivational and perceptual framework within the context of HCMF's recent programming. Combined with the insights gained through the fulfilment mapping exercise and personal diaries, it emerged that the HCMF's brand benefits exist at many levels: personal, social and functional, with subtly different emphases dependent on the person's attitudinal category.

The research revealed that the Festival location in Huddersfield was a considerable asset; creating a unique brand experience due to the 'feel', architecture and intimate spatial dynamics of the town centre and its layout. Areas of under-achievement were identified which related both to the practical/physical experience of the town's infrastructure, together with more intangible identity-related issues such as the impact of the Hub's location on the social currency of the Festival, a key brand benefit. The Hub is the key meeting place for Festival goers – a place to relax, network and exchange ideas with audiences and artists. The Hub has occupied a number of temporary sites

over the past few Festivals. These insights will materially inform future experience-management initiatives at the Festival.

The personally drawn metaphors revealed previously unearthed insights into participants' 'bitter-sweet' experience of the Festival. Regular attenders in particular had a much higher-risk threshold and adopted a 'no pain no gain' attitude to attendance – the least popular concerts acting as a 'badge of honour' in their currency of informed conversation with other 'aficionados'. Recent attenders were much more focused on identifying 'moments to savour'. Their risk threshold was much lower; their 'pain' was felt more acutely there-fore they chose more carefully, attending fewer events. What both Regular and Recent Attenders needed were relevant access points to a challenging, highly niche and often opaque art form that would cultivate their interest, appreciation and knowledge base.

Moreover, the research revealed how HCMF was experienced as an inten-sive 'brandfest' – that is, a concentrated brand experience within a two-week period – that in some cases left a palpable void for the remaining 50 weeks of the year – a void which constitutes the Festival's most significant market and product development opportunity.

The impact of the qualitative element of the research is that HCMF is embarking on a wholesale rethink of how it engages with its audiences and on what its definition of 'audience' is. The vision is to create a year-round brand/knowledge community in which, through different entry points dependent on their degree of interest/initiation, people can discover, cultivate their interest in and share their passion with like-minded others in a way that suits and is meaningful to them. This could be achieved through appropriate sound and knowledge gateways across multiple live and digital platforms (using interactivity, immersion, participation, exchange and discovery as experiential touch points). The aim is to move contemporary music – and by association HCMF – into a more central position in the existing and potential audience's cultural lives and to move HCMF away from the limited 'brandfest' experience it currently offers. The desired result is a more durable, engaged and rewarding relationship with HCMF's enlarged cultural community, irrespective of whether they attend or not.

INNOVATIVE METHODOLOGIES TO UNDERSTAND PEOPLE'S EXPERIENCES OF THE ARTS

Whilst qualitative research can, using a variety of projective and elicitation techniques, access motivational drivers, brand perceptions, barriers to attend-ance and so forth, its inherently reflective nature poses a significant problem

when trying to understand a person's experience of the arts. As a research medium that explores, in part, past experiences and behaviours, qualitative research tends to rely on participants' selective and reconstructed memory, which may not recall automatic or spontaneous behaviours or the intangibles of a person's personal, subjective experience of a specific arts encounter.

And yet, is not this the 'Holy Grail' of arts research? Should not arts marketers, programmers and artists be seeking to understand and empathize with the human dimensions of the arts experience, its intrinsic and cumulative impacts and transformative nature? Without this, how can they hope to inform new product development, shape experience management initiatives or develop authentic, resonant communications?

I was fortunate enough to take part recently in an Arts and Humanities Research Council/Arts Council England funded project designed to explore exactly this – innovative qualitative methods of enquiry into the arts consumption experience and its impact. Working in collaboration with the University of Sheffield and Audiences Yorkshire, this represented an exciting and safe space to take risks in trialling inventive approaches. We began by facilitating a workshop with academic, arts and commercial research practitioners, exploring what it means 'to capture an arts experience' and sharing current and potentially innovative practice. We concluded that experience can only be partially captured because of a multitude of factors including the blurring of thresholds in relation to where an arts experience begins and ends; the elusiveness of capturing cumulative and latent impacts as well as the multiple intrinsic and extrinsic factors that influence experience; the multidimensional, ephemeral nature of experience and associated difficulties in articulating it; the drawbacks of reliance on memory; and the challenge of 'bringing to awareness' deeper, beyond conscious, subliminal impacts.

We decided to focus our research on the latter three points, exploring the intrinsic, ephemeral, intuitive and sensory dimensions of an arts experience.

One of the studies involved Magna Science Adventure Centre – a visitor attraction based in a vast former steelworks building in Rotherham. Within Magna, *The Face of Steel* is a large-scale multimedia installation housed in a dark, nine-storey-high space designed to bring to life the sounds, sights and atmosphere of the steelworks. Magna was concerned that visitors did not connect with this space fully and wanted to understand more about how family visitors in particular interacted with this exhibit.

The format of the research was a 2½-hour group session, including a 15-minute visit to *The Face of Steel*, with local regular family visitors. The number of participants – all adult parents – was limited to five in order to ensure maximum share of voice in what constituted quite an ambitious methodological configuration which included guided visualization and graphic capture.

Guided visualization is a technique about which very little is written, which is not generally used within the commercial or arts sector and yet appeared to meet the research objectives precisely. Its methodological appeal was the potential to enable participants to more fully engage with the arts consumption experience retrospectively through 're-experiencing' their arts encounter in the richest possible way. Guided visualization can achieve this by generating a participant frame-of-mind or 'conscious-state' which brings them closer to the felt experience.

Through the guided visualization exercise, participants were taken on a journey back into *The Face of Steel*. The visualization script was designed to attune participants to their embodied experience by immersing them in the sensory, emotional and visceral elements of their arts encounter. The exercise brought to awareness their arts experience in a manner that was rich, detailed and highly nuanced. The verbatim account below describes one visitor's embodied experience of *The Face of Steel*. This male participant, having unlocked those experiences from his physical memory, was then able to articulate how his physical, emotional and visceral responses created a heightened sense of atmosphere, awe, excitement and anticipation.

> . . . suddenly you get that almost kind of butterfly feeling; the sense of what's to come, and that works really well as an entrance. I didn't realize you were supposed to stop and look at it. It just suddenly gets you, the butterflies and you think 'Wow'. And then the sound walking up the gangways . . . You can kind of feel the sound . . . I think that possibly helps with sort of the excitement building. You can actually feel it . . . It's sort of anticipation.
>
> (Research participant)

The depth of the experiences revealed throughout this research underscores the value of guided visualization in accessing the tangibles and intangibles of the arts-consumption experience in a way that pure dialogue and cognitive recollection cannot.

Immediately after the visualization, participants were invited to represent their sensations and feelings on paper, expressed as words, diagrams, doodles, pictures; whatever they felt most comfortable with. This combination of guided visualization with graphic capture was an attempt to eschew the pitfalls of a purely verbo-centric approach by encouraging participants to first 're-embody' their arts experience and then immediately capture the intangibles of that experience creatively, laterally, intuitively before being processed or 'rationalized'. Why? Because sometimes words are just not up to the job of articulating the inchoate. The work of Prosser and Loxley (2008) in the

emergent field of visual research methods served as inspiration for this approach:

> In a research study exploring friendship groups from the perspective of children with special education needs, the following was observed which, in my experience, is more broadly relevant beyond individuals with diagnosed learning difficulties:
>
> Graphical-elicitation and other sensory methods have the potential to provide agency where none existed for those on the periphery of society. Children with disabilities make sense of their lives through the interplay of sensory relations not accessible through discourse; words are mere proxies for their direct experiences. Text-and-number based approaches are limited because they fail to move beyond inherent psychophysical characteristics to reveal taken-for-granted, embodied, sensorial lives.
>
> Those who find words and numbers difficult do not perform well in interviews or questionnaires and hence fail to figure in representative samples and societal norms.
>
> (Prosser and Loxley 2008: 28)

Like Prosser and Loxley, I wanted to explore research methods which 'invoke beyond text sensations' that are 'employed to access sensory phenomena which are highly meaningful and in ways that are ineffable and invisible using conventional research methods' (2008: 35).

The graphic capture element of the research was less cut and dried than the guided visualization, with some participants going straight into 'rational mode' and expressing themselves more with words and sentences than pictures. However, there was evidence of participants producing visual representations of complex experiences, group dynamics and states of being that added real depth and dimension to the visualization insights through both self-interpretation and researcher interpretation.

One of the key findings from the Magna research was that family visitors perceived the space as a 'non-site', delivering none of the benefits or desired experiences they derived from the rest of the attraction. Their frame of mind on entering the space was one of anticipation, not of *The Face of Steel*, but of everything that lies beyond. Whilst some responded viscerally to the atmosphere of the space (positively and negatively), others weren't 'mentally there' because the family dynamic compelled them through the space to the attractions beyond, reducing *The Face of Steel* – which was designed as a reflective space – to a thoroughfare. And yet there is, within that gallery, the potential to evoke in visitors a thrilling sense of atmosphere and connection with the original purpose of the building that could only be achieved through

the juxtaposition of a site-specific post-industrial space and the 'wow' of a large-scale multi-media installation. The value of this deep insight is not limited to pinpointing the 'experiential shortcomings' of *The Face of Steel* in relation to family visitors, but in revealing that the solution may lie in encouraging family visitors into the right frame of mind prior to entering or engaging with the space in order to be open and fully receptive to the experience.

What is the practical value of this kind of experience research to an arts marketer? In my view, it represents an exciting new approach to developing empathy with how different elements of your constituent communities might experience you differently, so as to positively influence how work is programmed, produced or curated, as well as help arts marketers shape and manage the in-venue visitor/brand experience, how it is communicated and how it is received.

IN SUMMARY

It is my view that for arts marketing to serve the arts and the public best, it needs to radically rethink its whole approach through the inclusion of audience-focused qualitative practice as a core activity, not at the expense of quantitative data but in tandem with it. It is *only* by doing this that arts organizations can attune themselves to their consumers and the humanity of their marketplace in order to deliver external public value and internal economic benefit.

NOTE

1 Coined by Kevin Roberts, CEO Worldwide of Saatchi & Saatchi, as an alternative to trademarks, lovemarks are brands that 'reach your heart as well as your mind, creating an intimate, emotional connection that you just can't live without' (www.lovemarks. com).

Chapter

10

DREAMING OF ARTISTIC EXCELLENCE, POPULARITY, OR BOTH?

Michela Addis and Morris B. Holbrook

ARTISTS IN ANY field must face a similar dilemma: Should they pursue their own ideals of artistic integrity as a pure creative expression of their most profound thoughts and deepest feelings, or should they instead try to please their targeted markets in order to gain popular acceptance and commercial success? Any answer to this question produces long-lasting effects – not only for the artists themselves, but also for audience members who may gain or lose opportunities to benefit in knowledge and experience from appreciating the most inspired pieces of art. Potentially, such a difficult choice might be resolved by achieving popularity through the attainment of high artistic quality, but the efficacy of such a rapprochement must not be taken for granted. Due to the availability of plentiful data on the motion-picture industry, this chapter addresses the art-versus-commerce dilemma in the context of cinematic consumption. To understand whether excellence and popularity diverge, converge, or proceed on independent paths, we review previous research suggesting that, from different perspectives favouring alternative modes of analysis, past studies interpret similar data sets differently. Whether excellence and popularity are independent or correlated has a strong impact on many aspects of the movie industry, such as the role of expert critics, the influence of Academy Awards, and the importance of various cinematic product features. Hence, this problematic issue raises relevant questions for artists, consumers, and researchers with an interest in arts marketing.

INTRODUCTION

The contribution of marketing strategies and tools to the success of cultural organizations is now generally recognized. This is especially true for popular

arts, whose managers usually adopt marketing principles in product-creation processes in an explicit effort to please their audiences by satisfying their needs and desires. However, even the most elitist and puritan arts experts who strongly believe in mission-driven artistic institutions cannot deny the potential utility of marketing. Specifically, non-profit cultural organizations typically pursue their cultural and educational missions by offering high-quality art works, while also benefiting from the communication and promotional tools designed by savvy marketers.

Recent trends, such as the growing scarcity of public funding and the vanishing of any border between high- and low-brow arts, bring the application of relevant marketing concepts to the forefront in various areas of arts management (Hume and Mort 2008; Sullivan Mort, Weerawardena, and Carnegie 2003). Along with different interpretations of artistic products – whether a piece of art is the result of a creative and innovative genius or is just something to sell to the market like so much deodorant or toothpaste – the whole concept of success raises various questions. Specifically, artistic success might be considered as aesthetically, ethically, spiritually and socially important – even if it is less discussed than commercial success in the marketing literature.

This chapter examines the definition of success and its drivers in an artistic and cultural environment in general and in the motion-picture industry in particular. Towards this end, we review previous theoretical and empirical contributions to this topic. We have selected films as our primary focus for a variety of reasons. First, with more than 500 commercial films released each year in the USA (Oligopoly Watch 2003), the motion-picture industry has generated over $25 billion of worldwide box-office grosses in recent years (MPAA 2007). Actually, such an impressive financial performance underestimates the economic relevance of this industry, since the box-office data do not take into account the value drained by piracy and the monetary contributions of video sales and rentals.

Hence, among the artistic industries, motion pictures evoke substantial interest both from practitioners who develop the cinematic business opportunities and from audiences who appreciate cinematic consumption experiences. Second, films lend themselves to in-depth study by virtue of widely available, easily accessible, and demonstrably relevant data. Thus, broad interest and pertinent data recommend this industry as a fruitful domain in which to explore the determinants of, and relationship between, artistic and commercial success.

TWO CONCEPTUALIZATIONS OF SUCCESS IN THE MOTION-PICTURE INDUSTRY

Like any other artistic product category, motion pictures have a dual nature: They result from a creative, expressive, artistic process; and, at the same time, they are a commercial product for sale in the marketplace (Sochay 1994). Such a complex nature complicates our view of success in this context – involving, as it does, both commercial and artistic aspects.

Even if both the artistic and commercial dimensions are relevant and deserve attention in the marketing literature, the economic returns of motion pictures have gathered by far the most attention as the measure of how well a film satisfies its audience's needs and wants (Garreson 1972). Thus, studies investigating the commercial dimension of success usually adopt box-office revenues as the main dependent variable (Austin 1980), by gathering data early or late in the film's product life cycle (Sawhney and Eliashberg 1996). Further, box office might refer only to the US market or to worldwide ticket sales, with the former being the most commonly analysed competitive context due to the vast and accurate availability of relevant data. Besides box-office revenues, other investigated measures as proxies of commercial success have included distributor rentals (Sochay 1994); profits – but with many difficulties (Simonton 2009); the number of weeks a movie runs in theatres (Chang and Ki 2005; Lampel and Shamsie 2000; Sochay 1994); number of screens (Gemser, Leenders, and Wijnberg 2008); and popular appeal as a measure of audience acceptance (Holbrook 1999b).

The second and comparatively neglected dimension of success refers to artistic excellence. Obviously, evaluating the aesthetic quality of an art work involves a high degree of subjectivity, leading to different perspectives according to who it is that appreciates a film's artistic merit. In the motion picture industry, at least three different types of participants play roles in evaluating a film's excellence: (1) experts; (2) people working in the industry; and (3) ordinary audiences.

1. Experts (critics, reviewers, and other commentators) are generally considered those who, after extensive education and long training, have developed the knowledge needed to report the most discriminating grasp of a motion picture's aesthetic excellence or lack thereof (Holbrook 1999b). Besides specific evaluations of each movie, experts can evince aesthetic judgments by bestowing various awards – such as the Golden Globes (Hollywood Foreign Press Association) or the Critics' Choice Awards (Broadcast Film Critics Association). (For interesting comparative insights on the implications of several awards, see Gemser, Leenders, and Wijnberg 2008.)

2. Others who evaluate motion pictures are those who work in the movie industry itself. Peers can be regarded as experts not because of their academic training, but because they know the nitty-gritty, back-lot, day-to-day practicalities of film making better than anyone else. These industry participants also express their judgments in the form of awards, with the most important and well-known being the Academy Awards or Oscars (Dodds and Holbrook 1988; Nelson, Donihue, Waldman, and Wheaton 2001). Oscars appear to matter not only to the success of those films that win, but also to the fortunes of those nominated (Deuchert, Adjamah, and Pauly 2005). In any case, Academy Award nominations and Oscar statuettes are widely regarded as quality signals in the industry (Hennig-Thurau, Walsh, and Wruck 2001).

3. If critical evaluations and industry awards are generally recognized as quality-related dimensions of performance (Kamakura, Basuroy, and Boatwright 2006; Simonton 2009), the third perspective on cinematic excellence – namely, that expressed by ordinary consumers – is commonly understudied (Chang and Ki 2005). However, a few previous studies of musical and cinematic consumption have emphasized the strong role played by ordinary evaluation (judgments of excellence by audience members themselves) as an additional perspective on quality (Hennig-Thurau, Houston, and Sridhar 2006) and as an aspect of perceived quality that is potentially correlated with expert evaluations (Holbrook 2005b; Wanderer 1970). Thus, assessments of artistic excellence by non-expert consumers correlate strongly with judgments of quality by expert professional critics.

A review of the findings from previous studies addressing the relationships among the three quality perceptions – expert judges, industry peers, and ordinary consumers – reveals the consistency found in judgments of artistic excellence. Specifically, recent studies of ordinary evaluations find that the quality perceived by ordinary consumers is strongly related to that perceived by expert judges. For example, one study addressing the link between expert judgments and ordinary evaluations refers to 200 recorded performances of 'My Funny Valentine' (Holbrook, Lacher, and LaTour 2003) and reports a fairly strong correlation ($r_{EJ,OE} = .548$) between EJ (expert judgments by highly trained musicians) and OE (ordinary evaluations by college students with no musical training). More recently, analyses of new datasets on cinematic consumption have addressed this issue, by raising the question of whether consumers (ordinary audience members) have good taste (as reflected by the judgments of professional film critics). Indeed, a study of 219 movies released during the year 2000 in the USA reports a strong correlation of $r_{EJ,OE} = .841$

(Holbrook 2005b). Moreover, when the potential contaminating influences of variables related to market success are removed from the variables of interest (via partial correlation), the relationship between these two residual variables (ej and oe, where the small letters indicate residuals) increases to $r_{ej,oe} = .910$ for the year 2000 and to $r_{ej,oe} = .873$ for a new sample of 192 motion pictures released in the USA during 2003 (Holbrook and Addis 2007). Such a result suggests that even non-trained audience members might understand what constitutes quality, as judged by professional critics. This convergence of evaluations between expert critics and ordinary consumers could reflect the implicit expertise that consumers develop with increases in their exposure to films (Plucker, Kaufman, Temple, and Qian 2009) or other art works (Holbrook, Greenleaf, and Schindler 1986). Hence, the experience needed to evaluate the quality of motion pictures might be generated through formal education (as with expert critics) or, autodidactically, via mere exposure and other informal influences (as with audience members) (Chakravarty, Liu, and Mazumdar 2008). Also, consistently, people working in the industry register perceived quality similar to that of experts – again, with a positive link between these two judgments of excellence (Simonton 2009). For example, Holbrook (1999b) looks at industry awards (IA) as a proxy for quality that predicts expert judgments (EJ) and reports a standardized regression coefficient of $\beta_{EJ,IA} = .47$.

DRIVERS OF COMMERCIAL SUCCESS IN THE MOTION-PICTURE INDUSTRY

Economic returns of motion pictures have generally attracted the most interest of researchers eager to identify the antecedents of commercial success (Hennig-Thurau, Houston, and Sridhar 2006). The general wisdom of people in this industry is that motion pictures are one of the most risky and uncertain product-category arenas in which to do business (Lampel and Shamsie 2000): Not only do individual projects frequently fail financially, but the reasons for such failures often remain deeply mysterious (Vogel 1998). Thus, the simple question of 'What drives success in the motion-picture industry?' has no simple answer but, rather, evokes a variety of different explanations.

The most extreme position is represented by De Vany and Walls (1999), who state that 'There are no formulas for success in Hollywood' (p. 286) since any marketing effort to improve a film's chances of success is subject to the whims of audience acceptance as the supreme judge. In their view, big budgets and popular stars provide no guarantee of high box-office revenues. The reason may lie in the dynamic and complex nature of this product category,

which combines many elements that unfold in complex patterns over time. Thus, according to the two authors, there is no specific ingredient that can transform a movie into a success.

By contrast – because of the possibilities for changing film-marketing strategies easily, quickly, and adaptively (Sawhney and Eliashberg 1996) – other researchers have tried to provide insights with greater predictive power. Because audience choices are driven by information (Albert 1998; Burzinsky and Bayer 1977; D'Astous and Touil 1999; De Vany and Lee 2000; Hennig-Thurau, Houston, and Sridhar 2006; Lampel and Shamsie 2000), previous studies have tested several movie features as potential antecedents of their financial performances. For example, it appears that the Motion Picture Association of America (MPAA) ratings play a relevant role in driving popularity, even if the details are somewhat contradictory. In this connection, Austin (1980) reports that popularity increases for films rated PG (parental guidance advised) or R (restricted), whereas more recent studies have found that R-rated films are more likely to suffer at the box office while those rated PG-13 are more likely to achieve commercial success (De Vany and Walls 2002; Ravid 1999; Ravid and Basuroy 2004). Similarly, as a key cinematic feature, the genre of a film significantly affects its financial performance. Specifically, audiences prefer to watch family-oriented films, while dramas score low on box-office success (Chang and Ki 2005; Holbrook 1999b; Prag and Casavant 1994; Ravid 1999). Other movie traits positively related to audience acceptance include running time, colour cinematography, US versus other origins, and production budget (Holbrook 1999b; Lampel and Shamsie 2000; Prag and Casavant 1994; Wallace, Seigerman, and Holbrook 1993). Researchers have also investigated other features that increase market performances by drawing on shared aspects of collective memory. For example, via the use of sequels and remakes, filmmakers adopt brand-extension strategies and capture value generated by previous successes (Basuroy, Desai, and Talukdar 2006; Chang and Ki 2005; Ravid 1999). However, other ways of tapping cultural familiarity – such as the adaptation of plays, novels, or historical stories – result in decreased of box-office revenues (Hennig-Thurau, Houston, and Walsh 2007; Simonton 2009). Another category of frequently investigated movie characteristics focuses on the people engaged in a motion-picture project. Potentially, this focus encompasses many different participants – including writers, cinematographers, costume designers, film-music composers, producers, directors, actors and actresses, and so forth – but, among these, stars on the screen have received by far the most attention, especially as another quality signal driving audience choices (Chang and Ki 2005; Elberse 2007; Hennig-Thurau, Houston, and Sridhar 2006; Hennig-Thurau, Walsh, and Wruck 2001). However, findings on the impact of movie stars are

contradictory at the best, perhaps as a result of the wide heterogeneity of measures and variables adopted (Simonton 2009). Further, recently, Meiseberg, Ehrmann, and Dormann (2008) have found that market performance depends not on the presence of an individual star but, rather, on the team of stars as a whole (say, Meryl Streep and Brad Pitt as compared with Meryl and Robert Redford or Brad and Angelina Jolie).

Besides production-related features, marketing investments play a role in driving the commercial returns of motion pictures. Most relevant among the variables belonging to this category, the level of advertising expenditures is positively related to box-office receipts (Basuroy, Desai, and Talukdar 2006; Hennig-Thurau, Houston, and Walsh 2006; 2007; Lehmann and Weinberg 2000; Moul 2005). Similarly, the market power of distributors, the number of opening screens, and the number of copies available at the movie's release are important tools in the competitive struggle (Belvaux and Marteaux 2007; Chang and Ki 2005; Elberse and Eliashberg 2003). As a final component of a film's marketing strategy, the choice of release time has an impact on box-office results (Weinberg 2006) insofar as a holiday release increases market potential but also puts a movie in competition with others that fill the theatres during the same time period (Simonton 2009).

DIFFERENCES IN DRIVERS OF ARTISTIC EXCELLENCE VERSUS COMMERCIAL SUCCESS IN THE MOTION-PICTURE INDUSTRY

Among the three perspectives on movie quality, the most frequent efforts have been aimed at understanding the antecedents of expert judgments. Excepting only the length of the film – which is generally appreciated, regardless of who is making the judgment – findings reveal many distinctive antecedents of evaluations by experts. Indeed, Holbrook (1999b) finds that experts respond favourably to the sci-fi genre, to foreign origins, to black-and-white cinematography, and generally to films that challenge hegemonic influences or question conventional values, regardless of what actors or actresses play the starring roles. Other studies find that experts respond negatively to remakes but positively to adaptations (tendencies opposite to those of the general audience) (Chang and Ki 2005). Meanwhile, Simonton (2009) reports that experts react unfavourably to marketing investments in general and to number of screens in particular, but that they react favourably to times of release that are late in the year.

To the best of our knowledge, no studies explicitly and rigorously compare the drivers of evaluations by expert critics, ordinary consumers, and industry

peers – perhaps due to the practical difficulties in testing for the significance of differences among them. However, Addis and Holbrook (forthcoming) find that ordinary judgments by consumers respond positively to action, crime, family-oriented, music, and war genres – as well as to longer films, to black-and-white cinematography, and to movies with production budgets in the vicinity of 16 million US dollars. Further, in their study of sequels and their impact on consumers' evaluations, Sood and Drèze (2006) show that sequels are more appreciated by consumers when they are dissimilar extensions of the original movie, indicating a complex nature of the relationship. The partial overlapping in antecedents between experts and consumers might explain the generally reported strong correlations of their evaluations. However, to better address this topic, we await a badly needed complete analysis of factors that drive ordinary and expert evaluations.

Similarly, only scattered information is available concerning the determinants of assessments by members of the motion-picture industry. Oscars are more rare for R-rated movies, sequels, and remakes, while they are more likely for dramas, for films based on true stories or adapted from other literary works, and for those released during the last quarter of the year (Nelson, Donihue, Waldman, and Wheaton 2001). Meanwhile, the number of screens seems not to affect industry opinion (Simonton, 2009).

ALTERNATIVE OR INTEGRATED PATHS TO SUCCESS?

The coherent nature of artistic excellence – as recognized by expert critics, ordinary consumers, and industry practitioners – indicates that all of the players in this cultural arena know how to evaluate the quality of a film. However, this shared knowledge does not necessarily imply that the market recognizes such cinematic excellence in the form of economic returns, especially because the two differ noticeably in their antecedents.

Because the two dimensions of motion-picture success – market performance and artistic excellence – are both relevant to our ultimate assessment of a film's success, whether they represent goals achievable simultaneously poses an interesting and important question. Potentially, one might expect any of three different answers:

- a positive correlation, indicating that efforts towards one goal encourage a better achievement of the other objective;
- a negative correlation, indicating that a film cannot achieve both goals at once because greater success on one objective implies failure on the other;

- a negligible correlation, indicating that artistic excellence and commercial pay-offs are independent aspects of success, making it possible to strive for both outcomes insofar as they are driven by different antecedents.

But, unfortunately, empirical findings that address this important issue are sparse, inconsistent, and controversial at best.

One salient example of the difficulty in identifying clear links among the relevant variables refers to the impact of Academy Awards on market performance. Even if it is well known that Oscars exert a significant positive effect on box-office receipts – indicating that achieving a visibly high level of quality as perceived by people in the motion-picture industry stimulates popular acceptance (Dodds and Holbrook 1988; Gemser, Leenders, and Wijnberg 2008; Litman and Ahn 1998; Nelson, Donihue, Waldman, and Wheaton 2001; Simonton 2009) – some such awards (Best Film, Best Actor, Best Actress, Best Director) are clearly more powerful than others in predicting commercial success. Interestingly, further analyses show that being nominated matters more to box-office receipts than actually winning the relevant awards (Deuchert, Adjamah, and Pauly 2005).

More controversy surrounds the impact of quality as perceived by experts on market performance. The link between the expert judgments of motion pictures by professional critics (widely regarded as the standard of excellence in that particular cultural field) and the audience acceptance of those products by ordinary consumers (via popularity polls or box-office receipts) has been long investigated as one indicator of the level of consumer taste: The stronger/ weaker the association is, the more/less consumers show 'good taste' (Basuroy, Chatterjee, and Ravid 2003; Basuroy, Desai, and Talukdar 2006; Boatwright, Basuroy, and Kamakura 2007; Dellarocas, Awad, and Zhang 2004; Desai and Basuroy 2005; Elberse and Anand 2005; Eliashberg and Shugan 1997; Hennig-Thurau, Houston, and Walsh 2007; Holbrook 1999b; Kamakura, Basuroy, and Boatwright 2006; Litman 1983; Litman and Ahn 1998; Prag and Casavant 1994; Ravid 1999; Ravid, Wald, and Basuroy 2006; Reinstein and Snyder 2005; Sawhney and Eliashberg 1996; Sochay 1994; Wallace, Seigerman, and Holbrook 1993; Zufryden 2000). Because of the generally reported significant-but-weak positive correlations between expert judgment (EJ) and popular appeal (PA) – typically about $r_{PA,EJ} = .35$ or smaller, accounting for less than 10 per cent of the variance in popularity or market performance (Holbrook 2005b) – conclusions have been drawn that consumers show 'little taste'. However, thanks to an improved methodology for analysing the links of interest – adopting a correct time sequence of measuring the relevant variables; gathering data independently from separate sources; and controlling for potential confounding biases due to various marketing- and market-related

factors (Holbrook and Addis 2007) – consumers are recognized as showing aspects of 'good taste' because of strong positive links both between residual measures of expert judgment and ordinary evaluation after partialling out market-related aspects (with a $\beta_{oe,ej}$ of about .9 in all analyses) and between ordinary evaluation and popular appeal as a proxy of market performance (with $\beta_{pa,oe}$ ranging from .415 to .695). Despite these links, their multiplicative combination results in the famous 'little taste' phenomenon – especially when not controlling for the confounding biases of market- and/or marketing-related influences – that weakens the overall correlation between expert judgment and popular appeal and that dissipates the emerging aspects of good taste. According to the above studies, a motion picture can obtain the praise of experts and/or ordinary people and, at the same time, can achieve some measure of market success. It might be the case that the increase in market performance is not as big as one would expect, but at least the findings do clearly show that these goals are not directly antagonistic. Stars, directors, producers, and others striving for artistic excellence might be willing to pursue this goal because its achievement, as signalled by expert judgments, is not only recognized by ordinary consumers but contributes, at least marginally, to the attainment of higher market performances. To better refine such a suggestion, based on previous findings, one could even advise movie stars and others to follow the path of artistic excellence – especially when the audience lacks relevant signalling information to assess the quality of a film (Lampel and Shamsie 2000) and/or when movie-making participants are involved in a drama or in a project with a narrow-release distribution strategy (Reinstein and Snyder 2005).

However, more recent research would question this, by suggesting that the path for artistic excellence and that for commercial success refer to separable and independent phenomena. Specifically, by analysing 190 movies released in 2003, Holbrook and Addis (2008) model two orthogonal dimensions of motion-picture success – i.e. artistic excellence (measured by Oscars and other awards) and market performance (measured by box-office receipts and video rentals) – as being uncorrelated outcomes of distinguishable paths. Their Two-Path Model of Motion-Picture Success starts with a film's market-directed effort or marketing clout, as manifested by its production budget, the number of opening screens, and the opening box-office revenue. Such combined aspects of marketing clout affect both (1) critical and popular evaluation (i.e. the appraisal of excellence by film reviewers and/or by ordinary consumers themselves) leading to industry recognition (i.e. Oscars and other awards from the motion-picture industry) and (2) critical and popular buzz (i.e. the tendency of reviewers and/or audience members to praise a film they like by recommending it to others) leading to market performance (i.e. overall

financial earnings of a film). Via the estimation of orthogonal factors (that are, by definition, uncorrelated) for evaluation versus buzz and for recognition versus performance, the authors explore a set of ordinary least-squares regressions to show support for the general principle of a contrast between art and commerce in general and for the Two-Path Model in particular. Thus, evaluations of excellence respond negatively to marketing clout ($\beta = -.497$) and lead towards higher industry recognition ($\beta = .564$). By contrast, buzz shows a positive effect of marketing clout ($\beta = .608$) and ultimately results in lucrative market performance ($\beta = .492$). This study appears particularly interesting because its adoption of a new approach produces findings that shake our common assumptions about the determinants and correlates of motion-picture success. According to the aforementioned results – while there is consistency of evaluation among expert critics, ordinary consumers, and industry peers, as indicated by the path of artistic excellence – this dimension of artistic excellence is uncorrelated with the dimension of commercial performance, where these two orthogonal aspects of success respond in opposite directions to the influence of marketing clout. In practical terms, this result questions the possibility for people working in this industry to pursue both popular fame and artistic quality simultaneously insofar as the marketing efforts lavished on a movie operate on the two paths in opposite directions. In short, where motion pictures are concerned, art and commerce appear to reflect two mutually exclusive positioning strategies.

CONCLUSIONS

As previously indicated, success in the motion-picture industry is a Big Deal – not only because of the difficulties found in its forecasting but also because of its complex nature. Indeed, previous findings depict a composite framework of movie success and its antecedents, with two independent dimensions of excellence and popularity being driven by different movie and marketing traits. Hence, a definitive answer to the question of whether artistic excellence might be sought together with popular acceptance remains elusive. Due to the practical importance of this issue, it appears likely that it will receive sustained attention in the days to come. Meanwhile, this essay identifies some key considerations that must be addressed in order to make progress in this direction. First, a longitudinal study is needed in which – because motion pictures are subject to the dynamics of many different players – it would be very useful to adopt a time sequence of measuring the relevant variables that reflects the theoretically appropriate order of events. For instance, it might be relevant to correctly assess whether ordinary evaluations drive market

performance or whether causality instead flows in the opposite direction. Second, data analyses would benefit from an approach based on structural equation modelling so as to analyse all the relevant links simultaneously. Finally, all the variables of interest should be included in the analysis, with particular attention to the ones that reflect the biases coming from the market- and marketing-related influences. In these and other ways, the path towards understanding cinematic success might be as risky but potentially rewarding as the fate of a motion picture itself.

11

BETWEEN FAN CULTURE AND COPYRIGHT INFRINGEMENT

Manga Scanlation

Hye-Kyung Lee

IN RECENT YEARS, the Japanese comic book or manga has gained remarkable popularity outside Japan, particularly in the US and Europe (Hickley 2005; Fishbein 2007; JETRO 2005, 2006; Schodt 1996; Wong 2007). Manga has been widely read in the East Asian region, including Hong Kong, Korea and Taiwan, for a long time, but the current surge of demand for manga in the US and European countries does not seem to have been predicted. As the Japan External Trade Organization's (JETRO) report *Cool Japan's Economy Warms Up* (2005) shows, Japanese cultural producers and cultural policy makers are pleasantly 'puzzled' about why this is happening. There might be a variety of driving forces for this phenomenon: Western society's increasing fascination with contemporary and popular culture in Japan; Japanese governmental agencies' support for manga-related studies and events overseas; the critical and commercial success of Japanese animation, which is often based on manga; and a variety of manga for girls ('shoujo' manga), which immediately created a new, rapidly growing, market (Deutsche Welle 2002, 2006; Hickley 2005; JETRO 2005; Kelts 2007; Kinsella 2000).

Behind the successful globalization of manga there exists manga scanlation (Deppey 2005, 2006; Macias 2006; Yang 2004). 'Scan(s)lation' basically refers to the phenomenon whereby ardent fans scan in manga titles, translate them from Japanese to another language and release the translated version via the internet free of charge. Scanlators say that while duly respecting the copyright owned by manga artists and publishers, their goal is to make a buzz about their favourite mangas and encourage publishers outside Japan to license and release official print versions. It can be argued that manga scanlation has been driven by two main factors: first, demand exceeding the supply of manga outside Japan; and second, the availability of digital technologies and the

internet, which allow the digitalization of manga and its international distribution through internet chat channels, peer-to-peer file sharing, scanlation distribution websites and simply websites run by scanlators.

According to Japanese copyright law, artists (and thus publishers) are entitled to the right to translate, reproduce and exploit derivative works (CRIC, 2008). Their copyright is protected in foreign countries under the Berne Convention for the Protection of Literary and Artistic Works. The Convention states that works originating in one of the contracting states must be given the same protection in each of the other contracting states. Both Japan and the US are signatories. Under the WTO Agreement on Trade-Related Aspects of Intellectual Property Rights (TRIPS), the Berne Convention binds WTO member states regardless of whether they are signatories to the Convention (WIPO).[1] From a US copyright law perspective, which often sees a parodist use of copyrighted cartoon characters as copyright infringement (Mehra 2002), scanlation is obviously illegal.[2] In comparison, the Japanese counterparts take a relatively relaxed approach to fair use of copyrighted materials. Among various limitations on copyright protection, there are exceptions for 'private use' (personal use, family use or other similar uses within a limited circle) and 'not for profit-making' (non-profit-making purposes and without charging any fees to audiences and spectators) (CRIC 2008). In addition to the strong fan culture, it might be because of such a legal framework that 'doujinshi' (fan books), which are produced in enormous volume every year and sometimes even make a profit, is tolerated by the industry and legal authorities in Japan.

As a creation of participatory consumers, scanlation could be seen to be a private and not for profit use of copyrighted manga. Similarly, it also fits into the existing description of fan culture: it is conducted by fans for pleasure; the fans scanlate the titles they love and want to share with other fans; their activities are not for profit and even cost money; and it is closely associated with other participatory activities such as forums or discussion groups (Fiske 1992; Grossberg 1992; Jenkins 1992). At the same time, however, scanlation is proximate to music file sharing in the sense that scanlated manga (files) could be shared by endless readers and could potentially function as a substitute for the officially translated version and thus could cause financial damage to manga artists and publishers in Japan and overseas licensees. Scanlators themselves succinctly describe this situation as 'a paradox', 'a double edged sword', 'dilemma' or 'a love/hate relationship'. An active scanlation group calls itself 'XXX [title of a manga] Illegal Scanlations'. As there have been no lawsuits filed against scanlators or related debates in the media, however, it is difficult to know how the industry and legal authorities in Japan and overseas approach the issue of scanlation.

As a fan culture which aims to 'promote' manga in non-Japanese-speaking territories through potentially infringing copyright, scanlation seems to have an intriguing relationship with the industry, which could become antagonistic but has generally been nonchalant so far. The existence of scanlation and its peaceful relationship to the industry raises some fundamental questions on the dynamics in the relations between cultural products, fans and the industry in the age of globalization and digitalization: for example, how the development of digital technologies, the internet and globalization are changing the ways cultural products are produced, distributed and consumed; whether cultural industries can ever stop unauthorised file sharing between consumers; and whether globalization and digitalization are bringing forward a need for a new set of business models and ethics to govern the cultural industries and their consumers. In order to provide a stepping stone to such enquiries, this essay aims at exploring the culture of English scanlation and the nature of its relationship with the industry through investigating the following three factors: first, the nature of the manga industry in Japan and beyond; second, the motives and ethics of scanlators; and, finally, the industry's reaction to scanlation. In doing so, the essay also demonstrates that scanlators' distinctive motives, ethics and beliefs, which, to some degree, are also respected by the industry, have allowed their activity to position itself somewhere closer to fan culture than illegal file sharing.

METHODOLOGY

For this research, a range of different research methods has been used. Overall, they can be divided into two categories: literature review and an empirical study of scanlation and scanlators. In addition to academic literature, a variety of written materials on the manga industry has been reviewed. Given the fact that, except for some news reports, there has been little writing on the topic of manga scanlation, internet research has constituted an essential part of the research methodology. Such a situation has led me to adopt some elements of the 'netnography' methodology devised and used by researchers who work on the online consumer community and its culture (Giesler and Pohlmann 2003; Kozinets 1997, 1998). This has involved the examination of manga news websites and related forums, the analysis of scanlation groups' website texts and email interviews with selected scanlators. The author's access to related websites was from March to July 2008.

A sample of 120 English scanlation groups was randomly selected based on the index of 'active' scanlation groups at Baka-Update (http://www.baka-updates.com/), one of the most comprehensive websites indexing scanlation

Table 11.1
Nine scanlators interviewed

Name (pseudonym)	Location	First scanlation	Genres	Other information
Amy	US	Around 2004	Doujinshi (fan books)	Age 28
Iris	US	2003	Shoujo (manga for girls)	High-school student
Charlie	US	2003	Shoujo	University student, Japanese major
Cindy	US	2001/2	Shoujo (dedicated to a particular manga artist)	Age 22, interested in working in a manga publishing company
Adam	US	Around 2001	Various, mainly shounen (manga for boys)	Stopped scanlating and currently working in the publishing industry
Duke	US	2002	Various, mainly shounen, shoujo & sports	Once offered a job by a manga publisher
John	Austria	Around 2003	Shounen (dedicated to a popular, ongoing series)	Age 37, technician
Peter	US	2001	Shounen, shoujo, etc. (less popular series)	Age 25, webmaster
Tom	US		Action, shounen	College student, Japanese major

groups. By analysing the groups' websites, the author has attempted to obtain information on the process of scanlation, the division of labour within the group, nationality of members, distribution methods, disclaimers, credits and their networks. Then the author selected for in-depth interview a total of 21 scanlation groups seen as the most active (i.e. number of releases and average days for release) and experienced (i.e. date of first release) among the 120 groups. The selection was also based on the criterion of a balanced representation of genres. Leaders of those groups were contacted, and nine scanlators were willing to be interviewed by email (see Table 11.1). They were asked to comment freely on questions about the following themes: a brief history of their involvement in scanlation, motives, ethics, audience for their projects,

and scanlation's influence on the manga industry. Generally from six to ten emails were exchanged between the author and the interviewee per interview. Finally, the author interviewed seven individuals working in the manga publishing industry in the UK, the US and Japan. In order to secure the anonymity of interviewees, pseudonyms are used whenever necessary.

MANGA INDUSTRY: AN OVERVIEW

Manga is one of the most popular media in Japan. According to Kinsella (2000: 4), the best metaphor for manga is 'air': manga is almost everywhere and penetrates the everyday life of many ordinary Japanese. Although a decline in the market has been reported since the mid-1990s, manga is still big business. As of 2005, the value of manga sales was around 260 billion yen for comic books and 242 billion yen for comic magazines, which was almost 23 per cent of total sales for published books of 2,195 billion yen (JETRO 2006). Currently the industry is dominated by the three big publishers, Shueisha, Shogakukan and Kodansha (JMPA 2007). As seen from *Naruto* and *Nana*, many popular manga series normally feed into TV animation series, feature films, full-length animations, computer games and/or a wide range of merchandisable items. Manga's domestic market is large and mature. Readers are diverse in terms of age and interests and their sophisticated and specific demands are likely to be satisfied by various niche manga in the form of weekly, biweekly, monthly, bimonthly or quarterly magazines as well as books (Schodt 1996).

One distinctive element of the industry is fans who are themselves amateur manga artists. These fans produce 'doujinshi', fan books often based on parodies of plots and characters in existing, popular manga titles. Their activities resemble those of *Star Trek* or *Dr Who* fans in the West. Since the 1980s doujinshi culture has found a great affinity with slash literature, part of *Star Trek* fandom (Penley 1992). Doujinshi depicting homosexual relationships between male characters ('yaoi' genre) is produced by female amateur artists and consumed by female readers. What distinguishes doujinshi from slash literature or from science fiction fandom in the English-speaking world is the sheer size of the sector and the volume of the doujinshi trade. There are tens of thousands of amateur manga circles in Japan and their biannual convention, Comic Market or Comiket, attracts approximately 35,000 circles and more than 500,000 visitors (Birmingham 2008; Schodt 1996). Nowadays doujinshi is also sold in mainstream bookshop chains. Another distinct feature of doujinshi culture is the 'ethics' that govern amateur artists, manga artists and publishers. In spite of doujinshi's heavy borrowing from copyrighted materials, both manga artists and publishers tend to be tolerant towards these

amateur artists. In return, doujinshi artists work within boundaries which include an understanding that their work should be a parody not a mere copycat (Kinsella 2000: chapter 4; Lessig 2004: 25–28; Mehra 2002; Pink 2007; Schodt 1996: 36–43). Such an unspoken agreement between both sides seems grounded on the understanding that doujinshi functions as a bridge between producers and consumers and that without copying doujinshi cannot exist. Doujinshi is also seen as being helpful in nurturing future manga artists, which is well exemplified by the case of CLAMP, which was a manga circle and became a popular professional manga collective.

Recent years have seen a rapid growth in the popularity of Japan's manga outside Japan, particularly in Europe and the US. Increasing demand for manga in the European comic market and its potential threat to home-grown titles such as *Asterix* and *Tintin* are metaphorically described in *Asterix and the Falling Sky*, Albert Uderzo's 33rd *Asterix* comic book (2005). This book is about the invasion of the Gaulish village by outer space aliens called 'Nagma', which is an anagram of 'manga'. The villagers defeat Nagma, with help from a good alien named 'Tadsylwine' (an anagram of 'Walt Disney'), who looks somewhat similar to Mickey Mouse, and his companion 'Superclone', who unfailingly reminds readers of Superman. The plot rightly reflects the sea change experienced by the European comic book industry. According to news reports, Manga and their Korean cousins, manhwa, accounted for about half of European comic sales in 2005 (Hickley 2005) and manga alone accounted for 70 per cent of all comic sales in Germany in 2007 (Fishbein 2007). Another example of the popularity of manga is the debut of *Shonen Jump*, the most popular weekly manga magazine, in the form of a monthly magazine in Germany (*Banzai!* in 2001), Sweden (2004) and Norway (2005) (JETRO 2006). In 2000, *Shonen Jump* was launched in the US and has developed a circulation of 180,000, and 2005 saw the launch of *Shojo Beat*, an English-language comic monthly for girls (JETRO 2005).

The US has seen a noticeable growth in manga during the past ten years: industry commentators say the market has virtually doubled every year and the UK is now mirroring this pattern (my interviews, 2008). In English-speaking territories, there are three key players: Viz Media, Tokyopop and Del Rey Manga. Viz Media, the English publisher of the popular series *Naruto* and *Death Note* in addition to *Shonen Jump* and *Shojo Beat* magazines, is owned by three of Japan's largest publishers of manga and animation, Shueisha Inc., Shogakukan Inc. and Shogakukan Production Co. Ltd. Tokyopop is another English manga publisher operating in the US, the UK, Germany and Australia. Meanwhile, Del Rey Manga was launched in the US in 2004 when Random House, the publishing distribution arm of Bertelsman, entered into a publishing deal with Kodansha of Japan. Reflecting manga's huge potential,

recent years have seen big global publishing houses entering the manga business. Simon & Schuster, part of the entertainment operation of Viacom, entered a distribution deal with Viz. HarperCollins, a subsidiary of News Corporation, is collaborating with Tokyopop in publishing manga titles based on US novels (e.g. *Princess Diary*) and in distributing some of Tokyopop's titles (Reid 2006). In the UK, Gollancz, part of the Orion Publishing Group, started publishing manga in 2005 and Random House created Tanoshimi, its own manga imprint, in 2006 (Horn 2007). Meanwhile, Pan Macmillan became Tokyopop's sales and distribution partner in 2006.

In spite of globalization, the manga business is still based on language territories. Different manga publishers (licensees) can be seen working in different territories. For example, a US-based publisher is licensed by a Japanese publisher to translate and publish manga in English and also enters into distribution deals to cover the US and beyond. Depending on its deal with the Japanese publisher, it also can give a licence to a publisher in other English-speaking territories such as the UK. This means that there exists an inevitable time gap, from a few months to a few years, in the publication of manga between Japan and overseas and between different language territories. Even between the US and the UK there is currently a few months' time difference. Another aspect of the global manga industry is the geographical gaps resulting from territories that lack publishers or distributors, which tend to lead to 'grey importing', that is, booksellers importing manga directly from other countries, by-passing local publishers or distributors (my interviews, 2008). One can also point out repertory gaps. If one looks at the huge volume and variety of manga published in Japan every week and every month, it is easily realized that overseas publication of manga reflects only a tiny section of the manga catalogues available in Japan. To a lesser degree though, such gaps exist between different language territories or even within the same territory, such as the US and the UK.

MANGA SCANLATION AS A GLOBAL PHENOMENON

It is difficult to know when manga scanlation began. However, anecdotes from scanlators' accounts suggest it might have been the turn of the century or slightly earlier. The number of scanlation groups has increased rapidly during the past few years. The development and wide diffusion of scanlation activity should be seen within the bigger context of a new and increasingly popular way of global consumption of Japanese cultural products. That is, overseas fans are willing to digitally copy, translate and distribute these products for other fans, particularly those who cannot access them due to geographical and

linguistic barriers. For example, many Japanese animations or 'animes' are now digitally 'fansubbed'. That is, fans download animes, translate them, provide subtitles in English or other languages, and release the subtitled version on the internet free of charge (Hatcher 2005; Leonard 2005; Patten 2004). Today it is not difficult to find fansubbing almost synchronized with TV broadcasting of the original anime. Similarly, one can see Japan's popular light novels[3] being translated by fans of various nationalities into their own language. For example, a website run by a translation group provides Nagaru Tanigawa's light novel *The Melancholy of Suzumiya Haruhi* in English, French, Spanish, Vietnamese, Russian, Polish, Indonesian, Tagalog, etc. Although the processes of scanlation, fansubbing and novel translation and their impacts on the industry might be different due to the different natures of those media, their social, cultural and ethical aspects are not greatly dissimilar.

Noticeably, audiences from many parts of the world are drawn towards Japanese cultural products. Leonard (2005: 283–84) sharply conceptualizes this phenomenon as the 'cultural sink', a lack of quality supply from the domestic market, which consequently leads disappointed consumers to turn their eyes to foreign products, and argues that the cultural sink corresponds to the early stages of demand formation before centralized suppliers organize themselves. In the case of manga this seems true. Mainstream comic books in the US are criticized as being centred on superheroes, with clichéd themes, plots, characters and styles. Fans express their frustration with the lack of comic books that serve the tastes of female and adult readers. In contrast to this, manga provides wide-ranging storytelling. Within its broader thematic and artistic stance, there are highly specified genres which attract specific audiences. In addition, fans identify certain 'Japanese' – often perverted, funny, exotic or quirky – elements as another pulling power of manga (Tom – names given are of research respondents). The current popularity of manga for girls, both in the US and Europe, clearly demonstrates the way a void in the domestic market is being filled by foreign products. The problem is that the response of the industry to the ever-increasing cultural gravity of manga is not sufficiently satisfactory for enthusiastic manga fans outside Japan, who have developed highly articulated tastes and, thanks to the internet, are well informed of the latest news on manga in Japan. For those who want to read the same manga (same chapter, volume or series) available in Japan, the geographical, repertory and time gaps seem a problem which is intolerable but could easily be solved by their *own* efforts.

As of April 2008, the manga section of Baka-Update website, which is one of the most comprehensive websites providing information on fansubbing and scanlation, lists approximately 1,300 manga scanlation groups. Among them,

648 groups are active, which means that those groups have 'released' their work in the past six months. MangaJouhou, another well-established website on manga and scanlation, lists 717 scanlation groups. However, it should be noted that this site lists groups that primarily use English. If one includes groups which use other languages, the number increases. According to the sample survey of 120 active groups, the groups vary in size: from independent, individual scanlators to big groups which have fifty staff or members.

The scanlation process consists of various stages which need various skills: getting 'raws' (obtaining hard copy of manga to scan); scanning (this process generally needs a book form of manga to be unbound); translating; proof reading; cleaning (taking out Japanese text, removing grey areas and some-times redrawing background erased when the text was taken out); editing (inserting English text inside and outside speech bubbles); quality checking; and releasing the scanlated version on the Internet. Independent scanlators do all these jobs themselves while one can see a clear division of labour in larger groups. Often group members tend to take on more than one role. One interesting finding is that most translators are native English speakers who learnt Japanese as their second or third language. Peter says that nowadays the groups are getting a huge influx of semi-capable translators – he gets applications for translators' jobs every other week – who have taken a few or several years of Japanese in high school or college.

Many groups tend to focus on particular genres while also working on others. The manga ranges from currently ongoing, popular series to lesser-known, non-mainstream titles. There are many groups and individuals who scanlate doujinshi (fan books). Some are totally dedicated to doujinshi while others work on doujinshi along with romance or yaoi manga. It appears that the scanlation community treats doujinshi as a legitimate part of manga and contributes to the promotion of doujinshi culture, which is very country-specific, beyond Japan.

Although the majority of scanlators are based in the US and thus are keen on manga licenses and releases in the US, scanlation projects themselves can be seen as an *international* collaboration. Not all sample groups reveal the nationality or geographical location of their members but according to those who do, English scanlation groups involve members from European, Asian, South American and African countries. Iris, who is the leader of a group whose 21 members are based in the US, Europe and Asia, says 'I am amazed at how many parts of the world love manga. I didn't exactly "meet" my staff members – I put up a post on my website saying I needed staff, and they came to me.' The following example shows the variety of nationalities among scanlation group members.

Table 11.2
Variety of nationalities among scanlation group members

Group 1.15	doujinshi	US and France
Group 2.15	doujinshi, boy's love	Britain and Russia
Group 3.20	doujinshi, yaoi and boy's love	Italy, Malaysia and Finland
Group 7.20	shoujo	US, Canada, Philippines, Belgium, Britain and India
Group 17.10	shoujo	US, Germany, France, Canada and Philippines
Group 19.15	ecchi (sexually charged manga) and comedy	US, Canada, Australia and France
Group 26.10	shoujo	US, Singapore, Canada, Italy, Germany, UK, Netherlands, Brazil. South Africa, Vietnam and Malaysia

MOTIVES AND ETHICS OF SCANLATION

Scanlation involves various actors and processes and has its own rules and norms, which in a sense resemble the field of manga production, and thus one may find it relevant to apply the notion of a 'shadow cultural economy' (Fiske 1992: 30). However, it should be also noted that scanlation has unique features that are not easily explained or conceptualized by existing accounts of fan culture and which tend to put great emphasis on the unfixed and dynamic relationship between fan and cultural texts. The core element of scanlation is the 'translation' of Japanese texts to another language and its cultural and linguistic accuracy, the aesthetic quality of editing and sometimes the speediness of release rather than fans' borrowing, inflecting and poaching of texts (Jenkins 1992). In this sense, scanlation is a – sometimes highly organized – serious hobby which could fill the current gaps in the industry and the products of which could function as a temporary or even permanent substitute for an official printing, rather than its alternative reading.

MOTIVES OF SCANLATORS

Motives for scanlation range widely, but one thing scanlators tend to have in common is a strong, *missionary* zeal for *promoting* manga and sharing their chosen manga titles with many others. For them, their motive first and

foremost is their love of, and passion for, manga. Iris says that her group scanlates 'just because we love manga' and, once she started, she became 'addicted'. As a hobby, scanlating gives Peter 'a chance to relax . . . Zen moments . . . a wonderful feeling' allowing him to forget about stresses in his work life. For Amy, who taught herself Japanese for the sole purpose of being able to read her existing collection of doujinshi, scanlation of often unknown doujinshi is her main, expensive hobby. Scanlators places great emphasis on their desire to 'share' their favourite manga and consequent enjoyment with other manga fans and want to see the manga 'reach a wider audience' (Adam, Iris, Peter, Tom). They think the language barrier or lack of translated versions is the biggest obstacle ('It sucks not being able to because of something like it's not in a language you can understand', Tom), which could or should be overcome by their efforts. Group 7.20 says: 'For some, manga is hard to reach in their countries, so we also hope for our scanlations to reach those manga-lovers. And nothing beats the joy and satisfaction of knowing that we can bring others happiness.' Such enthusiasm for sharing looks anew when one considers the existing description of comic fan culture, which is based on differentiation and alienation from newcomers or non-fans (Fiske 1992; Pustz 1999: xiii).

Some scanlators are devoted to particular artists and want to read and fully understand all of the manga their favourite artists have published in Japan. As the artists' old and unknown manga are not likely to be licensed in the English market, they see scanlation as the only way to make these manga widely accessible. This idea is shared by many groups who work on lesser-known manga series: 'they're almost certain to never get licensed in English, and they're great mangas that people should read' (Peter). In the case of popular, ongoing manga series, barriers are more about time lag rather than a lack of English translation. In this case, scanlation means 'the fans can read its weekly chapters every Saturday or early Sunday just after its release in Japan' (John). However, such an approach is criticized by other scanlators, who see their job as being limited to scanlating *unlicensed* manga.

Sharing manga often means creating and participating in a community of manga fans. Adam, one of scanlation's pioneers, found 'a lot of enjoyment in posting a new chapter on my website and seeing the discussion it would generate on the forums'. For Duke, being part of the community was a fundamental motive of scanlating: 'You had your fans, they stayed in your chatrooms, they were grateful for your work, they talked to you and talked about your projects. It was fun.' In addition, scanlating is often seen as being good for learning skills such as Japanese, translation, or editing skills (Charlie, Iris, Tom). The scanlation process requires various skills and the completion of a project gives scanlators a sense of accomplishment. For many scanlators,

achieving a high quality ('to get the chapters and volumes done at the best quality possible in terms of graphics and translations', John) is a strong motive behind their hard work.

ETHICS

Scanlators adopt distinct ethics, which are fundamentally different from those held by music file sharers. It is a well-known fact that peer-to-peer music file sharers are likely to relate their activity to resistance against the music business dominated by big media corporations. They also promote alternative views, which see music file sharing as gift-exchange on a reciprocal basis (Giesler and Pohlmann 2003). Meanwhile, scanlators see using copyrighted manga as inevitable in their effort to provide 'provisional' complements to those currently on offer by the industry. They say that their aim is to get the manga licensed in the US, not to just get free manga. For them, the sharing of scans of officially translated manga or even scanlating licensed – but not published – manga is not very different from illegally downloading music or film files. Evidently, scanlators are governed by their *own* code of ethics which consists of various elements, for example scanlators' rationale or justification for their activities, widely shared rules and norms, and scanlators' views of the issue of copyright and licensed manga. Meanwhile, one should note that there exist various conflicts and tensions between attitudes held by different groups.

NOT-FOR-PROFIT PRINCIPLE

Scanlators firmly believe in the non-profit and voluntary principle. This is generally translated into not making money out of scanlation, for example by charging fees to their readers. However it is common to see many groups welcoming donations (e.g. through Paypal), while others emphasize the full principle of being non-profit. For example, a group says that it does not allow any sites that are supported by donations to host their projects (group 24.15). Nonetheless, the scanlation community shares the idea that scanlation for commercial purposes should be strictly forbidden.

GETTING RAWS: 'AT LEAST BUYING THE ORIGINAL'

'Raws' refers to an original Japanese version of manga which is used for scanlation. There are a number of ways to obtain raws: buying Japanese

manga; downloading scanned Japanese raws from English 'raws websites'; or downloading scanned manga from peer-to-peer file sharing websites in Japan. Many of the interviewees argue that buying Japanese manga and magazines and scanning them in themselves is the best way because at least this allows them to support manga artists in Japan and to achieve high-quality scans. Iris says that she does not like 'using stuff people have already put online' since she 'at least owes them the purchase of their book (or magazine)'. Similarly, Peter does not respect 'anyone who refuses to buy and scan in their own raws'. Amy, who only scanlates doujinshi, always buys doujinshi – whatever the price in the case of books for which she has been looking – and uses her own collection as raws. However, John's group, which is dedicated to an ongoing series, uses raws sites in order to get raws once a week. Nevertheless, John owns the volumes of XXX in Japanese and some English prints.

'WE DROP THE PROJECT ONCE IT IS LICENSED' RULE

Another influential norm is that when a manga is licensed its scanlation and distribution is stopped. Although there are groups – particularly those who work on ongoing series – who are not tightly bound by this norm, many participants tend to regard it as an important criterion that distinguishes scanlation from illegal file sharing. The websites of many scanlation groups say they would drop the project and stop distributing scanlations when a title or series has been licensed by a publisher in the US or when the US publisher asks them to stop. Scanlators are alerted about, and generally have a good knowledge of, licence deals in the industry. In a sense, they have a clear 'sense of place or time' in spite of their entire reliance on the Internet and digital technology for their work and communication. For example, one can easily come across various announcements of licence deals between Japanese and US publishers on scanlation websites:

> [Four titles of manga series] have been licensed and translated by X, all rights are reserved to them. If they ask for those pages to be taken off they will be. XX holds the North American rights to [two titles], though we are still scanlating them. If they ask for us to stop, we will. [Two titles] are licensed by XXX and again, if this is asked to be taken off, they will be . . . (group 2.25).

Once a manga has been licensed, scanlators think their job is over and strongly suggest that their readers should buy licensed manga in order to support the artist and the industry: 'If you liked these scanlations, please support the

mangaka [manga artists] by buying their works!' (group 7.20); 'We are not trying to rip off the authors; in fact we have always encouraged readers to buy their own copy' (group 2.20). For them, scanlation is not an excuse for not buying the book but *'an incentive'* for buying it (group 11.5, original emphasis). Those who scanlate old or less popular manga think their activity fits nicely into this norm as the manga they use is unlikely to be licensed in the US. In this sense, the ethics of scanlation seemingly give more weight to US copyright law than to its Japanese counterpart. Although it is not clear if this is a result of serious deliberation of potential costs for breaching the former which is much stricter than the latter, scanlators' focus on unlicensed manga appears to strike a balance between satisfying fans' eagerness to access manga that is not available in the US market and guaranteeing financial motives of US licensees. However, this rule is sometimes criticized as being US-centric by fans outside the US, who rely on English scanlations to access manga.

THE IMPORTANCE OF 'BEING CREDITED'

While freely borrowing copyrighted manga, scanlators stress that 'All rights of the manga belong to the authors and their respective copyright holders' (group 7.70), for example through a disclaimer section at their website. As for scanlation *per se*, however, they tend to claim strong ownership and control. A scanlated manga normally has a 'credits page' at the beginning or end. For example, each chapter of the scanlation of a shoujo manga, which was later licensed by Viz Media, has a total of three dedicated credits pages. While the first and final pages state that the 'scanlation is presented by' XXX group and give details of the group, the second page specifies who scanned, translated and edited.

The scanlated manga is distributed in various ways including scanlation distribution and hosting sites. While some scanlators do not want redistribution, many tend to be happy about it but under the condition that they receive appropriate credits. The websites which want to host scanlations are normally required (1) to get permission from scanlators or at least let them know in advance, (2) not to alter the content of the zip file which contains the credits pages, (3) not to claim the scanlation as their own or (4) to provide a link to the scanlators' own website. In addition, application of the 'three (or four) days' rule is often requested: scanlations may be redistributed three or four days after release. Similar rules apply to the 're-translation' of English scanlators' work into another language such as Spanish, Polish or Russian. For example, group 5.20 says:

ALSO it is **MANDATORY** that you [re-scanlators] credit us for the original work and link every translated scans back to us, please use the Credit logos that we've attached per chapter for this purpose and link your website back to us.

Some groups ask re-scanlators to stop using their scans and translations immediately if the project is licensed in English. Meanwhile, there are groups who do not allow re-translation of their work for various reasons, ranging from the problems of 'improper credit', 'multiple re-scanlation of a manga' and 'damaged integrity' to the promotion of a self-help attitude ('we spend a lot of our time and money. You should do the same'). In some cases, English scanlation groups want their scanners, editors or translators to be independently consulted as they believe that those participants have the right to give permission, for example for scans of Japanese manga or the English translation itself. Scanlators' strong sense of ownership over their work looks paradoxical considering their free use of copyrighted materials. Their identity seems to move between that of fans who borrow copyrighted manga for personal uses and that of cultural producers who are emotionally and artistically attached to their products and conscious of their audiences.

SCANLATION AND THE MANGA INDUSTRY

It is difficult to know how the Japanese manga industry perceives scanlation as there is little discussion on it apart from a few news reports. Given the industry's tolerance to doujinshi, one can assume that scanlation might be seen as a similar kind of fandom. For some manga artists, the scanlation of their work into various languages could be a surprising experience. For example, when CINDY met her favourite manga artist – a very popular shoujo manga artist – to whose work her group is committed, the artist said that while she could not talk about scanlation's legalities and how the Japanese publishers might feel, she 'appreciated the exposure and was overwhelmed that there were so many fans . . . '. However, contrary anecdotes also exist: the scanlators interviewed have not been contacted by Japanese manga artists or publishers but have heard about such a case, although it is exceptional. The interviewees in the US and UK manga industry have rarely discussed the issue of scanlation with Japanese artists or publishers. Some of them suggest that the Japanese manga industry is not bothered too much with scanlation taking place in 'foreign countries' because it is facing bigger issues such as declining domestic sales due to the decreasing youth population, the rise of second-hand bookshops and manga cafes, and the abundance of alternative options for

personal entertainment. Recently, the issue of scanlation has gradually drawn more attention as Japanese publishers are becoming keener on exploiting overseas markets. However, the industry's attitude seems watchful. It appears to see the scanlation boom as an indicator of unfulfilled demands for licensed manga in foreign countries, rather than taking it as a legal issue (IT Media News 2007). There also emerged an attempt to induce scanlation to legitimate manga publishing: Manganovel and Toshiba launched a website which allows readers not only to download Japanese mangas but also to scanlate them and offer the scanlations for sale (Business Wire 2007).

The US and the UK manga industry is clearly aware of the existence of scanlators ('I know it's there') and regards it as illegal. However, the industry does not fail to recognize the fan culture aspects of scanlation, for example its personal and emotional nature. As an individual's hobby, scanlation is seen as something the industry cannot simply manage to stop: 'you know we cannot stop them from doing it . . . because they are doing it for fun and it is their hobby' (my interviews). Nonetheless, the industry wants the rule of 'drop the project once it is licensed' to function effectively. When publishers get a licence for a particular title, they ask scanlation groups or distribution websites to stop scanlating and distributing it. In general such a request is responded to positively by the scanlation community though there are groups who are not willing to comply with the rule. Industry observers say that the US manga publishers have not issued 'cease and desist letters' to scanlators and are reluctant to do so as taking legal actions might harm their relationship with hardcore fans (Deppey 2006; my interviews). This might be the reason why the industry has not even tried to shut down for-profit scanlation distributors such as Narutofan.com, which is heavily criticized by the scanlation community.

While acknowledging the 'double-edged sword' nature of scanlation, both scanlators and the publishers do not see scanlation as having any detrimental effect on the sales of manga. On the contrary, many interviewees believe that the success of scanlation as 'a word of mouth' and 'community way of reading manga' has helped certain manga series become licensed and released in the US. For example, Dallas Middaugh, an associate publisher for Del Rey Manga acknowledged that when he was at Viz Media in 2001 and 2002, he was 'following scanlations as a way of discovering new titles' (Deppey 2006). Similarly Steve Klechner, the then Tokyopop's vice-president of sales and distribution, said that he found scanlation 'flattering, not threatening' and useful for sensing what the market wants (Yang 2004). In the case of Adam's group, all of its projects were licensed and thus his site stopped releasing them. Even for popular ongoing and licensed series such as *Naruto*, it is difficult to know if scanlation has had a harmful effect on their sales because 'the series

that are most scanlated have sold the best' and 'they are so popular that even people who are reading scanlation would buy physical copies as well' (my interviews).

Interestingly, the scanlation community and the manga industry share the opinion that scanlation's substitutability for licensed manga is low. Scanlators firmly believe that there is a fundamental difference between 'opening the book and sitting down reading it' and peering at a screen. This assumption is seconded in the industry: 'there are a lot of them who may be still buying the books if available'. It is in this context that both the scanlation community and the industry often compare scanlation to anime fansubbing – its sub-stitutability for DVD is relatively high – saying that scanlating does not cause the same harm as fansubbing because fans still want to own the actual book. However, the recent development of the e-book industry, and particularly the growth of the e-comic book business, as exemplified by the mobile comics boom in Japan and the launch of Marvel Digital Comics Unlimited, implies that the landscape might change in the future (Glaister 2007; my interviews).

CONCLUSION

Manga scanlation succinctly demonstrates how fans outside Japan engage with Japanese popular culture in the age of globalization and digitalization and how many gaps exist between the industry's current offer and the demands of fans. In many senses, it presents a unique dynamic in the industry–consumer relationship which needs to be further investigated. One hypothesis that could be deduced from the findings of this chapter is that the global manga industry which relies primarily on Japanese artists and publishers is by nature different from other cultural industries. It might be heavily influenced by the 'culture' of the Japanese manga industry, where a strong fan culture flourishes and participatory fans' borrowing of copyrighted manga has been tolerated. Similarly one could identify a great proximity between the ethics of scanlation and that of doujinshi. Another hypothesis might be that scanlation is a temporary phenomenon occurring in the global manga industry while it is still in its infancy. By functioning as a market tester and a demand former, scanlation is filling the gaps which unavoidably exist in the process of the industry's early development. However, it might become less attractive as the industry matures and global manga publishing becomes synchronized. In order to examine these hypotheses and their links, more empirical research should be conducted. In the meantime, scanlation's balancing act between the interests of publishers and consumers is likely to lead one to leave behind for a while those familiar debates around illegal file sharing and to deliberate on

the possibility of a cultural industry developing its own ethics that are agreeable to and can be respected by both producers and consumers, however temporarily.

NOTES

1 World Intellectual Property Organization's Summary of the Berne Convention for the Protection of Literary and Artistic Works at http://www.wipo.int/treaties/en/ip/berne/summary/summary_berne.html (accessed on 27 June 2008).

2 An established manga translator and the founder of Proteus Studio, Toren Smith states on an anime blog that ' . . . scanlations are illegal derivative works to which the producers of same have no rights whatsoever'. See http://chizumatic.mee.nu/ianal#c6 (accessed on 10 August 2008).

3 According to Wikipedia, a light novel ('wasei-eigo') refers to a novel with anime- or manga-style illustrations, which mainly targets teens and young adults. These novels are often adapted into a manga or a TV anime series. See http://en.wikipedia.org/wiki/Light_novel (accessed on 23 May 2008).

12

BLUEGRASS REVIVAL

Marketing and Authenticity in the Hills of Appalachia

Elizabeth C. Hirschman

An INTRIGUING MUSICAL movement is under way in the hills of Appalachia that stretches well beyond the secluded mountains and notoriously independent inhabitants. This phenomenon is the rebirth of bluegrass music which now is becoming as 'hot' as rap and hip-hop among the musical cognoscenti and tastemakers. What is fascinating about this is that it echoes the underlying mythology that informed the attribution of authenticity to urban hip-hop as a musical form a decade earlier (George 2005; Kitwana 2003; Chang and Herc 2005; Watkins 2006). Just as urban blacks are seen as having a genuineness of experience that is communicated to the rest of us through their music, and the 'street-cred' of black singers and musicians is evaluated both within and outside the community by references to violence, prison time and gang membership (Kitwana 2003), the rural whites who are the source of bluegrass are evaluated using the same 'down and dirty' criteria of authenticity, yet they are geographically situated in dense green rugged mountains instead of sagging cityscapes.

Both the urban hip-hop culture and the hillbilly world of bluegrass seem to be viewed as authentic *because* they represent places (both physical and emotional) where the majority of white, suburban music buyers greatly fear to go. The implication is that if one is capable of making music in such threatening terrain as downtown Detroit or rural West Virginia, then the musician must possess some inner strength, some resolute determination, some source of courage and toughness that the majority of Americans are sorely lacking. Fans hope that perhaps by buying and listening to these musical forms, some of their sought-after essence will be transferred to the listener.

My present purpose is to report the results of a summer spent in Appalachia travelling to various music-making venues and observing the musicians, promoters, local audience members and tourists/outsiders who are participating in the making and re-making of bluegrass. What I *suspected* we would

find is an upwelling of pride among Appalachian residents that 'their' music and culture are becoming valued by the population outside of the mountains. Here is what actually happened.

WHERE AND WHAT IS APPALACHIA?

Appalachia is both a place and mind-set. Like the term 'inner-city', it can refer to a physical locale. For example Downtown Detroit, Harlem, Chicago's South Side, and New Orleans Ninth Ward can be 'translated' into Appalachian locales such as Harlan County, Kentucky, Beckley, West Virginia, Big Stone Gap, Virginia, Hancock County, Tennessee, and Flat Rock, North Carolina. From the outside, they are perceived as wild, dangerous and uncharted – in a sense, both the inner-city and Appalachia represent undeveloped, third world countries that happen to exist inside the borders of the United States. Many researchers of both tourism and cultural anthropology have noted the association of authenticity with such locales. Appalachia and its residents represent the Exotic, the Other; they just happen to be located off major US

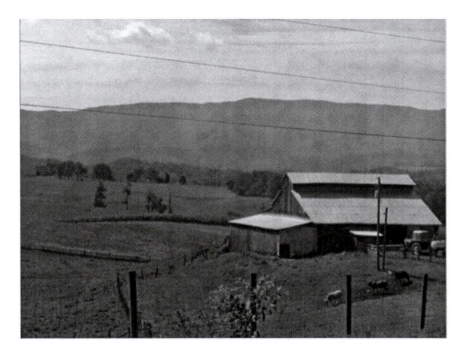

Figure 12.1
The rural Appalachians represent security to residents, but can be threatening to outsiders

highways instead of in Africa, the Andes, or Azerbaijan. Yet, like those regions, Appalachia is characterized by a largely rural economy and endemic poverty.

An article in *Newsweek* magazine (August 11, 2008: 4), for example, states that 'while the [US] presidential candidates debate health care policies, uninsured residents are lining up for teeth extractions at volunteer clinics in places like Wise, VA'. The 14th July 2008 issue of *Newsweek* carried an article titled 'The voters of Appalachia are Hicks, Hillbillies, Rednecks' written by a journalist, Steve Tuttle, who was born in Appalachia. He terms it 'the last forgotten place in America' inhabited by 'my people: a bunch of ornery, racist, coal minin', banjo pickin', Scots Irish hillbillies clinging to guns and religion on the side of some Godforsaken, moonshine-soaked ridge in West Virginia' (p. 40).

A brochure by the Appalachian Community Fund, headquartered in Knoxville, TN, targets four impoverished areas of central Appalachia: eastern Kentucky, southwest Virginia, east Tennessee and West Virginia (in its entirety), characterizing them as 'a region whose rich and varied culture and natural resources have been taken for vast profits, leaving behind the deepest rural poverty in the nation' and promising to promote community-based economic opportunity, medical assistance for disabled miners and environmental activism.

This same theme is echoed metaphorically in the *Trail of the Lonesome Pine*, an outdoor drama performed every July and August in Big Stone Gap, Virginia. The brochure for this play declared it to be:

> a fascinating, exciting and tender love story of a beautiful Virginia mountain girl and a handsome young mining engineer from the East. The drama depicts the story of the great boom in Southwest Virginia when the discovery of coal and iron ore forced the lusty, proud mountain people into making many drastic changes in their way of life. The homespun wit and humor of these mountain folk is intermingled with stark tragedy . . . , violence, and final acceptance of their inevitable destiny.

The two principal characters in the story are:

> June Tolliver, the mountain lass, who through her love for Jack Hale, becomes transformed into a sophisticated young lady [and] Jack Hale, the dashingly handsome engineer, [who] uses his sophisticated, worldly charm to win her heart amid the frustrations of a feuding mountain clan.

In sharp contrast to the Appalachian Community Fund brochure, which cast mining and industrialization as destructive of the population and its culture,

this theatrical offering depicts it as beneficial. Yet there are internal contradictions here, as well. For example, the brochure has a subhead below the map showing how to reach the town which states, '4-lane [highway] all the way to Big Stone Gap'. This is clearly aimed at enticing tourists on the interstate highways to exit and come by for a visit. They are promised that the Craft Shop nearby carries 'articles made by the mountain people such as weaving, painting, woodcraft, corn shuck dolls and other unique mountain handicrafts, including coal jewelry and figurines'.

The tendency of the Appalachian region to market itself as more primitive, natural and unchanged than the 'outside world' is reiterated in other communications. For example, the *Blue Ridge Digest* published in Asheville, NC, by the Blue Ridge Parkway Association, contains articles and advertisements for the Appalachian Quilt Trail which promise to help 'you gain an even greater understanding of why the quilt is an enduring symbol of family, heritage and community . . .'(p. 18, *BRD*, summer 2008). The Annual Craft Fair of the Southern Highlands,

> a local tradition since 1948, . . . offers people the opportunity to connect with the artists by purchasing directly from them. In an age of mass production and imports, the connection to fine American craft and the individual maker is more relevant than ever.
>
> (p. 13)

And yet the presence of modernity lurks everywhere. An advertisement for New Found Lodge in Cherokee, NC, (in the same issue of *Blue Ridge Digest*) promises the tourist a 'phone, coffee maker, fridge, cable [tv], two restaurants: a [Shoney's] Big Boy and Pete's Pancakes and Waffles. Three gift shops, a Citgo Station with Mini Mart . . ., Outdoor drama and Indian Village [and only] two miles to Harrah's Casino'.

The *2008 Visitors' Guide for Northeast Tennessee*, published in Jonesboro, TN, contains a listing for Appalachian Caverns, 'used by Native Americans and as a Civil War hospital and shelter by early settlers . . . RV camping is available with electricity and water' (p. 2). Other recommended venues include the Union County Heritage Museum ('the unique history of this small mountain community'), Exchange Place in Kingsport, TN ('. . . will take you back to a pioneer farm homestead when people lived off the land' (p. 6)), and, antithetically, the Bristol Motor Speedway and Dragway, 'American's favorite NASCAR track . . . the new fan zone provides interactive videos, drag racing simulators and real cross-sectioned stock cars' (p. 3).

BLUEGRASS AS SYNECDOCHE OF APPALACHIA

I am going to argue that 'as-goes-bluegrass,-so-goes-Appalachia'; that is, the reputation, popularity and promotional activities on behalf of bluegrass music, I believe, are indicative of the perceptions and attitudes of non-natives towards Appalachian culture, generally. This is because bluegrass music is seen as a metonym or synecdoche for Appalachian culture both within and outside its regional borders. Tuttle (2008, p. 40, *Newsweek*, July 17, July 14) in his extensive article on 'The Voters of Appalachia' states towards the end of his article:

> As soon as I finish writing, I'm getting in my Jeep and driving with my brother and Dad to a blue-grass festival in Summersville, WV, where I'll spend a solid week standing in a field playing songs with names like Cripple Creek and Rabbit in the Log on my banjo
>
> (p. 41)

Tuttle is from West Virginia; therefore his article implies that bluegrass music is something Appalachian natives 'do'.

An article by Thomas Beller (September 2008, *Travel and Leisure*, p. 100, 'Virginia Real') strikes this same theme from the perspective of an outsider to Appalachia: 'Friday nights at the Floyd Country Store, a jamboree of blue-grass music starts at 6:30 and ends around 10:30. It has been going on for as long as anyone can remember. The performers are mostly amateurs from the surrounding hills, and there is dancing. The first time [his friend] saw the jamboree, she was moved to tears.

BLUEGRASS IDEOLOGY

The term bluegrass encompasses an ideology as much as it does a musical form. Consider what Erbsen (2005) says about hearing his first bluegrass performance in 1964:

> As soon as Vern [the singer] opened his mouth to sing, I knew I had found what I was looking for. Sitting in that hot, smoky room, I could feel the shivers running up and down my back. Just the tone and power of his voice spoke volumes about life in rural America. His high, piercing voice had a raw power that conjured up images of rustic log cabins and tall craggy mountains.
>
> (p. 7)

Historian Neil Rosenberg (2005) writes that,

> Bluegrass. . . . was discovered in the fifties by people who perceived it as a vital new musical form coming from America's hardiest folk pocket, Appalachia . . . [It was] the latest authentic expression of poor, rural, working-class, pioneer America . . . Most of those involved . . . were white Protestants of rural origin . . . [and] predominately young men'.
>
> (pp. 13, 18)

Additionally, bluegrass is characterized by specific instruments: the fiddle, mandolin, guitar, 5-string banjo, Dobro and bass, which are played acoustically rather than electrically. Virtuoso skills are required and the tempo is quite rapid (Rosenberg 2005). Singing is often high pitched and uses flat and sharp notes, giving it a strained, often shrill, caustic sound (Rosenberg 2005). The unconventionality and 'wildness' of the music helps establish it as a metaphor for the unconventionality and uncivilized nature of Appalachia.

Album promotional texts further reinforce this analogy:

> . . . real, authentic, hill country pickin' and singin' . . . Listen to the spirit and sincerity of the Stanley Brothers as they sing . . . They really live and feel their music . . . We at Mercury are extremely proud of the Stanleys, these hardy men of the hills, who are so true to their heritage.
>
> (Quoted in Rosenberg 2005, p. 141)

> [These musicians] play mountain music in the authentic style which was passed on by America's first settlers and is the kind of pickin' and singin' that lovers of real country music like to hear. These are the old songs sung in the old mountain manner without corruption by the many modern sounds that characterize some of the so called country music of today . . . Clean, down to earth . . . If you are one of those people who want the real McCoy, who likes to hear the best traditional style country musicians in the business, playing the instruments that our forefathers played, you are in for a treat . . .

These descriptions idealize bluegrass performers as being both purer and less corrupted than current musicians, while at the same time calling upon nostalgic images of a golden past in which life was not only simpler, but *better*.

DATA GATHERING AND INTERPRETATION

My daughter, Shannon, and I lived in Abingdon, VA, located in the extreme southwestern section of the state, during June, July and August 2008. We have a small summer house there, and Shannon is able to ride horses almost every day at a nearby horse farm. Abingdon is virtually at the centre of southern Appalachia – lying at the midpoint where Tennessee, Kentucky, North Carolina, West Virginia and Virginia come together. This location provided an ideal site for experiencing both Appalachian culture and bluegrass music.

Over the course of the summer, I visited several venues in the surrounding states; some were festivals directed towards attracting tourists and travellers, while others were highly localized. I took field notes at six locales. My working hypothesis or foundational narrative evolved from an initial expectation that the venues would be fairly commercialized and feature sophisticated marketing efforts designed to attract outside tourists (and their dollars). This way of thinking gave way fairly quickly to the recognition that marketing efforts were relegated to secondary status (at best) and that a distinct ambivalence was present towards promoting the region, and its music, as a destination for those living outside its borders. Most emphatically, the musical presentations were not designed – or intended – to be slick, professional or mainstream. Indeed the concerts and performances were truly authentic in the core sense that they were created by and consumed by locals, i.e. the Natives, not the Others.

The discussion below progresses through the summer's site notes in a longitudinal fashion.

Jonesboro, TN, 4:00pm, July 4, 2008.

Jonesboro promotes itself as 'Tennessee's Oldest Town', is listed on the National Trust for Historic Preservation and invites visitors to 'watch a crafts-man at work, and take a tour or carriage ride through our historic district'. During the July 4 weekend, the town celebrates Jonesborough Days: 'a time when the community expresses its patriotism and pays tribute to the traditions, heritage and courageous settlers of the area'.

I arrive at 4:00pm and sit down in a small café area within the town square where a young, female fiddler and an older, long-haired, male guitarist are playing as part of the festival. About half the audience of thirty or so people appear to be locals, while the rest appear to be tourists who have come by to see the town and celebrate July 4 in Appalachia. The age range is from infants to nineties. All are white. I am struck by how much the setting, the music and the audience are a blend (or compromise) between the rural and the modern,

the old and the new, the genuine and the fake. The musical duo, for example, improvise as they play, declaring, 'We're makin' this up as we go along . . . Whatever fits together, fits together', and yet they mention they have CDs for sale. They are playing under a white canvas canopy held up by a new lumber frame; their instruments are plugged into amplifiers and they use microphones.

The next performer is a young man (thirtyish) wearing a cowboy hat who plays an acoustic guitar. He describes his music as 'unadorned, unglamorous . . . just real'. He mentions singer Johnny Cash and the motion picture *Walk the Line*, and the film *Oh Brother, Where Art Thou?* with actor George Clooney. He tells the crowd the other concerts he will be performing over the next few weeks (all local venues) and mentions he has CDs for sale: 'Please buy some; I need the money.' He provides a commentary on the 'sacrifices of the military in Iraq', freedom (e.g. 'they don't have freedom in North Korea or Tajikistan') and then closes his set with *America the Beautiful*.

I venture into the surrounding shops and displays. There is a man selling antique guns, rifles and saddles (all of which are functional) in a log cabin that also serves as a historical monument. The cabin has no electric lights, but the

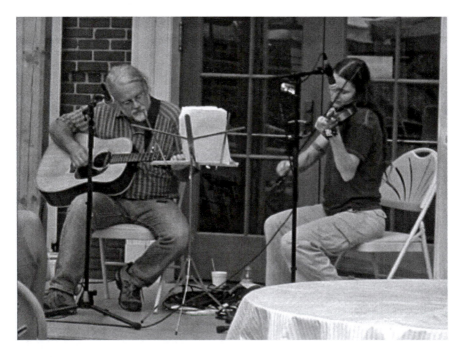

Figure 12.2
Musicians at the Jonesboro, TN, Fourth of July Festival

merchant does have a battery-powered laptop computer. A little farther down the block there is a Native American street vendor from Guatemala (Central America) who is selling Southwestern-style Indian souvenirs that are made in China. The juxtaposition and interblending of the real, the fake, the displaced, the pretend and the authentic is startling.

July 10, 2008, 7:20pm, Bristol Mall, Bristol, VA.

I attend the 'Pickin' Porch', a regular Thursday night concert sponsored by the Mountain Music Museum and Appalachian Culture Association. This is held every Thursday at the Bristol, VA, shopping mall. The concert locale, itself, is across from the mall's food court in the Chic-fil-a-Auditorium, a fast-food restaurant at the mall. The auditorium holds around 200 people and tonight is around two-thirds full; the audience is about 60 per cent female; most are aged 40 and above. There are several sets of grandparents with grandchildren. There are no teenagers. The audience is entirely white, and almost wholly local.

The band is a regional bluegrass group consisting of three men and two women. They introduce themselves and the leader tells the audience, 'I stayed down South . . . They wouldn't let me go nowhere else.' He asks the audience 'who is from the farthest away?' and a visitor from Alabama wins. As the band launches into a bluegrass favourite, *Shady Grove*, a heavy-set woman and her child go up to the front of the auditorium and begin clog dancing. They are soon joined by several others. Notably, the dancers are not in couples, just in clusters or singles. I note that there is a giant Chic-fil-a stuffed toy cow sitting in a chair to the side of the stage.

The band alternates between fast, high-spirited bluegrass numbers and slow, melancholy country ballads. Many of the latter deal with alcoholism, unemployment, and emotional loss, e.g. 'He's a dead man walkin', chains around his feet, in a prison of his own makin' . . . ' The band (which includes a bass player from New York City) closes with a gospel ballad, *There's a Healer* [i.e. Jesus] *in this house*. I am reminded of Presidential candidate Barack Obama's comments about rural folk being 'bitter and clinging to guns and religion'. These rural folk do not seem bitter in the least, but they do hold religion dear.

Friday, July 25, 8:00pm, Highlands Festival, Abingdon, VA.

For the past sixty years, Abingdon has held a two-week Highlands Festival in late July and early August. The festival includes craft exhibits and vendors, an antiques fair, historical re-enactments, town tours, a farmers' market, balloon race and musical concerts. The July 25th musical presentation – held in a large

outdoor tent set in a parking lot – featured performers from the area who had put together a collection of songs about coal mining, an industry integral to Appalachia.

The audience is packed, seated in folding chairs on the pavement, and consists of about 150 persons, mostly white, ages 40+. The great majority are locals from surrounding towns. The first song of the set, *Dyin' to make a Livin'*, is indicative of the themes presented during the concert. Coal mining is dangerous, difficult work, but it pays more than farming (the other primary type of job available in the area). There are several women performers, often singing a cappella, who render ballads about losing husbands and fathers in the mines: 'Dirty old coal, you've stolen my soul', 'Once I had a Daddy and he worked down in a mine . . . Will he ever come back to me or will they leave him in the ground?'

Mention is made of the film *Coal Miner's Daughter* which is about country singer Loretta Lynn who is from Kentucky. The film *Matewan*, which documented the coalfield violence in Harlan and Hazzard, KY, is also noted. It is as if these 'unreal' cinematic offerings of popular culture render more authentic the actual lives of the local folk who are miners. Yet it is an intensely real evening. Between songs, I can hear the cicadas humming furiously in the trees, while incongruously, a helicopter flies overhead. The man sitting next to me turns sideways to spit out his tobacco juice, and the people sitting behind me engage in conversation from time to time with passers-by they know. The ambience is comfortable and intimate.

Several of the songs are about highly specific places and events, e.g. Harlan, KY, the Blue Diamond Mine, the Pittstown (WV) mine disaster. I am reminded that Appalachian culture is *intensely local*. Many of the Appalachian people are born, live, work and die in very circumscribed areas. Tonight I do detect the rural 'bitterness' that has been alluded to nationally. As one performer put it, 'there's a lot of anger here toward the outsiders who promised people money and then exploited them'.

August 6, 2008, 10:00am – 2:00 pm, Jubilee Retreat House, Abingdon, VA.

$12.00 workshop on Old Time Music

As part of the Abingdon Highlands Festival, several arts, crafts, photography and music workshops are held with local persons serving as the instructors. This Old Time Music workshop is led by a woman named Jane Rhodey who was born in West Virginia and has a master's degree in Appalachian Cultural Studies from Appalachian State University in Boone, NC. She is also a professional musician and – consistent with the other performers I observed – has CDs, as well as a $75 'baby dulcimer', to sell. She has brought to the

Figure 12.3
Concert-goers at the Bristol, VA, shopping mall concert

workshop her collection of 20 or so hand-made Appalachian musical instruments – ranging from a bass to dulcimers to banjos – for attendees to see and try.

Most of the attendees are from surrounding retirement developments; several hail from the Northeast (e.g. Boston, New Hampshire, Connecticut) and Midwest (e.g. Chicago). All are white; most are female. There is one male and one female teenager. Most are dressed very casually in shorts, sneakers or sandals, with loose cotton shirts. Jane Rhodey, herself, wears an ankle-length, multi-colour cotton dress and a kerchief over her hair.

During the workshop, she asks for volunteers to come up and try various instruments. One of the most primitive is a bass fiddle consisting of a 4 foot wooden stick, an inverted aluminum wash tub, a pig gut and a #3 metal ring bolt. Frets have been cut on the stick to guide noting. Remarkably, it makes a good musical sound and most of us are able to pick out a tune on it. Rhodey's point here is, 'Anyone can make good music; they've just got to try.' That is, making traditional Appalachian music is not a rarified art form or specialized skill. It is common and 'commoner' music, capable of being produced by plain, rural people out of everyday household equipment.

Figure 12.4
A collection of handmade Appalachian musical instruments

Several of the home-crafted instruments have leather or hide parts obtained from local wild animals. One dulcimer has a sound-board made of groundhog hide. Another dulcimer is strung with cat gut. Rhodey states that 'Yeller [yellow] cats have the best guts for stringing . . .'

Interestingly, she draws a distinction between Old Time Appalachian music, which she claims originated in eastern Tennessee, southwestern Virginia and eastern Kentucky, and bluegrass music, which she describes as 'all about being on stage and showing off on your instrument'. She notes that early commerce in Appalachia was based on barter (the local term is 'sworping', i.e. swapping) and that dulcimers and banjos were often made and exchanged as barter goods. Many were labelled with the maker's name and often are highly idiosyncratic in design and decoration. One dulcimer in her collection is constructed from a cardboard box.

As the workshop progresses, specific audience members become increasingly confident in their handling of the instruments and are able to form an impromptu band accompanying Rhodey in her singing. Rhodey tells us, 'These are very friendly instruments; you can personalize the music, develop your own style.' She also states that, 'Old Time music is carried [forward in

the culture] by women, while bluegrass is mostly men.' One of the men in the audience aims to prove her wrong and volunteers to play the washtub bass, dancing as he strums. Everyone claps for him.

By the close of the workshop, virtually all audience members, including the two teenagers, have had a try at playing. The 'hands on' style of instruction has made most attendees feel not only competent, but happy, at making Appalachian music. Even those whose roots are from far outside the region seem to now feel more at home.

August 9, 2008, WMAX in Norton, VA and Carter Fold in Hiltons, VA.

Shannon and I drive for over an hour to Norton, VA, to see radio station WMAX which, according to their website, is supposed to have a live bluegrass concert every Saturday night. The concerts are called the VA-KY Opry and began in 1995. The website claims it 'has become a landmark in area entertainment and a lasting attraction for both local fans and tourists'.

However, when we arrive at 7:00pm, Saturday night, the doors are locked, the ticket office is closed and the street in front of the station is largely empty. There are no signs or listings of performances posted. Deeply disappointed, we next head toward the Carter Fold in Hiltons, VA, a 1½ hour drive over narrow roads in the opposite direction. Because there is no street address listed for the Carter Fold either on its website or in its promotional brochures, and virtually no roadway signing, we must stop at several gas stations and convenience stores to ask directions. These instructions are often conflicting and unclear. I call the Carter Fold on my cell phone and get incorrect directions, as well. Night is falling and we are soon driving on a desolate, dark, winding highway that seemingly is heading to oblivion. (It dawns on me that an actual tourist in this situation would probably be panic-stricken. Will they soon be set-upon by drunk, in-bred mountain dwellers?) Being a native, I am just angry and frustrated to be spending Saturday night driving all over southwestern Virginia. However, Carter Fold is the Holy Grail of country music/old time music/bluegrass music, and so we press on.

Then, in the distance, there is a bright glow. Scores of cars are now parked along the highway. We pull up at a large, handsome, wooden building covered in flood lights. A Carter Family mural is painted on the exterior walls. Bluegrass music flows out of the building which is literally located in the middle of nowhere!

The cashiers let us enter for free because we have arrived so late (9:00pm). Inside is a remarkable scene. A local bluegrass band is playing on stage and about 200 persons – mostly female and 40+ and consistently white – are in the audience. In front of the stage is a large, wooden dance floor upon which

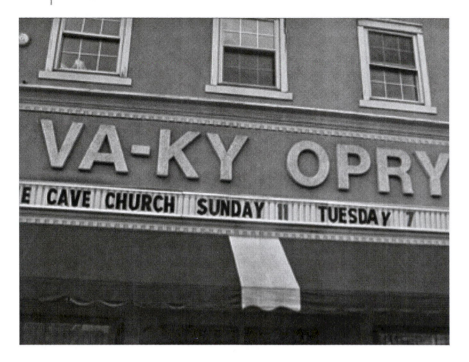

Figure 12.5
The Norton, VA, bluegrass music radio station marquee

persons of ages ranging from 3 or 4 years old to 80+ are 'clogging'. Some are in family groups, some are in girl–girl groups, some are in couples, and some are just singletons out on the floor clomping away. Dress is very casual. Most people are wearing shorts, pants or jeans, t-shirts or cotton button shirts. Notably, several of the dancers are wearing black patent leather tap shoes. Some are just pounding away on the floor, while others are rhythmically moving along the floor in graceful arcs and lines.

I am amazed to see a friend, Lisa Alther, who lives in Kingsport, TN, and her friend, Ina, who is superintendent of the Bristol, VA, school system. They have brought their out-of-town houseguests who are now sitting, somewhat nervously, in the stadium-style seats, watching while Lisa and Ina clog. (Both Lisa and Ina are wearing the fancy black tap shoes.)

My daughter, Shannon (born and raised in New Jersey), is similarly anxious about the scene before her: 'This is Hicksville. Let's out of here!', she declares. (I can tell that she is relieved to see Lisa and Ina there; the strangeness of the whole scene was unnerving to her.) And yet the venue is remarkably safe. There is no alcohol or smoking; no yelling or screaming. Except for the presence of electricity and a modern sound system, the performance and

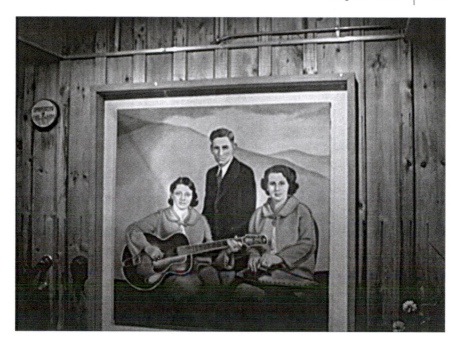

Figure 12.6
Portrait of the country music Carter Family on the exterior wall of the Carter Family Fold, Hiltons, VA

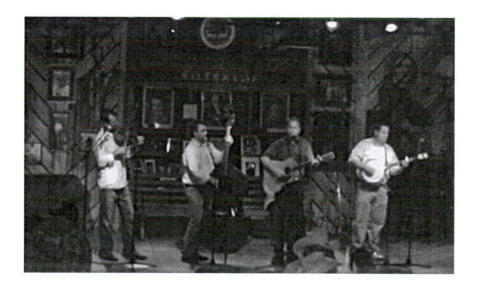

Figure 12.7
Bluegrass musicians play for a happy crowd of 'cloggers' at the Carter Family Fold

dancing could have been occurring during the late 1800s, 1930s or early 1950s. The cashier accepts 'cash money' and personal cheques, but not credit cards. People are modestly dressed; there is no body-revealing Spandex, no cleavage and no tight or short pants.

Closer inspection reveals that there *are* several teenagers, including several cute teenage boys which Lisa and Ina point out to Shannon. There are also many small and medium-sized kids who seem to greatly enjoy the clogging. The event perfectly embodies the old cliché: 'Good, clean family fun'. The bluegrass band is named the Scott County Boys, because all the members live in nearby Scott County, VA. Members also play in other local bands. One has brought CDs to sell from another band he plays in, the Scott County Boys having no CD of their own.

As we drive back along the dark, winding highway to Abingdon, I realize that Carter Fold – and even the closed WMAX radio station – both likely represent the purest essence of Appalachian culture and its synecdoche of bluegrass music; they are largely hidden and *inaccessible* to outsiders. Even when one gets there, often after a difficult journey, they may remain remote, off-putting and ungraspable to the non-native.

DISCUSSION

As I and others have noted (Hirschman 1983), there is often a trade-off between artistic authenticity and commerciality. This inverse relationship would seem to hold true for the marketing of bluegrass music in Appalachia, as well. Just as hip-hop artists gain stature within their community by displaying personal histories of crime, violence, ghetto-origins and even prison time (Chang and Herc 2005), the Appalachian producers of bluegrass music perform in remote, unmarked venues accessible largely through local knowledge of their whereabouts.

The promotional and marketing efforts seem to have almost purposely built in self-destruct buttons: modern-style websites fail to provide addresses and driving directions, brochures fail to mention seasonal closings, road signs are non-existent, auditoriums are tucked away behind food courts in local shopping malls. These omissions, consciously or unconsciously, help to ensure that only those with local knowledge, i.e. the natives, will actually find their way to the performance.

Another aspect of Appalachian bluegrass (and one which is at odds with my earlier hip-hop analogy) is its purposeful avoidance of celebrity. The musicians we encountered were not successful in a financial or fame sense. Most were local folks who enjoyed playing music and believed they could earn some

money at it. The majority had other jobs in addition to performing music. I did not get the sense that any were hoping or expecting to 'make it big'. They were content to hang out, play periodically for the local crowd, and then go on about their lives.

This attitude is consistent with Jane Rhodey's (the Old Time music instructor) thesis that bluegrass is an indigenous art form. It is rooted in the Appalachian community, is an organic outgrowth of that community, and if uprooted and commercialized, it loses its genuineness and purity. It resists professionalism because, as she notes, 'anyone' can do it: retirees from Chicago, Boston and Vermont can quickly learn to strum a bass or pick a dulcimer.

And yet the community can, and does, make qualitative distinctions among performers and performances. During the Abingdon Highlands Festival 'Music of Coal' concert, for example, performers took pains to describe their families' lives in the coal-mining industry. Credibility to sing about dying in a mine, developing black lung disease or celebrating on a coal-town Saturday night is linked to personal or family-based experience with such events. This aspect of Appalachian music the retirees from the North would not be able to duplicate.

A final proposition to emerge from the study is that in Appalachia 'the commercial is communal'; that is, the commercialism I witnessed was manifested almost entirely at the local or community level. For example, performers were selling CDs of their music, but at low prices (e.g. $10, $12). The Bristol Mall auditorium concert was supported by the Appalachian Music Association and Chik-fil-a Restaurant and both had signage in the auditorium, Chik-fil-a even had a toy stuffed cow seated on stage, and yet the admission fee for the two-hour concert was only $4.00. Arriving late at the Carter Fold, Shannon and I were told to 'come on in; you don't need to pay nothin', 'cause you missed a lot of the show'. Clearly, making large sums of money through playing Bluegrass music is not a high priority. Notably, many in the audiences *did* purchase CDs from the musicians as a way of helping them earn a living. No one begrudged them the right to make enough to 'get by', and conversely the performers were not aiming to 'rip-off' consumers. There was an assumed equivalence of both social and financial status – virtually all were likely in the lower and working classes, though not broke or poor.

This last point brings us to a perhaps more profound grasp of the cultural context within which bluegrass music is produced and consumed. Both the Appalachian performers and the Appalachian audiences are implicitly aware that their lifestyles (and lives) are considered inferior by those dwelling outside the region. While some non-natives may venture into the mountains searching for the scent of rural, hillbilly authenticity, they usually quickly

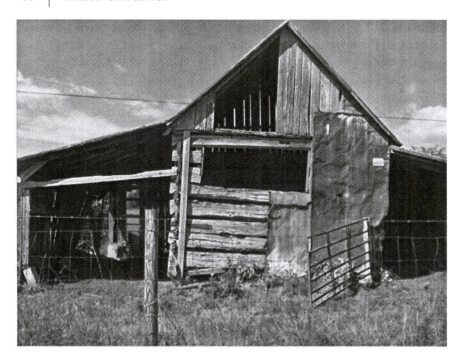

Figure 12.8
The antique barn is an apt metaphor for Appalachian culture and bluegrass
music: 'We've been around for a while, but we're still standing.'

depart to their suburban affluence, carrying tales of the rustic 'hillfolk' whose
music and lives they briefly encountered. Lisa and Ina's Yankee houseguests,
and Shannon – my own daughter-of-privilege – were discomfited by their
experiences, yet eager to tell their friends and colleagues how interesting and
remarkable their visits 'in Appalachia' had been.

The frequent mention by the bluegrass performers of motion pictures,
e.g. *Oh Brother, Where Art Thou?* and *Coal Miner's Daughter*, which features
bluegrass and Appalachian music seemed to me to be part of an ongoing
effort to overcome an inner sense of inferiority. Perhaps this is the key to
why I found such ambivalence in marketing efforts aimed at attracting
tourists. Better to be happy, comfortable and 'real' among ourselves – pickin',
grinnin' and cloggin' away, than to be gazed upon as a fascinating subspecies
of humanity living semi-wild and dirt-poor in the mountains.

And herein lies a final contrast with the hip-hop culture. My sense is that
hip-hop music and its African-American performers *enjoy* being viewed
as dangerous, threatening and uncontrolled/uncontrollable. Their overt man-
nerisms and implicit aim seem designed to scare, to shock, to *disturb* the

surrounding white culture; this has proven an effective way not only of getting attention, but also of getting even. Hip hop enables its performers and audiences to accrue social power and cultural influence by rending – or at least tearing a sizable rip in – the social fabric.

For the rural Appalachian whites who create bluegrass, such an affront to accepted, i.e. white, social norms is inherently self-destructive; it simply reaffirms their unique position as the white culture's cast-offs, the relics of a bygone age, the Neanderthals of modern America's suburban, affluent, cosmopolitan society.

13

EVOLVING PERSPECTIVES ON MUSIC CONSUMPTION

Gretchen Larsen and Rob Lawson

INTRODUCTION

M USIC CAN be heard everywhere. Not only do people choose to listen to or consume music privately or socially as a leisure activity, but they are also exposed to music in innumerable day-to-day situations. Some examples include musical soundtracks on television, jingles in advertising, music from a passing car and background music in retail outlets. The diversity of ways in which music infiltrates our existence is illustrated in the following quote:

> It [music] inspires people to move and dance. It keeps people from lone-liness. It allows others to escape from abusive situations in their family to their social world. It provides the background for social interaction between and among the sexes. It allows close friends the pleasure of charting their life experiences with the charts of popular music. It conveys intrapersonal messages to listeners when songs make deep connections. It can make listeners laugh, cry, empathise, hate, love and react for a moment while the song is playing.
>
> (Orman 1992: 285)

In addition to the social role music plays, music is also important economically. The total retail value of global recording sales in 2006 was US$31 billion (International Federation of the Phonographic Industry 2007). Complementary products, such as stereo systems, are also of economic importance. As early as 1984, 97 per cent of British adolescents owned audio recorders (Frith 1987). Technological developments such as MP3 players and digital music have increased the size of the market by facilitating access to and ownership of music and music related items (e.g. Hargreaves and North 1999).

Music is pervasive, as it is heard in a huge range of different situations and contexts. It infiltrates human lives in numerous diverse and culturally meaningful ways. In fact, Merriam (1964: 218) proposed that music is the most pervasive of any human cultural activity as it 'reaches into, shapes and often controls so much of human behaviour'. Investigating the reasons why someone might want to listen to music, the majority of the literature has focused on intrapersonal reasons for listening to music, such as emotional expression and aesthetic enjoyment (e.g. Cherian and Jones 1991; Hargreaves and North 1999; Kellaris and Kent 1993; Lacher and Mizerski 1994; North and Hargreaves 1997; Sloboda 1985). However, these factors do not fully explain the variation of music consumption behaviour found in different settings. A key point in the quotation from Cook (1998) below is the recognition of the close link between music and the construction and expression of the self. It has long been recognized that people can and do use music as a 'badge of identity'; however, there is only a small amount of actual research on the symbolic consumption of music.

> For music isn't just something nice to listen to. On the contrary, it's deeply embedded in human culture (just as there isn't a culture that doesn't have language, so there isn't one that doesn't have music). Music somehow seems to be natural, to exist as something apart – and yet it is suffused with human values, with our sense of what is good or bad, right or wrong. Music doesn't just happen, it is what we make it, and what we make *of* it. People *think* through music, decide who they are though it, express themselves through it.
>
> (Cook 1998: vi)

This chapter outlines the main areas of research that have been conducted on the consumption of music and outlines some directions for future research. We begin by defining the nature of music. Within this section, the different approaches to music can be identified. Much of the literature regarding listening to or consuming music has been written by academics in the field of musicology. Musicologists and ethnomusicologists focus on the role of music in society as opposed to the behaviour of individuals with regard to music. It becomes apparent in this section that there are many more ways of conceptualizing what music is and why it is important.

Within the marketing and consumer behaviour literature, music has generally been treated as a factor influencing consumer decision-making and consumers' intentions to purchase other products. From this perspective, music is not seen as a product in its own right but rather a communications vehicle to manipulate mood or represent some characteristic of the product or

its use. Issues related to the active consumption of music have often not been considered and, where work has been done, it has focused primarily on the choice and purchase of music. In the last few years a new direction has been established looking at the symbolic aspects of music consumption. We review what is known about the symbolic consumption of music so far and conclude with a discussion of issues pertinent to future research in this area.

THE NATURE OF MUSIC

Perhaps because of its pervasive character, it is difficult, but important, to address the question 'what is music?' A typical dictionary definition describes music as:

> (1) an art form consisting of sequences of sounds in time, especially tones of definite pitch organised melodically, harmonically and rhythmically;
> (2) the sounds so produced, especially by singing or musical instruments;
> (3) written or printed music, such as a score or set of parts,
> (4) any sequence of sounds perceived as pleasing or harmonious.
>
> (Collins Shorter English Dictionary 1993)

As all-encompassing as this definition appears to be, it still privileges a particular philosophical perspective regarding what music is. For example, the limitation of what is considered as music to sounds produced by singing or musical instruments discounts sounds made from other materials such as pieces of wood and typewriters, and also compositions such as those written by John Cage. Cage's '4'33"' (1952) comprises three movements, each which is marked 'Tacet' (meaning 'do not play'). Thus the music of this composition consists of the background noises (e.g. traffic noise, audience sounds) that are normally considered a distraction from music. Although this is an extreme example, it clearly illustrates that definitions such as these are driven by a particular philosophical perspective.

The question of what the nature and significance of music is has long been of great interest to philosophers. The responses to this question (Table 13.1) are diverse and often problematic, although some discernible patterns can be seen. A number of different dimensions of the nature and value of music can be identified in Table 13.1 on pages 194–5.

First, the perspectives differ on how they view the nature of the musical meaning. The meaning of musical events is viewed from the 'Music as Autonomous Form' as formal, autonomous and intra-musical, suggesting that

the meaning of music is inherent in the music itself. Alternatively, from the 'Music as Symbol' perspective, musical meaning is expressive, heteronymous and extra-musical. From this viewpoint, meaning is subjective, socially constructed and based on cultural factors (e.g. Firat 1987; Wattanasuwan and Elliott 1997).

The second dimension is the question of whether music functions separately from society or whether it is part of society. The 'Music as Idea' perspective views music as being something that functions apart from society as it is a product of the human mind; 'music deals not so much with the world "out there" as "in here"' (Bowman 1998: 71). However, many of the remaining philosophical perspectives agree that music is inextricably tied to the social world (e.g. Music as Imitation, Music as Symbol, Music as Experienced, Music as Social and Political Force and Music as Contemporary).

A final point is that it is demonstrated that musical philosophy is wider than musical aesthetics. Kant's 'Account of Aesthetic Experience' has had a significant impact on what people have come to believe music is and how it relates to other aspects of human activity. It is clear, however, that there are other ways of perceiving what music is and why it is important. The current philosophical viewpoint suggests that any, if not all, of the philosophical perspectives may be relevant in understanding the nature and significance of music and musical experiences.

It is clear from the literature on the philosophy of music that different approaches can, and probably should, be taken, as they will provide a different perspective on music consumption experience.

MUSIC AND CONSUMPTION

Music is a product that has not traditionally been of interest to consumer researchers. The focus of early consumer researchers was on the tangible benefits and utilitarian functions of goods and services. The common view of the consumer was of a rational decision-maker who purchased products that maximized the utility they gained from them (Bhat and Reddy 1998). Music as a product does not fit easily within this focus, although its potential influence on the consumer decision-making process did not go unnoticed. Consequently, music has generally been treated within the consumer behaviour literature as a marketing tool – a factor that could influence consumer decision-making and the intention to purchase other products.

The emergence of the 'experiential perspective' within consumer research, and the associated interest in 'aesthetic products' (Holbrook and Hirschman 1982) has led to an increased interest in music. The treatment of music has

Table 13.1
Philosophical perspectives on music

Perspective	Nature of music	Significance of music	Key philosophers
Music as Imitation	Music is an imitative art. Doctrine of mimesis: music is an imitation of the ideal. Musical, social, political and moral concerns are intimately connected.	Significance lies in music's resemblances to other things (e.g. harmonious balance and unity). Concern with potentially adverse effects (e.g. capacity to deceive).	Plato (427–347 BC) doctrine of mimesis Aristotle (384–322 BC) excellence of imitation vs. the goodness of what is imitated Kant (1724–1804) account of aesthetic experience
Music as Idea	Music is a product of human minds. Dualistic foundation: relationships between music's ephemeral felt nature and the realm of ideas.	Significance lies in music's relation to other human mental activity. Music entails some kind of knowing and awareness of aesthetic value.	Hegel (1770–1831) artistic vs. natural beauty Hanslick (1825–1904) defence of music's purely musical value Gurney (1847–1888) musical experience mediated by a special mental faculty
Music as Autonomous Form	Music is intrinsic and located wholly within a purely musical realm. Formalist foundations: focusing on the sonorous event.	The course of musical beauty is none other than tonally moving forms. The meaning of music is wholly intramusical and contained within music's own materials, events and patterns.	Langer (1895–1985) music is a logical symbolic expression of the inner, felt life Nattiez (b.1945) music is plural and dynamic, its meaning relative to interpretive variables
Music as Symbol	Music is a symbol that mediates cognition and interpretations of the world.	Music is an important vehicle by which humans construct their conceptions of 'reality'.	Dutrenne (b.1910) aesthetic experience deploys imagination Clifton (1935–1978) music is

Music as Symbol (contd)	Semiotic theory: music is a distinctive kind of symbol situation with its own musically unique, semantic devices.	Musical meanings do not have assigned reference and are multiple, fluid and dynamic.	what I am when I hear it Adorno (1903–1969) normative, hierarchical account of musical value
Music as Experienced	Music is a lived, bodily experience. Phenomenological basis: resists efforts to explain what music is about, preferring to richly describe what music itself says and how music is experienced.	The world of music is vital, replete with its own meanings and values. The value of music can only be determined through close attention to how it is experienced.	Attali (b.1943) music indicates changes in socio-political and socio-economic relations
Music as Social and Political Force	Music is a human construction intimately connected to power. Cultural perspective: music is cultural and thus is constantly being created, re-created, modified, contested and negotiated.	Importance of music is the way it shapes and defines human society. Musical value is not absolute, but is culturally and historically relative. Human and social orders are in turn constructed and sustained by musical practices.	Göltner-Abendroth: articulation of a matriarchical alternative to the dominant patriarchical aesthetic McClary: link between music and matters of gender, sex and the erotic.
Contemporary Pluralism	Musical practices are plural, diverse and divergent. Pluralist perspective: shifts away from grand theory to accounts that figure plurality and difference, e.g. feminism and postmodernism.	Musical value is not fixed, singular or uniform. What is important is how value and meaning have been constructed.	

Source: derived from Bowman 1998

widened from simply being considered as a sales tool to a product in its own right. Music as a product has its own distinctive characteristics. The literature related to the use of music as a marketing tool and to the nature of music as a product is outlined in the following sections.

MUSIC IN THE MARKETING CONTEXT

There is a notable amount of research that is concerned with how music can lead to a profit by increasing the effectiveness of marketing practices (e.g. Gorn 1982; Park and Young 1986; Smith and Curnow 1966). The basis for this interest is that when used in marketing-related contexts, music is 'capable of evoking non-random affective and behaviour responses in consumers' (Bruner 1990: 99). The three main areas where the influence of music as a marketing tool has been studied are (1) as a background feature in advertising (e.g. Park and Young 1986; MacInnis and Park 1991; Stewart and Punj 1998), (2) in classical conditioning (e.g. Alpert and Alpert 1989; Bierley *et al.* 1985, Gorn 1982) and (3) as a background to purchase behaviour (e.g. Smith and Curnow 1966; Milliman 1982; Areni and Kim 1993; North *et al.* 1999; Mattila and Wirtz 2001; Yalch and Spangenberg 1990; Kellaris and Mantel 1994). In this sense, music is perceived as a sales or marketing tool rather than a product (North and Hargreaves 1997).

It is clear that music has great potential as a marketing tool. However, from a music consumption perspective, this area of research focuses on the passive consumption of music, which is when consumers are exposed to music, but have not specifically chosen to listen to that music at that time. Accordingly, music is not treated as a product in its own right.

The differences between music and other products do not lie in the tangible aspects of the music itself, but in the way that it is consumed (Lacher 1989; Lacher and Mizerski 1994; North and Hargreaves 1997). There are a number of ways that the consumption of music differs from that of other products. It is the combination of all of these factors that distinguishes music from other products. Lacher (1989) and Lacher and Mizerski (1994) identify a number of ways in which music differs:

1. it is not destroyed by consumption, neither is its recorded form altered;
2. the same music can be consumed many times and is often consumed prior to, or without, purchase;
3. its consumption may be active (choosing to listen to music) or passive (hearing music while performing day to day activities); and
4. it can be consumed both publicly and privately.

To this we would add the distinctive way in which consumers experience music. Apart from radio, it is the single product that is primarily auditory. While recent trends in the music industry have emphasized the combination of music and video, we primarily receive and experience music through different perceptual mechanisms to other products. Neither is music easily subject to cognitive evaluation. Like other 'arts' products it feeds directly into our emotions.

MUSIC AND THE INDIVIDUAL

The combination of unusual consumption features and significant influence on social and economic aspects of life suggests that music should be an important area of study for consumer behaviour researchers. However, issues related to the active consumption of music have not often been considered and, where work has been done, it has focused primarily on the choice and purchase of music.

Studies that have investigated the intention to purchase music include those by Holbrook (1982), Kellaris and Kent (1993), Kellaris and Rice (1993), Lacher and Mizerski (1994), Mizerski, Pucely, Perrewe and Baldwin (1988). For example, Lacher and Mizerski (1994) found that the strongest indicator of purchase intention was the need to re-experience the music. There has also been some interest in the development of musical preferences. The best-known study in this area is that of Holbrook and Schindler (1989) who concluded that the development of tastes for popular music peaked in about the 24th year and followed an inverted U-shaped pattern.

The actual purchase of music is only a small part of the consumption experience, as music can be 'consumed without purchase and re-experienced without repurchase' (Lacher and Mizerski 1994: 367). Despite this, the post-purchase consumption of music is an area that has largely been ignored by consumer researchers.

'Music consumption is the act of listening to a piece of music' (Lacher and Mizerski 1994: 366). The question is then asked, why do we choose to listen to music? It is widely recognized that people consume products, including music, to fulfil a need or reach a goal (e.g. Arnould *et al.* 2002; Solomon 1992). Much work has been done on the identification and classification of the different needs or goals that motivate human behaviour, and therefore, consumption. Classic theories of motivation include Freud's 'drives', Jung's 'archetypes', Murray's 'human needs' and what is perhaps the best known, Maslow's 'hierarchy of needs'. Although these theories provide useful frameworks for conceptualizing motivation, they are not exhaustive and are necessarily very general.

A good place to begin understanding the consumption of music is the functions that music performs. Music is fundamentally social. It is socially constructed and embedded. The nature and significance of music are inherently social (Bowman 1998). This notion is also supported by the number of philosophical perspectives on music that view music as functioning within a social context (Table 13.1). On this basis, Hargreaves and North (1999) argue that all functions of music can be viewed as essentially social. The most explicit of these are the functions that music performs at a societal or cultural level. Evidence of this can be seen in Meyer's (1956) theory of musical meaning, which states that the communication of shared meaning via music can only take place in a cultural context. However, because the question is why do people choose to listen to, or consume, music, an individual or social psychological perspective should be taken.

Sloboda (1985) proposes that the central problem in music psychology is to explain the structure and content of musical experience. However, it has been noted by Hargreaves and North (1997) that social psychologists have often neglected the social dimension, and that both the immediate social environment and broader-based cultural norms should be included.

Lacher (1989) provides a broad summary of potential reasons for consuming music. These are as follows:

1. *Emotional stimulation*: this refers to the ability of music to evoke emotions. 'The reason that most of us take part in musical activity, be it composing, performing or listening is that music is capable of arousing in us deep and significant emotion' (Sloboda 1985: 1). The emotional aspects of music consumption seem to be its most compelling product characteristic.

2. *Cognitive stimulation*: provided through the discrimination and assimilation of melody, harmony, rhythm, tempo and instrumentation via a series of complex and as yet largely unexplained processes that are required by listening to music (Lacher and Mizerski 1994).

3. *Situational/social factors*: people use music to facilitate/or to supplement social situations (Konecni 1982). Certain occasions have particular appropriate music that is played only for those occasions and would seem inappropriate in another setting. These are learned, as are most of our music responses (Lacher 1989).

Hargreaves and North (1999) argue that music psychology has focused on the first two of these reasons whereas the situational/social factors have been neglected. They then identify a more comprehensive list of music functions that are based upon their interpretation of Merriam's (1964) proposed functions of music. Hargreaves and North (1999) suggest that social elements

Table 13.2
Functions of music

Merriam (1964)		Hargreaves and North (1999)
1 Emotional expression	1	Emotional expression
2 Aesthetic enjoyment	2	Aesthetic enjoyment and entertainment
3 Entertainment		
4 Communication	3	Communication
5 Symbolic representation	4	Symbolic representation
6 Physical response		
7 Conformity to social norms	5	Conformity to social norms
8 Validating social institutions and religious rituals	6	Validating social institutions and religious rituals
9 Continuity and stability of culture	7	Continuity and stability of culture
10 Integration of society	8	Integration of society

exist in all of these reasons. An outline of both Merriam's (1964) functions of music and Hargreaves and North's (1999) revised functions is provided in Table 13.2.

Hargreaves and North (1999) propose that Merriam's (1964) 'emotional expression' function has been a major growth area in music psychology over the previous decade. The basis for this interest is the notion that music can act as a vehicle for feelings that it may not be possible to convey by other means. This notion has, however, been investigated in slightly different ways. Some research (e.g. Sloboda 1991) shows that certain music can facilitate such physical reactions as sweating, sexual arousal and 'shivers down the spine'. This research links emotional expression with physical response, the sixth of Merriam's (1964) proposed functions. Another area of research on the emotional expression function investigates the emotional effects of music on mood at a more everyday level (e.g. North and Hargreaves 1997). From any of these perspectives, emotional responses are dependent on the social context within which they occur.

The second of Hargreaves and North's (1999) functions combines Merriam's (1964) second and third proposed functions: aesthetic enjoyment and entertainment. In the broadest sense, an individual's response to a stimulus depends on the interaction between the characteristics of the person, the music and the situation in which it is encountered. In line with the lack of

emphasis on situational factors in music psychology, most research has focused on the first two of these variables. Aesthetic responses are characterized by an affective component and an element of cognitive appraisal. The social dimension has been neglected in most research on the aesthetics of music; however, adding the entertainment function makes the social dimension more explicit.

Hargreaves and North (1999) agree with Merriam's (1964) fourth function of music – communication. Music can be used by people who do not share a verbal language to communicate with each other. This function is primarily cognitive in that specific information is conveyed by musical structures and messages, but it is also social in the sense that these structures only acquire musical meaning when they are interpreted within the appropriate social context.

'Symbolic representation' comprises the fifth of Merriam's (1964) proposed functions of music. Merriam (1964) uses the term to refer to the transmission of non- or extra-musical information, such as narratives, values or ideals. This is what is known as cultural meaning within consumer research. This representational or symbolic function involves the social construction of musical meaning within particular cultural contexts. As noted by Crafts *et al.* (1993), 'musical tastes sometimes reflect important social statements and experiences that may seem only incidentally related to the music itself' (p. xviii).

Hargreaves and North (1999) recognize that Merriam's (1964) four remaining proposed functions of music are explicitly social in nature. These are all functions that music performs at a societal level and thus are maintained as such in Hargreaves and North's (1999) interpretation. They do not however, provide much insight at an individual, social psychological level into why people choose to listen to music.

In summary, there are many reasons for the consumption of music. Music can be listened to for its own value or because of situational/social variables (Lacher and Mizerski 1994). However, even when music is listened to for its own value, social aspects are involved. Hargreaves and North (1999) suggest that the social functions of music they have outlined are manifested in three main ways, namely in the management of self-identity, interpersonal relationships and mood in everyday life. In a separate paper in the same year, North and Hargreaves clearly state that adolescents were using music as a 'badge of identity'. These sentiments also reflect Frith's (1996:124) conclusions concerning the documentation of the different ways in which genres of music work 'materially to give people different identities'. Despite this, it is the intrapersonal reasons for listening to music, such as emotion and aesthetic enjoyment that have received the most attention from researchers.

SYMBOLIC ASPECTS OF MUSIC CONSUMPTION

While the conclusion from North and Hargreaves above gives weight to the notion of the symbolic consumption of music, it provides little insight into the processes that might be involved. Similarly, research by Goulding *et al.* (2002) found that the construction and expression of one's identity is one key reason (among others) as to why people attend raves. In particular, their work supports the postmodern conceptualization of the multiple, fragmented self and shows that the fragmentation and compartmentalization of the working week and the rave weekend is an example of how these identities are managed.

Both Holbrook (1986) and Shankar (2000) have used a subjective personal introspective approach in order to gain an understanding of the relationship between their own musical preferences and their sense of self. Holbrook's (1986) study focuses on how, in his youth, he used music to 'feel hip'. This study refers mainly to the construction of personal identity and not the outward presentation of self. Similarly, Shankar's (2000) paper addresses the author's use of music to guide him through a transitional phase in his life and thus discusses the role of music as a reminder of past selves. In an extension of this work, Shankar *et al.* (2009) use a narrative approach to examine identities-in-process as reflected in people's record collections. They find that record collections are objects which are active in identity or subject formation. Shankar *et al.* (2009) do however take a different position from Shankar (2000), as they emphasize the identity rather than the consumption element of symbolic consumption.

Hogg and Banister's (2000) study of young consumers and pop music explores some of the processes involved in the self-symbolic consumption of music. This study is based on McCracken's (1986) Model of the Movement of Meaning, focusing particularly on the instruments of meaning transfer that adolescents use to consume the images of pop stars. The results indicate that a variety of means are used to transfer the meaning and images from the pop stars to the individual consumers. Adolescents, via different aspects of fan behaviour, then consume these meanings. This study provides some insight into the potential processes involved in the symbolic consumption of music, but as it focuses on the image components, it does not provide a detailed description.

In an attempt to provide a detailed understanding of the relationship between the consumer's self, music and the social context, Larsen *et al.* (2009) describe a conceptual framework of the consumption of music as self-representation. The results of subsequent testing and refining of this framework are presented in a revised version in Figure 13.1. The basis of the revised framework (Figure 13.1) is the comparison between the image of the music

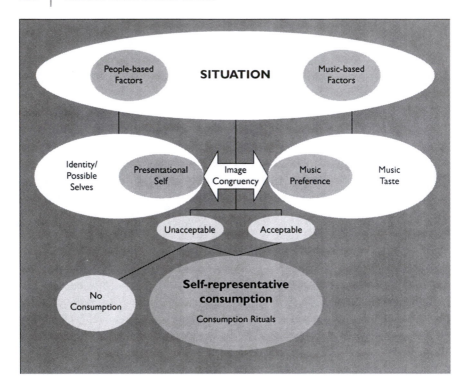

Figure 13.1
Framework of the consumption of music as self-representation

and the presentational self. At the point of comparison, the individual evaluates not only the level of congruency, but also the acceptability of that congruency. Individuals consume their preferred music in a self-representational manner only when there is congruency between the image of that music and their presentational self. However, in some circumstances, individuals might still consume music that is congruent with a negative self-concept to represent the self, for example when the individual is expressing themselves through their distastes. Situation is an important influence not only on the comparison, but also on the selection of presentational self and musical preferences. Certain consumption rituals, for example singing, dancing and knowledgeable discussion of the music, support the representation of self through the consumption of music, and any feedback influences future decisions related to individuals' music preferences. This framework is based on Grubb and Grathwhols' (1967) self/brand image congruency model, but extends it to account for situational factors, a judgement of acceptability of the level of congruency and consumption rituals. A particular feature of Larsen *et al.*'s (2009) approach is

the attempt to further develop the understanding of the processes of symbolic consumption by using knowledge combining perspectives from social psychology regarding the structure and nature of self-concept.

FUTURE RESEARCH

There are a number of areas for future research that would further our understanding of the symbolic consumption of music. First, research should be conducted on a much wider range of consumers than currently studied in the extant literature. With the exception of Shankar *et al.* (2009), all research has been undertaken on adolescents, albeit with good theoretical justification (i.e. involvement in music, self-concept and taste formation). However, research on older consumers whose tastes and self-concepts are likely to be more stable and who might, therefore, be less susceptible to the desire for social approval, would be insightful. This would allow further exploration into such aspects of the symbolic consumption of music as the link between musical tastes and personal identity narratives, situational influence and established consumption rituals. Similarly, most of the existing research has been conducted in a Western context. Exploration of the symbolic consumption of music in other cultural contexts would potentially require the adoption of alternative theories of the self, but would illuminate not only cultural differences in the symbolic consumption of music, but also in consumption practices more generally.

Second, the growth of both the digital and live music sectors of the music industry offers rich contexts for the investigation of issues related to the symbolic consumption of music. For example, exploring the symbolic consumption of music in the context of MP3 players will problematize the distinction between private and public consumption of music. On the one hand, listening to music on an iPod is a very private experience, but on the other it is a multi-layered public and symbolic act. The symbolic consumption of live music offers opportunities for many of the social, situational and cultural elements to be explored, e.g. how are shared meanings constructed and consumed symbolically, what rituals are enacted and how do these co-construct a shared symbolic experience?

Third, there are a number of specific elements of symbolic consumption that warrant much more further research. One example is consumption rituals. Wendy Fonarow's (2006) *Empire of Dirt: The Aesthetics and Rituals of British Indie Music* provides a wonderfully rich and detailed account of the British indie music scene, and demonstrates that the ritual aspect of music consumption is central to, and potentially very varied amongst, different

genres and settings of music performance and consumption. There are many issues still to explore. For example, one consumption ritual – grooming – is closely related to the repeated nature of the consumption of music that was discussed earlier. Understanding how repetition works in the movement of meaning and how it may vary across contexts could be significant. The actual situational elements are also very important. Larsen *et al.*'s (2009) research identifies situation as being a very influential element of self-representation through the consumption of music. However they suggest that the situational factors that relate to musical preferences need to be further identified and explained.

Finally, it is also important to investigate the symbolic consumption of music through various different lenses, which will in turn bring certain elements to the fore. As noted in Table 13.1, there are many different philosophical perspectives on the nature and significance of music, of which a few (Kant and Adorno) tend to dominate academic research on music. The symbolic consumption of music sits at an interesting but potentially problematic nexus between the individual, symbolic meaning and the cultural world. Other perspectives would provide different accounts of, and interpretive lenses for, understanding this complex relationship. For example, the experiential paradigm would provide a postmodern interpretation, while contemporary pluralism would provide a lens to interpret identity as it is related to gender. It is important that these are acknowledged and granted legitimacy as valuable and insightful routes to further understanding the symbolic consumption of music.

MUSINGS FROM MILES[1]

What Miles Davis Can Tell Us about Music and Marketing

Noel Dennis and Michael Macaulay

During the course of the authors' twin careers in music and academia, we have frequently come across the notion of a debate between art and commerce. This debate interests us for many reasons, both philosophical and practical, not least because it has often appeared so demonstrably wrong: the professional artist is not, it seems to us, a contradiction in terms but rather a fact of life. And always has been. To this end we undertook an exploratory investigation into the mindsets of professional musicians, the very people who are most directly challenged by the apparent tension between art and commerce. Their evidence led us to conclude that while the dichotomy between music and marketing may be false, there remains a parallax perspective at work. Commercial and artistic views are indeed distinct but these co-exist rather than combat each other, and where the observer stands directly affects his or her sense of the relationship.

This chapter builds directly on our previous work and attempts to explore the music/marketing parallax further, with reference to one of the great artistic masterpieces of jazz, as well as the most commercially successful jazz recording of all time, Miles Davis' *Kind of Blue*. This seminal record, which celebrates its 50th anniversary in 2009, encapsulates the parallax perspective and in so doing greatly adds to the already admirable amount of work on this subject by such notable commentators as Holbrook and Bradshaw (2007), Fillis (2006), Holbrook (2005), Kubacki and Croft (2004, 2005) and many others.

KIND OF BLUE

To many, *Kind of Blue* epitomizes jazz. Herbie Hancock eloquently defines *Kind of Blue* as the cornerstone record for jazz and other musical genres

(*The Making of Kind of Blue* DVD 2008). Of all of the albums Miles Davis recorded, *Kind of Blue* is arguably his most profound and the one that moved jazz to a new level. Up until 1959, bebop (or modern jazz as it was often referred to) was very much the at the forefront of jazz, with key figures such as Charlie Parker and Dizzy Gillespie leading the way in its development. The bebop era of jazz marked a huge change in the jazz scene and several commentators have argued that this was the point that jazz became an 'art form' (Early 2008). Gabbard (1996) notes that bebop made jazz much more complex and arguably more esoteric and less appealing to the masses. Prior to the bebop period, jazz was very much regarded as the popular music of the day.

Bebop differed from previous styles of jazz, as Gioia (1997) points out; it took limited inspiration from previous styles, i.e. the experimental big band sounds of the swing era. Instead, bebop was an innovative style of jazz developed by leading jazz modernists of the 1940s and was certainly not intended for commercial consumption. Gioia (1997) notes that proponents of this new exciting genre developed it in backrooms and after hours clubs, often on the road with travelling 'commercial style' bands.

What differentiated bebop from previous styles of jazz was its complex harmonic structures and fast tempos. Musicians had more chord changes to contend with at fast tempos, which required a very different approach to improvisation and immense technical command of the instrument. To fully appreciate bebop it is worth listening to some Charlie Parker recordings, such as the album *Now's the Time* (Savoy Jazz).

Bebop continued to flourish during the 1950s and the vocabulary of jazz continued to develop. There were, however, a number of musicians, including Miles Davis, who were becoming disgruntled with bebop and felt that the harmonic complexity of the music was actually hindering their creativity. It was time for change and Miles Davis – the innovator in jazz – was the man to lead this change to take jazz in a completely new direction.

It is no surprise, then, that the release of the album had such a profound impact on jazz. *Kind of Blue* marked the start of a new era of what is now termed 'modal jazz'. The term 'modal jazz' originated with George Russell, who offered an alternative perspective to improvising on chords and chord changes by using scales or a series of scales, instead of myriad chord changes. It is fair to say that Russell's theory also influenced composition and many great jazz works such as Coltrane's 'A Love Supreme', Bill Evans' 'Re: Someone I Knew 'and Russell's very own 'All About Rosie' which are all based on the concept (Nisenson 2000). Adopting Russell's method, the music on *Kind of Blue* was far removed from bebop in the sense that it was based on minimal structures and chord changes. It was much more relaxed and less frantic than bebop and required a very different approach to improvisation.

For such an iconic work, Miles took an astonishingly minimalist approach to recording, deliberately avoided writing complete musical charts and instead sketched out the form of the tunes only hours before the recording session, which was far removed from what the musicians had been used to. The team Miles assembled for the recording were all classed as 'innovators' in jazz (nicknamed by trumpeter Eddie Henderson 'the justice league of jazz'): John Coltrane (tenor saxophone); Cannonball Adderley (alto saxophone); Wynton Kelly (piano track two only); Paul Chambers (bass); Billy Cobham (drums) and finally, the twist, Bill Evans (piano). Bill Evans was a controversial appointment by Miles; at a time when race relations in the US were particularly tense it was a huge risk for Miles to employ a white musician. Regardless of this, Evans was the perfect appointment and it is argued by many that he had a major role in the compositions, in particular the ballad *Blue in Green*. Evans captures the mood of each of the pieces and plays with beauty and empathy. His harmonic sense was essential to the concept and his approach to the accompaniment and improvisation on the album is almost 'impressionistic' in nature, with echoes of Ravel, particularly at the start of the first track, 'So What' and in others ('Blue in Green' and 'Flamenco Sketches').

Each piece was recorded in one take (although there were some false starts); the simplicity and loose nature of the compositions allowed the musicians to explore the harmony and to express their inner creativity, which resulted in an album that explores a variety of emotions from mystery to romance. It is advisable for the reader to listen to the album (if you have not done so already) to appreciate the aforementioned point and forthcoming section.

The opening track 'So What' begins with a haunting piano, which progresses with a memorable melody played on the bass. 'Freddie Freeloader' is much more bluesy, humorous and bouncy in its approach, which is why the pianist Wynton Kelly was selected for this. His style of playing reflected all of the aforementioned traits and the resulting performance is perfect for the track. 'Blue in Green' is a beautiful romantic ballad – what Herbie Hancock describes as an 'Ophelia ballad' – which many believe that Bill Evans wrote, although Miles took credit for it on the album. Bill Evans plays haunting chords at the start that form a perfect platform for Miles' mellifluous harmon mute sound to state the melody. 'All Blues' is another variation on a blues but it is written in compound time 6/8, giving it an almost march feel. Once again, the track is relaxed and moody, with Bill Evans playing 'impressionistically' and Cannonball Adderley exploring the bluesy nature of the track, resulting in a unique sound. The final track on the album, 'Flamenco Sketches', is another reflective ballad with a Spanish feel to it. The piece is based around five scales and both Miles and John Coltrane explore these

with aplomb, in particular Coltrane, who plays a series of very simple 'nursery rhyme' type phrases, which differ greatly from his usual approach to improvisation.

Kind of Blue has become a legendary recording and is without doubt the most admired jazz record of the LP era (Cook 2005). Its presence is ubiquitous and musically it is ageless and invincible: it was ranked 12th in the *Rolling Stone* top 500 albums of all time in 2003 (www.rollingstone.com) and has, since the 2008 release of the 50th anniversary box set, made fresh appearances in the album charts in various countries. No one really knows what makes *Kind of Blue* a huge artistic success, but Cook (2005) speculates that it is most likely down to its unobtrusiveness and simplicity that create an aura of tranquillity and rest.

Perhaps more importantly from our standpoint, *Kind of Blue* has sold approximately four million copies worldwide and continues to sell on average 5,000 copies per week worldwide (www.cannonball-adderly.com). Its commercial potential was also at the forefront of the distributor's mind. According to Cook (2005), Columbia records invested heavily – for a jazz album – in the marketing and advertising. Clearly, by the end of 1959 there was a return on this investment in marketing and advertising, with handsome sales of the album evident. In addition, *Kind of Blue* appeared to open a new segment of the market, with people who had not listened to jazz prior to its release taking an active interest in the music. By any measurable standard, Miles Davis' masterpiece was (and continues to be) a tremendous commercial success, arguably the biggest commercial hit that the jazz genre ever produced, and yet its artistic integrity can never be in doubt. The success of the album seemingly cocks a snook at the art versus commerce debate, so beloved of many academics, but we suggest that it actually enhances that debate. We suggest that *Kind of Blue* is the apotheosis of a music and marketing parallax.

THE PARALLAX PERSPECTIVE

Hold your finger up about four inches away from your face squarely between your eyes. Close your left eye. Simultaneously open it and close your right eye. You should notice that your finger appears to move in front of you even though, as you well know, it does not. You have just experienced a very simple parallax perspective. A parallax is a *perceived* shift of an object due to it being viewed from a different line of sight. It is primarily a scientific term that is used in astronomy to measure the distance of stars: the further away an object is, the less pronounced its parallactic shift; a phenomenon that has led to the

scientific measurement of literally thousands of stars. You can try it yourself by repeating the finger experiment; this time, hold your finger at arm's length while opening and closing your eyes.

More importantly for our purposes the concept of parallax has become increasingly of interest to cultural and critical theory. The parallax has been used as a means to advance the Hegelian notion of dialectics, which is usually incorrectly centred on the triad of thesis–antithesis–synthesis. Hegel himself mocked this misrepresentation of his logic and instead insisted that dialectics is a means of identifying ongoing dynamic change, requiring a constant shifting of perspective between object and subject (Macaulay 2009). Obviously many philosophical schools have played with dialectics, from the Young Hegelians and Karl Marx, through existentialism, and on to the Frankfurt School and the philosophical scourge of jazz himself: Theodor Adorno. More recently, the impish Slovenian cultural theorist Slavoj Žižek has instigated fresh debate around dialectics, and has invoked the parallax concept as a means of approach: 'The philosophical twist to be added, of course, is that the observed difference is not simply "subjective", due to the fact that the same object which exists "out there" is seen from two different stances, or points of view' (Žižek 2006: 17). The relationship between subject and object is thus predicated on a series of perceptual shifts: before an observer can see an object properly he or she must overcome the parallax perspectives gained from their own subjective vision. Taken independently, each of these perspectives reveals only a partial truth; only when all perspectives are considered as a whole is the full truth revealed. Looking at the heads side of a coin will only give us a partial understanding of what it actually looks like; ditto the tails side. Some dialectical thinkers would seek to overcome this by philosophically attempting to unite, or synthesize, these two sides. The parallax thinker flips the coin in the air and observes both opposites simultaneously.

It is precisely this parallax approach that we suggest is the best way of conceptualizing debates surrounding music and marketing, which even now are regularly framed in terms of two opposing forces, locked in combat against each other. Holbrook (2005: 22), for example, suggests that the debate is between 'cultural forms aspiring to creative integrity and those seeking commercial success through popular appeal'. Other commentators (for example Gainer and Padanyi 2002; Kubacki and Croft 2004) have argued much the same thing: art exists for its own sake and is incompatible with commercial appeal. The implication of this position is clear – those who seek commercial success are not true artists. Needless to say this is a simplification of the art versus commerce debate and we can only acknowledge that myriad nuances surround it. It is not, however, misrepresentative of the two main camps, and it was this end to which our initial research was directed. We find this

distinction difficult to accept: not because the studies cited above are necessarily wrong (we respect people's artistic judgements even if we disagree with them) but because they may reflect a bias that is dependent on the people upon whom research was conducted. A parallax approach allows us to understand how even though art and commerce may *appear* to oppose each other, they are just sides of the coin that is the professional musician.

Our academic interest in jazz goes back many years (Dennis and Macaulay 2003; Dennis and Macaulay 2007; Dennis and Macaulay 2008; Macaulay and Dennis 2006). Indeed for one of the authors it goes back an entire lifetime – Noel Dennis has been playing since the age of four and has been a professional jazz musician for nearly fifteen years and counting. It was to his musical contacts that he turned to investigate the nature of the music/marketing debate, interviewing eight professional jazz musicians who are also assorted writers, educators and musical evangelists. All of the respondents were male, a fact that was in equal parts unsurprising and disappointing, although in mitigation we did ask four female jazz vocalists to help with the research but they were sadly unavailable. Each respondent was famous within the jazz community, which translates as being relatively well known to serious music enthusiasts but not really to the average Radio One or Radio Two listener. It is fair to say, however, that even if you haven't heard of them you have very likely heard their music at some point in your life.

We asked a range of related questions: did the musicians recognise any tension between their aiming for both artistic and commercial success; did they perceive themselves as being in any way market-oriented; and did they even understand what marketing was to begin with?

THE PERSPECTIVES OF PROFESSIONAL ARTISTS

One surprising result of the interviews was that the musicians themselves struggled to define what the music actually is. One interviewee complained that the task of defining such a diverse music is impossible, arguing that 'It's like the definition "food" covering steak, Danish pastries or salad.' Others tried to define the music in terms of personalized attributes: 'creative self-expression or creative, personalized music – not just a correct rendition of the notes'. Nearly every respondent emphasized the critical importance of improvisation to the jazz (although nobody offered a view as to how this impacts on improvisation in other musical genres, such as a guitar solo in a rock band), while only a single musician sought a broader contextualization for the music: 'jazz is a process, a cultural statement, trying to define it is like trying to define a moment'.

In true parallax fashion there was a mixed response to the perceptions of commercial jazz music. On the one hand musicians were clear advocates of a more commercial, market-aware approach to their craft: 'Jazz musicians have no business acumen. They need to take ownership of the business side of jazz and won't be able to do this without accruing key business skills.' Others saw musicians as lacking the appropriate personalities or character to be successful business people. Either way, it was apparent that respondents were comfortable in accepting a significant degree of responsibility for their own actions (or lack of them), although opinions were mixed as to how serious this problem was. Furthermore each respondent was positive towards the idea of providing more business education to aspiring musicians of all genres: '[Education is] great for music, rotten in terms of business education.'

Despite this openness towards the commercial world, however, there remained concerns that current jazz artists were (either explicitly or implicitly) diluting the musical form. Newer, more commercially successful, artists (notably artists such as Jamie Cullum, Diana Krall and Michael Bublé) along with established popular artists who have turned to jazz (for example, Robbie Williams and Westlife) were perceived primarily as pop acts rather than jazz musicians. Respondents also raised concern that they would lead to a further reduction in listener interest, rather than encouraging a deeper exploration of the form: 'Liking Jamie Cullum doesn't necessarily lead to listening to Thelonious Monk; when a vocal-free Coltrane track gets in the Top 20 things will be interesting. . . . '

Again, however, this resulted in a parallax perspective. From one vantage point, the proliferation of new jazz/pop crossover acts meant that professional jazz musicians were dumbing down their music: 'some jazz artists now are making music to fit the record company and radio format, otherwise it won't get played'. Equally, however, the success of these acts is at least providing paying work: 'These artists are not breaking into the "pop" market by playing jazz! They are doing it by playing popular music, so, good luck to them, at least they are providing a good living for the jazz musicians that they employ.'

Some interviewees further commented on how the more explicitly artistic musicians can actually alienate their potential audience, resulting not only in a lack of commercial success but also in a continuing rejection of the genre. Some musicians still unquestionably regard commercial success as 'compromising one's art', and, as a result, they restrict their activities to fit their artistic profile, regardless of the needs of the audience. This often results in limited revenue accrued, and even requires personal investment to realize their musical aspirations. Yet this is an increasingly small number, and our respondents overwhelmingly rejected such a view as both one-sided and self-defeating. Nowhere was the parallax shift more evident than in the response

of one international musician: 'I select and play material with the audience in mind but I do it in a way that will not compromise the artistic nature of jazz.'

The interviews led us to conclude that being a professional jazz musician is not to choose one side or the other (music or mammon) but to delicately balance between the two.

MILES FLIPS THE COIN

Our research suggests, then, that for jazz musicians in the UK today there is little conflict between their artistic and commercial sensibilities. To argue that music and marketing (or art and commerce more generally) stand in opposition to one another is to make a fundamental error of judgement. They exist as a parallax, seen through distinct lines of sight, which nevertheless can and do co-exist as different elements of the same professional whole. We just need to alter our own vantage points to make sense of the relationship. To quote a famous example, the two sides of a coin do not meet each other but neither do they stand against each other as enemies. They are simply two sides, and in order to understand this we need to flip the coin to witness the full picture.

Miles Davis was unusually adept at flipping the coin. Whilst he thought of himself as, above all, a musician and an artist, he certainly enjoyed the trappings of his commercial success: a nice home with modern art and more modern gadgets, trophy girlfriends, expensive, well-tailored clothes, and fast, foreign cars (Early 2008).

In marketing terms, Miles took a product-oriented approach to his music, composing and playing for himself rather than his audience, although it can be argued that Miles was very much in tune with cultural and market changes, exemplified by *Kind of Blue*. An experimental record, it ironically appealed to people who did not like jazz because it was easy to listen to and seemed so familiar. As Early (2008) points out, artistic innovations often work out because they take the audience somewhere they haven't been, while passing a lot of well-known gateposts.

Miles' eye for commercial opportunities is further exemplified by his development of the jazz-rock idiom, which clearly steered jazz in a completely new direction and developed a new audience. He collaborated with iconic musicians such as Jimi Hendrix and, towards the end of his career, attempted to update the standard repertoire by recording popular tunes on his 1985 album *You're Under Arrest*, such as Cyndi Lauper's ballad 'Time after Time' and 'Human Nature' by Michael Jackson. Despite his death in 1991, the music

of Miles Davis lives on while the man himself has become a global brand.

To conclude, then, we suggest (and Miles Davis exemplifies this) that artists can be commercially successful, without compromising their artistic integrity. Commercial success should not be viewed as selling out, as some academics argue (see, for example, Holbrook 2005). Miles' commercial success was only possible due to his creativity and artistry, but arguably more importantly, his ability to anticipate and respond to changing cultural patterns. Miles is, of course, only one of thousands of musicians who comfortably bestride both the artistic and commercial sides of music, both famous and anonymous. Our research argues that professional musicians continue to do so today. We suggest, therefore, that academics retire the art versus commerce debate and begin to find ways to conceptualize how these different aspects of the same endeavour work alongside, rather than against, each other.

NOTE

1 The title of this chapter is based on Miles Davis' 1955 recording *The Musings of Miles*.

15

A NIGHT AT THE THEATRE

Moving Arts Marketing from the Office to the Kitchen and Beyond

Annmarie Ryan, Matt Fenton and Daniela Sangiorgi

PROLOGUE

THE FOLLOWING TEXT is an outcome of myriad interactions, conversations and happenings that have brought the authors, along with our very helpful reviewer, to the point where we can speak to you, the reader, about the topic of how theatre can inform marketing, and arts marketing in particular. The early conversations involved a marketing lecturer, a theatre director and, later, a service design researcher. The marketing lecturer in particular wished to view the theatre as a site of learning for marketing students; a place where we could bring to life, and perhaps critique, the theatre metaphor in services. The theatre director was interested in how collaboration with marketing might help enhance the audience experience of the wider services of the theatre, and the service design researcher saw these emerging conversations on collaboration and experiences to be resonant with conversations ongoing in her own discipline. It would seem that the converging touch points were there, but we had no real idea where they would lead. In the end the Gob Squad (theatre company), and their production of *Kitchen,* was to be the turning point for us all.

INTRODUCTION

Art is adventurous, marketing safe; art seeks the unexpected, marketing yearns for the predictable; art wants the amazing, marketing the comfortable; art is organic, marketing anal. Yet we need both, and we both want to make money; we both want the biggest audiences. We have no

alternative but to live together in a constructive way, learning from and understanding one another.

<div align="right">Tusa (1999: 120)</div>

The above quote is taken from the introductory chapter of a book entitled *Imagining Marketing: The Arts, Aesthetics and the Avant Garde*, edited by Stephen Brown and Anthony Patterson. The quote speaks of a tumultuous yet necessary relationship between marketing and the arts. Moreover it alludes to the possibilities of building alliances not only between the sectors, but between the world-views that are most often espoused in each camp. The book itself is a collection of imaginings by eminent marketing academics, and forms an artistic vision for mainstream marketing. In *this* chapter we join others who attempt to take this vision one step further. Our aim is to reintegrate insights emerging from the artistic perspective on marketing back into the marketing of the arts themselves (e.g. Fillis 2002). In doing so, we should acknowledge the arguments and debates that surround the role of business in the arts; back to the language and myths of 'necessary evils' and 'sleeping with enemies'. While the objective of the arts marketer and the artist/director would *seem* to be the same (i.e. to connect and commune with as many people as possible), the reality is that the tools, and some might say tricks, of marketing and its incumbent paraphernalia set many artists/directors on edge. Arts marketing is generally painted as a concern for writing copy, stuffing envelopes and generally doing what it takes to get bums on seats. The role of artist/director is infused with higher goals. But these myths play into the hands of dualists, who would have us believe that marketing and the arts are oppositional forces, coming together only in compromise or discord.

In this chapter we consider arts marketing as it could be. To this end we build upon the work of Schroeder (2000, 2002), Fillis (2000, 2002) and (O'Reilly 2005) to see the arts anew; not just simply a new terrain to exploit, but as a source of potential insight and knowledge. By taking a closer look at contemporary performing arts practice, with Gob Squad's *Kitchen* as a central 'case', we ask how such practice could inform not just the artist–audience relationship, but arts marketing theory itself. First, we identify and explain why a Kotlerian approach to arts marketing has gained dominance within the Academy. Second, we consider the changing landscape of arts policy and practice, and begin to see that arts marketing has been limited by a delivery style approach. Third, building on the creative and often radical practices of Gob Squad we attempt to put forward a new model of arts marketing that is collaborative and experiential in tone. We build on existing marketing and service design literature to give a language and orientation to this new model, which is built on three key themes, that is, co-production, extended

experiences and the process of immersion. Finally, we build from this and consider particular modes of practice apposite in this approach, including, arts marketer as *collector and sharer of stories*, as *network facilitator* and as *guide*.

THE ROOTS OF ARTS MARKETING AS DELIVERY

It is true to say that a certain mythology has grown up around art and commerce, involving particular characters and narratives that embody, more than anything else, the duality between the disciplines. Nowhere is this more relevant than in arts marketing itself. The roots of this dualism reside in the origins of arts-marketing theory, which can be drawn from the project of Philip Kotler and colleagues to consciously extend the domain of marketing to include non-commercial settings including the arts (Kotler and Levy 1969). This extension can be construed as imperialistic in nature (Laczniak and Michie 1979), whereupon the linear relationship of learning was set very clearly, that is, the non-profit arts sector would be enriched by being brought under the wing of marketing. Not only was this extension critiqued within the mainstream marketing academy (e.g. Foxall 1989), but it also set the tone for the backlash which marketing faced from within the public sector and the arts in particular (e.g. Tusa 1999).

Notwithstanding these early critiques, we can view the project of domain extension to be, by and large, a successful one. This is evidenced by the primary role taken by Kotler himself in the writing of the theory on arts marketing (for example Berstein and Kotler 2007; Kotler and Andreasen 1991) and in the creation of a canon of arts marketing which essentially 'looks' like mainstream marketing with its product, price, place and promotion sub-categories (Hill *et al.* 1995; Kolb 2005). Taking a critical stance on the particular 'marketing mix' perspective espoused by this approach, O'Malley and Patterson (1998) argue that the role of the marketer becomes reified and the consumer conceptualized as a passive agent susceptible to promotional messages. What the extension did offer the arts, however, was a theory that went some way towards the efforts of the emerging disciple to professionalize. However, in order to insulate itself from the horrors of market forces, the 'arts' insisted that the art and the market remain separate. This situation was reproduced by arts marketers themselves who were quick to maintain the separation, where there is the core product (the art) and the augmented product (surrounding services, i.e. box office, refreshments, cloakroom, parking, etc.) (Ní Bhrádaigh 1997). A clear division of labour ensued, with the artistic director caring for the core product and its relation to the audience, and the arts marketer dealing with the consumer and other ancillaries. A key

problem with this is that the 'consumer' and the 'audience member' are of course the same person. The consumer's domain is the foyer shop and the café/bar, and in this state they are open and susceptible to marketing messages, can be researched and engage in focus groups, and generally enable marketing to do its job. As audience however, their role changes utterly. Their goal now is to immerse themselves in the experience, and in so doing influence the very delivery of the core product itself, through feedback and atmosphere generated in the performance. When art marketing follows a 'product' logic (i.e. considering art as a product to be 'chosen', 'purchased' and 'consumed') the marketing tools follow traditional approaches that tend to keep 'consumer' and 'audience' as separate actors with the former making rational purchase decisions as part of a sequential process. In this chapter we explore a more experiential as well as collaborative approach and question this separation and more importantly explore how our view of the audience and the art can be extended beyond the performance itself.

CHANGING CULTURE CONTEXTS

The last two decades have seen a gradual shift in the framing of arts organizations as presenters of pre-ordained programmes decided behind closed doors, to providers of experiences, participatory projects and events. The key question we pose is whether the ongoing reimagining of theatre might now facilitate a reimagining of the marketing of the arts themselves. In this regard we must recognize that the 'theatre' is not a single genre but a complex and shifting set of dynamic relationships between audience and performers, and between audience members themselves. The move in the twentieth century away from the notional 'fourth wall' (behind which a performance takes place almost as if the audience were not there, as unacknowledged voyeurs of a hermetically sealed world) and the proscenium arch (which frames the action and marks the divide between stage and auditorium), has led to a shift in performance practices to those which highlight the 'liveness' of the relationship between performer and audience. Much contemporary performance now acknowledges the fact that people with real names and lives are doing strange things for the entertainment of those sitting just across the room from them. In so doing, contemporary theatre practice can in fact sit very close to more traditional and much more openly two-way performance modes such as cabaret or pantomime, that rely heavily on responsiveness on the part of the audience.

Responding to cultural policy and funding models increasingly based on engagement, development and participation rather than presentation, arts

managers, programmers and curators are becoming less gate-keepers of culture than facilitators of its access and understanding (Knell 2006). Education and Outreach departments that once provided add-on activity to develop new audiences for established content now increasingly drive projects and productions to be featured in the core programme. This goes further in the emerging trend for arts institutions to work with artists and local people in the decision-making process itself, guiding policy, commissioning and arts programming. In the theatre industry, the emergence of 'Scratch' schemes (most notably developed at Battersea Arts Centre, but now common in many UK venues) has brought audiences into the creative process very early in a show's development. Their responses provide artists with a quick feedback mechanism, and such events go some way to develop an informed audience for the finished production, not least by providing marketing departments with an insight into how audiences might describe and respond to the emerging work. Artists, performing arts companies and theatres are therefore exploring the creative potential of going beyond the boundaries of the theatre and invading and transforming the way space, time and interaction modes are conceived. Our aim is to consider how these practices can inform and offer new directions to arts marketing. We build on Knell's (2006) position therefore, which calls for a broadening of the emerging practices of artists into the way arts organizations themselves are managed and marketed; 'where such practice occurs it is resulting from the creative decisions of artists, not shifts in the mission or purposes of arts organizations' (ibid., p. 13). In order to explore this further, and to do so in a manner which allows us to maintain connectivity to the arts themselves, we investigate how one theatre company, in particular, is blurring the boundaries between artist, audience and marketer.

ARTISTS RE-FORMING KEY RELATIONSHIPS: THE CASE OF GOB SQUAD'S *KITCHEN*

If tomorrow I find somebody who is pretty much like me and I put her here to sing, she can be Nico while I go and do something else.

(Nico)

The Anglo-German theatre company Gob Squad has for the last 15 years been making performances, films, installations and happenings across Europe. Their current show *Kitchen: You've Never Had It So Good* takes as its starting point an attempt to re-create the rarely seen 1965 film *Kitchen*, made by Andy Warhol and featuring a number of the artists and hangers-on that were part

of his Factory scene at the time. While the performance conforms to many of the acknowledged expectations of a traditional theatre show (end-on seating configuration, a clear delineation between stage and auditorium, identifiable named characters, a running time of 80 minutes with a fairly clear beginning, middle and end), the piece calls into question every element of the theatrical illusion, revealing it as a site of play, role-reversal, make-believe, sham and fantasy. In thinking through this performance, we hope to shed some light on how one might begin to rethink the theatrical, and more specifically, the performative, as a source of insight for arts marketing.

As we enter the theatre, four performers and two technicians, dressed casually, welcome audience-members backstage and across the set, before we take our seats. What we see is an artfully constructed film set, surrounded by appropriate paraphernalia: tripods, light stands, mixing desks, microphones, sound consoles and rudimentary painted backdrops. The audience is therefore immediately in on the construction and artifice of what we are about to witness, and welcomed as individuals rather than as a singular, massed entity. As it turns out, we are also being covertly 'auditioned' for our own role in the evening's events.

The show itself presents a knowing, seemingly tongue-in-cheek attempt to re-create *Kitchen* live on stage, while acknowledging that the performers have not actually seen the film, nor do they have much idea about the kinds of performances it contained, beyond being cool, sexually ambiguous and hip. The set, which we now know to be backstage, is projected live on three large screens at the front of the stage, and behind which almost all the live action takes place. For long periods therefore, we do not actually see the performers themselves, but rather their projected on-screen images. The two side screens present live constructs of other Warhol works: *Sleep*, in which John Giorno famously does just that for eight hours; and *Screen Tests*, in which famous and not-so-famous faces sat for Warhol's video camera for extended periods, apparently doing nothing. Gob Squad's performers take it in turn to fulfil these roles, interchangeably, yet always infused with their own personality and a particular understanding of what is at play at any given moment.

The stage sets include many signifiers of the mid-1960s, although a performer at one point playfully acknowledges that incongruous items from the 1950s might also have been in the original film, 'the funny thing about the 1960s is that there were things from the 50s just lying around'. The performers constantly highlight the wrongness of these objects: instant coffee, sliced white bread and breakfast cereal are all acknowledged as new and exciting (for the time), but the performers cannot help but notice that the brands – Nescafe, Spar – are completely wrong for the supposed time and place. The same pertains to the furniture: Ikea, a performer notes. And yet it

works: the shots have a sense of impromptu abandon that feels exactly right for the kind of unscripted, semi-improvised film *Kitchen* indeed was. The actual words are surely wrong, but the spirit is somehow spot on.

Where the show starts to transcend convention however, and to take on a very particular sense of poetry and possibility, is from the mid-point, at which performers start to pick audience members to stand in for them. People are chosen and guided backstage, only to re-appear on-screen (visibly wearing ear-pieces) to act out the performance. Gradually, audience members populate the screens, simulating sleep, staring fixedly into a Screen Test or, most impressively, continuing the druggy dialogue of *Kitchen* itself. By this point, the performers are themselves sitting in the auditorium with us, whispering instructions to these new performers into microphones. The new cast absolutely understand what is expected of them, and appear to be enjoying themselves; and the end of the show is marked by them all having a beer together, still on screen.

Of course it is all Gob Squad's careful construct; but the sense that we are seeing ourselves projected, that refusal or disaster may come at any moment, and that we are all part of an elaborate prank, charges the atmosphere and provokes unexpectedly emotional readings and responses.

It is clear that many performance companies are increasingly looking to blur the traditional lines between audience and performer, back stage and front stage, and between the beginnings and ends of events into the wider experience of the institutions within which they are presented, and indeed beyond the confines of institutionalized venues altogether. For example, computer and online gaming have become rich influences for companies looking to eradicate the traditionally strict lines between audience member, participant and artist (e.g. Blast Theory, Quarantine, as well as Gob Squad themselves). However, when the organization commissioning or presenting such work tries to market such events, they have for the most part relied on traditional means of marketing and promoting, via print, mailings and the press. Online networking sites such as MySpace and Facebook have proved extremely timely as a more responsive and less institutionally owned (at least at face value) means of disseminating information, and more importantly creating a buzz. However, the marketing of this production can be regarded as a reproduction of a more traditional 'delivery' approach. By this we mean that the arts marketer is 'delivered' the arts programme, and then 'delivers' this to the target market using a range of differing media.

A NEW MODEL FOR ARTS MARKETING

It is clear that the separation of the core product and augmented services in arts marketing has enabled the art to be protected from market forces while also supporting the notion of 'arts marketing' as a separable and distinguishable concern. The above case exemplifies an opposing perspective, however, with the artist resituating their role to include that of guide (Carù and Cova 2006). Moreover, the audience is reconstituted as a cooperative producer of the work. We would like to elevate this approach, not only as a form of theatre with a strong history but as a potential lens through which to re-imagine the nature of the relationship between artist-audience-marketer. Traditional arts marketing presupposed a linear sequence from consumer-related functions (awareness-affect-action) or activities (visit web site, purchase ticket, park car, check coat, buy drink) to audience-related functions (appreciation, involvement, immersion) and activities (booing, clapping) and back to consumer-related functions and activities (after-performance drink, collect car, etc.). When moving from a 'product' to a more experiential perspective, however, we recognize that the performance is situated amongst many other, different, but related engagements that form a more complex (spatially and experientially) terrain in which contemporary arts marketing is embedded. Of particular importance in this regard then, are the notions of a guide (Arnould and Price 1993), who facilitates co-production on the part of artist and audience (Prahalad and Ramaswamy 2004), such that experiences can be extended beyond the theatre and beyond the artist–audience dyad (i.e. communities) (Cova 1997, 1999; Muniz and O'Guinn 2001).

The questioning and subverting of traditional boundaries within theatre, resonates with what is happening in contemporary marketing theory and practice. With the advent of a more experiential and service dominant logic (Vargo and Lusch 2004), marketing's exploration of the concept of co-production (Prahalad and Ramaswamy 2004) and consumer involvement (Celsi and Olson 1988) has taken on increased momentum. In our Gob Squad example, the manner in which the audience enters the scene, taking an active role in the co-production of the performance, based on given instructions and using available tools in the scenery, is comparable to the growing role of users entering the service stage and participating in the co-creation of the service delivery. Bringing in these different streams of research and practice we might envision a theory of arts marketing that is sensitive to the artistic vision, while at the same time it acknowledges an enhanced role for the audience. Moreover, adopting an experiential approach forces marketers to 'manage the integrated and coherent project of all [the] elements that determine the quality of [service] interaction' (Pacenti 1998: 123), performance included.

However, any situation where we have cause to blur the boundary between art and market should be handled with caution. We hope to avoid the postulation that what we mean by the traversing of old boundary lines is nothing more than a repetition of the Kotlerian imperialist project of old. In fact it's the opposite. Rather than presupposing that the arts can learn from marketing, we are saying that arts marketing can learn from the arts, and that we can enable this translation with the use of concepts and language explored within *contemporary* services research and consumer marketing theory. In the service design literature (Sangiorgi 2009), key ideas such as personalization, participation, co-production, engagement and empowerment are emerging (Burns *et al.* 2004; Parker and Parker 2007). From a passive role as recipient of *delivered* services, users are considered more and more as a critical source of innovation (Miles 2001; Peer Insight 2007; Meroni 2007) and as key 'actors' in the design and production of the service performance (Cottam and Leadbeater 2004; Jegou and Manzini 2009). This shift from a 'delivery' model to a more 'collaborative' one can significantly affect the mode in which art is marketed and managed. In this regard we will now build on key concepts from recent service design and marketing theory to elaborate on three themes in order to frame this new perspective on arts marketing.

CO-PRODUCTION

One of the earliest demarcations of services, as opposed to products, was the recognition of the key role played by users in their co-production (Berry 1983; Grönroos 1994). The level of participation and engagement in the delivery of services has been considered at a strategic level in service design innovation. Here there has been a shift from presenting solutions which reduce user effort (i.e. services that minimize process complexity and take the role of producing the main output leaving the users to choose among possibilities) to more enabling ones, where users take an active role in the shaping of the process and output. In recent research, enhancing the role of users has been considered as a specific means of enabling motivation, engagement and personalization as well as a way of reducing the use of centralized resources and accessing more distributed ones.

When users take an active role in the shape of art performance and service delivery, it becomes generally difficult to define controlled sequential and scripted experiences. This means that the experience cannot be pre-defined, including where the art is located, when it starts or when it will end, thus creating a space for a wider experience that is co-produced. This open and collaborative paradigm is changing the way marketers and designers work as

well as the way services themselves are conceived: from services as the result of scripted and sequential service encounters to services as open ended (Winhall 2004) and collaborative solutions (Jegou and Manzini 2009).

Artists are increasingly pushing the envelope of what constitutes a night at the theatre, blurring the line between performance and non-performance by animating found spaces (from taxi cabs, to hotel rooms, to disused swimming baths), radically expanding or shortening the duration of a performance, and creating performances which rely entirely on audience complicity (if not participation). Yet the arts marketer is still relying on modes of description and dissemination based on expectations of what an audience is likely to experience based solely on the three-act play, taking place well behind a notional fourth wall. Once the audience takes an active role in the performance the art organization needs to evaluate the potential role of the audience outside the traditional temporal and spatial frame of the theatre. Alternatively, the organization needs to evaluate how much the performance can enter traditional spaces of 'marketing'-related activities and re-define service encounters in order to provide more synergistic and coherent experiences. This can be seen as an extension of the more widely recognized role of audience in co-production which has been explored in the 'open rehearsal' tradition for instance (Sicca 2000).

EXTENDED AND OPEN-ENDED EXPERIENCES

The desire to blur where the performance, the venue and the audience begins and ends, and to expand the performance beyond its normal confines by any means possible, is exemplified in Gob Squad's hugely popular *Super Night Shot*. In this work the theatre audience watch hastily assembled films of company members out in the city only one hour earlier, trying desperately to find the stock characters with whom to populate the show from passers-by. In a neat flipping of theatrical convention, the piece begins with the triumphant return of the company to the venue. Only in hindsight does an audience member at the end of the show realize exactly what they were applauding at its opening. In this sense we can see that contemporary performing arts are not only breaking down the fourth wall, but the other three walls in the theatre as well. There is a conscious blurring of the lines between 'normal' life without art, and artistic experiences, creating a more extended liminal space between (Turner 1969).

According to O'Sullivan (2005: 2) 'the members of a performing arts audience cross a very visible threshold, and enter into a very specific way of being together (with each other and with the performers) as they enter the

auditorium and the lights go down'. This special and out of the everyday experience allows space for the creation of communitas.

> Communitas is a sense of community that transcends typical social norms and convention . . . when individuals from various walks of life share a common bond of experience. The spirit of communitas emerges from 'shared ritual experience' that transcends the mundane of everyday life
>
> (Celsi *et al.* 1993: 12).

The concept of communitas has emerged from anthropology, primarily from the work of Turner (1969). It was developed initially as a way to describe the experience of initiands during both the initiation process itself and its effects thereafter. It has since moved onto more abstract concepts such as the interplay between anti-structure (communitas) and structure in explaining society and its development. It has already found favour within marketing research, most prominently in the work of Celsi *et al.* (1993), a study of consumption practices within the skydiving community. Here the concept was used to describe the extra-ordinary space created within the skydiving experience itself, where class, gender and other social structuring devices fade into the background. Communitas, in this context is seen as a sense of community that allows what may be seen as a disparate group find a sense of coherence. An important element of this is the 'out of everyday lived experience' aspect, which allows us to consider such experiences as more sacred than secular. Turner himself views the experience of theatrical drama as a contemporary example of a ritual process, bringing the audience out of the everyday into a world characterized by symbolic action, myth and experi-ence (Turner 1974). Key dimensions of the concept of communitas that are important here include; an experience outside everyday lived experience; a sense of equality where 'secular distinctions of rank and status disappear or are homogenized' (Turner 1969: 95); and most importantly, a shared experi-ence that can impact on relations between those who share the experience beyond the event itself; where the 'immediacy of communitas gives way to the mediacy of structure, while in rites of passage, men are released from structure into communitas only to return to structure *revitalized* by their experience of communitas (Turner 1969: 129).

This movement in and out of structure (the everyday) and communitas is of importance here. If we widen the scope of the metaphor, we can see that the performance itself can be expanded beyond the theatre. Therefore, the sites of communitas can also be broadened, to the street, the foyer or any other site the artist has consciously chosen to be included. Without the calling card of

the 'house lights going down' we have to learn to draw different lines between structure and communitas. In this more spatially complex terrain, moreover, we argue that the arts marketer has a particularly important role to play.

THE PROCESS OF IMMERSION

As much as for a contemporary theatrical performance, when the audience are enabled to move and act in the scene, the marketer or designer of the event becomes more a 'provocateur' or 'facilitator' than a traditional 'director', providing the platform, the knowledge and the tools to support the enactment. This changing role of the designer as facilitator, who sets the scene and exchanges the necessary knowledge for people to act and interact, is significant for the arts marketer who could act as facilitator between the audience and the artist and between the audience and the audience or the general public. Like the service provider described by Arnould and Price (1993), the art marketers' role shifts from conveying messages and providing information, towards setting the scene for a more active participation, creating space for surprise, space for reflection and for interaction. This guiding role has been explored further by Carù and Cova (2006) when discussing the practices the service provider can engage in to enable and direct consumer immersion in experiences; defined as 'a moment of intensity that a consumer lives through' (ibid., p. 11).

Rather than assuming immersion to be immediate (Pine and Gilmore 1999) or automatic, Carù and Cova (2006) stress the operations involved in achieving a level of appropriation which characterizes immersion; these include nesting, investigating and stamping, whereby the service provider offers referents at each stage to guide consumers so they fully engage in the experience. Nesting involves the comfort derived from a degree of familiarity with some aspects of the experience, where for example even if the audience is not familiar with the artist, they may have already been to the venue, or vice versa. From this feeling of comfort, at some level, the audience member is more ready to explore and investigate the more unfamiliar terrain; 'this enhances knowledge of the context of the experience being faced and progressively extends one's territory' (ibid, p. 6). Stamping then involves meaning making whereby the audience member attributes specific meaning to an experience which will have a unique personal resonance based on that persons experience, history, etc. In their study of immersion at a classical music performance the authors suggest that these operations occur in a cyclical and iterative manner throughout the performance experience. We would like to go one step further to suggest that not only can the artist support

these operations in their mode of performance, but that these operations can be elevated to describe the practices of the marketer of the art as well.

We would now like to take these three themes and consider how they can inform the arts marketer's mode of practice in this more collaborative and experiential approach to arts marketing. In this regard we outline how the marketer can play a key role in mediating and facilitating audience co-production or co-authoring (Knell 2006), build connections between the actors in the network (artistic director, management, box office, technical staff and audience) and guide the audience through this more complex terrain.

IMPLICATIONS FOR ARTS-MARKETING PRACTICE

When art blurs spatial, temporal and role boundaries it can get into conflict with more traditional art spaces and organizations that still deal with service marketing and delivery in conventional spaces, service sequences and roles. In order to enable a coherent and synergistic performance, art organizations and marketers need to look at artists and audiences as collaborators in the co-production of the overall experience. Moreover, in order to attract, engage and retain the audience, we suggest that art organizations should develop new modes of collaboration that enable 'co-produced' and 'extended' experiences that break up traditional boundaries between producers/consumers, marketing/ performing, etc. This is possible only when the creative process becomes open and more collaborative, redefining organizational roles and using the creative process as a vehicle to generate participation and attract a growing community around the art event. We suggest that this approach requires a particular configuration of skills, or modes of practice that are different from the skills more typically ascribed to this role.

ARTS MARKETER AS COLLECTOR AND SHARER OF STORIES

In the delivery-style approach, the role of the arts marketer is to bring the 'product to market', which involves writing copy, direct marketing, engaging with the press, etc. However, with a collaborative approach, the role of the audience in the generation and sharing of stories around the event come more to the fore. The arts marketer's role then moves to one of ethnographer, who goes out, interacts with the audience and the artists over extended periods of time, and integrates those stories into a creative 'whole'. This role is not entirely new in the arts. As already mentioned, the pioneering work at the Battersea Arts Centre and their 'Scratch' schemes, enables the audience

to participate in the process of art making, which goes to heighten their experience and creating a bond between the audience and the work itself. More and more artists are exploring this participative style, for example Manchester-based Quarantine, who make intimate and revealing performance works with non-performers, or rather with non-trained actors of all ages and backgrounds, and in which there is only a fine line between audience member and performer. Quarantine have both pushed performance out into the city and have brought audiences into the heart of the performance. In *See Saw*, performers are sited across town to be glimpsed, perhaps unknowingly, by audience members on their way to the theatre. The show then sees the audience divided between two facing seating banks, to literally watch itself, opening up myriad possibilities depending on who and what is perceived to be part of the performance. For example, in *Eat Eat* creating a performance meal in which local asylum seekers are only gradually revealed as both cooks and performers within the piece, and in which impromptu conversation between performers and audience members forms the majority of the show.

ARTS MARKETER AS NETWORK FACILITATOR

Extending the domain of the performance beyond the confines of the theatre and extending the authorial role beyond the artist means that the nature and situation of actors involved in the creative process become more complex. As such, rather than view the marketing of the arts as a discrete activity, we must now look at the whole production (creation) and marketing (dissemination) of the arts as a web of activities embedded in a network. In this shifting space of roles and responsibilities, the arts marketer is in an important position to take up the baton of network facilitator. The marketer's predisposition to look both externally towards the consumer and internally towards the organization provides them with a unique perspective in this regard. Through the use of social networking platforms the arts marketer can enable audience-to-audience interaction in the generation and dissemination of stories; thus extending the experience.

> The new technologies extend the possibilities for collaboration and collective working, while eroding the traditional barriers between arts and science, artist and technician. The idea of the artist-auteur will weaken, and the concept of 'inter-authorship' will strengthen.
>
> (Hewison 2000)

When the experience of the traditional audience becomes one of active engagement in the art process and performance through a more complex set of

channels and media, the arts marketer (or service designer) needs to move beyond the design of single touch points or encounters. Of particular importance in this will be the concept of 'navigation' (Ramirez and Mannervik 2008), which enables audience participation and co-creation of value. We will now explore this in more detail.

ARTS MARKETER AS GUIDE

While the co-production concept is well recognized in services marketing, the seminal work of Arnould and Price (1993) goes further to suggest that from an extended experiential perspective the more relational and communal qualities of the service provider come to the fore. As such, in extended experiences the provider becomes a member of the community thus intensifying their relationship 'shifting it into a boundary open transaction . . . that transcends commercial interaction' (ibid., p. 41). In becoming a member of the community or network (populated by artists and audiences) the arts marketer cannot stand outside and direct; he/she must understand, deeply, the practices of the network members in order to truly guide and enable their experiences. As Carù and Cova (2006) suggest, the role of the guide becomes even more important in situations that are new or novel, but where the guide can support the audience by creating a sense of safety and the familiar. Moreover, when one recognizes that deep immersion is not immediate or automatic, as Carù and Cova (2006) argue, it becomes possible to see how this role of the arts marketer as guide can be employed in more 'traditional' art forms or repertoire. As such, while the examples we have drawn upon in this chapter evidence the possibilities of aligning contemporary performance practice and arts marketing, Knell (2006) acknowledges that there is scope for more traditional repertoire, groups, or organizations to explore this more collaborative and experiential approach to the marketing of the arts.

> Newer art forms lend themselves more naturally to these new forms of co-production. Equally however, this does not mean that traditional arts forms cannot innovate at both ends of the personalization spectrum, not least because co-production is not a new idea in the arts. [There is enormous] scope for innovation across the whole sector, encompassing both the established arts infrastructure and the new.
>
> (Knell 2006: 13)

CONCLUSION

The traditional tools of arts marketing do not fit with the transformative, collaborative nature of the generation as well as of the representation of contemporary performing art. A serious gap between art practice and the marketing of the arts characterizes the current situation. A significant driver for change in arts marketing is the growing emphasis on the collaborative mode of the creative process. Once the creative process becomes open, it can become a vehicle for communication, development and engagement. In order to enable personalization and participation, the audience are also engaged in the process, which is not anymore a one-off session or formal consultation process; 'it is more a creative and interactive process which challenges the views of all parties and seeks to combine professional and local expertise in new ways' (Cottam and Leadbeater 2004: 22).

To allow this level of participation, not only does the service interface need to change, but also organizational models and culture. New service organization models are emerging, often based on open collaborative platforms where more stakeholders participate in the co-creation of the final solution. Applying these emerging models to theatre organizations could help managers to reduce the barriers and gaps between the core product (the art) and the augmented product (surrounding services, i.e. box office, refreshments, cloakroom, parking, etc.), using the artists' creative process and performances as the engine for change. In building on the three themes of co-production, extended and open-ended and guided experiences, we offer three modes of practice for the contemporary arts marketer, that is, arts marketer as the collector and sharer of stories, network facilitator and as guide. We feel that this brings into line contemporary art practice and the marketing of the arts themselves. While we recognize that this more collaborative tone sits well with the current zeitgeist of art practice, we do recognize that there will be resistance to this. Among a range of professions there is an ongoing critical discussion as to the rise of the consumer's voice which seems to be carrying more weight than those that were heard before (doctors, teachers, designers and of course artists). However, we suggest here that the myth of the single artist-auteur (Knell 2006) is just that. Art has always involved some level of collaboration, be that with funders, technicians or directors. Bringing the audience directly into the process of production can enrich, and not detract, from the artistic merits of the work, as long as the artistic vision remains central. So too with the arts marketer, who can enable dialogue and participation, but who must not 'get in the way' of the primary relationship in the arts, that is, the relationship between the artist and the audience (Knell 2006).

ACKNOWLEDGEMENTS

We would like to thank, in particular, Maurice Patterson for his help and support in reviewing this chapter. His insights and suggestions have been invaluable. Any remaining errors, omissions or generally flawed logic remain the responsibility of the authors! We would also like to acknowledge the support of Gob Squad, the theatre company discussed in the chapter; their work was the inspiration which provided a metaphorical meeting place to develop our work.

Chapter

16

MUSEUMS IN SOCIETY OR SOCIETY AS A MUSEUM?

Museums, Culture and Consumption in the (Post)Modern World

Elizabeth Carnegie

Museums are important because they serve to remind us of who we are and what our place is in the world.

(Davis 2007: 53)

INTRODUCTION

MUSEUMS HAVE DEVELOPED as a consequence of changes in society. From the nineteenth century onwards they were being developed and promoted to the increasingly urbanized working classes as a form of rational leisure (Bennett 1995) with a strongly educative and morally edifying role. As Davis (2007) argues above in the opening quote, museums retain an important role within the modern world as spaces in which to explore, confirm or even reject questions of personal, social and cultural identity and thus to form, re-form and challenge the shaped visions and versions of the past and present. However, museums continue to be defined by their visiting communities (Hooper-Greenhill 2007) and by the staff and political will of the funding bodies, still in many cases directly or indirectly local or national government. This has the inevitable consequence that museums are shaped for, and I argue by, that visiting community, given that museum personnel also tend to be reflected in the museum-going classes.

Whilst museums remain cultural temples intended as secular 'civilising influences' (O'Neill 1996: 191) which can provide a forum for understanding cultural change, the social and political role of museums is changing as they are increasingly required to be *actively* engaged with visitors, specifically

targeting particular audiences in order to meet government agendas in terms of social inclusion and cultural relevance – to be relevant to all social groups within wider society and not just to 'traditional' museum visitors.

These 'adapt or die' arguments are not new, and, indeed, Clifford (1990: 449) asserts that museums routinely 'adapt to the tastes of an assumed audience' which he acknowledges is likely to be 'educated, bourgeois and white' even when – as I have argued elsewhere – the displays are initially targeted towards particular social or community groupings (Carnegie 2006). Given the growth in tourism is it hardly surprising that museums are largely consumed by tourist visitors as Graburn (2007: 227) states: 'both museums and tourism, . . . appeal to the middle classes all over the world'.

The idea of the museum as simply providing a container for material culture is therefore changing, being challenged, and is the subject of continuous debate often framed within wider questions about modernity and the impact of postmodern thinking on citizenship (Ison 2002). Harris (1990: 81 quoted in Clifford 1999) questions whether museums in the modern world are simply another form of 'asylum', becoming spaces associated with 'special kinds of memory baths and gallery going rituals'. Bennett (2006: 46) argues that museums function as 'exhibitionary complexes' aimed at developing citizenship and are becoming 'differencing machines' intent on 'promoting cross cultural understanding' in a society where their very existence in ever increasing numbers denotes, as Clifford puts it, the 'ambiguous failure of cultural difference' (1999: 455). Social exclusion policies can equally be viewed in this light.

At the same time the distinctions between what is a museum and what is a civic space for the location of culture have become increasingly blurred as society can be deemed to have become more like a museum, a staged space 'creating a sense of "hereness"' (Kirschenblatt-Gimblett 1998: 7) that we can project ourselves into and experience the sense of 'us'. Within this chapter then, I discuss current key developments and shifts within museum interpretations and in the way people experience museum-related culture within society, both inside and beyond the museum, to determine what impact these have on museum consumption.

I initially determine the changing role of museums in society and draw on contemporary museology and heritage theorists to argue that cultural change sometimes serves to reinforce ideas about peoples and cultures as much as it has fragmented the nature of society. Thereafter, I consider how heritage culture is created and consumed in wider society, both influenced by and influencing museum products.

MUSEUMS IN SOCIETY

Given the nature of changes within society and the way museums respond to, or reflect, such changes, it might be a fair question to start with what is a museum and why preserve material culture? Morgan and Pritchard (2005) posit that 'the shaping, appropriation and consumption of the material world is one of the key ways that we show "society" who we are and indeed how "societies" influence us'. Traditional definitions which define the museum space as containing and interpreting the material evidence of human activity are challenged by any number of questions about whose past and present is being reflected, and, crucially, to whom. Hooper-Greenhill argues that museums have 'been active in shaping knowledge' and 'providing ways in which it has been possible to know the world' (1992: 8). Such cultural spaces continue to be 'world making' (Hollinshead 2004: 25) as well as world reflecting in the way they organize, construct and interpret their collections. But the means by which they tell their stories is ruptured by the changes in society leading to the charge of 'othering' amidst accusations of perpetuating dominant cultural narratives or at best of cultural complacency.

Therefore another key question drawn from these debates and not easily answered in this chapter is what is society – or more accurately – what is society becoming? Museums' organizational aims evolve and change in step with societal change – or at least as mentioned earlier in step with the assumed visitors' changing world/world view. Can then society be materially defined within museums in a fast changing and increasingly globalized world? Pearce offers compelling reasons why we would want to try to when she argues that society is socially constructed, so that 'each of us, lonely and fearful individuals, needs to feel there is an "us", a broader grouping of souls with a shared culture' (1997: 17). Material culture provides the 'raw material' capable of being 'organised into the kind of cultural construct which we call human society' (1995: 13), rendering collections of objects a uniting, and by this view *necessary*, 'act of imagination' (Pearce 1995: 17). Society becomes a term which is both intended to be inclusive and to promote cultural distinctiveness. Thus collections of 'things' create meanings; a series of signs and symbols that can be readily understood by those who shaped their meaning in society. As society changes so too will the objects' meanings and messages and their central importance to people's lives. As societies change as a consequence of globalization, this form of cultural positioning through organizing and classifying the material culture as a way of finding a sense of 'us' and determining what/who is not us and is therefore 'other' is problematic.

Key debates centre round the characteristics of late modernity (movements of people, knowledge, technology) and with them the consequences of cultural

change and the impact of the global on the local and indeed vice versa. Some writers have argued that museums have become more localized as a consequence of globalization. Indeed Bennett argues that many contemporary museums are less globally ambitious then their nineteenth-century counterparts with a new emphasis on the multi-vocal (Bennett 2006). However, as Kirshenblatt-Gimblett (2006) has argued, 'the discourse of heritage is diplomatic and celebratory . . . it prioritizes the rights of consumers to be able to access global heritage over the needs of those whose habitus is transformed into heritage'. Museums and other cultural spaces globally are increasingly being consumed by individuals whose global sense of culture and heritage has been shaped by the dominant narratives of Western ideology which reflect and shape in turn the policies that define the global cultural movements. The 'educated, bourgeois white audience' that Clifford (1999: 449) cites, becomes the global audience, consuming and therefore shaping or having the museum products shaped for them if not directly by them.

Therefore, global movements such as World Heritage Sites, and their associated tourisms, 'are hegemonic in themselves in that they promote these values as global *needs* and in turn are blatantly neglectful of local voices' (Tucker and Emge 2008: 5). This tends to suggest that heritage interpretations become a *necessary* product of collusion between consumers, producers and sellers. Indeed, Kerstetter and Cho (2004: 977) argue that consumers as 'knowledgeable individuals depend more on their own internal sources', which in turn leads destinations to respond by creating an experience which best fits those consumer expectations which 'theoretically leads to satisfaction'. Local museums may still be viewed in this frame despite seeking to focus on local audiences and issues. Witcomb (2004) considers that a 'New Museology' based on community engagement is part of the political repositioning of museums keen to move away from the charge that they are hegemonic institutions. However, local museums seem likely to be subject to, and influenced by, global politics and cultural change as I will now consider.

RESHAPING MUSEUMS/RESHAPING OF THE PAST?

Given the difficulty in defining society in order to then understand museum politics and publics at local, national or international level, several other questions arise: if there is no such thing as one society and the term community is itself open to question, can it ever be possible to meet community needs? Can those communities needs exist or be met at local level without being subject to external and global influence? Kurkowska-Budzan (2006), in her work on the development of Museum of the Rising, Warsaw, argues that

it is possible under some conditions, of which the main one is 'that the interpretations of the past produced by authorities or the spokespersons . . . not contradict the lived experience of individuals'. However, museums struggling to change the dominant narrative in tune with the needs of local people and with the aim of inclusiveness are of necessity often trying to distance themselves from the events of the past. Kirschenblatt-Gimblett (2006: 40) notes that the South Africa Museum is 'engaging in a museology which includes elements of self-critique and self-indictment' whilst at the same time creating displays which include new versions of the history 'of indigenous pasts as part of a postapartheid triumphalism'. She determines that it is the role of the museums of the aggrieved to set the record straight. O'Neill (2004: 200) responding to claims of 'universalism' being put forward by world-leading museums such as the British Museum, Louvre, and the Metropolitan Museum, New York, argues that it is the role of all museums as safe spaces to explore 'the tensions of being torn between empathy and possession' to explore issues that impact outside of the museum and yet are also part of their structural and organizational political histories.

Williams (2007: 102) highlights that 'memorial museums' are intent on reclaiming certain pasts rendered powerless by political regimes and now subject to repositioning in the light of cultural and political change. Such museums he argues, 'operate against the conventional premise that we preserve markers of what is glorious and destroy evidence of what is reviled'. That some societies revere or at least condone what is reviled in others is challenged by the global consumer morality which at times forces reading of sites in the ways suggested above. Indeed Bonnell and Simon (2007: 65) argue that it is our responsibility as consumers and producers of our cultural inheritance 'to critically engage with a past that is both inspiring *and* despairing'.

Museums responding to cultural change after war or political change may not be able or seek to represent events in ways that meet the immediate needs (or desires) of locals. Visitors to the 'Killing Fields', Cambodia are overwhelmingly (and mostly Western) tourists, whilst locals come to terms with, and may as yet not fully comprehend, the events that led to the site's construction as a heritage space. Expatriate Bosnian returnee Amir, believing the state-run museum in Sarajevo was ineffective in helping locals and returning exiles understand the events of the war, collected material culture from the time of the siege and created an open-air display in the heart of the market area. Visitors to the official museum are noticeably tourists and this is reflected in the visitors' books.

Such sites as is evidenced in Robben Island, South Africa, have the potential to represent the intimate and global in terms of subject matter, visitors and aims. There the intimate and personal details of individuals' lives and deaths

are consumed as part of the wider and global political issues and agendas of post-apartheid South Africa, but within a symbol and iconic space which offers 'place' authenticity as a consequence. Buntinx and Karp (2007) suggest that such museums are able to take advantage of the 'symbolic capital associated with the idea of the museum' whilst presenting an alternative more community-orientated point of view which may challenge any universal claims.

Scholars (Seaton 1996; Lennon and Foley 2000; Williams 2004; Tarlow 2005; Stone 2006) note the increasing number of tourists to a growing number of 'museumified' sites associated with death or disaster. Theorists are concerned with the motivations of tourists to such sites. Whilst they are not arguing that such visits are solely or simply a consequence of late modernity, they do, however, maintain there is a clear link with 'moral panics' as a consequence of mediated versions of events and the increased uncertainty associated with the loss of community. Graburn (2007: 129) contends that museums as the 'storehouses of humanity's heritage' are natural spaces to visit in the quest for individual identity. In short, visitors to such sites may well be seeking to make sense of their own lives through examining the dark side of other people's existence.

What results though, is a repackaging of such sites as heritage spaces which are then marketed to attract visitors, leading Stone (2006) to argue the need for social marketing as such sites become tourist attractions. Arguments about the authenticity of sites associated with death and disaster and therefore the experience offered are further muddied by the moral questions about whether such sites should be consumed as part of a tourist experience. The onus appears to be on the consumer to have 'appropriate' motivations to attend and 'appropriate' behaviour at the site. As Bonnell and Simon (2007) argue, other people's 'dark histories' impact on all society and therefore it is important that all peoples have access to such displays.

Object authenticity alone does not ensure authentic interpretations even assuming such truths were possible. Hall (2006: 70–71) questions whether the playfulness, and indeed plethora, of simulated environments typified by Disney World and any number of themed environments, including the everyday spaces such as hotels and bars, are evidence that hyper-reality has become the 'new authenticity'. He questions whether material objects are still essential to 'grounding our sense of identity' and asks what 'are the consequences of questions such as these for museums in the global public sphere of the contemporary world?' Objects consumed within museums or heritagized spaces can be conceived as having less authenticity, their meanings fractured by the loss of context and cultural knowledge. Museums may well try to reflect use and meaning within a particular society but they remain

consciously apart from society. As Message (2006: 5) argues it is 'common for a disjuncture to exist between museums (as signifiers of high culture) and the quotidian environment that they are at once located within, but from which they may seek to maintain a separation'.

However, increasingly consumers seem to be blurring the distinctions between museum/heritage visits and other forms of leisure within their social lives – between Bennett's (2006) 'exhibitionary complex' and Hall's (2006) 'experiential complex' as the boundaries between museums and heritage spaces and our lived environment are becoming less clear as the heritagized culture, the consequence of modernity (see, for example, Hobsbawm and Ranger 1983; Wright 1985; Hewison 1987) gives way to the hyper-reality arguments of post-modernity (Goodacre and Baldwin 2002; Graburn 2007; Hollinshead 2004; Kirshenblatt-Gimblett 2006), which I will now discuss.

SOCIETY AS A MUSEUM

When Hewison (1987: 9) questioned how long it would be 'before the whole United Kingdom became one vast museum' he did so in the belief that the heritagizing of society was a consequence of, and response to, a Britain 'in the climate of decline'. He argued that 'instead of manufacturing goods we are manufacturing heritage, a commodity which no-one seems able to define, but which everyone is eager to sell'. Samuel (1999: 163) determined that the ever growing enthusiasm for the recovery of the national past as a 'timeless one of tradition' resulted in an increased sense of 'nostalgia for the present' (Jameson 1991), itself a product of the rupture and fast-paced social change that typified the juncture between the modern and postmodern.

Interestingly, Goodacre and Baldwin (2002: 1) challenge this view that considers the interpretations of 'pastness' as heritage. These traces of the past are for them partial representations that can be usefully shaped to create *history* and that history interpretation can take many forms embracing new media and less book-based interpretations. Their own work is preoccupied with re-enactment as a legitimate historical form rather than an expression of the playfulness of late-modern consumption of heritage and identity.

Strathern (2003: 38) notes that within definitions of society and values expressed or shared therein, a common assumption remains that society is moving forward, or changing. By 2006, Kirshenblatt-Gimblett seems to be arguing that the process of acceptance of change is complete and that therefore society has changed. Heritage as a mode of cultural production has succeeded in creating and shaping a world where we are self-consciously selecting, shaping and saving that which we can attribute social value to in the present.

She maintains that 'the result is transvaluation that preserves "custom" without preserving the "custom-bound" self' (2006: 40). Thus we have become self-conscious, and are able to be self-selecting, consumers. In this way heritage is no longer necessarily something that is done to us, shaped by government will or as a compensation for the immediate sense of loss of the traditional modes of production at a time when self and societal definitions seemed less problematic.

Yet the freedom to shape and change our projected or felt identities and self-consciously 'select from a lifestyle wardrobe', developing an 'identity through possession' (Morgan and Pritchard 2006: 33) can reinforce uncertainty and doubt. Equally the heritage products on offer from which to select identity or 'bits' of a fluid identity may or may not be a good fit for a specific imagined identity. Consumption practices reflect the shared values of the dominant 'heritage providers'. Society may mirror the museum in terms of the 'heritagization' of culture, but if museums are still defined in terms of their audiences (Hooper-Greenhill 2007) and if those audiences remain traditional museum-goers as defined by Clifford (1999) and outlined in Hargreaves (1997) and Carnegie (2006), it seems fair to make an assumption that the key consumers of society within society remain the museum-going class and vice versa. This means they are also the key consumers, shapers, and ironically, *critics* of the whole range of heritage products, including the sites associated with 'dark tourism'. This further reinforces debates that high and low culture as a concept is replaced within late modernity by more popularist heritage consumption. As Harrison (2005) points out traditional museum values were victim to the anti-intellectualism that pervaded the 1990s. At the end of the first decade of the twenty-first century, museums remain sites of consumption, although they are increasingly adapting to the 'experiential' model (Hall 2006) in order to compete with the growing number of more popularist visitor attractions. 'New museology' debates centre round the distinctiveness of museums based on their relationship to material culture. Museums, in a time of hyper-reality and the loss of the 'real' amidst arguments about what can be deemed authentic in the modern world, are only one of the ways in which 'heritagized' culture is reflected and only one of the ways to acquire museum-related knowledge.

CONCLUSION

Although theorists disagree to the extent that museums in the postmodern world reflect cultural change, all agree that museums remain important, if selectively structured spaces, which offer particular insights into human

activity. Some like Davis (2007) argue their continued importance as spaces in which to explore cultural identity amidst the fragmentation and cultural confusion which renders definitions of community and even society (and therefore self) problematic. Others such as Bonnell and Simon (2007) and O'Neill (2004) maintain that museums need to be more issue-led and challenging in their subject to reflect the realities of life, and that local issues have global resonance and vice versa. O'Neill (1996 and 2004) and Sandell (2002) maintain that museums have a social responsibility to promote inclusivity and that this is more important when organizations are aiming to be global in their vision. Bonnell and Simon (2007) believe that the global nature of audiences can promote and support change. They can force debate and learn to confront the 'brutality' and the dark side of life both within the museum and in wider society, and ultimately within themselves. Several of the authors cited here, however, conclude that despite the shift to a more localized cultural viewpoint evidenced within museums, audiences have changed little.

However, even when museums are constructed as socially relevant institutions which are engaged at local level, they may be consumed, as they are likely to be, as 'cultural stations' (Burns 2000) by different audiences as journeys of selfhood. As Kirshenblatt-Gimblett (2006) argues above, audiences read museums as texts according to their own cultural and world view, thus (super)imposing that world view on museums visited as part of overall consumption of people and places, societies and communities that form part of the 'heritagification' of cultural spaces.

Museums have the potential to explore the global through exploration of the local and to reach beyond the production of dark heritage or romanticized views that shape much heritage provision to offer the potential for engagement at a deeper level. In this way visitors may also find 'authenticity within the self' (Wang 1999). Museum staff, mindful that people still seek to find that sense of 'us' within museums, would do well to maintain their distinctiveness within the heritagized global culture, as well as to acknowledge their part within it.

Chapter

17

EXTREME CULTURAL AND MARKETING MAKEOVER

Liverpool Home Edition

Anthony Patterson

BLOT ON THE MARKETING LANDSCAPE

THE HEARTRENDING, TEAR-INDUCING stories told by incredibly worthy individuals at the beginning of every episode of *Extreme Makeover: Home Edition* certainly provides interesting TV fodder, not to mention an honourable imperative for spending heaps of money building spanking new homes equipped with expensive furniture and cool gadgetry, but they pale into insignificance when compared to the city of Liverpool's sorry tale. Surely, if ever a makeover show were made for forlorn, down-on-their-luck cities teeming with urban ragamuffins, Liverpool would – until recently at least – have been a prime candidate to receive the full makeover treatment. Undoubtedly, viewers would have been affected by the maudlin narrative, the mawkish mythology that casts it as a blot on the landscape, a national cultural joke, Cinderella at the national city ball (Belchem 2006; Grunenberg and Knifton 2007). Thoroughly woe betided, Liverpool is frequently characterized as 'one of Britain's most blighted cities' (Kivell 1993: 164), a dystopia mired in 'decay and dereliction, high levels of unemployment, poor housing conditions' (Savage and Warde 1996: 267), and as 'a scarred, de-industrialized landscape' (Childs and Storry 1999: 283). From the comical 'calm down caricature' to the cheerless hardscrabble image of 'shell suited scallies', Scousers have been derogatorily labelled and stereotyped like no other city-dwellers in England (Boland 2008). Such has been Liverpool's downtrodden stature, its reversal of fortune in the wake of industrial decline, the yawning gap between it and the rest of England, that, despite once being the second city of the English empire (Haggerty and White 2008), it is now, somewhat speciously perhaps, cast as a postcolonial city on a par with those in the Third World (Munck 2003).

Jacqueline Brown (2005: 131) goes so far as to say that 'its postcolonial displacement, its dislocation from the would-be embodiment of British modernity' stands as 'a signifier of all that is wrong with Britain'.

The good news, of course, is that Liverpool's plight sufficiently plucked the heartstrings of the Capital of Culture jury such that it secured an extreme makeover of its own. Against strong competition from other UK cities such as Belfast, Newcastle–Gateshead, Bristol, Cardiff, Oxford and Birmingham, it was awarded the status of European Capital of Culture (ECoC) 2008, an achievement that has injected some £800 million into the region. Liverpool was acknowledged for its strong cultural heritage, regeneration plans and recent UNESCO World Heritage site status to name but a few winning elements. Such a win also served as a huge catalyst to Liverpool's ongoing culturally led redevelopment project that has made only incremental progress since the 1980s, partly because it always came a poor second to its eternal resources rival, Manchester. Of course, the radical remodelling of a place's urban reality by capitalizing on its cultural assets is an increasingly popular route taken by many towns and cities (Philo and Kearns 1993; Miles and Miles 2004; Mark 2006; Roodhouse 2006). The hope of such schemes is not only to ensure that such a reinvigoration and revitalization will provide a competitive advantage over its nearest neighbours, but that it will also boost visitor numbers, enhance the city's appearance, make it a more conducive place for residents to live, and, more broadly, place the city in an advantageous position in relation to the dynamic global currents of finance, information, and public perception (Williams 1997; Hambleton and Gross 2007).

The tried and tested format of such a makeover, to a cynic at least, involves: scouring the history books for points of hometown distinction; celebrating a sense of place by making local landmarks more tourist friendly, perhaps by installing a touch-screen kiosk or two, erecting plinths in honour of famous locals from the past and present, renovating and renewing public architecture, shopping precincts; and generally polishing the town's jewels, whatever they might be, for the purposes of public display. Ultimately, the goal is to create a more palatable and exciting place tale. The danger is, of course, that if everyone follows this trajectory then it becomes a zero-sum game, one culture-led regeneration project simply cancels out another. I was vividly alerted to this incongruity recently on returning to my obscure hometown in Ireland, where I discovered that the new town hall extension had been artfully etched, no doubt to the mayor's gleeful satisfaction, with words and phrases lifted directly from what seemed like some generic 'how to do culture-led regeneration projects' manual. Facile and nondescript statements like, 'from weaving cloth we weave thoughts', 'wind bouncing on my face' and 'feels like freedom' were everywhere, and any semblance of deeper meaning was

entirely precluded (Ward 1998). It made me wonder if these schemes, which rely on intangible notions like culture and creativity to market destinations, are now too frequent in number to actually benefit the places themselves, or is the Organization for Economic Co-Operation and Development correct in asserting that all regions should be 'trying to increase their comparative advantage by adding to their stock of cultural attractions' (OECD 2009).

The purpose of this chapter then is to explore whether or not Liverpool, during its 'cultural moment', has really become representative of anything distinctive and different, or has, in fact, the project seen the place become just another conventional landscape of consumption, characterized only by the homogenized symbols of multinational stores that line its streets, losing along the way something of its true identity? Naturally, the focus will be on marketing's not inconsiderable role in Liverpool's cultural metamorphosis. The promise of marketing, after all – whether it is called 'place marketing', 'city branding', 'tourism marketing', 'destination marketing', 'place branding', or in the case of this book, 'arts marketing' – serves as the rationale behind all of these cultural transformational packages (Miles and Miles 2004; OECD 2009). The latest textbooks in the field purport to be able to reposition a city suffering from a seemingly terminal case of bad press and to promise to transform destinations in crisis into places that people might once again like to visit (Anholt 2007; Avraham and Ketter 2008). Nonetheless, marketing centrality in this process is not without controversy. The objectives of place marketing schemes, some argue, are entirely misplaced and counterintuitive (Kavaratzis and Ashworth 2005; Jamrozy and Walsh 2009). Urban planners and geographers have been most vociferous in their condemnation of such schemes. They argue that, 'Packaging and promoting the city to tourists can destroy its soul. The city is commodified, its form and spirit remade to conform to market demand, not residents' dreams' (Holcolm 1999: 69); and that using place marketing is an 'extremely fragile basis on which to build the fortunes of a city' (Oatley 1998: xiii). Bearing this in mind, this chapter will commence with an elaboration of the methodology, and then proceed by introducing the capital of culture concept and Liverpool's brand heritage. Two main empirical issues will be explored: whether the negative perceptions of Liverpool have been altered by the project; and the extent to which local people are involved or not. Finally, some conclusions will be drawn about the future Liverpool faces in respect of the ECoC project's legacy.

IN MY LIVERPOOL HOME

To thoroughly address this research agenda I adopted a three-pronged ethnographic-style methodology. The first element consisted of in-depth interviews with Liverpool residents aged 19–65, and the second consisted of in-depth interviews with the organizers of the ECoC events. In total eight key informants were interviewed by my research student, Amy Smith, without whose sterling efforts this chapter would remain unwritten. Among others, interviews were conducted with key informants such as Phil Taylor, Infrastructure Manager for Creative Communities, and Christine Peach, South Liverpool Neighbourhood Manager for Liverpool City Council. The third plank of this research project involved the solicitation of 156 intro-spective essays from individuals who on the one hand can be classified either as locals or visitors to the region, and on the other, can be collectively regarded as a research-enabling student cohort. The field methods employed in this study are similar to those of most interpretive arts marketing research projects in which the researcher, in this case positioned in the vantage point of his Liverpool home, attempts to understand a culture by living, participat-ing in and observing its everyday enactment. All in, this entire research process generated a total of 348 typed A4 pages of interview transcription and introspective text. For the purpose of conducting the empirical analysis and writing this chapter, I also drew upon a bundle of academic papers, a fat notebook of ideas and observations, and interdisciplinary insights drawn from fields such as urban studies, tourism, retailing, geography, place branding, city marketing, sociology and cultural studies.

CITIES OF CULTURE

Considered separately, the linked ideas of 'cities' and 'culture' can be exasper-atingly ambiguous; considered together, they become virtually inscrutable. What is Liverpool really? One could argue that it is enclosed within the geography of its centre and surrounding districts, but it is not quite as simple as that, for the idea of Liverpool is also connected to the myth and icon-ography of its real and imagined cultural history. A city then resists totalizing description, has a shifting pulse of experience and place, and crucially, is not hermitically sealed from the rest of the world (Alter 2005). In Liverpool, for instance, one might easily imagine a scenario where a tourist purchases an Italian espresso in a Japanese restaurant from a Portuguese waitress while listening to the late Michael Jackson. And where is Liverpool in this experi-ence? Maciocco and Tagliagambe (2009: 62) would assert that it is nowhere,

by rather dramatically claiming that cities do not exist anymore, that they have become representations, textual signifiers, that what defines them is often 'opaque and mysterious'. Add to this, the illusive nature of this thing called 'culture', which has, to put it mildly, a vast array of meanings and values (Evans and Foord 2003; Miles 2007), and one might be forgiven for thinking that those whose responsibility it is to captain this so-called city of culture are onboard a rudderless ferry adrift a Mersey of meaninglessness.

While such nuanced academic intrigue and scope for discussion has perhaps been the prize truffle that has led so many academics and PhD students, each with their own interests and agenda, to coalesce around Liverpool's cultural moment (Munck 2003; Belchem 2006; Grunenberg and Knifton 2007; Boland 2008), the ambiguous and multifaceted meaning of both 'cities' and 'culture' did not deter the European Commission from setting up the ECoC programme in the first place, nor indeed did it stop Liverpool putting together a successful bid to become one (Miles 2007). The meat and magic of Liverpool's bid was to design an annual calendar of themed years that stretched from 2004 right through until 2010, thereby emphasizing that although 2008 was the focal point, the project would have impetus for seven years. These yearly themes include: Faith in One City (2004), Sea Liverpool (2005), Liverpool Performs (2006), Liverpool's 800th Birthday (2007), European Capital of Culture (2008), Year of Environment (2009) and the Year of Innovation (2010). By employing this strategy, Liverpool cleverly illustrated not only its strong cultural heritage, but also its desire to create a lasting legacy (Liverpool Culture Company 2007a).

More specific initiatives were aimed at encouraging locals to get involved in the ECoC and generate a sense of involvement in the city's neighbourhoods. By doing so, it was hoped that new and exciting local talent that stands, after all, as an example of culture in the city would be discovered. The Creative Communities initiatives, which apparently is the biggest community art programme in the UK, and has been held aloft by the Office of the Deputy Prime Minister as a fine exemplar of how other cities should use culture and creativity to regenerate a city, was one such driver of local participation (Liverpool Culture Company 2007b). The schemes rhetoric is impressive, seeking: 'To be a grant giving programme which places citizens and their wishes centre-stage. To develop partnership projects which weave culture into the fabric of regeneration. To utilize the best local, national and international artists in making culture a relevant part of everyone's life' (Liverpool City Council and Liverpool Culture Company, The Open Culture Project 2005). 'Song for Liverpool' run by the Open Culture Project also illustrates how attempts were made to actively engage locals in the Capital of Culture. A local radio station, Radio City, challenged local singers and songwriters to

write a celebratory song about Liverpool for the ECoC 2008. Local people had the opportunity to vote for the best song and the winner recorded the song as the anthem for Liverpool's celebrations (Liverpool Culture Company 2007c).

AN OUTSIDER BRAND

Prior to examining the impact of ECoC, it is perhaps worth commenting on Liverpool's unique brand heritage. According to Holt (2004: 215), understanding any brand needs 'a cultural historian's understanding of ideology as it waxes and wanes, a sociologist's charting of the topography of social contradictions, and a literary expedition into the popular culture that engages these contradictions'. I cannot hope to offer anything as deeply nuanced here. It would take a book-long treatment to unpick the layers of myth and iconography that make up the idea of Liverpool. It might just be possible, though, to identify some of the distinguishing features of Liverpool's commercial viability.

Its geographical location situated on the far North West of England places Liverpool very much on the periphery, on the outskirts, out of reach. It's a place that is easy to circumnavigate, easy to unintentionally exclude from the country's mainstream activities, such that Liverpool becomes what Stark (2005: 20) describes as 'the least "English" part of England'. Brown (2005: 6) similarly argues that, 'Liverpool may very well be in Britain but the city's national citizenship, as it were, cannot be assumed.' So without even a sip of marketing formula or branding bromide, Liverpool can lay claim to a natural source of distinction, of differentiation, that other cities would drain their rivers to obtain, probably. Its location on the edge of England, which might at first seem wholly disadvantageous, has wrought unexpected benefits. As Adams (2005: 3) also states, 'Edges are interesting. They are places of tension, of transformation, of discovery, creativity and disaster. And edges are – yes – edgy.' And which city in the world does not want to be edgy? Speaking of which, for a time I lived in the appropriately named Edge Lane, a suburb of Kensington, which I can assure you is nothing like its London namesake. It was a dangerous place; friendly on the surface, but a late night party, a stabbing, a robbery, a drug overdose never seemed very far away. I loved it. Nor am I alone in this fascination. According to Fincher *et al.* (2002: 29), there is now a new bohemian class in post-industrial cities that is attracted to 'the frisson of living in proximity to multiple deprivation'. Liverpool, with some of the wealthiest postcodes in the country, located directly alongside some of the poorest, is well placed to offer this new bohemian experience. Tours of the hotspots could even be offered, visiting perhaps the scene of the Toxteth

inner-city riots of the 1980s which lasted for four days, during which 150 buildings were burnt down and 781 police injured (Childs and Storry 1999).

The Beatles also stood, and still stand, for something that is distinctly Liverpudlian. Of course, it is terribly fashionable these days to suffer from Beatles ennui. Fab Four fatigue. Terence Davies, for instance, in his recent documentary about Liverpool, *Of Time and the City* (2008), dismissed them with a mocking and derisory, 'Yeah, yeah, yeah'. Nonetheless, though they might have the status of cliché, no one can deny the phenomenal influence and commercial viability their music retains. More than anything, though often forgotten, they epitomized the notion that 'middle-class virtue was a sham; authorities were there to be mocked; irreverence was the order of the day' (Stark 2005: 20). Singing about places in Liverpool 'Penny Lane', 'Strawberry Fields' and 'In My Life', also lent Liverpool, alongside the collective popularity of 'Mersey sound', a certain romance that to this day still brings tourists to the city. Music tourism, related to the city's famous past, has been a key linchpin in the rejuvenation of previously abandoned sites in the city. The Albert Dock, for instance, has been transformed into a tourist Mecca complete with souvenir shops, a Museum of Liverpool Life where Beatles artifacts are on show and The Beatles Story, a museum devoted to depicting 'authentic' scenes, such as a copy of the Cavern Club, where the Beatles began their career. As an acknowledgement of the importance of tourists to Liverpool's economy, it has also renamed its airport John Lennon Airport (Connell and Gibson 2003).

In summary, Liverpool has always had a whiff of the countercultural about it. Edginess and the sense of alienation that Liverpool has felt for many a year, made worse perhaps by being made a scapegoat by the rest of England for the sins of all English slave-traders, has inadvertently conferred on it a cape of authenticity, which as (Sorkin 2001: 68) notes is 'the costume worn by contemporary styles of alienation'. Stark (2005: 40) eloquently summarizes the historical impetus that helped create Liverpool's outsider brand identity:

> Liverpool seemed almost like the frontier – impertinent, emotional, and a lot less important than the capital city, which was considered the centre of almost everything the establishment considered English. This sentiment contributed mightily to the sizable chip on northern shoulders that fuelled a kind of antiestablishment attitude. Liverpool was a place, remarked one critic, that marked you for life and identified you as something of an outsider – a sensibility that was enhanced in a town populated by sailors, who have always tended to view themselves as outsiders as well.

Of course, one should not overstate the extent to which Liverpool is a city of difference, an outsider brand. It is crucially important for the sake of its visitors that it retains an overwhelming sense of familiarity, or what researchers in tourism call 'cultural approximation'; that is, the extent to which the culture and language of visiting tourists are similar to the place they are visiting (Tuna 2006). Thankfully, Liverpool can claim a fairly good cultural fit to the rest of the English-speaking world. Placed into context alongside Liverpool's key attractions – an outstanding architecture of refined streets and elegant vistas that few other cities can match, the knowledge that Liverpool is home to the highest number of protected buildings outside London, a waterfront of World Heritage Site status, an eight-mile stretch of docklands in development full of high-rises and coffee bars, and a rich maritime heritage – one wonders why all previous attempts to revitalize Liverpool and restore the city to its former glory have always fallen short (Munck 2003). So a lot was riding on the ECoC project to finally deliver on the huge potential of this underappreciated city.

LABELLING LIVERPOOL AND STEREOTYPING SCOUSERS

In the run-up to and during 2008, considerable positive media attention focused on Liverpool as the city celebrated its year as the ECoC. Nonetheless, its success was always going to be partly judged on whether the title could help reposition Liverpool's lamentable, and long-standing reputation as bleak, toxic, and populated by work-shy rogues. It did not matter that this was a faintly ludicrous expectation, since stereotypes, like stubborn weeds, are incredibly persistent. Perhaps this dubious outcome of the ECoC project was repeated so often partly since a frequent message from marketers is that a brand like Liverpool, any brand in fact, should not aim to be perfect, but should concentrate on 'removing the bits of the brand that do not work as well as they might' (Braun 2007: 170). Another reason is that Liverpool's negative reputation is such a local bugbear that emphasizing such a possibility might possibly get the locals on board. Its corrosive effect was certainly crystal clear to the Liverpudlian interviewees, as one lady from Garston made plain: 'Liverpool, I believe, gets a very bad press and always has done, from way back. When you tell people that you're from Liverpool, they sort of recoil, because they always think of Liverpool as being dull and dirty, and that's not how it is' (Female 52, Interview). A dire reputation all the same, might be something city residents could just about cope with, but as a classic British example of urban regeneration in the same vein as Glasgow, Cardiff and Leeds, Liverpool's national standing is vital to its success. Quite simply its economy

would dramatically shrink without a heavy influx of tourists and shoppers (Middleton and Lickorish 2007). It must have been a relief then, when even before regeneration plans were drawn up and events organized, that the mere idea of Liverpool as a receptacle of culture, while a source of endless mirth to some, made some people, especially non-Liverpudlians, question and revaluate their prejudices against Liverpool, while at the same time conferring Scousers with a renewed sense of civic pride and confidence. This sentiment was strongly evident in the empirical data:

> Liverpool has acquired many negative stereotypes over the years and when I told people it was where I wanted to go to university, many people asked why or made remarks such as, 'Oh you'd better watch your wallet' and 'Make sure you don't pick up that annoying accent!' But I quickly followed it up by, 'Oh but did you know that Liverpool is going to be the European City Capital of Culture in 2008? There is lots of regeneration and there will be plenty going on in the city.' My comeback always worked a treat. People seemed impressed and interested, which made me feel like I had made the right choice of city. All my friends were going to Glasgow, Edinburgh or Newcastle, which all seemed to have something that little bit extra over Liverpool, but I stuck by my guns and hoped that Liverpool wouldn't let me down.
>
> (Male 20, Introspection)

> And then there's the reputation, and the stereotypes. No, Liverpool has little postcard appeal. And yet I still chose to study here. Partly because I know that love at first sight is always at risk of fading all too quickly. It's the love that's given time to develop which is most likely to last – cheesy but true. Also the Capital of Culture thing, I have to admit it played a part in my decision. Yes it sounds fancy, but not just that; you'd think that the 'European Capital of Culture' would be given a certain amount of funding to go into things like infrastructure which would be beneficial to the city in years to come. You think of job opportunities, all kinds of exciting events, just an overall atmosphere of departure. Well I did, anyway. Whenever I asked one of my friends or fellow students about their motivation for coming to Liverpool I usually got a variation of one of the following two answers: 'the football', or 'I dunno, it wasn't even my first choice I just kind of ended up here'. Yet once they reach their second year most have become ardent supporters of this year's 'European Capital of Culture'. Quite a pompous title that seldom fails to impress.
>
> (Male 22, Introspection)

I am the ultimate definition of a Scouser with the permanent tan, the hair extensions and a wardrobe full of cricket bags, but there is more to me than that. I am a university student, a champion horse rider and a county sports player, and I believe most Liverpudlians are in a similar situation. Assumptions are made, and they never get the chance to amend them. This Capital of Culture 08 will give people a chance to see behind the prejudices and stereotypes and see Liverpool for what it really is. This has already began by the Sunday Times running a piece on Liverpool's style, and Scouse girls have been voted the most stylish in the UK, spending more man hours and percentage income on hair and beauty than the rest of the country (by quite a bit actually). The shops are being praised, the clubs and bars are teeming with celebrities. I was sat next to Jennifer Ellison and Dwight Yorke last night and Jordan and Alex Curran a few weeks earlier. So evidently the stereotype is falling away and people are embracing the lives and even idolising our lifestyles.

(Female 23, Introspection)

Yet despite the initial euphoria and excitement that was expressed, it was not long until a muted sense of disillusion and disenchantment became apparent. Troublesome issues such as the constant changes in the board members of these governing bodies (e.g. Robyn Archer quitting as Artistic Director), the curiously non-Liverpudlian constituency of these boards, their exorbitant salaries, the infighting, the magnitude of inertia, the frittering away of money on unpopular projects (e.g. the unpopular 'Summer Pops') and the cancellation of others (e.g. the Mathew Street festival), while not exactly provoking a riot, caused mild irritation and unease among locals:

. . . I mean this Australian lady who recently left the council, what does she know about our city? And that is so frustrating, that they brought all these outsiders in to tell us what we need!

(Female 46, Tuebrook, Interview)

We're making a show of the city, but it's not people from Liverpool making a show of the city, not one of the organisers are from Liverpool, they're all from just outside, so they've got no vested interest in the city other than the fat wage slip they get. That's why they've got Phil Redmond in. A lot of people I know have just lost patience with it, they're not bothered any more, I don't know anyone who cares about it at the moment.

(Male 19, Knotty Ash, Interview)

While this is all water under the historical bridge, occasional negative reports in the media especially in *Private Eye* and a controversial online blog called *Liverpool Subculture* which revelled in mistakes made by the organizers and made numerous allegations of corruption (see: http://liverpoolsubculture. blogspot.com) did not help matters. As a result, trust in the municipal bodies, the Liverpool Culture Company and the Liverpool City Council, who collectively organized Liverpool ECoC lessened. Adding to this murmur of unease was the make or break situation that Liverpool faced. This was Liverpool's one and only opportunity to illustrate to the rest of the UK and the entire EU that they were worthy holders of the ECoC title. Failing to put on a good show was unthinkable. Imagine the unbearable flood of ridicule dispensed by those on the south side of the English divide that would have ensued. Imagine suffering the indignity of having such grim stereotypes confirmed rather than eradicated. The indignity, the humiliation, the insult to injury would have been enormous, and could have led to the further erosion of Liverpool's already tarnished reputation.

LIVERPUDLIAN PARTICIPATION

According to Sir Jeremy Isaacs, Head of the Capital of Culture judging panel, the most important element that influenced the decision in favour of Liverpool was that it had a 'greater sense that the whole city were behind the bid' (BBC News 2003). Yet as we have seen, it was not long until disgruntled Liverpudlians began to demonstrate that perhaps this was not entirely true. The general literature on this subject would seem to confirm the legitimacy of their concerns. Parker (2008: 8), in a recent panoptic review of place marketing literature, concluded that 'the marketing of places has often been seen as something you do to those outside a place, rather than those within it'. There was a growing fear that what was happening in Liverpool would disenfranchise locals, and that all the statements of bringing them on board, of inclusion, of participation amounted to nothing more than meaningless rhetoric:

> When you tell people that you're going to make their city better and regenerate their houses, people love that, they love their city and they want it to look nice, you want nice housing and you want nice shopping areas and you want nice things, but I think that most people are still clinging onto the hope that this event will change things in Liverpool that can only be seen after next year.
>
> (Female 46, Tuebrook, Interview)

At the time of the bid many people were behind it, but I think that it's in our nature to be cynical about things, people I think still are behind the bid, they want things to be changed in Liverpool and improvements to be made to their city and want the result of the bid to change Liverpool.

(Male 30, Kirkdale, Interview)

Specifically, locals most often vent their spleen at the apparent disparity between core and periphery. The perception is that the core (i.e. the city centre), will feast on the influx of new investment, while the periphery will be left with meagre pickings. This attitude is most evident in the periphery itself in the depths of Kensington and Toxteth where many regard the entire project as a gigantic waste of time:

All this money is being ploughed into the city centre, but none of it is going to the outside areas, Kensington has been promised money for the past 15 years and all they've done is knock up a few new shop fronts, that's the regeneration. The money's gone into the city centre and nowhere else and made it unbearable for people who have to live here and go to work everyday or go to shop.

(Female 46, Tuebrook, Interview)

A lot of the old council houses are derelict and the word ghettos would be an adequate word to describe a lot of areas outside the city centre.

(Male 30, Kirkdale, Interview)

Take Kensington, there's so much crime, they've got a huge prostitute problem, I just want to see the city get cleaned up. All the money's going into the city centre; take the £700 million shopping centre on the docks, and the Arena on the front. I don't think that the needs of the local people are actually being taken into consideration, when you look, all the money is being concentrated into the city centre, as I say when you go a couple of miles outside the city centre, when you look around there, you don't see the benefits for the local people.

(Male 19, Knotty Ash, Interview)

I think that whilst it's all positive, all what they've brought to the city centre, the whole point of 2008 was not just for the city centre and they've just focussed on the city centre, in my opinion the amount of houses boarded up in Kensington where we live is just ridiculous . . . So whilst it's great for the city centre, 2008 isn't just about the city centre, it's about everywhere, it's about creating a positive image of the whole place.

(Female 22, Kensington, Interview)

To make way for the massive Grosvenor Project – a tastefully designed development of steel and glass, offices, apartments, cafes and shops, shops and more shops – Liverpool had to give up some of its most cherished cultural treasures. Quiggins, an alternative shopping centre for local Liverpool businesses, had to move from its original building, a prospect that some local residents find unacceptable:

> Another thing, take Quiggins, that was one of the things that contributed to us getting the Capital of Culture and then all of a sudden, the Grosvenor project decided that they wanted it and because they've got the money and it can buy them everything, Quiggins got pushed out. I went past the new place, Grand Central, and it is great, you've just lost something that was close to peoples' hearts. It was just a place that everyone knew about, it was like Liverpool's little secret. In that sense I think that the locals have lost out a bit, like. Major firms have pushed out smaller businesses. Big companies have come to the city centre, seen the space and developed on the land, whereas over a period of years that space would have been taken up by local businesses. So they've lost out.
>
> (Female 20, City Centre, Interview)

> Well, I've personally come to think over the last 18 months that in this headlong race to regenerate Liverpool in time for 2008, many of the smaller niche business enterprises have been heavy-handedly brushed aside. For example, Quiggins has only got one year left, the Liverpool Palace has already been shut by Urban Splash in order to cash-in on the big business clients when it's redeveloped and the Church Street traders are finally being extinguished this April. It's therefore good that somewhere like the new Gostins alternative shopping arcade on Hanover Street is still holding out some hope for small traders with their vibrant eclectic mix of fashion designers, music shops, fortune tellers, body piercers, hairdressers and the like. Because unless places like Gostins continue to provide affordable premises for small start-ups, in 2008 you won't be seeing Capital of Culture, you'll be seeing Capital of Bland!
>
> (Male 2005, Online Discussion Board)

Some participants also voiced concern that many of the regeneration works, such as the new apartments, hotels, and shopping centre, were simply beyond the means of local people, most of whom would never be able to use these facilities however amazing they might be. Such a sentiment further emphasizes the idea that attracting visitors to the city is the key priority. In response the organizers maintain that they are aware of the simmering resentment

such relocation decisions can cause. Christine Peach, from Liverpool City Council, was quick to point out that people hold conflicting views as to what 'regeneration' means; as a result it is difficult to please the entire Liverpudlian community.

> Some people, their definition of regeneration is not what other people's is. We're trying to do is put people in the situation whereby they can at least say what they'd like to see. It's about having short lead in our long term aspirations trying to come up with ways to make things happen then if not giving a reason why.
>
> (Christine Peach, South Liverpool Neighbourhood Manager, Interview)

With regards to the programme of celebratory events that took place in and around Liverpool throughout 2008, it is evident that some local people think that they did not accurately represent the culture of Liverpool. Although some participants recognized that the events were intended to appeal to both the local people and to visitors, they felt that the needs of outsiders were prioritized. Phil Taylor, the Creative Communities Infrastructure Manager, countered this viewpoint, detailing how the Creative Communities schemes had communicated to local people, how they encouraged people to get involved in the ECoC, and how they involved local people in the decision-making processes. When reflecting this back to interview participants, none of them had heard of the schemes and grants that are available to local people and had never heard of the term Creative Communities, although assurances were made that every effort had been made to reach as many people in the community as possible. The council recognized that reaching everybody is an almost impossible task.

> I wouldn't suggest that's the case from the outside but I would say that there have been excellent marketing and communications from the Culture Company itself, you know they've been very proactive in that, the schemes that they have run have all been very, very good. I think that you need lots of intervention to make people feel involved, and some people will always feel more involved than others, I think these local projects are certainly a way of, very good for getting local people involved.
>
> (Christine Peach, South Liverpool Neighbourhood Manager, Interview)

As the years have progressed, we have managed to penetrate most of the local wards in the city. We've gone out to try and engage people and also

find out why they've not been involved before. It's interesting because when you speak to people, some people don't find out about these things although publicity has been high, because, their communication networks. We have people doing door to door leafleting and there's a huge turnout but we are conscious that sometimes these programmes don't reach everybody.

(Phil Taylor, Creative Communities Infrastructure Manager, Interview)

This constant tension between locals and municipal bodies over tourist versus local needs is a typical problem faced when trying to market and manage a city like Liverpool, which simply could not survive without its annual flood of tourists. Revitalization strategies cannot by themselves alleviate the poverty of low-income Liverpudlians, and any forlorn hope that the ECoC project might do so, is wishful thinking (Zielenbach 2000). Revitalization strategies can, nonetheless, attract businesses that create additional jobs, many of which will be filled by individuals living within the Liverpool community. Ultimately, the ECoC project is, 'an exercise in balancing the global with the local, complementing images of local allure with global appeal on the one hand, while striking a balance between the needs of residential constituents and external interests on the other' (Chang and Huang 2004: 229).

FUTURES FOR LIVERPOOL

So what is the final verdict on Liverpool's 'cultural moment'? Certainly, it is unfortunate that the launch of Liverpool's cultural and shopping transformation coincided with the worst recession the country has seen since the 1930s. Back in 2003 when the award was announced, the organizers could not have foreseen that the entire nation would no longer be on a frenzied shopping spree, and only in the worst possible scenario would Liverpool One owner, Grosvenor, have imagined that the value of its £1 billion development would have lost over a third of its original value. This same shopping precinct, beautifully designed though it may be, is also tarred with that most damming indictment of globalization, that it offers only the same shops selling precisely the same goods as everywhere else (Ballantyne 2006). Its concession, amid 1.6 million square feet of retail space, to set aside a dozen small units for independent shopkeepers seems quite tokenistic (Pickard 2007). To make matters worse, there have been some very vociferous critics of Liverpool's future architectural ambitions. Tom Dyhoff (2008) on *The Culture Show* questioned why Liverpool's recipe for the future is: 'so depressingly familiar,

so ordinary. . . . Liverpool's new face could be anyone, anywhere. It's like a Botoxed bimbo. It's got no character, no distinction, no Liverpudlianess.' Combine this with the knowledge that Liverpool currently has many empty blocks of unsellable buy-to-let flats, and one might conclude that the project has been less than successful (Piloti 2009).

Still the Liverpool brand has clearly been reinvigorated and its place-based cultural capital boosted. Its pre-ECoC brand was tired and formulaic, grim and colourless. It relied too heavily on football and the Beatles as sources of distinction. Geographically, the sheer size of the Liverpool One project will undoubtedly, in time at least, help the city realize Reilly's (1931) law of retail gravitation, whereby shoppers congregate in greater numbers due to the increased size of the shopping district. Liverpool might not quite have attained the status of 'the world in one city' as its ambitious strapline claims, but one can hardly fault its ambition and there is no denying that it has become a significant and prominent European city, and has now more 'cultured' representations of place in place. The negative publicity that still encircles Liverpool will remain an ongoing challenge (Boland 2008), because, however good its rebranding efforts are, it is impossible to control what is said about and done to the Liverpool brand elsewhere in the country. Nonetheless, there is a definite groundswell of opinion that the ECoC award has been good for Liverpool, certainly as good as it was for Glasgow.

Nor has the city's identity dissolved into similitude and sameness via a creeping cultural and commercial apostasy. As Anholt (2007) astutely observes, a city's culture is not always easy to distinguish from the culture of its country. Liverpool has no such problem. For a time it might have been a mildly less attractive place to work and 'produce', since, as the empirical research illustrates, some local residents felt temporarily disaffected, but ironically as the infrastructural investment took hold, it became a more attractive place to 'consume', thereby increasing job opportunities and the productivity of local residents (Ritzer *et al.* 2005). As a brand, Liverpool has always been firmly located on the map of the imagination, but the ECoC project has given it a new lease of life and creativity. The city, as this chapter has shown, has been a source of creative inspiration for poets, photographers, historians, philosophers, and even the odd marketing professor. You only need to witness the success of Liverpool's newest mascot, the Superlambanana, or the fifty foot La Machine spider sculpture that recently stalked the streets, to see that Liverpool has a new momentum that the city council will not easily let slide. Plans are already underway to host 100 free events in 2009 to build on the success of the ECoC year, and further monies have been set aside to continue the rebranding of the city into the next decade. As this chapter has demonstrated, Liverpool is a sophisticated outsider brand that fuses progressive

and retrogressive, optimistic and pessimistic, traditional and contemporary elements of the kind that 'Cultural Consumers' are said to adore (Martin 2007). So, if as Marshall (2004: 54) maintains, distinctive competitive advantage remains 'the catch-cry of the modern era', then Liverpool is well placed.

18

THE BRAND STRIPPED BARE BY ITS MARKETERS, EVEN

Stephen Brown

WHO'S THE DADA-DADDY?

IT'S HARD TO believe that Surrealism is one hundred years old. Almost. Of all the isms that the twentieth century called forth (Goldwag 2008), Surrealism is perhaps the best known and most recognizable. If art movements were brands, which to some extent they are, Surrealism would surely rank alongside Impressionism as the art-market leader. Not only is the spirit of Surrealism alive and well in the work of Damien Hirst, Jeff Koons, Tracey Emin, Sarah Lucas and suchlike (Gale 1997), but its ability to shock and surprise remains delightfully undimmed. Whereas Pop Art often looks a little forlorn in the flesh – Lichtenstein's paintings, in particular, haven't aged very well – Dali's lobster telephone, Oppenheim's fur-covered teacup and Man Ray's flat-iron with spikes continue to attract excited 'come and see', 'look at that', 'well I never' reactions from flabbergasted gallery goers.[1] Similarly, the eyeball slitting scene from *Un Chien Andalou* remains near-enough unwatchable despite decades of slasher movies, *Saw* sequels and shockers by M. Night Shyamalan. Surrealism, as Hopkins (2004: xiv) rightly points out, is 'modern art incarnate'.

Purists, pedants and know-it-all nit-pickers – yes, I'm referring to you – will no doubt retort that Surrealism isn't one hundred years old. To the contrary, it is a mere stripling of eighty-five or so. The movement began, as is well known, with André Breton's celebrated *Surrealist Manifesto* of 15 October 1924, which contended that the pursuit of autonomous art – that is, art for art's sake, art as an end in itself – was an aesthetic dead-end. Avant-garde art works, he maintained, must draw upon 'a certain psychic automatism which corresponds to the dream-state'. Their focus should be 'the actual functioning of thought, in the absence of any control exercised

by reason, exempt from any aesthetic or moral concern' (quoted in Brandon 1999: 215).

So there!

Surrealism, of course, long pre-dated Breton's formal statement and the simultaneous founding of its 'in-house' magazine, *The Surrealist Revolution*. The term was coined by Guillaume Apollinaire in 1917, just as Dada was getting under way in Zurich (Dachy 2006). Dada, for many, is surrealism's dry run, its batty big brother, a sort of John the Baptist to André Breton's son of God.[2] In fact, Dada differed from Surrealism in several significant respects. Dada was essentially an anti-art movement, dedicated to overturning traditional bourgeois assumptions of what art is and what it isn't. It was confrontational, iconoclastic, driven by a desire to shock, outrage, unsettle, destroy. It was proto-punk, polemical, provocative, pugilistic, perverse. For most casual art-lovers, though, Dada and Surrealism are, if not quite joined at the hip, certainly part of the same freakish family (Gay 2007).

Be that as it may, Hugo Ball's to-the-wall antics in the Cabaret Voltaire were themselves far from unprecedented. Just as Dada pre-dated Surrealism, so too Dada had forerunners of its own. The most important of these was the incorrigible Marcel Duchamp. A shadowy figure in his day, Duchamp is now regarded as one of the most influential – arguably *the* most influential, Picasso notwithstanding – artists of the twentieth century. As Januszczak (2008: 16) observes à propos a recent Duchamp exhibition at Tate Modern:

> If you went through this show counting on all your digits the number of modern-art strategies he invented, you'd quickly run out of limbs. Long before Warhol, he was putting his own face on wanted posters. And as far back as 1919, he preserved a mouthful of French air in a glass bowl, and began cutting out strange shapes in his hair with a tonsorial insouciance worthy of a modern footballer. Dressing up as someone else was second nature to him. The urinal, the bottle rack, the whole idea of the ready-made, were and remain invigorating challenges to the rules of art.

Duchamp, then, was the fountainhead of Dada and Surrealism alike, though he characteristically refused to categorize himself as a Dadaist or a Surrealist or anything other than a Duchampian (Mink 2000). He was the apotheosis of anti-art. He abhorred the 'retinal stance' of his painterly peers – eye appeal, in short – and argued for the pre-eminence of the concept over craftsmanship, the intellect over manual dexterity, the idea over technical virtuosity. Nowhere was his artistic anarchism better illustrated than in his ready-mades in general and *Fountain* in particular. The latter was a porcelain urinal that he

purchased from a plumber's supply store, signed with the pseudonym R. Mutt, and submitted anonymously to the New York Independent Artists' exhibition of April 1917, along with the $6 fee that guaranteed its inclusion. The shocked and affronted selection committee (which included Duchamp, naturally) refused to show the unspeakable piece, thereby ensuring its immortality.

AVIDA DOLLARS

Fountain is rightly regarded as a defining moment in modern art. But the really interesting thing, from a marketing perspective, is that the *Fountain* affair was carefully stage-managed (Hopkins 2004). The committee's decision would have passed unnoticed if it weren't for a dissenting article – plus photograph of the offending artefact by Stieglitz, no less – that subsequently appeared in a small-circulation art journal, *The Blind Man*. Although the article wasn't penned by Duchamp himself, its air of mock outrage at the committee's philistine decision, coupled with a pseudo-philosophical defence of Mr Mutt's urinal as a work of art ('HE CHOSE IT'), indicate that he was the presiding spirit behind the protest. More pertinently, *Fountain* provides prima facie evidence that Duchamp was an astute self-publicist, a self-branding marketing man of considerable skill. His 'assisted readymade' *LOOHQ* (the *Mona Lisa* with moustache and goatee), his *Bride Stripped Bare by Her Bachelors, Even* (an enormous glass installation that was more talked about than seen) and his *Nude Descending a Staircase* (an 1912 art work that was spurned in France but scandalized middle America) all attest to Marcel Duchamp's superlative marketing savvy.[3]

Duchamp was not alone. Both Dada and its Surrealist successor were sold with singular aplomb. They were pioneers of what we today call 'experiential' marketing, attention-grabbing events that were vigorously promoted to all and sundry. They adapted the trade fair model to disseminate their ideas, most notably the Dada Fair in Berlin and the International Exhibitions of Surrealism in London, Prague and Paris. They were never unwilling to knock up eye-catching posters or coin memorable advertising slogans, such as 'Art is Dead!', 'Unlock Your Head!', 'Grab Hold' and 'Hang On Tight!' They recruited their earliest members through newspaper ads; they worked with fashion designers like Elsa Schiaparelli; they doubled as art dealers, especially when money was tight; they were well aware that nothing sells as well as sex, the kinkier the better; they trawled for found objects in flea markets (in a kind of thrift shop retail therapy); and indeed Dada was named after a Swiss brand of hair restorer (or, possibly, a Belgian brand of soap, depending on who you believe).[4]

As Fillis has cogently shown, moreover, Salvador Dali was nothing less than a marketing mastermind. Whether it be his trademark upturned moustache, or his promotional escapades in a deep-sea-diver's suit or his department-store shenanigans in the United States, where he dressed the window of Bonwit-Teller, then promptly smashed through it, 'Avida Dollars' was 'one of the greatest self-publicising marketers of all time' (Fillis 2000: 61). Even Sigmund Freud fell for Dali's irrepressible antics. The formidable father of psychoanalysis had no time for the rest of the Surrealists, who misconstrued his ideas about the unconscious, but he was amused and charmed by 'the young Spaniard with ingenious fanatical eyes' (Jackson 2004: 189).

Better yet, was the one and only Arthur Cravan (Dachy 2006). Now almost forgotten, Cravan was simply off-the-scale when it came to selling himself. The nephew of Oscar Wilde (though he liked to hint that he was the sainted Oscar's illegitimate son), Cravan was not only a self-appointed man of letters but an eminent lumberjack, pickpocket, snake charmer, card sharper, sneak thief, taxi driver, orange picker and 'the poet with the shortest hair in the world'. He was also a prize fighter. A boxing ring occupied one corner of his studio, where he scandalously 'sparred with Negroes' (Brandon 1999: 76). He launched a scurrilous literary review in 1912, which published his poems, essays and 'conversations' with the ghost of his late-lamented uncle. *Maintenant* also published invented interviews with leading *littérateurs*, such as André Gide, and mounted unprovoked attacks on members of the artistic establishment ('Delaunay has the face of an inflamed pig!'). The outbreak of the First World War put paid to *Maintenant*, but not Arthur Cravan, who promptly fled to Switzerland (on the proceeds of a fake Picasso), paused for breath in Spain (where he fought the world heavyweight champion, Jack Johnson), and ended up in New York, which he treated to an unforgettable 'lecture' on the latest trends in European art:

> Cravan sober was a charming fellow, reserved, courteous, a faithful lover and devoted friend. This was the *poète*. Alcohol, however, liberated the *boxeur*. He barely made it to the podium, where he sank down at a small table and began scornfully to address the audience. Then all of a sudden his voice fell. He muttered about suffering intolerable pain: he couldn't possibly go on unless he took his clothes off. No sooner said than done. He then proceeded to remove his waistcoat, unfastened his braces, leaned over the table and began to hurl obscene epithets at the audience. At this critical juncture, before the descent of the trousers, several policemen, alerted by a distressed member of the audience, entered the room, handcuffed him and dragged him out.
>
> (Brandon 1999: 78–79)

After a spell in Sing Sing, Cravan moved to Mexico, bought a boat, set sail for Buenos Aires and was never seen again, though legend has it that the peerless pugilist survived the voyage and was the mysterious author of *The Treasure of the Sierra Madre*. However, his suicide (if that's what it was) was very much in keeping with the live-fast-die-young cult of artistic achievement that characterized both Dada-Surrealism (Jacques Vaché, Jacques Rigaut, René Crevel, etc.) and the cultural industries to this very day (Michael Jackson, Heath Ledger, etc.).

MAGNETIC FIELDS

In recounting the above, I'm not suggesting that marketing should do the noble thing and commit conceptual suicide, let alone renounce its non-achievements of the past half-century. My point is that marketing scholarship has much to learn from artists generally and the Surrealists especially. Three lessons, it seems to me, are particularly pertinent. The first concerns literature. Surrealism, for most people, is a quintessentially visual phenomenon – Dali's masturbatory landscapes, Max Ernst's mechanical elephant, *Celebes*, Man Ray's artfully blurred nude photographs, Magritte's rainstorm of bowler-hatted bourgeois bureaucrats, Duchamp's deliberately offensive *Etant donnés*, etc. History shows, however, that Surrealism and its anarchic predecessor were predominantly literary movements (Hopkins 2004). André Breton, Louis Aragon, Jacques Vaché, Philippe Soupault, Paul Eluard – the original surrealist brotherhood – were not painters and artists but poets and writers, as were Hugo Ball, Tristan Tzara, Richard Huelsenbeck and Raoul Hausmann, the prime movers of Dada. The first Dada performances at the Cabaret Voltaire comprised simultaneous poetry readings, accompanied by drumming, dancing, disguises and so forth. The principal Surrealist method was automatic writing, closely followed by Exquisite Corpse.[5] Dada-Surrealists disseminated their ideas through magazines, pamphlets and analogous literary ephemera. Their heroes were writers one and all (Rimbaud, Jarry, de Sade, Baudelaire, Apollinaire). Magritte's impact had as much to do with the disjunction between title and painting (the 'this-is-not-a-pipe' effect) as the actual art work itself. And Duchamp was much more of a punster than a painter, most notably via his cross-dressing alter ego, Rrose Selavy (i.e. *Eros, c'est la vie*).[6] As Hopkins (2004: 46) observes:

> Duchamp's myth was built up as much via magazines and enigmatic photographs as via exhibition of his relatively meagre output. He did not have a proper one-man show of his works until his retrospective of 1963.

Even the reputation of his greatest work, *The Bride Stripped Bare by Her Bachelors, Even,* was built up through appreciative descriptions and asides in Surrealist journals . . . rather than through people actually seeing the work.

Arts marketing scholarship, analogously, is overwhelmingly literary. Notwithstanding occasional calls for an oracular focus and despite the undeniable achievements of videographic auteurs, such as Russ Belk and Robert Kozinets, the vast bulk of our academic output – even our output about visual artists – boils down to words on a page. Our careers, our reputations, our very jobs depend on what we publish. We are writers first, last and, in all likelihood, always. One day, perhaps, RAE panels and tenure track committees will treat performance, photography and painting as legitimate forms of academic output. But until such times as they do, writing will continue to rule the academic roost (Brown 2005).

In such circumstances, one might reasonably think that a community of writers would devote much time, effort, thought and energy to its principal practice, especially those with artistic inclinations. Sadly, this is not the case. The vast majority of arts marketing articles are written in standard social-science prose. The bulk of our writings are frustratingly formulaic.[7] The marketing scholars who pontificate about metaphors and myths and narratives and what have you seem to be incapable of coining metaphors and inventing myths, much less composing compelling narratives. Where are our Dadaist academics? Where are the Surrealists of scholarship? Where is the Marcel Duchamp of marketing thought? Shouldn't the arts marketing community be a crucible of creative writing, a beacon for the benighted marketing multitudes? Wouldn't it be wonderful if someone had the gall to write a Tristan Tzara-style academic poem, following his celebrated compositional procedure:

Take an article.
Take some scissors.
Choose from this article a paragraph of the length you want to make your poem.
Cut out the paragraph.
Next carefully cut out each of the words that makes up this paragraph and put them all in a bag.
Shake gently.
Now take each cutting one after the other.
Copy conscientiously in the order in which they left the bag.
The poem will resemble you.

And there you are – an infinitely original scholar of charming sensibility, even though unappreciated by the Kotlerite herd.

(Adapted from Brandon 1999: 100)

TROPE SURGE

The second Surrealist lesson relates to antecedents. Dada and Surrealism are commonly regarded as zeitgeistian phenomena, artistic responses to the horrors of the First World War and the political convulsions of the interwar era respectively (Gay 2007). There is of course much truth in this inference. But the artists themselves went to great lengths to identify their antecedents, to reclaim the past for the present. This aesthetic retrofit extended all the way back to the Romantic, Symbolist and Decadent poets, to say nothing of eighteenth-century libertines like de Sade. Breton's *Surrealist Manifesto*, for example, spelled out the literary-historical background to the movement. This not only included Freud's theory of the unconscious but also the writings of Rimbaud, the aphorisms of Lautréamont, the Gothic novels of 'Monk' Lewis, the satires of Jonathan Swift, the fantasies of Lewis Carroll, the horror stories of Edgar Allan Poe, the poetry of Saint-Pol-Roux and Baudelaire, the perturbing plays of Alfred Jarry and Raymond Roussel.[8]

Arts marketing scholarship, by contrast, is characterized by a comparative lack of attention to illustrious antecedents. It tends to focus on the here and now. The cultural industries are often portrayed as the final frontier of resistance that has finally, belatedly, reluctantly surrendered to the special forces of marketing scholarship. Forty years after Kotler and Levy's broadening of the marketing concept beyond the profit-making sphere, recalcitrant artistic types increasingly recognize the need for marketing and concede that marketing has its place. Arts marketing is hot. Arts marketing is hip. Arts marketing is cutting-edge. Arts marketing is the avant-garde of academia. All hail the arts-marketing heroes!

Appealing though this SIG-rhetoric is, the problem with such a 'too cool for school' narrative is that it misconstrues the prehistory of arts marketing. Far from being a backwater, where marketers are hesitantly accommodated at best and roundly detested at worst, the arts have long been at the forefront of best marketing practice. The arts pioneered much of what passes for modern marketing. The nineteenth-century antics of P.T. Barnum, a museum proprietor-cum-circus impresario, the bookselling heroics of itinerant Bible barkers, like the imperishable Mason Locke Weems, the scandal-mongering of the French Impressionists, most notably Édouard Manet, the extravagant, exaggerated, exhilarating sales pitches of patent-medicine purveyors,

mesmerists and more, are testament to the deep-rooted marketing savvy of the cultural industries (Brown and Patterson 2000). Many historians regard Josiah Wedgwood, the magnificent Staffordshire pottery merchant, as the primal marketing man, though a compelling case can also be made for William Caxton, the fifteenth-century bookseller. Regardless of the precise point of inception – some say the first marketer was Satan, tempting Eve in the Garden of Eden – the key point is that the arts are not a dewy-eyed newcomer, a recent convert to the marketing cause. We would do well to remember that the Dadaists and Surrealists were marketing their wares pretty effectively fifty-plus years before Phil Kotler 'broadened' the field.

ALCHEMICAL ALTERNATIVE

Our third lesson is occult. The Dada-Surrealist's rejection of the rigidities of Judeo-Christian culture was not confined to their fondness for oneiric worlds where the unpredictable prevailed. Many went much, much further. The mystical, the magical, the hermetic, the esoteric – the supernatural, in short – also attracted considerable attention and not a little participation. The automatic writing procedures of René Crevel owed much to séances, spiritualism and trance states *tout court*, as did those of Philippe Soupault and Robert Desnos. André Breton was obsessed with astrology, acknowledged his intellectual debt to Nicolas Flamel, a fourteenth-century alchemist, and leaned heavily on Eliphas Lévi, the foremost black magician of the nineteenth century. Victor Brauner collected voodoo chimeras and cast spells on a regular basis. Max Ernst cultivated an avian familiar, *LopLop*. Salvador Dali was a practising sorcerer. Hans Arp was inspired by Jacob Boehme, the German mystic. Joan Miró was influenced by the Catalan cabbalist, Ramon Lull. Hugo Ball's phonetic poetry represented an attempt to reconnect with 'the inner alchemy of the word'. And Fulcanelli, arguably the greatest necromancer of the twentieth century, was closely associated with the Surrealist movement (Brown 2008).

If, as some have argued, marketing is inherently magical – advertising slogans are spells by another name, marketing planning is a form of clair-voyance, mathematical models are not far removed from numerology – the question has to be asked: why do we academics persist in the superstitious belief that marketing is a science? More to the point, why do we marketing scholars continue to write our articles, essays and book chapters in pseudo-scientific prose? Convention, admittedly, plays an important part in the perpetuation of scientism, as do manuscript-submission guidelines, eager copy-editor interventions, the pernicious double-blind review process, PhD

training programmes, the internalization of social-science ideology and the like.[9] But the sterility of our output, our writing, our art (if you will), is very striking. Marketing is magic yet we make it mundane. Surely we can do better. Surely we are capable of injecting a little art, a much-needed modicum of magic, into our academic endeavours. Aren't we?

FISH ON A BICYCLE?

The foregoing, suffice it to say, aren't the only meaningful marketing lessons that can be extracted from Dada and Surrealism. The rejection of predict-ability, rationality and logic in favour of providence, irrationality and serendipity characterized both artistic movements. The history of marketing, likewise, reveals that chance, accident and happenstance play as important a part as analysis, planning and control.[10] Both movements, moreover, spurned arts for art's sake aestheticism for real-world political engagement. Dada was an anarchistic anti-war movement, as much as anything, and the Surrealists aligned themselves with the Trotskyite wing of the Communist Party. An analogous tension is apparent in marketing, where ivory-tower scholar-ship nestles uneasily beside the pragmatic imperatives of an 'applied' discipline and the anti-capitalist critiques of the Critical Marketing coterie. If the experiences of Dada and Surrealism teach us anything it is that ever-increasing fragmentation and mutual hostility between warring marketing tribes is the fate that awaits us. Some would say it has already arrived (Hackley 2009).

My intention here is not to pile up the parallels, since cultural movements are akin to Rorschach inkblots, where observers see what they set out to see. My aim is to appeal for more artistic approaches to arts marketing. Admirable though they all are, the essays in this book adhere to the norms, the codes, the protocols, the prevailing rubric of social-science writing. Speaking for myself, I believe that we should seek inspiration from our great predecessors, the working artists who pioneered the tools and techniques of contemporary marketing practice. I believe that arts-marketing scholars should lead the way when it comes to new/alternative/experimental modes of academic com-munication. Where are our discipline's dream works? Why not conceptual cut-ups? When will we see marketing Magnetic Fields? Is ready-made marketing out of the question? Anyone for Exquisite Corpus?

NOTES

1 This assertion, I must make clear, is entirely subjective. It is based on personal observation in art galleries worldwide.

2 Aptly, André Breton was known as the 'Pope' of Surrealism on account of his pontifical manner. 'A ferocious and possessive guardian of its spiritual purity across the decades' (Jackson 2004: 185), Breton routinely excommunicated heretics and consigned doubters to the flames of social exclusion.

3 A quasi-Cubist, semi-Futurist oil painting, *Nude Descending a Staircase*, was the star of the legendary Armory Exhibition of January 1913, which effectively introduced modern art to North America. It was famously described as 'an explosion in a shingle factory'.

4 There are countless conflicting accounts of Dada's origin. Apart from the brands of shampoo and soap, some say the name was picked randomly from a dictionary. Others claim it was deliberately selected for its nonsensical character coupled with its multiple meanings. 'In French it means a small wooden horse. In German: farewell, goodbye, be seeing you. In Romanian: yes, really, you're right, that's it, fine, yes yes, we're taking care of it' (Dachy 2006: 17).

5 Exquisite Corpse was a Surrealist game of consequences, which was used to generate collective poems and hybrid images. Jackson (2004: 188–89) explains the procedure thus: 'A folded piece of paper is passed from hand to hand, and each participant adds a new component to the text or picture without being aware what his or her predecessors have contributed.' *The Magnetic Fields*, incidentally, was the first fruit of Breton and Soupault's automatic writing experiments.

6 Many Dada-Surrealists were both writers and artists. Arp, Ernst, Picabia, Schwitters and of course Duchamp contributed to a multitude of artistic domains.

7 I'm not for a moment suggesting that there are no good writers in marketing. Morris Holbrook, Russell Belk, Linda Scott and John Sherry, to name but the most prominent, are blessed with considerable literary ability. They are the exceptions rather than the rule, though.

8 Duchamp, likewise, attributed his proto-Dadaism to attendance at one of Roussel's plays, *Impressions of Africa*. As he later acknowledged, 'It was fundamentally Roussel who was responsible for my glass, *The Bride Stripped Bare By Her Bachelors, Even*. From his *Impressions d'Afrique* I got the general approach . . . I saw at once that I could use Roussel as an influence. I felt that as a painter it was much better to be influenced by a writer than by another painter. And Roussel showed me the way' (quoted in Mink 2000: 29).

9 The ultimate irony is that marketing academia's apparent desire to enhance its scientific standing is itself a form of magic. Just as celebrity endorsement is akin to contiguous magic – insofar as the charisma of one transfers to the other by simple juxtaposition – so too marketers seem to believe that if we get close to science, embrace the scientific method and metaphorically wrap ourselves in white laboratory coats, like secular Josephs, that somehow marketing will be magically transformed. Into a science!

10 As Dyer *et al.* (2004) demonstrate in their chronicle of Procter & Gamble, perhaps the most rigorous marketing organization on the planet, the discovery of almost every billion-dollar brand – from Ivory soap via Tide detergent to Pantene shampoo and Pringles potato chips – was either somewhat unplanned or entirely accidental.

REFERENCES

Adams, P. (2005) 'Foreword', in Charlesworth, E. (ed.) *Cityedge: Case Studies in Contemporary Urbanism*. Oxford: Architectural Press.

Addis, M. and Holbrook, M.B. (forthcoming) 'Consumers' Identification and Beyond: Attraction, reverence, and escapism in the evaluation of films', *Psychology & Marketing*.

Adorno, T.W. (2002) 'Culture and Administration', in Bernstein, J.M (ed.) *Adorno – The Culture Industry*, Vol. 3. London: Routledge.

Alberge, D. (1999) 'Rebels Get Stuck into the Brit Artists', *The Times*, 26 August: 7.

Albert, S. (1998) 'Movie Stars and the Distribution of Financially Successful Films in the Motion Picture Industry', *Journal of Cultural Economics*, 22(4): 249–70.

Aldridge, J. (2009) 'The Open Organisation', *Arts Professional*, Issue 199, 27 July: 11.

Alpert, J.I and Alpert, M.I (1989) 'Background Music as an Influence in Consumer Mood and Advertising Responses', *Advances in Consumer Research*, 16, 485–91.

Alter, R. (2005) *Imagined Cities: Urban Experience and the Language of the Novel*. London: Yale University Press.

Anderson, Chris (2007) *The Long Tail: How Endless Choice is Creating Unlimited Demand*. London: Random House Business Books.

Andreasen, A.R. and Belk, R.W. (1980) 'Predictors of Attendance at the Performing Arts', *Journal of Consumer Research*, 7, September, 112–20.

Ang, I. (1985) *Watching Dallas: Soap Opera and the Melodramatic Imagination*. London: Methuen.

Anholt, S. (2007) *Competitive Identity: The New Brand Management for Nations, Cities and Regions*. Basingstoke: Palgrave Macmillan.

Aoki, P.M., Grinter, R.E., Hurst, A., Szymaniski, M.H., Thornton, J.D. and Woodruff, A. (2002) 'Sotto Voce: Exploring the Interplay of Conversation and Mobile Audio Spaces', *Proceedings of the Conference for Human Factors in Computing Systems* (CHI'02), Minneapolis: ACM-Press: 431–38.

Appalachian Community Fund (2008) *If You Believe in Central Appalachia*, brochure, Knoxville, TN.

Areni, C.S. and Kim, D. (1993) 'The Influence of Background Music on Shopping Behaviour: Classical versus Top-Forty Music in a Wine Store', *Advances in Consumer Research*, 20, 336–40.

Arnould, Eric J. and Price, Linda L. (1993), 'River Magic: Extraordinary experience and the extended service encounter', *Journal of Consumer Research*, 20(1): 24–45.

Arnould, E., Price, L., and Zinkhan, G (2002) *Consumers*. New York: McGraw Hill.

Arrendondo, P. (1996) *Successful Diversity Management Initiatives: A Blueprint for Planning and Implementation*. Thousand Oaks, CA: Sage Publications.

Arts Council England (2003) *Focus on Cultural Diversity The Arts in England – Attendance Participation, Attitudes*. London: Arts Council England.

—— (2005) *Creative Yorkshire*. Leeds: Arts Council England.

—— (2008) *What People Want from the Arts*. London: Arts Council England.

Arts Council of Great Britain (1988) *The Arts Council Three-year Plan 1988/89 – 1990/91*. London: Arts Council Great Britain.

Augusto, M. and Coelho, F. (2007) 'Market Orientation and New-to-the-world Products: Exploring the Moderating Effects of Innovativeness, Competitive Strength and Environmental Forces', *Industrial Marketing Management*, 38: 94–108.

Austin, B.A. (1980) 'The Influence of MPAA's Film-rating System on Motion Picture Attendance: A pilot study', *Journal of Psychology*, 106: 91–99.

Australia Council (1997) *The Taxidriver, the Cook, and the Greengrocer: The representation of non-English speaking background people in theatre, film, and television*. Australia Council. Surry Hills, NSW.

—— (2004) *Who Goes There? National Multicultural Arts Audience Case Studies*. Canberra: Australia Council.

—— (2008) *Beats a Different Drum*. Sydney: Australia Council.

Australian Bureau of Statistics (2007) *Australian Bureau of Statistics 2006 Census QuickStats : Australia*. http://www.censusdata.abs.gov.au/ (accessed 3 July 2009).

Avraham, E. and Ketter, E. (2008) *Media Strategies for Marketing Places in Crisis: Improving the Image of Cities, Countries and Tourist destinations*. Oxford: Butterworth Heinemann.

Badot, O. and Cova, B. (2008) 'The Myopia of New Marketing Panaceas: The case for rebuilding our discipline', *Journal of Marketing Management*, 24(1–2): 205–19.

Baker, M. (1998) *Museums, Collections and Their Histories*. New York: Harry N. Abrams.

Balabanis, G., Stables, R.E. and Phillips, H.C. (1997) 'Market Orientation in the Top 200 British Charity Organisations and Its Impact on their Performance', *European Journal of Marketing*, 31(8): 583–603.

Ballantyne, A. (2006) 'Architecture as Evidence', in Arnold, D., Altan, E., Turan-Özkaya, E. and Turan-Özkaya, B. (eds) *Rethinking Architectural Historiography*. London: Routledge.

Bamossy, G. J. (2005) 'Star Gazing: The mythology and commodification of Vincent van Gogh', in D. Mick and S. Ratneshwar (eds) *Inside Consumption: Frontiers of Research on Consumer Motives, Goals, and Desires*. New York: Routledge.

Bartak, A. (2007) 'The Departing Train: Online museum marketing in the age of engagement', in Rentschler, R. and Hede, A.M. (eds) *Museum Marketing: Competing in the global marketplace*. Amsterdam, London: Butterworth-Heinemann.

Basuroy, S., Chatterjee, S. and Ravid, S.A. (2003) 'How Critical are Critical Reviews? The box office effects of film critics, star power, and budgets', *Journal of Marketing*, 67 (October); 103–17.

Basuroy, S., Desai, K.K. and Talukdar D. (2006) 'An Empirical Investigation of Signaling in the Motion Picture Industry', *Journal of Marketing Research*, 43 (May), 287–95.

Battarbee, K. and Koskinen, I. (2005) 'Co-experience: User experience as interaction', *CoDesign*, 1: 5–18.

Baudrillard, J. (1988) 'Consumer Society', in Poster, M. (ed.) *Baudrillard: Selected Writings*. Stanford: Stanford University Press.

BBC News (2003) 'Liverpool Named Capital of Culture'. Available from http://news.bbc.co.uk/1/hi/entertainment/arts/2959944.stm (accessed 1 June 2009).

Becker, H.S. (1978) 'Arts and Crafts', *American Journal of Sociology*, 83: 862–89.

Beckmann, Suzanne and Elliot, Richard (2000). *Interpretive Consumer Research. Paradigms, Methodologies and Applications*, Copenhagen: Copenhagen Business School Press.

Belchem, J. (2006) *Merseypride: Essays in Liverpool Exceptionalism*, Liverpool: Liverpool University Press.

Belk, R., Sherry, J.F. and Wallendorf, M. (1988) 'A Naturalistic Inquiry into Buyer and Seller Behavior at a Swap Meet', *Journal of Consumer Research*, 14: 449–70.

Belk, R., Wallendorf, M. and Sherry, J.F. (1989) 'The Sacred and the Profane in Consumer Behaviour: Theodicy on the Odyssey', *Journal of Consumer Research*, 16: 1–38.

Beller, Thomas (2008) 'Virginia Real', *Travel and Leisure*, September, 97–103.

Belvaux, B. and Marteaux, S. (2007) 'Web User Opinions as an Information Source. What impact on cinema attendance?', *Recherche et Applications en Marketing*, 22(3): 65–81.

Bennett, A. (1999) 'Subcultures or Neotribes: Rethinking the relationship between musical taste', *Sociology*, 599–614, August.

—— (2000) *Popular Music and Youth Culture: Music, Identity and Place*. London: Macmillan Press.

Bennett, T. (1995) *The Birth of the Museum: History, Theory, Politics*. London: Routledge.

—— (2006) 'Exhibition, Difference and the Logic of Culture', in Karp, I., Kratz, C.A., Szwaja, L. and Ybarra-Frausto, T. (eds) *Museum Frictions: Public Culture/Global Transformations*, Durham: Duke University Press.

Bently, L., Davis, J. and Ginsburg, J. (eds) (2008) *Trade Marks and Brands: An Interdisciplinary Critique*. Cambridge: Cambridge University Press.

Berry, L.L. (1983) 'Relationship Marketing', in Berry, L.L., Shostack, G.L. and Upah, G.D. (eds) *Emerging Perspectives on Services Marketing*. Chicago: American Marketing Association.

Bernstein, Joanne Scheff and Kotler, Philip (2007) *Arts Marketing Insights: The Dynamics of Building and Retaining Performing Arts Audiences*. San Francisco: John Wiley.

Beverland, M.B. (2005) 'Crafting Brand Authenticity: The case of luxury wines', *Journal of Management Studies*, 42(5): 1003–29.

Bhat, S and Reddy, S.K (1998) 'Symbolic and Functional Positioning of Brands', *Journal of Consumer Marketing*, 15(1): 32–43.

Bierley, C., McSweeney, F.K. and Vannieuwkerk, R. (1985) 'Classical Conditioning of Preferences for Stimuli', *Journal of Consumer Research*, 12 (December): 316–23.

Birmingham, L. (2008) 'Manga's Doe-Eyed Girls, Ninja Boys Woo U.S. Comic-Book Readers', Bloomberg News (22 January). http://www.bloomberg.com/apps/news?pid=20601080andsid=apcSQGNG_Ti8andrefer=asia (accessed 11 April 2008).

Blackman, S.J. (1996) 'Has Drug Culture become an Inevitable Part of Youth Culture? A critical assessment of drug education', *Educational Review*, 48(2): 131–42.

Blankson, C., Motwani, J.P. and Levenburg, N.M. (2006) 'Understanding the Patterns of Market Orientation among Small Businesses', *Marketing Intelligence and Planning*, 24(6): 572–90.

Bloch, C. (1996) 'Emotions and Discourse', *Human Studies*, 16(3): 323–41.

Blonski, A. (1992) *Arts for a Multicultural Australia: An Account of Australia Council Policies 1973–1991*. Sydney, Australia Council.

Bloom, J.N. and Mintz, A. (1992) 'Museums and the Future of Education', in Nichols, S.K.

(ed.) *Patterns in Practice: Selections from the Journal of Museum Education*, Washington, DC: Museum Education Roundtable: 71–78.

Blue Ridge Parkway Association (2008) *The Blue Ridge Digest*, Summer, Asheville, NC.

Boatwright, P., Basuroy, S. and Kamakura, W. (2007) 'Reviewing the Reviewers: The impact of individual film critics on box office performance', *Quantitative Marketing and Economics*, 5: 401–25.

Bockris, V. (2003) *Warhol: The Biography*. Cambridge, MA: Da Capo.

Boerner, S. and Renz, S. (2008) 'Performance Measurement in Opera Companies: Comparing the subjective quality judgment of experts and non-experts', *International Journal of Arts Management*, 10: 21–37.

Boland, P. (2008) 'The Construction of Images of People and Place: Labelling Liverpool and Stereotyping Scousers', *Cities: The International Journal of Urban Policy and Planning*, 25(6): 355–69.

Bonnell, J. and Simon, R. (2007) ' "Difficult" Exhibitions and Intimate Encounters', *Museum and Society*, 5(2): 65–85.

Boorsma, M., (2006) 'A Strategic Logic for Arts Marketing – Integrating customer value and artistic objectives', *International Journal of Cultural Policy*, 12(1) (March): 73–92.

Boswell, D. and Evans, J. (1999) *Representing the Nation, Histories, Heritage and Museums*. London: Routledge.

Botti, S. (2000) 'What Role for Marketing in the Arts? An analysis of arts consumption and artistic value', *International Journal of Arts Management*, 2(3):14–27.

Bourdieu, P. (1984) *Distinction – a Social Critique of the Judgment of Taste*, trans. R. Nice. London: Routledge.

Bourdon, D. (1989) *Andy Warhol*. New York: Harry Abrams.

Bowman, W.D (1998) *Philosophical Perspectives on Music*. Oxford: Oxford University Press.

Bradbury, R (1953) *Fahrenheit 451*. New York: Ballantine.

Bradshaw, A. (forthcoming) 'Before Method: Axiomatic Review of Arts Marketing' in Larsen, G. and O'Reilly, D. (eds) Special Issue on Creative Methods of Inquiry in Arts Marketing, *International Journal of Culture Tourism and Hospitality Research*.

Bradshaw, A. and Holbrook, M. (2007) 'Remembering Chet: Theorising the mythology of the self-destructive artist as self-producer and self-consumer', *Marketing Theory*, 7(2): 115–36.

—— (2008) 'Must We Have Muzak wherever We Go? A critical consideration of the consumer culture', *Consumption, Markets and Culture*, 11(1): 25–44.

Bradshaw, A. and Shankar, A. (eds) (2008) 'The Production and Consumption of Music', *Consumption, Markets and Culture*, 11, 4.

Bradshaw, A., McDonagh, P. and Marshall, D. (2006) 'The Alienated Artist and the Political Economy of Organised Art', *Consumption, Markets and Culture*, 9(2):111–18.

Brand Republic (2003) *Superbrands Case Study: Classic FM* [online]. Available at: http://www.brandrepublic.com/{...}/superbrands-case-studies-Classic-FM (accessed 12 April 2007).

Brandon, R. (1999) *Surreal Lives: The Surrealists 1917–1945*. London: Macmillan.

Braun, T. (2007) *The Philosophy of Branding*. London: Kogan Page.

Brown, J.N. (2005) *Dropping Anchor, Setting Sail: Geographies of Race in Black Liverpool*. New York: Princeton University Press.

Brown, S. (1995) *Postmodern Marketing*. London: Routledge.

—— (1998) *Consumer Research: Postcards from the Edge*. London: Routledge.

—— (2005) *Wizard!: Harry Potter's Brand Magic*. London: Cyan Books.

—— (2005) *Writing Marketing*. London: Sage.

—— (2006) *The Marketing Code*. London: Cyan.

—— (2007) 'Turning Customers into Lustomers: the Duveen proposition', *Journal of Customer Behaviour*, 6(2): 143–53.

—— (2008) *Agents and Dealers*. London: Marshall Cavendish.

Brown, S. and Patterson, A. (ed.) (2000) *Imagining Marketing: Art, Aesthetics and the Avant-Garde*. London: Routledge.

Bruner II, G.C. (1990) 'Music, Mood, and Marketing', *Journal of Marketing*, October: 94–104.

Bunting, Catherine , Chan, Tak Wing, Goldthorpe, John, Keaney, Emily and Oskala, Anni (2008) *From Indifference to Enthusiasm: Patterns of Arts Attendance in England*. London: Arts Council England.

Buntinx, G. and Karp, I. (2007) 'Tactical Museologies' in Karp, I., Kratz, C.A, Szwaja, L. and Ybarra-Frausto, T. (eds) *Museum Frictions: Public Culture/Global Transformations*. Durham, NC: Duke University Press.

Burns, P. (2000) *An Introduction to Tourism and Anthropology*. London: Routledge.

Burns C., Cottam H., Vanstone C., and Winhall J. (2006) 'Transformation Design', RED paper 02, Design Council, London.

Burzinsky, M.H. and Bayer, D.J. (1977) 'The Effect of Positive and Negative Prior Information on Motion Picture Appreciation', *Journal of Social Psychology*, 101, 215–18.

Business Wire (2007) 'World's First Interactive Japanese Manga Web Service Creates Community of "Reader-Translator"' (1 October). http://www.panapress.com/news wire.asp?code=5542 (accessed 10 August 2008).

Bussell, H. and Forbes, D. (2006) ' "Friends" Schemes in Arts Marketing: Developing relationships in British provincial theatres', *International Journal of Arts Marketing*, 8(2): 38–49.

Bystedt, J., Lynn, Siri and Potts, Deborah (2003) *Moderating to the Max: A full-tilt guide to creative, insightful focus groups and depth interviews*. Ithaca, NY: Paramount Market Publishing.

Caldwell, M.L and Woodside, A. (2001) 'Attending Performing Arts: A consumption system model of buying-consuming experiences. Advances in Consumer Research'; 28 (1), 348.

Camarero, C. and Garrido, M.J. (2008). 'The Influence of Market and Product Orientation on Museum Performance', *International Journal of Arts Management*, 10(2): 14–26.

Campbell, C. (1987) *The Romantic Ethic and the Spirit of Modern Consumerism* Oxford: Basil Blackwell.

Campbell-Johnston, R. (2007) 'Beyond Belief: Rachel Campbell-Johnston at White Cube, N1 and SW1, 2 June 2007'. TimesOnline: http://entertainment.timesonline.co.uk/tol/arts_and_entertainment/visual_arts/article1873042.ece (accessed on 7 December 2009).

Carnegie, E. (2004) 'Free Nelson Mandela? The politics and pricing of culture in society,' in Yeoman, I and McMahon-Beattie, U. (eds) *Revenue Management and Pricing: Case Studies and Applications*. London: Thomson.

—— (2006) 'It wasn't all bad': Representations of working class cultures within social history museums and their impacts on audiences', *Museum and Society*, 4(2): 69–83.

Carson, D., Gilmore, A., Gronhaug, K. and Perry, C. (2001) *Qualitative Marketing Research*. London: Sage.

Carter Family (2008) *Carter Family Memorial Festival and Craft Show*, brochure, Hiltons, VA.

Carù, Antonella and Cova, Bernard (2006) 'How to Facilitate Immersion in a Consumption Experience: Appropriation operations and service elements', *Journal of Consumer Behaviour*, 5(1): 4–14.

Caust, J. (2003) 'Putting the "Art" Back into Policy Making: How arts policy has been "captured" by the economists and marketers', *International Journal of Cultural Policy*, 9(1): 51–63.

—— (2005) 'Privilege or Problem: The distinct role of government in arts development in South Australia', *Journal of Arts Management, Law and Society*, 35: 21–35.

Celsi, R.L. and Olson, J.C. (1988) 'The Role of Involvement in Attention and Comprehension Processes', *Journal of Consumer Research*, 15(2): 210–24.

Celsi, Richard L., Rose, Randall L., Leigh, Thomas W. (1993) 'An Exploration of High-risk Leisure Consumption through Skydiving', *Journal of Consumer Research*, 20(1): 1–23.

Chakravarty, A., Liu, Y. and Mazumdar, T. (2008) 'Online User Comments versus Professional Reviews: Differential influences on pre-release movie evaluation'. Working paper #08-105, Marketing Science Institute.

Chang, B.H. and Ki, E.J. (2005) 'Devising a Practical Model for Predicting Theatrical Movie Success: Focusing on the experience goods property', *Journal of Media Economics*, 18(4): 247–69.

Chang, Jeff and DJ Cool Herc (2005) *Can't Stop, Won't Stop: A History of the Hip Hop Generation*. Los Angeles: Picador.

Chang, T.C. and Huang, S. (2004) 'Urban Tourism: Between the global and the local', in Lew, A.A., Hall, C.M. and Williams, A.M. (eds) *A Companion to Tourism*, Oxford: Blackwell.

Chartrand, H.H. (1984) 'An Economic Impact Assessment of the Fine Arts', Third International Conference on Cultural Economics and Planning, Akron, Ohio.

Cherian, J. and Jones, M. (1991) 'Some Processes in Brand Categorizing: Why one person's noise is another person's music', *Advances in Consumer Research*, 18: 77–83.

Childs, P. and Storry, M. (1999) *Encyclopedia of Contemporary British Culture*. London: Routledge.

Chong (2005) 'Stakeholder Relationships in the Market for Contemporary Art', in Robertson, I. (ed.) *Understanding International Art Markets and Management*. London: Routledge.

Chronis, A. and Hampton, R.D. (2008) 'Consuming the Authentic Gettysburg: How a tourist landscape becomes an authentic experience', *Journal of Consumer Behaviour*, 7(2): 111–26.

Clarke, J., Hall, S., Jefferson, T. and Roberts, B. (1997/1975) 'Subcultures and Class', in Gelder, K. and Thornton, S. (eds) *The Subcultures Reader*. London: Routledge.

Cleland, G. (2007) 'Hirst Boy's Painting Put Nunn in £27,000 Spin', *Daily Telegraph*, http://www.telegraph.co.uk/news/uknews/1554830/Hirst-boys-painting-put-Nunn-in-27000-spin.html (accessed 17 December 2008).

Clifford, J (1999) 'Museums as Contact Zones' in Boswell, D. and Evans, J. (eds) *Representing the Nation, Histories, Heritage and Museums*. London: Routledge.

Clopton, S.W., Stoddard, J.E. and Dave, D. (2006) 'Event Preferences among Arts Patrons: Implications for Market Segmentation and Arts Management', *International Journal of Arts Management*, 9(1): 48–77.

Close, H. and Donovan, R. (1998) *Who's My Market? A guide to researching audiences and visitors in the arts.* Sydney: Australia Council for the Arts.

Colbert, F. (1993) 'Entrepreneurship and Leadership in Marketing the Arts', *International Journal of Arts Management*, 6(1): 30–39.

Colbert, F. (2007) *Marketing Culture and the Arts*, 3rd edn. HEC Montreal.

Collings. M. (1999) *This is Modern Art.* London: Weidenfeld and Nicolson.

Connecticut Commission on Culture and Tourism and Alan S. Brown and Associates LLC (2004) *The Values Study: Rediscovering the Meaning and Value of Arts Participation.* July. Hartford, CT: Connecticut Commission.

Connell, J. and Gibson, J. (2003) *Sound Tracks: Popular Music, Identity and Place.* London: Routledge.

Connor, L. (2008) *Project Brief: Arts Experience Initiative.* The Heinz Endowments, Summer.

Cook, N. (1998) *Music: A Very Short Introduction.* Oxford: Oxford University Press.

Cook, R. (2005) *It's About That Time: Miles Davis On and Off Record.* London: Atlantic Books.

Cooke, M. and Horn, D. (2003) *Cambridge Companion to Jazz.* Cambridge: Cambridge University Press.

Copyright Research and Information Centre [CRIC] (2008) Copyright Law of Japan. http://www.cric.or.jp/cric_e/clj/clj.html (accessed 27 June 2008).

Costantoura, P. and Saatchi and Saatchi Australia (2000) *Australians and the Arts: What do the arts mean to Australians?* Sydney: Australia Council for the Arts.

Costelloe, T. (1996) 'Between the Subject and Sociology: Alfred Schutz's phenomenology of the life world', *Human Studies*, 19: 247–66.

Cottam, Hilary and Leadbeater, Charles (2004) *Health: Co-creating Services.* London: Design Council.

Cottrell, S. (2004) *Professional Music-Making in London – Ethnography and Experience.* Hampshire: Ashgate.

Cova, B. (1997) 'Community and Consumption: Towards a definition of the linking value of products or services', *European Journal of Marketing*, 31(3/4): 297–316.

—— (1999) 'From Marketing to Societing: When the link is more important than the thing', in Brownlie, D., Saren, M., Wensley, R. and Whittington, R. (eds) *Rethinking Marketing: Towards Critical Marketing Accountings.* London: Sage.

Crafts, S.D., Cavicchi, D. and Keil, C. (1993) *My Music.* London: Wesleyan University Press.

Creative NZ and Auckland City Council (2009) *Asian Aucklanders and the Arts.* Auckland: Creative NZ and Auckland City Council.

Creative Research (2007) *The Arts Debate: Findings of Research among the General Public.* London: Arts Council England.

Csikszentmihalyi, M. (1992), *Flow: The Psychology of Happiness.* London: Rider Press.

Cunningham, S. (2002) *From Cultural to Creative Industries: Theory, Industry, and Policy Implications.* Creative Industries Research and Applications Centre, University of Technology, Brisbane, Australia.

Cunningham, S., Hearn, G., Cox, S., Ninan, A. and Keane, M. (2000) *Brisbane's Creative Industries 2003, Report delivered to Brisbane City Council, Community and Economic Development*, Creative Industries Applied Research Centre, Queensland University of Technology.

Cushman, P. 1990 'Why the Self is Empty: Toward a historically situated psychology', *American Pyschologist*, 45(5): 599–611.

Dachy, M. (2006) *Dada: The Revolt of Art*. New York: Abrams Discoveries.

D'Astous, A. and Touil, N. (1999) 'Consumer Evaluations of Movies on the Basis of Critics' Judgments', *Psychology & Marketing*, 16(8): 677–94.

Davis, P (2007) 'Place Exploration: Museums, Identity, Community,' in Watson, S. (ed.) *Museums and their Communities*.London: Routledge.

Dawson, C.R. (2007) *The Arts Debate: Research among stakeholders, umbrella groups and members of the arts community*. London: Arts Council England.

Day, G.S. and Montgomery, D.B. (1999) 'Charting New Directions for Marketing', *Journal of Marketing*, 63: 3–13.

DCMS (1998) *Creative Industries Mapping Document*. London: DCMS

—— (2007) *Culture on Demand Ways to Engage a Broader Audience*. London: DCMS.

Debord, G. (1967) *The Society of the Spectacle*. Cambridge, MA: MIT Press.

Deck, F. (2004) 'Reciprocal Expertise', *Third Text*, 18: 617–32.

Dellarocas, C., Awad, N.F. and Zhang, X. (2004) 'Exploring the Value of Online Reviews to Organizations: Implications for revenue forecasting and planning', *Proceedings of the 25th International Conference on Information Systems (ICIS)*, ed. Agarwal, R. and Kirsch, L. Atlanta, GA: Association for Information Systems.

Dennis, N. and Macaulay, M. (2003), 'Jazz and Marketing Planning', *Journal of Strategic Marketing*, September, 11(3): 177–86.

—— (2007) 'Miles Ahead: Using Jazz to Investigate Market Orientation', *European Journal of Marketing*, 41(5/6): 608–23.

—— (2008) 'The Parallax of Art and Commerce: UK Jazz Musicians on Marketing', *Jazz Research Journal*, 1(2): 225–38.

DeNora, T. (2003) *After Adorno: Rethinking Music Sociology*. Cambridge: Cambridge University Press.

Department of Culture and the Arts (2004) *Journey Further: An Arts and Cultural Tourism Strategy*. Perth: DCA.

Deppey, D. (2005) 'Scanlation Nation: Amateur Manga Translators Tell Their Stories', *The Comics Journal*, 269 (13 July).

Desai, K.K. and Basuroy, S. (2005) 'Interactive Influence of Genre Familiarity, Star Power, and Critics' Reviews in the Cultural Goods Industry: The case of motion pictures', *Psychology & Marketing*, 22 (March): 203–23.

—— (2006) 'Dallas Middaugh', *The Comics Journal*, 277 (11 July).

Deuchert, E., Adjamah, K. and Pauly, F. (2005) 'For Oscar Glory or Oscar Money?', *Journal of Cultural Economics*, 29 (3): 159–176.

Deutsche Welle (2002) 'Manga Girls versus Spiderman' (26 June). http://www.dw-world.de/dw/article/0,2144,583423,00.html (accessed 16 June 2008).

—— (2006) 'Japanese Manga Made in Germany' (8 November). http://www.dw-world.de/dw/article/0,2144,2230500,00.html (accessed 16 June 2008).

De Vany, A. and Lee, C. (2000) 'Quality Signals in Information Cascades and the Dynamics of the Distribution of Motion Picture Box Office Revenues', *Journal of Economic Dynamics & Control*, 25: 593–614.

De Vany, A. and Walls, W.D. (1999) 'Uncertainty in the Movie Industry: Does star power reduce the terror of the box office?', *Journal of Cultural Economics*, 23 (4): 285–318.

—— (2002) 'Does Hollywood Make Too Many R-rated Movies? Risk, stochastic dominance, and the illusion of expectation', *Journal of Business*, 75: 425–51.

Dew, N., Sarasvathy, S.D., Read, S. and Wiltbank, R. (2008) 'Immortal Firms in Mortal Markets: An entrepreneurial perspective on the "innovator's dilemma"', *European Journal of Innovation Management*, 11(3): 313–29.

Dickman, S. (2000) *What's My Plan?* Sydney: Australia Council for the Arts.

Dodds, J.C. and Holbrook, J.C. (1988) 'What's an Oscar Worth? An empirical estimation of the effects of nominations and awards on movie distribution and income', *Current Research in Film: Audiences, Economics, and Law*, 4: 72–88.

Dorment, R. (2007) 'For the Love of Art and Money', *Daily Telegraph*, http://www.telegraph.co.uk/culture/art/3665529/For-the-love-of-art-and-money.html (accessed 12 February 2009).

Dovey, J. (2001) *Freakshow: First Person Media and Factual Television*. London: Pluto.

Drummond, K. (2006) 'The Migration of Art from Museum to Market: Consuming Caravaggio', *Marketing Theory*, 6: 85–105.

Du Gay, P., Hall, S., Janes, L., MacKay, H. and Negus, K. (1997) *Doing Cultural Studies, The Story of the Sony Walkman*. London: Sage.

Duque-Zuluaga, L.C. and Schneider, U. (2008) 'Market Orientation and Organisational Performance in the Nonprofit Context: Exploring both concepts and the relationship between them', *Journal of Nonprofit and Public Sector Marketing*, 19(2): 25–47.

Dyer, D., Dalzell, F. and Olegario, R. (2004) *Rising Tide: Lessons From 165 Years of Brand Building at Procter and Gamble*. Cambridge, MA: Harvard Business School Press.

Dyhoff, T. (2008) 'Capital of Culture – A Year in the Life', *The Culture Show*, London: BBC2 Documentary.

Early (2008) *Kind of Blue: 50th Anniversary Collector's Edition* (Box Set) Columbia/Legacy.

Eco, U. 1987 *Travels in Hyper-reality*. London: Picador.

Editorial (2007) 'Dumping the Shark', *New York Times*, http://www.nytimes.com/2007/07/20/opinion/20fri4.html?ei=5124anden=6a3ef26c4b767c7candex=1342584000 andpartner=permalinkandexprod=permalinkandpagewanted=print (accessed on 25 February 2009).

Elberse, A. (2007) 'The Power of Stars: Do star actors drive the success of movies?', *Journal of Marketing*, 71(4): 102–120.

Elberse, A. and Anand, B. (2006) 'Advertising and Expectations: The effectiveness of pre-release advertising for motion pictures'. Working paper #05-060, Harvard Business School.

Elberse, A. and Eliashberg, J. (2003) 'Demand and Supply Dynamics for Sequentially Released Products in International Markets: The case of motion pictures', *Marketing Science*, 22(3): 329–354.

Eliashberg, J. and Shugan, S.M. (1997) 'Film Critics: Influencers or predictors?', *Journal of Marketing*, 61 (April): 68–78.

Elliott, R. and Wattanasuwan, K. (1998) 'Brands as Symbolic Resources for the Construction of Identity', *International Journal of Advertising*, 17: 131–44.

Erbsen, Wayne (2003) *Rural Roots of Bluegrass*. Pacific, MO: Melbay Publications.

Evans, G. and Foord, J. (2003) 'Shaping the Cultural Landscape: Local Regeneration Effects', in Miles, M. and Hall, T. (eds) *Urban Futures: Critical Commentaries on Shaping the City*. London: Routledge, 167–81.

Evrard, Y. (1991) 'Culture et marketing: incompatibilité ou réconciliation?' in Colbert, F. and Mitchell, C. (eds) *Proceedings of the 1st International Conference on Arts Management*. Montreal, Ecole des HEC, University of Waterloo: 37–50.

Exploratorium. 2001. 'Electronic Guidebook Forum', San Francisco: Exploratorium Available HTPP: http://www.exploratorium.edu/guidebook/forum/.

Falk, J. and Dierking, L. (1992) *The Museum Experience*. Washington: AltaMira Press.

Falk, P. (1994) *The Consuming Body*. London: Sage.

Fanthome, C. (2006) 'The Influence and Treatment of Autobiography in Confessional Art: Observations on Tracey Emin's feature film *Top Spot*', *Biography*, 29(1): 30–42.

Featherstone, M. (1991) *Consumer Culture and Postmodernism*. London: Sage.

Featherstone, M., Hepworth, M. and Turner, B. (1992) *The Body, Social Processes and Cultural Theory*. London: Sage.

Fillis, I. (2000a), 'Being Creative: Lessons from the art industry', *Journal of Research in Marketing and Entrepreneurship*, 2(2): 125–37.

—— (2000b) 'The Endless Enigma or the Last Self-portrait (or, what the marketer can learn from the artist)', in Brown, S. and Patterson, A. (eds) *Imagining Marketing: Art, Aesthetics and the Avant-Garde*. London: Routledge, pp. 52–72.

—— (2000c) 'An Examination of the Internationalisation Process of the Smaller Craft Firm in the United Kingdom and the Republic of Ireland', unpublished doctoral thesis, University of Stirling.

—— (2002a) 'Creative Marketing and the Art Organisation: What can the artist offer?', *International Journal of Nonprofit and Voluntary Sector Marketing*, 7(2): 131.

—— (2002b) 'An Andalusian Dog or a Rising Star: Creativity and the marketing/ entrepreneurship interface', *Journal of Marketing Management*, 18(3/4): 379–95.

—— (2003) 'Image, Reputation and Identity Issues in the Arts and Crafts Organisation', *Corporate Reputation Review: An International Journal*, 6(3): 239–51.

—— (2004a) 'Visual Arts Marketing', in Kerrigan, F., Fraser, P. and Özbilgin, M.F. (eds) *Arts Marketing*. Oxford: Elsevier: 119–38.

—— (2004b) 'The Theory and Practice of Visual Arts Marketing', in Fraser, P. and Kerrigan, F. (eds) *Arts Marketing*. Oxford, Butterworth Heinemann: 119–38.

—— (2004c) 'The Entrepreneurial Artist as Marketer – lessons from the smaller firm literature', *International Journal of Arts Management*, 7(1): 9–21.

—— (2006) 'Art for Art's Sake or Art for Business Sake: An exploration of artistic product orientation', *The Marketing Review*, 6(1): 29–40.

Fillis, I. and Rentschler, R. (2005) *Creative Marketing: An Extended Metaphor for Marketing in a New Age*, Basingstoke: Palgrave Macmillan.

Fincher, R. Jacobs, J.M. and Anderson, K. (2002), 'Rescripting Cities with Difference', in Eade, J. and Mele, C. (eds) *Understanding the City: Contemporary and Future Perspectives*, Oxford: Blackwell.

Firat, A.F (1987) 'Towards a Deeper Understanding of Consumption Experiences: The underlying dimensions', *Advances in Consumer Research*, 14: 342–46.

Firat, A.F. and Dholokia, N. (1998) *Consuming People: From Political Economy to Theatres of Consumption*. New York: Routledge.

Firat, A.F. and Shultz, C. (1997) 'From Segmentation to Fragmentation: Markets and marketing in the postmodern era', *European Journal of Marketing*, 31(3/4): 183–207.

Firat, A.F. and Venkatesh, A. (1995) 'Liberatory Postmodernism and the re-enchantment of consumption', *Journal of Consumer Research*, 22(3): 239–67.

Firat, A.F , Dholakia, N. and Venkatesh, A. (1995) 'Marketing in a Postmodern World', *European Journal of Marketing*, 29: 40–56.

Fishbein, J. (2007) 'Europe's Manga Mania', *Business Week*, 26 December.

Fiske, J. (1992) 'The Cultural Economy of Fandom', in Lewis, L.A. (ed.) *The Adoring Audience: Fan Culture and Popular Media*. London: Routledge, pp. 30–49.

Fonarow, W. (2006) *Empire of Dirt: The Aesthetics and Rituals of British Indie Music*. Middletown, CT: Wesleyan University Press

Foucault, M. (1990) *The History of Sexuality*. New York: Vintage.

Fournier, S., Dobscha, S. and Mick, D.G. (1998) 'Preventing the Premature Death of Relationship Marketing', *Harvard Business Review*, 76(1): 42–51.

Foxall, G. (1989) 'Marketing's Domain', *European Journal of Marketing*, 23(8): 7–22.

Freud, S. (1921) *Group Psychology and the Analysis of the Ego*. London: Hogarth.

Frith, S. (1987) 'The Industrialisation of Popular Music', in Lull, J.T (ed.) *Popular Music and Communication*. Newbury Park, CA: Sage Publications.

—— (1996) 'Music and Identity', in Hall, S. and du Gay, P. (eds) *Questions of Cultural Identity*. London: Sage Publications.

—— (1997/1980) 'Formalism, Realism and Leisure: The case of punk', in Gelder, K. and Thornton, S. (eds) *The Subcultures Reader*. London: Routledge.

Fyvel, T. (1997/1963) 'Fashion and Revolt', in Gelder, K. and Thornton, S. (eds) *The Subcultures Reader*. London: Routledge.

Gabbard, K. (1996) *Jammin' at the Margins: Jazz and the American Cinema*. London: University of Chicago Press.

Gabriel, Y. and Lang, T. (1995) *The Unmanageable Consumer*. London: Sage.

Gainer, B. (1989) 'The Business of High Culture: Marketing the performing arts in Canada', *Service Industries Journal*, 9(4): 143–60.

Gainer, B. and Padanyi, P. (2002a) 'Applying the Marketing Concept to Cultural Organisations: an Empirical Study of the Relationship Between Market Orientation and Performance', *International Journal of Nonprofit and Voluntary Sector Marketing Theory*, 7(2): 182–98.

—— (2002b) 'The Relationship between Market-oriented Activities and Market-oriented Culture: Implications for the development of market orientation in nonprofit service organisations', *Journal of Business Research*, 58: 854–62.

Gale, M. (1997) *Dada and Surrealism*. London: Phaidon.

Garbarino, E. and Johnson, M.S. (1999) 'The Different Roles of Satisfaction, Trust, and Commitment in Customer Relationships', *Journal of Marketing*, April: 70–87.

Garfinkel, H. (1967) *Studies in Ethnomethodology*. Oxford: Blackwell.

—— (2002) *Ethnomethodology's Program. Working Out Durkheim's Aphorism*. Lanham, MD: Rowman and Lenfield Publishers Inc.

Garnham, N. (1987) 'Concepts of Culture: Public policy and the cultural industries, *Cultural Studies*, 1(1): 23–37.

Garreson, L.C. (1972) 'The Needs of Motion Picture Audiences', *California Management Review*, XV(2): 144–52.

Gay, P. (2007), *Modernism: The Lure of Heresy*, London: Heinemann.

Gebhardt, G.F., Carpenter, G.S. and Sherry, J.F. (2006) 'Creating a Market Orientation: A longitudinal, multiform, grounded analysis of cultural transformation, *Journal of Marketing*, 70: 37–55.

Gemser, G., Leenders, M.A.A.M. and Wijnberg, N.M. (2008) 'Why Some Awards Are More Effective Signals of Quality than Others: A study of movie awards', *Journal of Management*, 34 (1): 25–54.

George, Nelson (2005) *Hip Hop America*. New York: Penguin.

Gergen, K.J. (1991) *The Saturated Self: Dilemmas of Identity in Contemporary Life*. New York: Basic Books.

Giesler, M. and Pohlmann, M. (2003) 'The Anthropology of File Sharing: Consuming Napster as a gift', *Advances in Consumer Research*, 30: 273–79.

Gilmore, J.H. and Pine, B.J. (1997) 'Beyond Goods and Services: Staging experiences and guiding transformations', *Strategy and Leadership*, 25(3): 11–17.

—— (2007) *Authenticity: What Consumers Really Want*. Cambridge, MA: Harvard Business School Press.

Gioia, T. (1997) *The History of Jazz*. Oxford: Oxford University Press

Glaister, D. (2007) 'Marvel Comics Puts Its Superheroes Online', *Guardian* (14 November).

Glaser, B. and Strauss, A. (1967) *The Discovery of Grounded Theory*. Chicago: Aldine.

Globalism Institute and VicHealth (2006) *Creating Community Celebrations, Arts and Wellbeing Within and Across Local Communities*. Melbourne: Globalism Institute.

Godin, Seth (1999) *Permission Marketing: Turning strangers into friends, and friends into customers*. New York: Simon and Schuster.

Goldwag, A. (2008) *Isms and Ologies: 453 Difficult Doctrines You've Always Pretended to Understand*. London: Quercus.

Gombrich, E.H. (1999) *The Use of Images: Studies in the Social Function of Art and Visual Communication*. London: Phaidon.

Goodacre, B. and Baldwin, G. (2002) *Living the Past: Reconstruction, Recreation, Re-enactment and Education at Museums and Historical Sites*. London: Middlesex University Press.

Gordon, W. (1999) *Goodthinking: A Guide To Qualitative Research*. London: Admap Publications.

Gorn, G.J (1982) 'The Effects of Music in Advertising on Choice Behaviour: A Classical conditioning approach', *Journal of Marketing*, 46 (Winter): 94–101.

Goulding, C. (1999a) 'Contemporary Museum Culture and Consumer Behaviour', *Journal of Marketing Management*, 15: 647–71.

—— (1999b) 'Consumer Research, Interpretive Paradigms and Methodological Ambiguities', *European Journal of Marketing*, 33: 859–73.

—— (2001) 'Romancing the Past: Heritage visiting and the nostalgic consumer', *Psychology and Marketing*, 18: 565–92.

Goulding, C., Shankar, A. and Elliott, R (2001) 'Dance Clubs, Raves and the Consumer Experience: An exploratory study of a subcultural phenomenon', *European Advances in Consumer Research*, 5: 203–8.

Graburn, N (2007) 'A Quest for Identity', in Watson, S. (ed.) *Museums and their Communities*. London: Routledge.

Gray, C. (2007) 'Commodification and Instrumentality in Cultural Policy', *International Journal of Cultural Policy*, 13: 203–15.

—— (2008) 'Arts Council England and Public Value: A critical review', *International Journal of Cultural Policy*, 14: 209–14.

Greer, G. (2008) 'Note to Robert Hughes: Bob dear, Damien Hirst is just one of many artists you don't get', *Guardian*, http://www.guardian.co.uk/artanddesign/2008/sep/22/1/print (accessed on 17 December 2008).

Grinstein, A. (2008) 'The Relationships between Market orientation and Alternative Strategic Orientations: A meta-analysis', *European Journal of Marketing*, 42(1/2): 115–34.

Grönroos, Christian (1994) 'From Marketing Mix to Relationship Marketing: Towards a paradigm shift in marketing', *Asia-Australia Marketing Journal*, 2(1): 9–29.

Grossberg, L. (1992) 'Is there a Fan in the House? The affective sensibility of fandom', in Lewis, L.A. (ed.) *The Adoring Audience: Fan Culture and Popular Media*. London: Routledge.

Grubb, E. and Grathwohl, H (1967) 'Consumer Self-Concept, Symbolism and Market Behaviour: A theoretical approach', *Journal of Marketing*, 31 (October): 22–27.

Grunenberg, C. and Knifton, R. (2007) *Centre of the Creative Universe: Liverpool and the Avant-garde*. Liverpool: Liverpool University Press.

Guillet de Monthoux, P. (2004) *The Art Firm – Aesthetic Management and Metaphysical Marketing from Wagner to Wilson*. Stanford: Stanford Business Books.

Gummesson, E. (2008) 'Customer Centricity: Reality or a wild goose chase?', *European Business Review*, 20(4): 315–30.

Hackley, C. (2009) *Marketing: A Critical Introduction*. London: Sage.

Haggerty, S.L. and White, N. (2008) (eds) *The Empire in One City? Liverpool's Inconvenient Imperial Past*. Manchester: Manchester University Press.

Hall, M. (2006) 'The Reappearance of the Authentic' in Karp, I., Kratz, C.A., Szwaja, L. and Ybarra-Frausto, T. (eds) *Museum Frictions: Public Culture/Global Transformations*. Durham, NC: Duke University Press.

Hall, S. and du Gay, P. (2003) *Questions of Cultural Identity*. London: Sage.

Hall, S. and Jefferson, T. (1996) *Resistance Through Ritual: Youth Subcultures in Postwar Britain*. London: Routledge.

Hall, S., Held, D. and McGrew, T. (eds) (1994) *Modernity and its Futures*. Oxford: Blackwell.

Hambleton, R. and Gross, J.S. (2007) *Governing Cities in a Global Era: Urban Innovation, Competition, and Democratic Reform*. New York: Palgrave Macmillan.

Hargreaves, D.J. and North, A.C. (1997) 'Developing New Audiences', in Hooper-Greenhill, E. (ed.) *Cultural Diversity: Developing Museum Audiences in Britain*. London: Leicester University Press.

—— (1997a) 'The Social Psychology of Music', in Hargreaves, D.J. and North, A.C. (eds) *The Social Psychology of Music*. Oxford: Oxford University Press.

—— (1999) 'The Functions of Music in Everyday Life: Redefining the social in music psychology', *Psychology of Music*, 27: 71–83.

Harris (1990) *Cultural Excursions: Marketing Appetites and Cultural Tastes in Modern America*. Chicago: University of Chicago Press.

Harrison, C., Wood, P. and Gaiger, J. (1998) *Art in theory 1815–1900: An anthology of changing ideas*. Oxford: Blackwell Publishers.

Harrison, J. (2005) 'Ideas of Museums in the 1990s' in Corsane, G. (ed.) *Issues in Heritage, Museums and Galleries: An Introductory Reader*. London: Routledge.

Hatcher, J. S. (2005) 'Of Otakus and Fansubs: A critical look at anime online light of current issues in copyright law', *Script-ed*, 2(4): 514–42.

Hawkins, G. (1993) *From Nimbin to Mardi Gras Constructing Community Arts*. St Leonards: Allen and Unwin.

Hayes, D. and Kent, A. (2007) 'Educating for Entrepreneurship', in Hagoort, G. (ed.) *Read This First – Growth and Development of Creative SME's*. Utrecht. Economic Clusters of Cultural Enterprise.

Hayes, D. and Slater, A. (2002) 'Rethinking the Missionary Position' – the quest for sustainable audience development strategies', *Managing Leisure*, 7: 1–11.

Hayes, D. (2009) *Arts Marketing – Philosophies and Orientation*, unpublished working paper, London: University of the Arts.

Haynes, G. (1999) 'Expanding Horizons: Encouraging creative opportunities for people with a disability', *Arts Access Aotearoa*. Wellington: Arts Access.

Hearn, G., Pace, C. and Roodhouse, S. (2007) 'From Value Chain to Value Creating Ecology', *International Journal of Cultural Policy*, 13(4): 419–36.

Heath, C., Hindmarsh, J. and Luff, P. (2009) *Using Video in Qualitative Research: analyzing social interaction in everyday life*. London: Sage Publications.

Heath, C. and Luff, P. (2000) *Technology in Action*. Cambridge: Cambridge University Press.

—— (2007) 'Ordering Competition: The interactional accomplishment of the sale of fine art and antiques at auction', *British Journal of Sociology*, 58: 63–85.

Heath, C. and vom Lehn, D. (2004) 'Configuring Reception: (Dis-)Regarding the "spectator" in museums and galleries', *Theory, Culture and Society*, 21: 43–65.

—— (2008) 'Construing Interactivity: Enhancing engagement and new technologies in science centres and museums', *Social Studies of Science*, 38: 63–91.

Heath, C., Luff, P., vom Lehn, D., Hindmarsh, J. and Cleverly, J. (2002) 'Crafting Participation: Designing ecologies, configuring experience', *Visual Communication*, 1: 9–34.

Hebdidge, D. (1997/1979) 'Subcultures: The meaning of style', in Gelder, K. and Thornton, S. (eds) *The Subcultures Reader*. London: Routledge.

Hemmings, T., Randall, D., Francis, D., Marr, L., Divall, C. and Porter, G. (1997) 'Situated Knowledge and the Virtual Science and Industry Museum: Problems in the social-technical interface', *Archives and Museum Informatics*, 11: 147–64.

Hemmings, T., Randall, D., Marr, L. and Francis, D. (2000) 'Task, Talk and Closure: Situated learning and the use of an "interactive" museum artefact', in Hester, S.K. and Francis, D. (eds) *Local Educational Order. Ethnomethodological studies of knowledge in action*. Amsterdam and Philadelphia: John Benjamins.

Hennig-Thurau, T., Houston, M.B. and Sridhar, S. (2006) 'Can Good Marketing Carry a Bad Product? Evidence from the motion picture industry', *Marketing Letters*, 17: 205–19.

Hennig-Thurau, T., Houston, M.B. and Walsh, G.J. (2007) 'Determinants of Motion Picture Box Office and Profitability: An interrelationship approach', *Review of Managerial Science*, 1 (1): 65–92.

Hennig-Thurau, T., Houston, M.B. and Walsh, G.J. (2006) 'The Differing Roles of Success Drivers across Sequential Channels: An application to the motion picture industry', *Journal of the Academy of Marketing Science*, 34: 559–575.

Hennig-Thurau, T., Walsh, G.J. and Wruck, O. (2001) 'An Investigation into the Success Factors Determining the Success of Service Innovations: The case of motion pictures', *Academy of Marketing Science Review*. Online. Available HTTP: www.amsreview.org/articles/hennig06-01.pdf (accessed 30 April 2009).

Hesmondhalgh, D. (1998) 'The British Dance Music Industry: A case study of independent cultural production', *British Journal of Sociology*, 49(2): 234–51.

Hewison, R. (1987) *The Heritage Industry: Britain in a Climate of Decline*. London: Methuen.

—— (2000) *Towards 2010: New Times – New challenges for the Arts*. London: Arts Council England.

Heyer, S.J. (2003) Keynote Remarks, Advertising Age Madison + Vine Conference, Beverly Hills Hotel, Beverly Hills, Calif. Feb. 5: www.davidburn.com/stevenjheyerspeech.pdf.

Hewitt, P. (2005) *Changing Places*. London: Arts Council England.

Hickey, D. (2006) *Andy Warhol 'Giant' Size*. London: Phaidon.

Hickley, C. (2005) 'Asterix Retaliates as Asian Comics Invade the European Market', Bloomberg Report (26 October). http://www.bloomberg.com/apps/news?pid=1000 0085andsid=a6BN0d.7Ttr0andrefer=europe (accessed on 11 April 2008).

Hill, Elizabeth, O'Suillivan, Catherine and O'Suillivan, Terry (1995) *Creative Arts Marketing*. Oxford: Butterworth Heinmann.

Hirschman, E.C. (1983) 'Aesthetics, Ideologies and the Limits of the Marketing Concept' *Journal of Marketing*, 47: 45–55.

Hirschman, E.C. and Holbrook, M.B. (1982) 'Hedonic Consumption: Emerging concepts, methods and propositions', *Journal of Marketing*, 46(3): 92–101.

Hirst, D. (1997) *I Want to Spend the Rest of My Life Everywhere, with Everyone, One to One, Always, Forever, Now*. New York: The Monacelli Press.

Hobsbawm, E. and Ranger, T. (eds) (1983) *The Invention of Tradition*. Cambridge: Cambridge University Press.

Hogg, M.K. and Banister, E.N. (2000) 'The Structure and Transfer of Cultural Meaning: A study of young consumers and pop music', *Advances in Consumer Research*, 27: 19–23.

Holbrook, M.B. (1981) 'Introduction: The esthetic imperative in consumer research', in Hirschman, E.C. and Holbrook, M.B. (eds) *Symbolic Consumer Behavior*. Ann Arbor, MI: Association for Consumer Research.

—— (1982) 'Mapping the Retail Market for Esthetic Products: The Case of Jazz Records', *Journal of Retailing*, 58 (Spring): 115–29.

—— (1986) 'I'm Hip: An Autobiographical Account of Some Musical Consumption Experiences', *Advances in Consumer Research*, 13: 614–18.

—— (1987) 'O, Consumer, How You've Changed: Some Radical Reflections on the Roots of Consumption', in Firat, F., Dholakia, N. and Bagozzi, R., (eds) *Philosophical and Radical Thought in Marketing*. Lexington, MA: D.C. Heath.

—— (1994) 'The Nature of Customer Value: An Axiology of Services in the Consumption Experience', in Rust, Roland T. and Oliver, Richard L. (eds) *Service Quality: New Directions in Theory and Practice*. Thousand Oaks, CA: Sage Publications.

—— (1995) *Consumer Research: Introspective essays on the study of consumption*. London: Sage.

—— (1999a) 'Introduction to Consumer Value', in Morris B. Holbrook (ed.) *Consumer Value: A Framework for Analysis and Research*. London: Routledge.

—— (1999b) 'Popular Appeal versus Expert Judgments of Motion Pictures', *Journal of Consumer Research*, 26 (September): 144–55.

—— (2005a) 'Art versus Commerce as a Macromarketing Theme in Three Films from the Young-Man-with-a-Horn-Genre', *Journal of Macromarketing*, 25(1): 22–31.

—— (2005b) 'The Role of Ordinary Evaluations in the Market for Popular Culture: Do consumers have "good taste"?', *Marketing Letters*, 16(2): 75–86.

—— (2008) *Playing the Changes on the Jazz Metaphor*. Boston: Now Publishers Inc.

Holbrook, M.B. and Addis, M. (2007) 'Taste versus the Market: An extension of research on the consumption of popular culture', *Journal of Consumer Research*, 34 (October): 415–24.

Holbrook, M.B. and Addis, M. (2008) 'Art versus Commerce in the Movie Industry: A two-path model of motion-picture success', *Journal of Cultural Economics*, 32(2): 87–107.

Holbrook, M.B. and Hirschman, E.C. (1982) 'The Experiential Aspects of Consumption: Consumer Fantasies, Feelings and Fun', *Journal of Consumer Research*, 9 (September): 132–40.

Holbrook, M.B. and Schindler, R.M. (1989) 'Some Exploratory Findings on the Development of Musical Tastes', *Journal of Consumer Research*, 16: 119–34.

Holbrook, M.B. and Zirlin, R.B. (1983) 'Artistic Creation, Artworks and Aesthetic Appreciation: some Philosophical Contributions to Nonprofit Marketing', in Belk, R. (ed.) *Nonprofit Marketing Volume 1*. Greenwich, CT: JAI Press.

Holbrook, M.B., Greenleaf, E.A. and Schindler, R.M. (1986) 'A Dynamic Spatial Analysis of Changes in Aesthetic Responses', *Empirical Studies of the Arts*, 4(1): 47–61.

Holbrook, M.B., Lacher, K.T. and LaTour, M.S. (2006) 'Audience Judgments as the Potential Missing Link between Expert Judgments and Audience Appeal: An illustration based on musical recordings of "My Funny Valentine"', *Journal of the Academy of Marketing Science*, 34 (January): 8–18.

Holcolm, B. (1999) 'Marketing Cities for Tourism', in Judd, D.R. and Fainstein, S.S. (eds) *The Tourist City*, Newhaven, CT: Yale University Press: 54–70.

Holden, J. (2004) *Capturing Cultural Value: How Culture has Become A Tool of Government Policy*. London: Demos.

—— (2008) *Democratic Culture: Opening the Arts to Everyone*. London: Demos.

Hollinshead, K. (2004) 'Tourism and the New Sense: Worldmaking and the enunciative value of tourism', in Hall, M.C. and Tucker, H. (eds) *Tourism and Postcolonialism: Contested Discourses, Identities and Representations*. London: Routledge/Contemporary Geographies of Leisure, Tourism, and Mobility.

Holt, D.B. (2004) *How Brands Become Icons: The Principles of Cultural Branding*. Boston: Harvard Business School Press.

Hong, W.C. (2008) *Competitiveness in the Tourism Sector: A Comprehensive Approach from Economic and Management Points*. Heidelberg: Springer.

Hooper-Greenhill, E. (2007) in Watson, S. (ed.) *Museums and their Communities*. London: Routledge.

—— (1992) *Museums and the Shaping of Knowledge*. London: Routledge.

—— (ed.) (1997) *Cultural Diversity: Developing Museum Audiences in Britain*. London: Leicester University Press.

Hopkins, D. (2004) *Dada and Surrealism: A Very Short Introduction*. Oxford: Oxford University Press.

Horn, B. (2006) 'Barriers and Drivers: Building audiences at the Immigration Museum, Melbourne', *Museum International*, 58(3): 78–84.

Horn, C. (2007) 'Retailers "Miss out on Manga"', *The Bookseller* (7 September) http://www.thebookseller.com/news/44768-retailers-miss-out-on-manga.html (accessed on 25 March 2008).

Hoyle, B. (2008) 'Damien Hirst makes £95m in Sotheby's sale, despite global slump', *The Times*, http://entertainment.timesonline.co.uk/tol/arts_and_entertainment/visual_arts/article4769953.ece (accessed on 16 February 2009).

Hughes, R. (2008), 'Day of the Dead', /2008/sep/13/damienhirst.art/print (accessed on 17 December 2008).

Hume, M. and Sullivan Mort, G. (2008) 'Satisfaction in Performing Arts: The role of value?', *European Journal of Marketing*, 42 (3/4): 311–26.

Hume, M., Sullivan Mort, G. and Winzar, H. (2007) 'Exploring Repurchase Intention in a Performing Arts Context: Who comes? And why do they come back?' *International Journal of Nonprofit and Voluntary Sector Marketing*, 12(2): 135–48.

International Federation of the Phonograph Industry (IFPI) (2007) 'The Broader Music Industry' http://www.ifpi.org/content/library/the-broader-music-industry.pdf (accessed on 13 June 2009).

Ison, M. (2002) 'The Trials of Life', *Museums Journal*, 26–27, March.

IT Media News (2007) 'How is the World Enjoying Japanese Contents?' (23 November). http://www.itmedia.co.jp/news/articles/ 0711/23/news006.html (accessed on 10 August 2008).

Izquierdo, C.C. and Samaniego, M.J.G. (2007) 'How Alternative Marketing Strategies Impact The performance of Spanish museums', *Journal of Management Development*, 26(9): 809–31.

Jackson, K. (2004) *Letters of Introduction*. Manchester: Carcanet.

Jameson, F. (1991) *Postmodernism, or, The Cultural Logic of Late Capitalism*. London: Verso.

—— 1990 'Postmodernism and Consumer Society', in Foster, H. (ed.) *Post Modern Culture*. London: Pluto.

Jamrozy, U. and Walsh, J.A. (2009) 'Destination and Place Branding: A Lost Sense of Place', in McCool, S. and Moisey, R.M. (eds) *Tourism, Recreation, and Sustainability: Linking Culture and the Environment*. Wallingford: CABI Publishing.

Jansen-Verbeke, M. and van Rekom, J. (1996) 'Scanning Museum Visitors, Urban Tourism Marketing', *Annals of Tourism Research*, 23(2): 264–375.

Januszczak, W. (2008) 'Duchamp is the Dark Genius in the Art Bratpack', *Sunday Times Culture*, 24 February, 16–17.

Japan External Trade Organization [JETRO] (2005) 'Cool Japan's Economy Warms Up'. http://www.jetro.go.jp/en/market/report/pdf/2005_27_r.pdf (accessed on 15 April 2008).

Japan Magazine Publishers Association [JMPA] (2007) 'Magazine Data 2007'. http://www.j-magazine.or.jp/data_001/index.html (accessed on the 10 August 2008).

Jayasuriya, L. (2008) 'Australian Multiculturalism Reframed', *The New Critic*, Institute of Advanced Studies, Issue 8, September, http://www.ias.uwa.edu.au/new-critic/eight/ Jayasuriya 4 July, 2009.

Jayasuriya, L. (2009) 'Australian Multiculturalism Reframed', *The New Critic*, Institute of Advanced Studies, Issue 8, September, http://www.ias.uwa.edu.au/new-critic/eight/ Jayasuriya 4 July.

Jégou, François and Manzini, Ezio (eds) (2009) *Collaborative Services. Social Innovation and Design for Sustainability*. Milano: Edizioni Polidesign.

Jenkins, H. (1992) *Textual Poachers: Television Fans and Participatory Culture*. London: Routledge.

—— (2008) *Convergence Culture: Where Old and New Media Collide*. New York: New York University Press.

Jenkins, R. (1996) *Social Identity*. London: Routledge.

JETRO (2005) 'Japanese Publishing Industry' (JETRO Economic Monthly, July). http://www.jetro.go.jp/en/market/report/pdf/2005_42_r.pdf (accessed 15 April 2008).

—— (2006) 'Japanese Publishing Industry' (JETRO Economic Report, October–November). http://www.jetro.go.jp/en/market/report/pdf/2006_25_r.pdf (accessed 15 April 2008).

Johanson, K. (2008) 'How Australian Industry Policy Shaped Cultural Policy', *International Journal of Cultural Policy*, 14(2): 139–48.

Jones, J. (2007) 'Is This the Birth of 21st-century Art?,' *Guardian*, http:www.guardian. co.uk/artanddesign/2007/jun/05/art/print (accessed on 17 December 2008).

Jopling, D. 1996 'Sub-phenomenology', *Human Studies*, 19(2): 153–73.

Joss, T. (2008) *New Flow*, [online] Available at: http://www.missionmodelsmoney.org. UK/U/new-flow-tim-joss.pdf (accessed 12 November 2008).

Jowers, P. (1999) 'Timeshards: Repetition, timbre, and identity in dance music', *Time and Society*, 8(2): 381–96.

Kamakura, W.A., Basuroy, S. and Boatwright, P. (2006) 'Is Silence Golden? An inquiry into the meaning of silence in professional product evaluations', *Quantitative Marketing and Economics*, 4(2): 119–41.

Kapetopoulos, F. (2004) *Who Goes There? National Multicultural Arts Audience Case Studies*. Surry Hills, NSW: Australia Council.

—— (2009) *Adjust Your Vision*. Surry Hills, NSW: Australia Council for the Arts.

Katz, J. (1996) 'Families and Funny Mirrors: A Study of the Social Construction and Personal Embodiment of Humour', *American Journal of Sociology*, 101: 1194–237.

—— (1999) *How Emotions Work*. Chicago: University of Chicago Press.

Kavaratzis, M. and Ashworth, G. J. (2005) 'City Branding: An effective assertion of identity or a transitory marketing trick?' *Tijdschrift voor Economische en Sociale Geografie*, 96 (5): 506–14.

Kearney, R. and Rasmussen, D. (2001) *Continental Aesthetics: Romanticism to Postmodernism – An Anthology*. London: Blackwell Philosophy Anthologies.

Kellaris, J.J. and Kent, R.J. (1993) 'An Exploratory Investigation of Responses Elicited by Music Varying in Tempo, Tonality and Texture', *Journal of Consumer Psychology*, 2(4): 381–401.

Kellaris, J.J. and Mantel, S.P (1994) 'The Influence of Mood and Gender on Consumers' Time Perceptions', *Advances in Consumer Research*, 21: 514–18.

Kellaris, J.J. and Rice, R (1993) 'The Influence of Tempo, Loudness and Gender of Listener on Response to Music', *Psychology and Marketing*, 10 (Jan./Feb.) 15–29.

Kellett, P. (2007) 'Tennis Australia – what to do with a heritage collection of great significance', in Rentschler, R. and Hede, A.-M. (eds) *Museum Marketing: Competing in the Global Marketplace*. Amsterdam: Butterworth and Heinemann.

Kellner, D. (1992) 'Popular Culture and the Construction of Postmodern Identities', in Lash, S. and Friedman, J. (ed.) *Modernity and Identity*. Oxford: Blackwell.

—— (1995) *Media Culture*. London: Routledge.

Kelts, R. (2007) *Japanamerica: How Japanese Pop Culture Has Invaded the US*. Basingstoke: Palgrave Macmillan.

Kent, S. and Brown, N. (1998) *Tracey Emin*. London: Art Data.

Kerrigan, F. (2010) *Film Marketing*. Oxford: Elsevier.

Kerrigan, F., O'Reilly, D. and Vom Lehn, D. (eds) (2009) 'Producing and Consuming Arts: A marketing perspective', *Consumption, Markets and Culture*, 12, 3.

Kershaw, B. (2004) *The Cambridge History of British Theatre*, Vol. 3. Cambridge: Cambridge University Press.

Kerstetter, D. and Cho, M. (2004) 'Prior Knowledge, Credibility and Information Search', *Annals of Tourism Research*, 31(4): 961–85.

Kinsella, S. (2000) *Adult Manga: Culture and Power in Contemporary Japanese Society*. London: RoutledgeCurzon.

Kirchberg, V. (1996) 'Museum Visitors and Non-visitors in Germany: A representative survey', *Poetics*, 24: 239–58.

—— (1999) 'Boom, Bust and Recovery? A Comparative Analysis of Arts Audience Development in Germany between 1980 and 1996', *International Journal of Cultural Policy*, 5: 219–54.

Kirschenblatt-Gimblett, B. (1998) *Destination Culture: Tourism, Museums and Heritage*. Berkeley: University of California Press.

—— (2006) 'Exhibitionary Complexes' in Karp, I., Kratz, C.A., Szwaja, L. and Ybarra-Frausto, T. (eds) *Museum Frictions: Public Culture/Global Transformations*, Durham: Duke University Press.

Kitwana, Bakari, (2003) *The Hip Hop Generation : Young Blacks and the Crisis in African American Culture*. Los Angeles: Basic Civitas Books.

Kivell, P. (1993) *Land and the City: Patterns and Processes of Urban Change*. London: Routledge.

Knell, J. (2006). 'Whose Art Is It Anyway? Personalisation in the arts – driving adaptation or revolution?', Arts Council England: www.artscouncil.org.uk/documents/projects/whoseartisitanyway_phpbIPQaf.doc.

Kolb, Bonita M. (2005) *Marketing for Cultural Organisations: New Strategies for Attracting Audiences to Classical Music, Dance, Museums, Theatre and Opera*. London: Thompson.

Konecni, V.J (1982) 'Social Interaction and Musical Preference', in Deutsch, D. (ed.) *The Psychology of Music*. New York: Academic Press.

Kotler, P. and Andreasen, A. (1991) *Strategic Marketing for Non-Profit Organisations*. Upper Saddle River, NJ: Prentice-Hall.

Kotler, P. and Levy, S. (1969) 'Broadening the Concept of Marketing', *Journal of Marketing*, 33 (January): 10–15.

Kotler, P. and Bernstein, J. (1997) *Standing Room Only: Strategies for marketing the Performing Arts*. Boston, MA: Harvard Business School Press.

Kottasz, R., Bennett, R. Savani, S., Mousley, W. and Ali-Choudhury, R. (2007) 'The Role of the Corporate Art Collection in Corporate Identity Management: The case of Deutsche Bank', *International Journal of Arts Management*, 10(1): 19–31.

Kozinets, R. V. (1997) '"I want to Believe": A Netnography of the X-Philes' Subculture of Consumption', *Advances in Consumer Research*, 24: 470–75.

—— (1998) 'On Netnography: Initial Reflections on Consumer Research Investigations of Cyberculture', *Advances in Consumer Research*, 25: 366–71.

Kozinets, R.V. and Handelman, J. (2004) 'Adversaries of Consumption: Consumer movements, activism and ideology', *Journal of Consumer Research*, 31(3): 691–704.

Ksiazek, T.B. and Webster, J.G. (2008) 'Cultural Proximity and Audience Behaviour: The role of language in patterns of polarization and multicultural fluency', *Journal of Broadcasting and Electronic Media*, 52(3): 485–503.

Kubacki, K. and Croft, R. (2004) 'Mass Marketing, Music, and Morality', *Journal of Marketing Management*, 20: 577–90.

—— (2005) 'Paying the Piper: a Study of Musicians and the Music Business', *International Journal for Nonprofit and Voluntary Sector Marketing Theory*, 10(3): 225–37.

—— (2006) 'Artists' Attitudes to Marketing: A cross-cultural perspective', *International Journal of Nonprofit and Voluntary Sector Marketing*, 11: 335–45.

Kurkowska-Budzan, M. (2006) 'The Warsaw Rising Museum: Polish Identity and Memory of World War II', *MARTOR, The Museum of the Romanian Peasant Anthropology Review*, 11.

Kushner, R.J. (2003) 'Understanding the Links Between Performing Artists and Audiences', *Internatioanl Journal of Arts Management, Law and Society*, 33(2): 114–26.

Lacher, K.T. (1989) 'Hedonic Consumption: Music as a Product', *Advances in Consumer Research*, 16: 367–73.

Lacher, K.T. and Mizerski, R. (1994) 'An Exploratory Study of the Responses and Relationships Involved in the Evaluation of, and in the Intention to Purchase New Rock Music', *Journal of Consumer Research*, 21 (September): 366–80.

Laczniak, G. and Michie, D. (1979) 'The Social Disorder of the Broadened Concept of Marketing', *Journal of Academy of Marketing Science*, 7(3): 214–32.

Lampel, J. and Shamsie, J. (2000) 'Critical Push: Strategies for creating momentum in the motion picture industry', *Journal of Management*, 26 (2): 233–57.

Langman, L. (1992) 'Neon Cages: Shopping for Subjectivity', in Shields, R. (ed.) *Lifestyle Shopping*. London: Routledge.

Larsen, G., Lawson, R. and Todd, S. (2009) 'The Consumption of Music as Self Representation in Social Interaction', *Australasian Marketing Journal*, 17(1): 16–26.

Lash, S. and Lury, C. (2007) *Global Culture Industry*. Cambridge: Polity Press.

Lawrence, T.B. and Phillips, N. (2002) 'Understanding Cultural Industries,' *Journal of Management Inquiry*, 11(4): 430–41.

Leadbetter, C. and Oakley, K. (1999) *The Independents: Britain's New Cultural Entrepreneurs*. London: Demos, Redwood Books.

Lee, M. (1993) *Consumer Culture Reborn*. London: Routledge.

Lehmann, D.R. and Weinberg, C.B. (2000) 'Sales through Sequential Distribution Channels: An application to movies and videos', *Journal of Marketing*, 64 (July): 18–33.

Leinhardt, G. and Knutson, K. (2004) *Listening in on Museum Conversations*. Walnut Creek: Altamira Press.

Leinhardt, G., Crowley, K. and Knutson, K. (2002) *Learning Conversations in Museums*. Mahwah, NJ: LEA.

Lennon, J. and Foley, M. (2000) *Dark Tourism: The Attraction of Death and Disaster*. London: Continuum.

Leonard, S. (2005) 'Progress against the Law: Anime and Fandom, with the Key to the Globalization of Culture', *International Journal of Cultural Studies*, 8(3): 281–305.

Leppert, R. and McClary, S. (1989) *Music and Society: The Politics of Composition, Performance and Reception*. Cambridge. Cambridge University Press.

Lessig, L. (2004) *Free Culture: The Nature and Future of Creativity*. London: Penguin Books.

Lewis, D. and Bridger, D. (2001) *The Soul of the New Consumer: Authenticity – What We Buy and Why in the New Economy*. London: Nicholas Brealey Publishing.

Linnehan, F. and Konrad, A.M. (1999) 'Diluting Diversity: Implications for Intergroup Inequality in Organizations'. *Journal of Management Inquiry*, 8 (4), 399–414.

Litman, B.R. (1983) 'Predicting Success of Theatrical Movies: An empirical study', *Journal of Popular Culture*, 16 (4): 159–75.

Litman, B.R. and Ahn, H. (1998) 'Predicting Financial Success of Motion Pictures: The early '90s experience', in Litman, B.R. (ed.) *The Motion Picture Industry*. Boston, MA: Allyn and Bacon.

Liverpool City Council and Liverpool Culture Company (2005) 'The Art of Inclusion: Liverpool's Creative Community' (Part one), Available from: www.liverpool08.com/Images/THE%20ART%20OF%20INCLUSION%20PART1_tcm79–55068.pdf (accessed 1 June 2009).

Liverpool Culture Company (2007a) 'Themed Years'. Available from: www.liverpool08.com/Events/ThemedYears/index.asp (accessed 1 June 2009).

—— (2007b) 'Our Communities'. Available from: www.liverpool08.com/OurCommunities/index.asp (accessed 1 June 2009).

—— (2007c) 'Song for Liverpool'. Available from: http://www.liverpool08.com/Events/SongForLiverpool/index.asp (accessed 1 June 2009).

Livingstone, S. (2005) *Audiences and Publics: When Cultural Engagement Matters for the Public Sphere*. Bristol: Intellect.

Llewellyn, N. and Burrow, R. (2008) 'Streetwise Sales and the Social Order of City Streets', *British Journal of Sociology*, 59: 561–83.

London Industrial Strategy (1985) *The Cultural Industries*. London Industrial Strategy.

Lonesome Pine Arts and Crafts, Inc. (2008) *Trail of the Lonesome Pine*, brochure, Big Stone Gap, VA.

Lopez, M. (2000) *The Origins of Multiculturalism in Australian Politics 1945–1975*. Melbourne: Melbourne University Press.

Low, D.R., Chapman, R.L. and Sloan, T.R. (2007) 'Inter-relationships between Innovation and Market Orientation in SMEs', *Management Research News*, 30(12): 878–91.

Luff, P., Hindmarsh, J. and Heath, C. (2000) *Workplace Studies. Recovering Work Practice and Informing System Design*. Cambridge: Cambridge University Press.

Lusch, R.F. and Vargo, S.L. (2006) *The Service-dominant Logic of Marketing: Dialog, Debate and Directions*. Armonk, NY: M.E. Sharp.

Macaulay, M. (2009) 'The I that is We: Recognition and administrative ethics,' in Cox, R., Huberts, L., Kolthoff, E. and Rhodes, T. (eds) *Ethics and Integrity in Public Administration: Cases and concepts*. New York: M.E. Sharpe.

Macaulay, M. and Dennis N. (2006) 'Jazz – a philosophical problem for marketing?' *The Marketing Review*, 6(2): 137–48.

Macdonald, S. (2007) 'Interconnecting: Museum visiting and exhibition design', *CoDesign* 3: 149–62.

Macias, P. (2006) 'Fan Lift J-Culture over Language Barrier', *The Japan Times* (7 September).

MacInnis, D.J. and Park, C.W. (1991) 'The Differential Role of Characteristics of Music on High- and Low-Involvement Consumers' Processing of Ads', *Journal of Consumer Research*, 18 (September): 161–73.

Maciocco, G. and Tagliagambe, S. (2009) *People and Space: Urban and Landscape Perspectives*. Heidelberg: Springer.

Madden, C. (2005) 'Indicators for Arts and Cultural Policy: A Global Perspective', *Cultural Trends*, 14: 217–47.

Maffesoli, M. 1996 *The Time of the Tribes: The Decline of Individualism in Mass Society*. London: Sage.

Manning, P. and Uplisashvili, A. (2007) '"Our beer": ethnographic brands in postsocialist Georgia', *American Anthropologist*, 109 (4): 626–41.

Marechal, P. (2008) *Andy Warhol: The Record Covers, 1949–1987*. London: Prestel.

Mark, J. (2006) *Cities and Consumption*. London: Routledge.

Markus, H. and Nurius, P. (1986) 'Possible Selves', *American Psychologist*, 41(9): 954–69.

Marsh, J. (ed.) *Experimental and Theoretical Studies of Consciousness, Ciba Foundation Synopsium*, 174, Chichester: John Wiley.

Marshall, R. (2004) 'Remaking the Image of the City', in Marshall, R. (ed.) *Waterfronts in Post-industrial Cities*. London: Spon Press.

Martin, P. (2007) *RenGen: The Rise of the Cultural Consumer – And What It Means to Your Business*. Avon, MA: Platinum Press.

Mattila, A.S. and Wirtz, J. (2001) 'Congruency of Scent and Music as a Driver of In-Store Evaluations and Behaviour', *Journal of Retailing*, 77(2): 273–89.

Mauss, M. (1979/1936) *Body Techniques, Sociology and Psychology*. London: Routledge and Kegan Paul.

McCracken, G. (1986) 'Culture and Consumption: A Theoretical Account of the Structure and Movement of the Cultural Meaning of Consumer Goods', *Journal of Consumer Research*, 13 (June): 71–84.

McLuhan, M. (2001) *Understanding Media*. London: Routledge.

McMaster, Sir B. (2007) *Supporting Excellence in the Arts: From Measurement to Judgement*. DCMS, January.

McRobbie, A. (1994) *Postmodernism and Popular Culture*. London: Routledge.

—— (1995) 'Recent Rhythms of Sex and Race in Popular Music', *Media, Culture and Society*, 17(2): 323–31.

McRobbie, A. and Thornton, S. (1995) 'Rethinking Moral Panic for Multi-mediated Social Worlds', *British Journal of Sociology*, 46(4): 559–74.

Measham, F., Parker, H. and Aldridge, J. (1998) 'The Teenage Transition: From adolescent recreational drug use to the young adult dance culture in Britain in the mid-1990s', *Journal of Drug Issues*, 28(1): 932.

Meiseberg, B., Ehrmann, T. and Dormann, J. (2008) 'We Don't Need Another Hero – Implications from network structure and resource commitment for movie performance', *Schmalenbach Business Review*, 60: 74–98.

Mehra, S. (2002) 'Copyright and Comics in Japan: Does Law Explain Why All the Comics My Kid Watches Are Japanese Imports?', *Rutgers Law Review*, 55: 155–204.

Meisner, R., vom Lehn, D., Heath, C., Burch, A., Gammon, B. and Reisman, M. (2007) 'Exhibiting Performance: Co-participation in Science Centres and Museums', *International Journal of Science Education*, 29: 1531–55.

Mencarelli, R. and Puhl, M. (2006) 'Positioning the Supply of Live Performance: Innovative Managerial Practices Relating to the Interaction of Spectator, Performance and Venue', *International Journal of Arts Management*, 8(3): 19–29, 77.

Menger, P.M. (1999) 'Artistic Labor Markets and Careers', *Annual Review of Sociology*, 25, 541–74.

Merleau-Ponty, M. (1962) *Phenomenology of Perception*, trans. Smith, C. London: Routledge and Kegan Paul.

Meroni, Anna (ed.). (2007) *Creative Communities. People Inventing Sustainable Ways of Living*. Milano: Edizioni Polidesign.

Merriam, A.P. (1964) *The Anthropology of Music*. Chicago: Northwestern University Press.

Message, K. (2006) *New Museums and the Making of Culture*. Oxford: Berg.

Metzger, G. (2007) 'The Skull', paper delivered to the On the Conditions of Art and Politics conference, held by the Serpentine Gallery, 28 June, viewable at http://www.archive.org/details/serpentine_session_2 (accessed on 16 December 2008).

Meyer, J.-A. and Even, R. (1998) 'Marketing and the fine arts – inventory of a controversial relationship', *Journal of Cultural Economics*, 22: 271–83.

Meyer, L.B (1956) *Emotion and Meaning in Music*. Chicago: University of Chicago Press.

Mick, D.G. (1996) 'Are Studies of Dark Side Variables *Confounded* by Socially Desirable Responding? The Case of Materialism'. *Journal of Consumer Research*, September, Vol. 23(2): 106–19.

Middleton, V.T.C. and Lickorish, L.J. (2007) *British Tourism: The Remarkable Story of Growth*. London: Butterworth-Heinemann.

Miklitsch, R. (2006) *Roll Over Adorno: Critical Theory, Popular Culture, Audiovisual Media*, New York: State University of New York Press.

Miles, I. (2001) 'Services Innovation: A reconfiguration of innovation studies', PREST, University of Manchester, April.

Miles, M. (2007) *Cities and Cultures*. London: Routledge.

Miles, S. and Miles, M. (2004) *Consuming Cities*. Basingstoke: Palgrave Macmillan.

Milliman, R.E. (1982) 'Using Background Music to Affect the Behaviour of Supermarket Shoppers', *Journal of Marketing*, 46(3):86–91.

Mink, J. (2000) *Duchamp: Art as Anti-Art*. Cologne: Taschen.

Mizerski, R., Pucely, M., Perrewe, P. and Baldwin, L. (1988) 'An Experimental Evaluation of Music Involvement Measures and Their Relationship with Consumer Purchasing Behaviour', *Popular Music and Society*, 12 (Fall): 79–96.

Moody, N. (1998) 'Social and Temporal Geographies of the Near Future', *Futures*, 30(10): 1003–16.

Morgan, N. and Pritchard, A. (2005) 'On Souvenirs and Metonymy, Narratives of memory, metaphor and materiality', *Tourist Studies*, 5(1): 29–53.

Morris, M.H., Schindehutte, M. and LaForge, R.W. (2003) 'The Emergence of Entrepreneurial Marketing: Nature and meaning', in Welsch, H. (ed.) *Entrepreneurship: The Way Ahead*. Chicago: University of Illinois.

Moul, C.C. (2005) 'Consequences of Omitting Advertising in Demand: The case of theatrical movies'. Working Paper, Washington University.

MPAA (2007) 'International Theatrical Snapshot'. Online. Available HTTP: http://www.mpaa.org/International%20Theatrical%20Snapshot.pdf (accessed 1 May 2009).

Mulligan, M., Humphery, K., James, P., Scanlon, C., Smith, P. and Welch, N. (2006) *Creating Community: Celebrations, Arts and Wellbeing Within and Across Local Communities*. Melbourne: The Globalism Institute.

Munck, R. (2003) 'Introduction: The City, Globalisation and Social Transformation', in Munck, R. (ed.) *Reinventing the City: Liverpool in Comparative Perspective*. Liverpool: Liverpool University Press.

Muniz, A. and O'Guinn, T.C (2001) 'Brand community', *Journal of Consumer Research*, 27 (March): 412–32.

Myerscough, J. (1988) *The Economic Importance of the Arts in Britain*. London: Policy Studies Institute.

Narver, J.C. and Slater, S.F. (1990) 'The Effect of a Market Orientation on Business Profitability', *Journal of Marketing*, 54(4): 20–35.

Nelson, R.A., Donihue, M.H., Waldman, D.M. and Wheaton, C. (2001) 'What's an Oscar Worth?', *Economic Inquiry*, 39(1): 1–15.

Newman, A. and McLean, F. (2004) 'Presumption, Policy and Practice', *International Journal of Cultural Policy*, 10(2): 167–81.

Newsweek (2008) 'Doctors Within Borders', *Newsweek*, 11 August, p. 4.

Ní Bhrádaigh, Emer (1997) 'Arts Marketing: A Review of Research and Issues', in Fitzgibbon, M. and Kelly, A. (eds) *From Maestro to Manager: Critical Issues in Arts and Culture Management*. Dublin: Oak Tree Press.

Nielsen, H.K. (2003) 'Cultural Policy and the Evaluation of Quality', *International Journal of Cultural Policy*, 9(3): 237–45.

Nisenson, E. (2000), *The Making of Kind of Blue*, New York: St. Martin's Griffin.

Nixon, S. (1992) 'Have You Got the Look?' in Shields, R. (ed.) *Lifestyle Shopping*. London: Routledge.

North, A.C. and Hargreaves, D.J. (1997) 'Music and Consumer Behaviour', in Hargreaves, D.J. and North, A.C. (eds) *Social Psychology of Music*. Oxford: Oxford University Press.

—— (1999) 'Music and Adolescent Identity', *Music Education Research*, 1(1): 75–92.

North, A.C , Hargreaves, D.J. and McKendrick, J (1999) 'The Influence of In-Store Music on Wine Selections', *Journal of Applied Psychology*, 84(2): 271–76.

Northeast Tennessee Tourism Association (2008) *Visitors' Guide*, brochure, Bristol, TN.

Oatley, N. (1998) 'Introduction', in Oatley, N. (ed.) *Cities, Economic Competition and Urban Policy*. London: Paul Chapman Publishing Ltd..

O'Donohoe, S. (1994) 'Advertising Uses and Gratifications', *European Journal of Marketing*, 28(8/9): 52–75.

OECD (2009) *The Impact of Culture on Tourism*. Paris: Organisation for Economic Co-Operation And Development.

O'Guinn, T. and Belk, R.W. (1989) 'Heaven on Earth: Consumption at Heritage Village, USA', *Journal of Consumer Research*, 16: 227–38.

O'Malley, Lisa and Patterson, Maurice (1998) 'Vanishing Point: The Mix Management Paradigm Re-Viewed', *Journal of Marketing Management*, 14: 829–51.

Oligopoly Watch (2003) 'Industry Brief: Movies I.' Online. Available HTTP: http://www.oligopolywatch.com/2003/08/06.html (accessed 31 April 2009).

O'Neill, M. (1996) 'Making Histories of Religion', in Kavanagh, G. (ed.) *Making Histories in Museums*: London : Leicester University Press.

—— (2004) 'Enlightenment Museums: Universal or merely global?', *Museum and Society*, Nov. 2(3): 190–202.

O'Regan, T. and Ryan, M.D. (2004) 'From Multimedia to Regional Content and Applications: Remaking policy for the digital content industries', *Media International Australia*, 102: 28–49.

O'Reilly, D. (2004) 'The Marketing of Popular Music', in Kerrigan, F., Fraser, P. and Ozbilgin, M.F. (eds) *Arts Marketing*. Oxford: Elsevier

—— (2005a) 'Cultural Brands/Branding Cultures', *Journal of Marketing Management*, 21: 573–88.

—— (2005b) 'The Marketing/Creativity Interface: A case study of a visual artist', *International Journal of Nonprofit and Voluntary Sector Marketing*, 10: 263–74.

—— (2007) 'By the Community, for the Community: Exhibiting New Model Army's 25 years of rock visual heritage', in Rentschler, R. and Hede, A.-M. (eds) *Museum Marketing: Competing in the Global Marketplace*. Amsterdam: Butterworth and Heinemann.

O'Reilly, D. and Larsen, G. (2005) 'Adventures in Rock Music Videography: Reflections on Research Practice', 3rd Workshop on Interpretive Consumer Research, EIASM, Copenhagen, Denmark.

Orman, J. (1992) 'Conclusion: The Impact of Popular Music in Society', in Bindas, K.J. (ed.) *America's Musical Pulse: Popular Music in Twentieth Century Society*. Contributions to the Study of Popular Culture, n. 33. London: Greenwood Press.

O'Sullivan, T. (2005) 'House lights Up: Reimagining the Audience for performing Arts', in Academy of Marketing Conference. Dublin Institute of Technology, Dublin, Ireland (5–7 July).

—— (2007) 'Sounding Boards: Performing Arts Organisations and the Internet Forum', *International Journal of Arts Management*, 9(3): 65–95.

Pacenti, E. (1998) *La Progettazione Dei Servizi Tra Qualità Ambientale E Qualità Sociale.* Di Tec. Milano: Politecnico di Milano.

Paris, S. (2002) *Perspectives on Object-Centered Learning in Museums,* Mahwah, NJ and London: Lawrence Earlbaum Associates.

Park, C.W. and Young, S.M. (1986) 'Consumer Response to Television Commercials: The Impact of Involvement and Background Music on Brand Attitude Formation', *Journal of Marketing Research,* 23 (February): 11–24.

Parker, C. (2008) 'Extended editorial: Place – the Trinal Frontier', *Journal of Place Management and Development,* 1(1): 5–14.

Parker, Sophia and Simon Parker (2007) *Unlocking Innovation: Why Citizens Hold the Key to Public Service Reform.* London: Demos.

Patten, F. (2004) *Watching Anime, Reading Manga: 25 Years of Essays and Reviews.* Berkeley, CA: Stone Bridge Press.

Pearce, S. (1995) *On Collecting: An Investigation into Collecting in the European Tradition.* London: Routledge.

—— (1997) 'Making Other People,' in Hooper-Greenhill, E. (ed.) *Cultural Diversity: Developing Museum Audiences in Britain.* London: Leicester University Press.

Peer Insight (2007) 'Seizing the White Space: Innovative service concepts in the United States', TEKES Technology Review 205/2007, Helsinki.

Penley, C. (1992) 'Feminism, Psychoanalysis, and the Study of Popular Culture', in Grossberg, L., Nelson, C. and Treichler, P. (eds) *Cultural Studies.* London: Routledge.

Peterson, R.A. (2005) 'In Search of Authenticity', *Journal of Management Studies,* 42(5): 1083–98.

Phillips, H. and Bradshaw, R. (1993) 'How Customers Actually Shop – Customer Interaction with the Point-of-Sale', *Journal of the Market Research Society,* 35: 51–62.

Philo, C. and Kearns, G. (1993) 'Culture, History, Capital: A critical introduction to the selling of places', in Kearns, G. and Philo, C. (eds) *Selling Places: The City as Cultural Capital, Past and Present.* Oxford: Pergamon Press.

Phipps, M., Rowe, S. and Cone, J. (2008) 'Incorporating Handheld Computers into a Public Science Center: A Design Research Study', *Visitor Studies,* 11: 123–38.

Pickard, J. (2007) 'Independents Squeezed Out of Rebuilt Shopping Centres', *Financial Times,* (4 September): 7.

Piloti (2009) 'Nooks and Corners', *Private Eye,* No. 1227, (9–22 January): 12.

Pine II B.J. and Gilmore J.H. (1998) *Welcome to the Experience Economy.* Harvard Business Review, July–August.

—— (1999) *The Experience Economy: Work Is Theater and Every Business a Stage.* Boston, MA: Harvard Business Press.

Pink, D. (2007) 'Japan, Ink: Inside the Manga Industrial Complex', Wired. http://www.wired.com/techbiz/media/magazine/15–11/ff_manga (accessed 23 March 2008).

Plucker, J.A., Kaufman, J.C., Temple, J.S. and Qian, M. (2009) 'Do Experts and Novices Evaluate Movies the Same Way?', *Psychology & Marketing,* 26(5): 470–78.

Pope, J.A., Isley, E.S. and Asamoa-Tutu, F. (2009) 'Developing a Marketing Strategy for Nonprofit Organisations: An exploratory study', *Journal of Nonprofit and Public Sector Marketing,* 21(2): 184–201.

Prag, J. and Casavant, J. (1994) 'An Empirical Study of the Determinants of Revenues and Marketing Expenditures in the Motion Picture Industry', *Journal of Cultural Economics,* 18(3): 217–35.

Prahalad, C.K. and Ramaswamy, V. (2004). 'Co-creating Experiences: The next practice in value creation', *Journal of Interactive Marketing,* 18(3): 5–14.

Pratt, A. (2004) 'Creative Clusters: Towards the governance of the creative industries production system?', *Media International Australia: Culture and Policy*, 112: 50–66.

Prosser, J. and Loxley, A. (2008) *Introducing Visual Method*. ESRC National Centre for Research Methods Review Paper, NCRM/10.

Pustz, M. (1999) *Comic Book Culture: Fanboys and True Believers*. Jackson, MS: University Press of Mississippi.

Radbourne, J., Johanson, K., Glow, H. and White, T. (2009) 'The Audience Experience: Measuring Quality in the Performing Arts', *International Journal of Arts Management*, 11(3): 16–29, 84.

Radway, J. (1984) *Reading the Romance: Women, Patriarchy and Popular Literature*. Chapel Hill, NC: University of North Carolina Press.

Ragsdale, D. (2008) 'Surviving the Culture Change'. Address given to the Australia Council Arts Marketing Summit, Melbourne, July.

Ramirez R. and Mannerick U. (2008) 'Designing Value-creating Systems', in Kimbell, L. and Seidel, V. P. (eds) *Designing for Services – Multidisciplinary Perspectives: Proceedings from the Exploratory Project on Designing for Services in Science and Technology-based Enterprises*. Oxford: Oxford University Press.

Ravid, S.A. (1999) 'Information, Blockbusters, and Stars: A study of the film industry', *Journal of Business*, 72 (4): 463–92.

Ravid, S.A. and Basuroy, S. (2004) 'Beyond morality and Ethics: Executive objective function, the R-rating puzzle, and the production of violent films', *Journal of Business*, 77 (2): 155–92.

Ravid, S.A., Wald, J.K. and Basuroy, S. (2006) 'Distributors and Film Critics: It takes two to tango?', *Journal of Cultural Economics*, 30 (3): 201–18.

Redhead, S. (1993) *Rave Off: Politics and Deviance in Contemporary Youth Culture*. London: Avebruy.

—— (1997) *The Subcultures Reader: Readers in Popular Cultural Studies*. Oxford: Blackwell.

Reid, C. (2006) 'HarperCollins, Tokyopop Ink Manga Deal', *Publishers Weekly* (28 March).

Reilly, W.J. (1931) *The Law of Retail Gravitation*. New York: Knickerbocker Press.

Reinstein, D.A. and Snyder, C.M. (2005) 'The Influence of Expert Reviews on Consumer Demand for Experience Goods: A case study of movie critics', *Journal of Industrial Economics*, 53 (March): 27–51.

Rentschler, R. (1998) 'Museum and Performing Arts Marketing: A climate of change', *Journal of Arts Management, Law and Society*, 28(1): 83–96.

—— (1999) *Innovative Arts Marketing*. Melbourne: Allen and Unwin.

—— (2002) 'Museum and Performing Arts Marketing: The age of discovery', *Journal of Arts Management, Law and Society*, 32(1): 7–14.

—— (2006) *Mix It Up Project Report: Building New Audiences Evaluation Report*. Melbourne, Deakin University, Multicultural Arts Victoria, Arts Centre, Australia Council.

Rentschler, R. and A. Gilmore (2002) 'Museums: Discovering services marketing', *International Journal of Arts Management*, 5(1): 62–72.

Rentschler, R. and Radbourne, J. (2008) 'Relationship Marketing in the Arts: The new evoked authenticity', in Sargeant, A. and Wymer, W. (eds) *The Routledge Companion to Nonprofit Marketing*. London: Routledge

Rentschler, R., Le, H. and Osborne, A. (2008) *Western Australia Intercultural Arts Research Project*. Perth, WA: Office of Multicultural Interests.

Rentschler, R., Radbourne, R., Carr, J. and Rickard, J. (2002) 'Relationship Marketing, Audience and Performing Arts Organization Viability', *International Journal of Nonprofit and Voluntary Sector Marketing*, 7(2): 118–30.

Reynolds, S. (1998) *Energy Flash*. London: Picador.

Rietveld, H.C. (1998) *This is Our House: House Music, Cultural Spaces and Technologies*. Aldershot: Ashgate.

Ritzer, G., Ryan, M. and Stepnisky, J. (2005) 'Transformations in Consumer Settings: Landscapes and Beyond', in Ratneshwar, S. and Mick, D.G. (eds) *Inside Consumption: Consumer Motives, Goals, and Desires*. London: Routledge.

Roodhouse, S. (2002) *Creating a Sustainable Culture for Everybody*, Centre for Reform: The Reformer.

—— (2006) *Cultural Quarters: Principles and Practice*. Bristol: Intellect Books.

Rosenberg, N.V. (2005) *Bluegrass: A History*. Urbana, IL: University of Illinois Press.

Sacks, H. (1992) *Lectures on Conversation*. Oxford: Blackwell.

Samli, A.C., Palda, K. and Barker, A.T. (1987) 'Toward a Mature Marketing Concept', *Sloan Management Review*, 28(2): 45–51.

Samuel, R. (1999) 'Resurrectionism' in Boswell, D. and Evans, J. (eds) *Representing the Nation, Histories, Heritage and Museums*, London: Routledge.

Sandell, R. (2002) *Museums, Society, Inequality*. London: Routledge.

Sangiorgi, D. (2009) 'Building up a Framework for Service Design Research', Conference Proceedings of the 8th European Academy of Design Conference, Aberdeen, Scotland.

Sanders, C. (1985) 'Tattoo Consumption', *Advances in Consumer Research*, 11: 17–22.

Sarup, M. (1996) *Identity, Culture and the Postmodern World*. Edinburgh: Edinburgh University Press.

Savage, M. and Warde, A. (1996) 'Cities and Uneven Economic Development', in LeGates, R. and Stout, F. (ed.) *The City Reader*, 2nd edn. London: Routledge.

Sawhney, M.S. and Eliashberg, J. (1996) 'A Parsimonious Model for Forecasting Gross Box-office Revenues of motion Pictures', *Marketing Science*, 15(2): 113–31.

Saxe, R. and Weitz, B.A. (1982) 'The SCO Scale: A measure of the customer orientation of salespeople', *Journal of Marketing Research*, 19(3): 343–51.

Scheff Bernstein, J. (2006) *Arts Marketing Insights: The Dynamics of Building and Retaining Performing Arts Audiences*. Hoboken, NJ: Pfeiffer Wiley.

Schodt, F.L. (1996) *Dreamland Japan: Writing on Modern Manga*. Berkeley, CA: Stone Bridge Press.

Schouten, J.W. and McAlexander, J.H. (1995) 'Subcultures of Consumption: An ethnography of the new bikers', *Journal of Consumer Research*, 22(1): 43–52.

Schroeder, J.E. (1992) 'Materialism and Modern Art', in Rudmin, F. and Richins, M. (eds) *Meaning, Measure, and Morality of Materialism*. Provo, UT: Association for Consumer Research.

—— (1997) 'Andy Warhol: Consumer researcher', *Advances in Consumer Research*, 24: 476–82.

—— (2000) 'Édouard Manet, Calvin Klein and the Strategic Use of Scandal', in Brown, S. and Patterson, A. (eds) *Imagining Marketing: Art, Aesthetics, and the Avant-Garde*. London: Routledge.

—— (2002) *Visual Consumption*. London: Routledge.

—— (2005a) 'The Artist and the Brand', *European Journal of Marketing*, 39: 1291–305.

—— (2005b) 'Aesthetics Awry: The painter of light and the commodification of artistic values,' *Consumption, Markets and Culture*, 9(2): 87–99.

—— (2008) 'Visual Analysis of Images in Brand Culture,' in McQuarrie, E. and Phillips, B.J. (eds) *Go Figure: New Directions in Advertising Rhetoric*, Armonk, NY: M.E. Sharpe.

—— (2009) 'The Cultural Codes of Branding', *Marketing Theory*, 9: 123–26.

Schroeder, J.E. and Borgerson, J.L. (2002) 'Innovations in Information Technology: Insights into consumer culture from Italian Renaissance Art', *Consumption Markets and Culture*, 5: 153–69.

Schroeder, J.E. and Salzer-Mörling, M. (eds) (2006) *Brand Culture*. London: Routledge.

Schulze, C. (2001) *Multimedia in Museen. Standpunkte und Aspekte interaktiver digitaler Systeme im Ausstellungsbereich*. Opladen: Deutscher Universitäts-Verlag.

Screven, C.G. (1976) 'Exhibit Evaluation: A goal-referenced approach', *Curator*, 52: 271–90.

Searle, A. (2005) 'Is Damien Hirst the Most Powerful Person in Art?', *Guardian*, http://www.guardian.co.uk/culture/2005/nov/01/3/print (accessed 17 December 2008).

Seaton, A.V (1996) 'Guided by the Dark: From thanatopsis to thanatourism', *International Journal of Heritage Studies*, 2(4): 985–87.

Sellers, A. (1998) 'The Influence of Dance Music on the UK Youth Tourism Market', *Tourism Management*, 19(6): 611–15.

Serrell, B. (1992) 'The 51% Solution: Defining a successful exhibit by visitor behavior', *Current Trends in Audience Research and Evaluation*, 6: 26–30.

—— (1998) *Paying Attention: Visitors and Museum Exhibitions*.Washington, DC: American Association of Museums.

Shankar, A. (2000) 'Lost in Music? Subjective personal introspection and popular music consumption', *Qualitative Market Research: An International Journal*, 3(1): 27–37.

Shankar, A., Cova, Bernard and Kozinets, Robert (eds) (2007) *Consumer Tribes*. Oxford: Elsevier.

Shankar, A., Elliott, R. and Fitchett, J.A (2009) 'Identity, Consumption and Narratives of Socialization', *Marketing Theory*, 9(1): 75–94.

Shaw, A. (2008) 'Damien Hirst: The rise and fall?', *Daily Telegraph*, http://blogs.telegraph. co.uk/go/tag/view/blog_post/Damien%20Hirst (accessed on 16 February 2009).

Shettel, H. (1968) 'An Evaluation of Existing Criteria for Judging the Quality of Science Exhibits', *Curator*, 11: 137–53.

—— (1976) 'An Evaluation of Visitor Response to "Man in his Environment"', Washington, DC: American Institutes for Research.

—— (2001) 'Do We Know How to Define Exhibit Effectiveness?', *Curator*, 44: 327–34.

Shields, R. (1992a) 'The Individual, Consumption Cultures and the Fate of Community', in Shields, R. (ed.) *Lifestyle Shopping: The Subject of Consumption*. London: Routledge.

—— (1992b) 'Spaces for the Subject of Consumption', in Shields, R. (ed.) *Lifestyle Shopping: The Subject of Consumption*. London: Routledge.

Shirastava, S. and Kale, S.H. (2003) 'Philosophizing on the Elusiveness of Relationship Marketing Theory in Consumer Markets: A case for reassessing ontological and epistemological assumptions', *Australasian Marketing Journal*, 11(3): 61–71.

Sicca, Luigi Maria (2000), 'Chamber Music and Organisation Theory: Some typical organisational phenomena seen under the microscope', *Studies in Cultures, Organisations and Societies*, 6: 145–68.

Sieverts, T. (2003) *Cities Without Cities: An interpretation of the Zwischenstadt*. London: Spom Press.

Silverman, D. (1997) *Qualitative Research: Theory, method and practice*. London: Sage.

Simonton, D.K. (2009) 'Cinematic Success Criteria and Their Predictors: The art and business of the film industry', *Psychology & Marketing*, 26(5): 400–20.

Singer, J.L. (1993) 'Experimental Studies of Ongoing Conscious Experience', in Bock, G.R. and Slater, A. (2000) '"Constructive Chillers": A new market for museums', in Rentschler, R. and Hede, A.-M. (eds) *Museum Marketing: Competing in the Global Marketplace*. Amsterdam: Butterworth and Heinemann.

—— (2007) 'Escaping to the Gallery: Understanding the motivations of visitors to galleries', *International Journal of Nonprofit and Voluntary Sector Marketing*, 12: 149–62.

Sloboda, J.A. (1985) *The Musical Mind: The Cognitive Psychology of Music*. Oxford: Clarendon Press.

—— (1991) 'Musical Structure and Emotional Response: Some empirical findings', *Psychology of Music*, 19: 110–20.

Smith, C. (1998) *Creative Britain*. London: Faber and Faber.

Smith, J. Walker, Clurman, Ann and Wood, Craig (2005) *Coming to Concurrence: Addressable Attitudes and the New Model for Marketing Productivity*. Racom Communications.

Smith, M.B. (1994) 'Selfhood at Risk: Postmodern perils and the perils of postmodernism', *American Psychologist*, 49(5): 405–11.

Smith, P.C. and Curnow, R. (1966) '"Arousal Hypothesis" and the Effects of Music on Purchasing Behaviour', *Journal of Applied Psychology*, 50: 255–56.

Sochay, S. (1994) 'Predicting the Performance of Motion Pictures', *Journal of Media Economics*, 7(4): 1–20.

Solomon, M. (1992) *Consumer Behaviour: Buying, Having and Being*. Boston: Allyn and Bacon.

Sood, S. and Drèze, X. (2006) 'Brand Extensions of Experiential Goods: Movie sequel evaluations', *Journal of Consumer Research*, 33 (December): 352–60.

Sorkin, M. (2001) *Some Assembly Required*. London: University of Minnesota Press.

Spiegelberg, H. (1982) *The Phenomenological Movement: A Historical Introduction*. The Hague: Martinuss Nijoff.

Srubar, I. (1998) 'Phenomenological Analysis and Its Contemporary Significance', *Human Studies*, 21: 121–39.

Stafford, M. and Tripp, C. (2001) 'Age, Income, and Gender: Demographic determinants of community theater', *Journal of Nonprofit and Public Sector Marketing*, 8(2): 29–43.

Stark, S.D. (2005) *Meet the Beatles: a Cultural History of the Band that Shook Youth, Gender, and the World*. London: HarperCollins.

Stater, K.J. (2009) 'The Impact of Revenue Sources on Marketing Behaviour: Examining web-promotion and place-marketing in nonprofit organisations', *Journal of Nonprofit and Public Sector Marketing*, 21(2): 202–24.

Steidl, D.P. and Hughes, R. (1999) *Marketing Strategies for Arts Organisations*. Sydney: Australia Council for the Arts.

Stevens, R. and Hall, R. (1997) 'Seeing Tornado: How video traces mediate visitor understandings of (natural?) phenomena in a science museum', *Science Education*, 81: 735–47.

Stevens, R. and Toro-Martell, S. (2003) 'Leaving a Trace: Supporting museum visitor interaction and interpretation with digital media annotation systems', *Journal of Museum Education*, 28: 25–31.

Stevenson, G. (2004) *Art and Culture in Northern Ireland 2004 Baseline Survey*. Belfast: Arts Council of Northern Ireland.

Stewart, D.W. and Punj, G.N. (1998) 'Effects of Using a Nonverbal (Musical) Cue on Recall and Playback of Television Advertising: Implications for advertising tracking', *Journal of Business Research*, 42: 39–51.

Stone, P.R (2006) 'A Dark Tourism Spectrum: Towards a typology of death and macabre related tourist sites, attractions and exhibitions', *TOURISM: An Interdisciplinary International Journal*, 52(2): 145–60.

Strathern, M (2003) 'Enabling Identity, Biology, Choice and the New Reproductive Technologies', in Hall, S. and duGay, P. (eds) *Questions of Cultural Identity*. London: Sage.

Strati, A. (1999) *Organization and Aesthetics*. London: Sage.

Strauss, C. (1997) 'Partly Fragmented, Partly Integrated: An anthropological examination of postmodern fragmented subjects', *Cultural Anthropology*, 12(3): 362–404.

Strongman, J. (1999) 'Rave: The culture that isn't', http//www.dischord.co.uk.

Sturken, M. and Cartwright, L. (2001) *Practices of Looking: An Introduction to Visual Culture*. Oxford: Oxford University Press.

Sullivan Mort, G.M., Weerawardena, J. and Carnegie, K. (2003) 'Social Entrepreneurship: Towards conceptualisation', *International Journal of Non-profit and Voluntary Sector Marketing*, 8(1): 76–90.

Tarlow, P.E (2005) 'Dark Tourism – the appealing "dark" side of tourism and more', in Novelli, M. (ed.) *Niche Tourism, Contemporary Issues Trends and Cases*. Oxford: Elsevier Butterworth-Heinemann.

Tauber, E.M. (1974) 'How Market Research Discourages Major Innovations', *Business Horizons*, 17: 24–27.

Taylor, Y. (2000) *The Future of Jazz*. New York: A Capella Books.

Tharpe, Marye C. (2001) *Marketing and Consumer Identity in Multicultural America*. London: Sage.

The Entertainment Software Association (2008) 'Video Game Design Influencing Art [Online] available at http://www.theesa.com/gamesindailylife/art.asp [accessed 20 May 2009).

Thelwall, S. (2007) *Capitalising Creativity: Developing earned income streams in Cultural Industries organisations*. Proboscis Cultural Snapshot 14.

Thomas, E.G. and Cutler, B.D. (1993) 'Marketing the Fine and Performing Arts: What has marketing done for the arts lately?', *Journal of Professional Services Marketing*, 10(1): 181–99.

Thomas, S. and Mintz, A. (1998) *The Virtual and the Real: Media in the Museum*. Washington, DC: American Association of Museums.

Thompson, C.J. (1997) 'Interpreting Consumers: A hermeneutic framework for deriving marketing insights from the texts of consumers' consumption stories', *Journal of Marketing Research*, XXXIV (November), 438–55.

Thompson, C.J. and Haytko, D.L. (1997) 'Consumers' Uses of Fashion Discourses and the Appropriation of Countervailing Cultural Meanings', *Journal of Consumer Research*, 24(1): 15–42.

Thompson, C.J. and Hirschman, E.C. (1995) 'Understanding the Socialised Body: A poststructuralist analysis of consumers' self conceptions, body images, and self care practices', *Journal of Consumer Research*, 25(2): 139–53.

Thompson, D. (2008) *The $12 Million Stuffed Shark: The Curious Economics of Contemporary Art and Auction Houses*. London: Aurum.

Thompson, J. (1988) *The Media and Modernity: A Social theory of the media*. Cambridge: Polity Press.

Thornton, S. (1996) *Club Cultures: Music, Media and Subcultural Capital*. Cambridge: Polity Press.

Townsend, C. and Merck, M. (2001) 'Eminent Domain: The cultural location of Tracey Emin', in M. Merck and C. Townsend (eds) *The Art of Tracey Emin*. London: Thames and Hudson.

Tuna, M. (2006) 'Cultural Approximation and Tourist Satisfaction', in Kozak, M. and Andreu, L. (eds) *Progress in Tourism Marketing*. Oxford: Elsevier.

Turner, V. (1969) *The Ritual Process: Structure and Anti-Structure*. London: Routledge and Kegan Paul.

—— (1974) *Drama, Fields, and Metaphors: Symbolic Action in Human Society*. Ithaca and London: Cornell University Press.

Turner, V. and Turner, E. (1978) *Image and Pilgrimage in Christian Culture*. New York: Columbia Press.

Tusa, J. (1999) *Art Matters: Reflecting on Culture*. London: Methuen.

Tuttle, Steve (2008) 'The Voters of Appalachia . . .', *Newsweek*, 7–14 July, 40–44.

Underhill, P. (1999) *Why We Shop: The Science of Shopping*. Washington: Simon and Schuster.

Van Raaij, E.M. and Stoelhorst, J.W. (2008) 'The Implementation of a Market Orientation: A review and integration of the contributions to date', *European Journal of Marketing*, 42(11/12): 1265–93.

Vargo, S. and Lusch, R. (2004) 'Evolving to a New Dominant Logic for Marketing', *Journal of Marketing*, 68 (January): 1–17.

Velthuis, O. (2005) *Talking Prices, Symbolic Meanings of Prices on the Market for Contemporary Art*. Princeton and Oxford: Princeton University Press.

Venkatesh, A. (1992) 'Postmodernism, Consumer Culture and the Society of the Spectacle', *Advances in Consumer Research*, 19: 199–202.

Venkatesh, A. and Meamber, L.A. (2008) 'The Aesthetics of Consumption and the Consumer as an Aesthetic Subject', *Consumption Markets and Culture*, 11: 45–70.

Vogel, H.L. (1998) *Entertainment Industry Economics: A guide for financial analysis*, New York: Cambridge University Press.

vom Lehn, D. (2006) 'Embodying Experience: A video-based examination of visitors conduct and interaction in museums', *European Journal of Marketing*, 40(11/12): 1340–59.

—— (2010) 'Examining "Response": Video-based Studies in Museums and Galleries', *International Journal of Culture, Tourism and Hospitality Research*, 4(1).

vom Lehn, D. and Heath, C. (2005) 'Accounting for New Technology in Museums', *International Journal of Arts Management*, 7: 11–21.

—— (2006) 'Interaction at the Exhibit-face: Video-based studies in museums and galleries', in Knoblauch, H., Schnettler, B., Raab, J. and Soeffner, H.-G. (eds) *Video-Analysis. Methodology and Methods*. London: Peter Lang.

vom Lehn, D., Heath, C. and Hindmarsh, J. (2001) 'Exhibiting Interaction: Conduct and Collaboration in Museums and Galleries', *Symbolic Interaction*, 24: 189–216.

Von Bergen, C.W., Soper, B. and Foster, T. (2002), 'Unintended Negative Effects of Diversity Management', *Public Personnel Management*, 31(2): 239–51.

Voss, G.H. and Voss, Z.G. (2000) 'Strategic Orientation and Firm Performance in an Artistic Environment', *Journal of Marketing*, 64(1): 67–83.

Walker-Kuhne, D. (2005) *Invitation to the Party: Building bridges to the arts, culture, and community*. New York: Theatre Communications Group.

Wallace, W.T., Seigerman, A. and Holbrook, M.B. (1993) 'The Role of Actors and Actresses in the Success of Films: How much is a movie star worth?', *Journal of Cultural Economics*, 17, 1–27.

Wanderer, J.J. (1970) 'In Defense of Popular Taste: Film ratings among professionals and lay audiences', *American Journal of Sociology*, 76(2): 262–72.

Wang, N. (1999) 'Rethinking Authenticity in Tourism Experience', *Annals of Tourism Research*, 26: 349–70.

Ward, S.V. (1998) *Selling Places: The Marketing and Promotion of Towns and Cities 1850–2000*. London: E. and F.N. Spon.

Warhol, A. (1975) *The Philosophy of Andy Warhol (From A to B and Back Again)*. Harcourt Brace: Orlando.

Warren, S. and Rehn, A. (eds) (2006) 'Oppression, Art and Aesthetics', *Consumption, Markets and Culture*, 9(2).

Watkins, S. Craig (2006) *Hip Hop Matters: Politics, Pop Culture and Struggle for the Soul of a Movement*. Boston: Beacon Press.

Watson, S. (ed.) *Museums and their Communities*. London: Routledge.

Wattanasuwan, K. and Elliott, R. (1997) 'I Am What I Consume: From Advertising Literacy to Symbolic Consumption', *Proceedings of the 26th EMAC Conference*, 4: 2141–48.

Wayne, A. (1998) *Class of 88, the True Acid Experience*. London: Virgin.

Weinberg, C.B. (2006) 'Research and the Motion Picture Industry', *Marketing Science*, 25(6): 667–69.

Whistler, J. McNeil (1888) 'The Ten O'clock Lecture', reproduced in Harrison, C., Wood, P. and Gaiger, J. (eds), *Art in Theory 1815–1900*. Oxford: Blackwell Publishers: 837–47.

White, T.R. and Hede, A. (2008) 'Using Narrative Inquiry to Explore the Impact of Art on Individuals', *Journal of Arts Management Law and Society*, 38(1): 19–36.

White, T.R., Rentschler, R. and Hede, A. (2008) 'Perceptions of the Impact of art', *International Journal of the Arts in Society*, 3(1): 13–22.

Wijnberg, N.M. and Gemser, G. (2000) 'Adding Value to Innovation: Impressionism and the Transformation of the Selection System in Visual Arts', *Organization Science*,11(3): 323–29.

Wilde, O. (1881) *The Soul of Man Under Socialism*. Charleston, SC: Forgotten Books.

—— (1882) 'L-Envoi', Autograph manuscript of the introductory essay to Rennell Rodd's *Rose Leaf and Apple Leaf*.

Wiley, N. (1994) *The Semiotic Self*. Chicago: University of Chicago Press.

Williams, C.C. (1997) *Consumer Services and Economic Development*. London: Routledge.

Williams, P. (2004) 'Witnessing Genocide: Vigilance and Remembrance at Toul Sleng and Choeung Ek', *Holocaust and Genocide Studies*, 18(2): 234–54.

—— (2007) *Memorial Museums: The Global Rush to Commemorate Atrocities*. Oxford: Berg.

Willis, P. (1990) *Common Culture*. Buckingham: Open University Press.

—— (1996) 'The Cultural Meaning of Drug Use', in Hall, S. and Jefferson, T. (eds) *Resistance Through Ritual*. London: Routledge.

Wilson, G. (2004) 'Multimedia Tour Programme at Tate Modern', *Museums and the Web'04.*, Ontario, CA: ACM Press.

Winhall, J. (2004) *Design Notes on Open Health*. London: Design Council.

Witcomb, A (2004) 'A Place for Us? Museums and communities', in Watson, S (ed.) *Museums and their Communities*. London: Routledge.

WolfBrown (2009) *Philadelphia Cultural Engagement Index*. Commissioned by The Greater Philadelphia Cultural Alliance.

Wong, W.S. (2007) 'Globalizing Manga: From Japan to Hong Kong and beyond', in Lunning, F. (ed.) *Mechademia 1*. Minneapolis, MN: University of Minnesota.

Wright, P. (1985) *On Living in an Old Country: The National Past in Contemporary Britain*, London: Verso.

Yalch, R. and Spangenberg, E. (1990) 'Effects of Store Music on Shopping Behaviour', *Journal of Consumer Marketing*, 7: 55–63.

Yalom, I.D. (1980) *Existential Psychotherapy*. New York: Basic Books.

Yalowitz, S. and Bronnenkant, K. (2009) 'Timing and Tracking: Unlocking Visitor Behavior', *Visitor Studies*, 12: 47–64.

Yang, J. (2004) 'Asian Pop Manga Nation: No Longer an Obscure Cult Art Form, Japanese Comics Are Becoming as American as Apuru Pai', San Francisco Chronicle (June 14).

Zaltman, G. (2003) *How Customers Think: Essential Insights into the Mind of the Market*. Cambridge, MA: Harvard Business School Publishing.

Zaltman, G. and Zaltman L. (2008) *Marketing Metaphoria: What Deep Metaphors Reveal About the Minds of Consumers*. Cambridge, MA: Harvard Business Press.

Zielenbach, S. (2000) *The Art Of Revitalization: Improving Conditions In Distressed Inner-City Neighborhoods*. New York: Garland Publishing.

Žižek, S. (2006) *The Parallax View*. Cambridge, MA: MIT Press.

Zufryden, F. (2000) 'New Film Website Promotion and Box-office Performance', *Journal of Advertising Research*, 40: 55–64.

Zukin, S. (1991) *Landscapes of Power: From Detroit to Disney World*. Berkley, CA: University of California Press.

INDEX

CPSIA information can be obtained at www.ICGtesting.com
Printed in the USA
BVOW031844271112

306629BV00003B/35/P

9 780415 496865